The *Bulletin of Latin America*

BLAR/SLAS book series editors:

Jasmine Gideon
Geoffrey Kantaris
Patricia Oliart
Lucy Taylor
Matthew Brown
Ann Varley

The *Bulletin of Latin American Research* publishes original research of current interest on Latin America, the Caribbean, inter-American relations and the Latin American Diaspora from all academic disciplines within the social sciences, history and cultural studies. The BLAR/SLAS book series was launched in 2008 with the aim of publishing research monographs and edited collections that compliment the wide scope of the Bulletin itself. It is published and distributed in association with Wiley-Blackwell. We aim to make the series the home of some of the most exciting, innovatory work currently being undertaken on Latin America.

Shifting Horizons: Urban Space and Social Difference in Contemporary Brazilian Documentary and Photography

ALICE LOUISA ALLEN

This edition first published 2017
Editorial material and organisation © 2017 Society for Latin American Studies, text
© The Authors

Registered Office
John Wiley & Sons Ltd, The Atrium, Southern Gate, Chichester, West Sussex, PO19 8SQ, UK

Editorial Offices
350 Main Street, Malden, MA 02148-5020, USA
9600 Garsington Road, Oxford, OX4 2DQ, UK
The Atrium, Southern Gate, Chichester, West Sussex, PO19 8SQ, UK

For details of our global editorial offices, for customer services, and for information about how
to apply for permission to reuse the copyright material in this book please see our website at
www.wiley.com/wiley-blackwell.

The right of Alice Louisa Allen to be identified as the author of the editorial material in this work
has been asserted in accordance with the UK Copyright, Designs and Patents Act 1988.

Library of Congress Cataloging-in-Publication Data

Names: Allen, Alice Louisa, writer of supplementary textual content.
Title: Shifting horizons : urban space and social difference in contemporary
 Brazilian documentary and photography.
Other titles: Shifting horizons (John Wiley & Sons)
Description: Chichester, West Sussex, UK; Malden, MA, USA: John Wiley &
 Sons Ltd, [2017]
Identifiers: LCCN 2017022871 | ISBN 9781119328551 (hardcover)
Subjects: LCSH: Documentary photography–Brazil. | Documentary
 photography–Social aspects–Brazil. | Slums–Brazil–Pictorial works. | Social change–Brazil.
Classification: LCC TR820.5 .S514 2017 | DDC 770.981–dc23 LC record available at
https://lccn.loc.gov/2017022871

A catalogue record for this book is available from the British Library.

This book is published in the following electronic formats: Wiley Online Library
978-1-119-32855-1

Set in 10 on 13pt and Palatino
by Laserwords Private Limited, Chennai, India
Printed and bound in the United Kingdom by Page Brothers, Norwich

Contents

Preface

Inequality, injustice, difference. These are words with which the documentary community has wrestled over the last century. How can the powerful tools we have to create images, moving and still, be used to influence the way we think and, perhaps, act? Will telling people about something we think is problematic lead to a solution? Is it possible to inspire ourselves and others to move towards a better world? Perhaps the more pertinent question is: 'who decides what this better world might look like?'

This desire for change, so integral to the project of *conscientização* and socially concerned documentary, collides with numerous obstacles both during and well beyond the creative process. The impact and resulting shockwaves of these collisions stimulate ethical challenges and considerations that we cannot ignore.

Brazil, often labelled one of the most unequal countries in the world, seems itself to be always on the brink of change. At the time of writing it was hailed as a rising economic power and BRIC nation, looking forward with the 2014 World Cup and 2016 Olympics to a bright future – that has not yet arrived. There has been great unrest in more recent years, with protests over rising prices, police violence and government spending and corruption, and the impeachment of former President Dilma Rousseff in August 2016, flagging an end to more than a decade's rule by the left-wing Workers' Party.

In this book I have endeavoured to explore some of the challenges faced by today's filmmakers and photographers in Brazil as they negotiate both the representation of inequalities and the desire for change embedded in traditional social documentary practices. I have sought to approach with an open mind and as much self-awareness as possible; questioning conventional parameters in the consideration of two distinct media forms and seeking to incorporate a wide range of voices, from what is often referred to as the periphery, through to those at the heart of the nation's cultural elite. I hope that it will reach a little way, and indeed inspire others to reach much further, beyond the stalemate of discussion surrounding *porno-miséria* and *a cosmética da fome*, bringing to light innovative and often empowering responses to social difference.

Acknowledgements

I am extremely grateful to the University of Cambridge for funding my doctoral research under their Domestic Research Studentship scheme and fostering the ever-growing curiosity I feel for the art of documentary in its many forms. The support and guidance of those working in the field of Latin American culture has been invaluable over the years; my particular thanks go to Dr Geoffrey Kantaris and Professor Karl Posso, whose encouragement fuelled my research pursuits in the first instance.

The enthusiasm with which I was invariably received during research trips in Brazil has been greatly appreciated. Many artists, and in some instances their families, have very generously allowed me to reproduce within this book some of the striking images they have so thoughtfully created. For that I am extremely grateful.

Although too numerous to name individually here, I thank all of the artists (including those whose work has not featured in the final text), directors, producers, curators, critics, academics, directors of cultural and non-governmental organisations and other specialists who granted me interviews and so generously shared with me their time, thoughts and access to materials. I thank the organisers of the Festival do Rio and Mostra Internacional de Cinema São Paulo, the Observatório de Favelas and Imagens do Povo, the vibrant filmmaking and photographic community of Recife, Instituto Moreira Salles, Projeto Portinari, the Metropolitan Museum of Art, the Science Museum and the MAM Rio Cinemateca for their provision of images and archive material, together with Julie Coimbra at Cambridge University for her help in procuring research materials.

My particular appreciation goes to Jailson de Silva e Souza of the Observatório de Favelas for his role in orienting and challenging my endeavours at an early stage, helping me to clarify my position and identify important research questions; and to Angus Allen, Charles Allen, Lucy Bell, Elisa Birtwistle, Louise Calf and Sophia Ostler for their proofreading assistance and helpful observations.

Finally, and crucially, deepest thanks go to my mother Jennifer for believing in me and encouraging me every step of the way; always an inspiration in her curiosity and caring for the world and those around her. To my sisters and brothers, who no matter how far away are always near, and to PMG and Kimberley Kanté who accompanied much of this journey.

Introduction

> The power relations between individuals, groups, and even whole social classes, and the consequent capacity to find feasible paths of social transformation, are broadly defined through the meshing of monetary, spatial, and chronological nets that define the parameters of social action. (Harvey, 1989: 189)

> Se ha pasado a percibir al poder sólo como una acción dominadora ejercida verticalmente sobre los dominados a una concepción descentrada y multideterminada de las relaciones políticas, cuyos conflictos y asimetrías se moderan mediante compromisos entre los actores colocados en posiciones desiguales. (García Canclini, 1995: 173–174)

As we speed into the twenty-first century, the ever deepening fissures between wealth and poverty have made inequality an unavoidable and increasingly urgent subject for domestic and global decision makers. The tissue of citizenship, which has historically played a fundamental role in conceptually binding groups of people together to form unified national and social bodies, appears stretched in places to its utmost limits. The rapid technological and material advancements witnessed over the last century have not been accompanied by similar progress in the domain of human rights, the most basic of which continue to be violated on varying scales across the world. The strength of opposing interests continues to lead to war and conflict between and within nations, as factors such as corruption, repression, terrorism and religion, amongst many others, spur different groups to fight for their own idea of justice.

The economic inequalities upon which many of these tensions are built, or at least aggravated by, can often be traced to the doorstep of the reigning capitalist and neoliberal systems whose particular hold around the globe has developed and strengthened over the last half century: 'under neoliberalism, economic growth rates have declined, unemployment and underemployment have become widespread, inequalities within and between countries have become sharper, the living and working conditions of the majority have deteriorated almost everywhere, and the periphery has suffered greatly from economic instability' (Saad-Filho and Johnston, 2005: 5). Although the occurrence of widespread 'social, political, economic, and cultural destabilization' is linked to the *deregulation* of economic markets (Harrison, 2008:

149), neoliberalism has also been interpreted as the imposition of 'a specific form of social and economic *regulation* based on the prominence of finance, international elite integration, subordination of the poor in every country and universal compliance with US interests' (Saad-Filho and Johnston, 2005: 4). Alfredo Saad-Filho and Deborah Johnston are quick to stress the highly interconnected nature of neoliberalism, imperialism and globalisation as projects that commonly work to amass wealth in the hands of the few, demonstrating absolute disregard for the interests and wellbeing of the vast majority (2005: 2).

Brazil is a country often held up as an example of such distinct extremes of economic and social inequality. In the mega-cities of São Paulo and Rio de Janeiro an influx of immigration – especially from poorer regions in the north-east during the latter half of the twentieth century – has made for dynamic urban conglomerations of enormous and overflowing proportions where these differences are exacerbated and often clearly visible. Such disparities are particularly prominent in spatial terms where access to certain basic amenities and rights may frequently be determined by the area or nature of the space one inhabits. This has led to a repeated focus upon segregation as a defining and problematic characteristic of the urban environment: 'the economic and social reality of the country, the acute contradictions between different social groups and the progressive segregation and separation of residential areas make the coexistence and connection between the rich and the poor hard to achieve' (Hernández, Kellett and Allen, 2010: 175). This is a theme embraced by two emblematic texts from the field of journalism and anthropology respectively, Zuenir Ventura's *Cidade partida* (1994) and Teresa Caldeira's *City of Walls* (2000),[1] which enter my discussion on the so-called 'informal' occupation and contestation of urban living spaces in chapters 3 and 4.

The city has long been seen as the locus of difference par excellence. Commenting upon early twentieth-century cities in the classic essay 'Urbanism as a Way of Life', American sociologist Louis Wirth noted the radically changing nature of social relations brought about by migration and population growth in urban centres (1938: 11). Wirth observed that 'the multiplication of persons in a state of interaction under conditions which make their contact as full personalities impossible produces that segmentalization of human relationships' (1938: 12). Such divisions found their reflection in the spatial organisation of the city, which he described as resembling 'a mosaic of social worlds' (1938: 15). Alienation in the urban environment and difference as a source of

1 I refer to the English language edition throughout as the original version of the work, subsequently published in Portuguese as *Cidade de muros* (2000).

estrangement had been explored in the earlier work of German sociologist Georg Simmel, who pointed to the dynamic of 'rapid oscillation between two characteristic moods of urban life: the over-close identification with things, and, alternately, too great a distance from them' as contributing to the development of psychological ills such as agoraphobia (Vidler, 1991: 37).

The transition from a fundamentally rural to an urban-based population constitutes one of the most significant transformations that Brazilian society has experienced over the last century. In his canonical *Raízes do Brasil* (1936), Sérgio Buarque de Holanda highlights 1888, the year in which the Lei Áurea, or Golden Law, was passed abolishing slavery, as a pivotal moment in its instigation of changes that prepared 'o terreno para um novo sistema, com seu centro de gravidade, não já nos domínios rurais, mas nos centros urbanos' (2000: 178). As a marker separating free citizens from those destined to serve them, slavery was undoubtedly one of the most significant and public distinctions in social status and one related visually to skin colour and racial identity. It was during this same period that sociologist Gilberto Freyre published his emblematic *Casa-grande & senzala* (1933). This was to play a key role in the formation of a new sense of national identity in which both black people and native Indians were symbolically included in a picture that had hitherto exclusively privileged the European coloniser and settler. Freyre's philosophy of Lusotropicalism propounded the notion of a softer Portuguese colonisation – in opposition to the harsh and oppressive rule of the Spanish colonisers elsewhere in Latin America – and found support with other influential authors like Buarque de Holanda (2000: 38).

Although a landmark act that was well overdue, it is argued that the liberation of slaves did little to benefit their material conditions at the time:

> It was the old masters that gained freedom after abolition – freedom over their old workers, the freedom to deny them shelter and material sustenance, the freedom to deny them the social acknowledgement that they deserved to have a dignified existence just like any other citizen of a democratic state. (Sachs, Wilheim and Pinheiro, 2009: 47)

Observing that the rural estates continued to reflect the same patterns of domination and submission that existed in pre-abolition times, Freyre suggested that these relations were founded on 'a logic that presupposes complementarity and irreducible difference' amongst social actors (Sachs, Wilheim and Pinheiro, 2009: 25). The naturalisation of difference thus played a powerful role in maintaining and reinforcing clear-cut social positions and slamming the brakes on potential social mobility opened up by constitutional change. Ultimately the lack of economic progress and widespread poverty

that abounded in rural areas, together with the enticing prospect of employ-
ment in the industrialising cities of the south such as São Paulo and Rio de
Janeiro, spurred the occurrence of migration on a vast scale from the 1930s
onward (Winant, 2001: 222). Where rural workers remained mired in deeply
entrenched values and hierarchies, big cities became the space of possibility
as the implementation of a minimum wage together with other work-
ers' rights signalled change on the horizon (Sachs, Wilheim and Pinheiro,
2009: 37).

The idea of a harmonious co-existence of difference that was celebrated by
Freyre as a uniquely Brazilian phenomenon continues to find voice amongst
Brazilians today. An example often used to illustrate this assertion is the sup-
posed intermingling of different social groups in the 'democratic space' of the
former capital's public beaches (Freeman, 2002: 19). James Freeman goes on to
suggest that despite this popular opinion 'the beach seems to be divided into
many small cells of sociability […] whose boundaries are clearly demarcated'
(2002: 19). As Renato Ortiz notes, differentiation and division are processes
inherent to modernity and find a clear expression in the phenomenon of the
division of labour which became commonplace during this period (1998: 32).
He is quick to underline the fact that differences, far from being innate and
fixed qualities, are produced socially and as such are inseparable from the
power relations and vested interests that define them (1998: 31–32). The dis-
course of multiculturalism that has validated and celebrated concepts like
mestiçagem and hybridity in Brazil and other Latin American countries is one
in which the concept of difference can easily serve to mask what are funda-
mentally issues of inequality (Ortiz, 1998: 33). García Canclini is similarly
suspicious of the way in which populist celebrations of 'irreducible differ-
ences' house certain destructive agendas, ultimately serving to support the
understanding of 'las diferencias raciales o étnicas como concretas y un rec-
hazo al pensamiento igualitario como abstracto' (1995: 85).

As populations increase and the finite nature of our natural resources
becomes increasingly difficult to ignore, the conflict generated by difference
continues to foment international tensions. The dramas of inequality play
out in contexts ranging from the local to the national and global and the
clear ties between consumerism and social status have led to a bubbling
resentment amongst low-income groups at the vastly differential levels of
access to goods. These sentiments have overflowed in acts of mass violence
and looting exemplified by the UK riots in August 2011 (BBC, 2011) and
the wave of unrest in Argentina during December 2012 (C. Andrade, 2012).
As Zygmunt Bauman reminds us, 'the society of consumers has no room
for flawed, incomplete, unfulfilled consumers' (2004: 14). Such occurrences
suggest, however, that groups excluded from the consumer Mecca are
increasingly less willing to occupy the sidelines in a passive manner. With

large-scale urban expansion and population density a challenge for cities within Brazil and across the world, how we deal with socio-economic and cultural differences has become an increasingly pressing concern for those aspiring to durable cohabitations of urban space in the twenty-first century.

Film and still photography are two powerful visual media that have closely accompanied the development of cities throughout the twentieth century and, as such, they represent important fields within which to analyse these imbalances and perceived spatial divides today. Arguing that cinema is foremost a spatial rather than a textual system, Shiel and Fitzmaurice highlight its 'special potential to illuminate the lived spaces of the city and urban societies' (2001: 6). Documentary film is especially pertinent in this respect, given the history of its development in Latin America, described by critic Michael Chanan as being driven by a shared 'preoccupation to give voice to people normally excluded from public speech and outside the political power structures' (2007: 203). It is thus to spaces frequently neglected and marginalised by the state that many 'socially concerned' films turn.

In the realm of photography, photojournalism and documentary practices have been instrumental in creating what Susan Sontag critically terms a 'catalogue of misery and injustice throughout the world' (1979: 21). *Conscientização* or efforts to raise awareness around perceived social problems ostensibly drives much of this production and is historically bound to a belief in the political capacity of imagery to drive material change. The use of what Jacques Rancière describes as the 'intolerable image' was based upon the idea that there existed a 'straight line from the intolerable spectacle to awareness of the reality it was expressing; and from that to the desire to act in order to change it' (2009: 103). Although much scepticism surrounds this kind of image making today, it continues to be produced and has a firm place in news reportage and charity press campaigns in both filmic and photographic forms.

In the following sections I examine some of the principal ideas surrounding the documentary tradition in both film and photography, exploring trends that will help us to situate the works analysed over the coming chapters in both a Brazilian and an international context. I begin with the medium of film as an area that possesses a strong historic precedent for the production of socially concerned material in Brazil.

Documentary Film, *Conscientização* and 'Socially Concerned' Production

The subject of interest for this analysis is not documentary as a rigid category, but rather the lens of unstable ideas and desires through which certain cultural productions are framed as documentary. The decision to focus the study on documentary material, rather than validating the fiction/non-fiction

divide or an idea that the genre possesses certain intrinsic qualities, acknowledges the importance of continuing to question the parameters and expectations upon which the concept of documentary has been built and normalised in its practice over the years. It should also be noted that in Latin America 'cross-generic forays between fiction and documentary have become a privileged form of expressing a more general hybridization of culture' and that the boundaries between these conventionally different stylistic forms are thus already somewhat blurred (Page, 2009: 7). For this reason, I do not shy away from exploring trends in fiction film where relevant. Indeed, the extremely blurred line between these categorisations is acknowledged in the inclusion of several films, most notably *Juízo* (2007) and *Avenida Brasília Formosa* (2010), that rely upon either recreated or fictional scenes and might therefore even be more strictly classified as hybrid or 'docufiction'.

From the 1990s, the documentary genre has enjoyed a boost in popularity on the international scene, accompanied by a return to cinema screens that had become almost entirely dominated by works of fiction (Chanan, 2007: 3). A similar boom has been experienced in Brazil during the last decade. Lins and Mesquita cite the increasing affordability of digital cameras and the use of non-linear editing systems as important elements contributing to the rising number of documentaries produced from the late 1990s onward (2008: 11). The emergence and strengthening of exhibition contexts specifically for the genre and forums of debate around the practical issues of both exhibition and distribution are also mentioned as key factors in this trend (2008: 7). The annual documentary festivals Forumdoc.bh in Belo Horizonte and É Tudo Verdade in São Paulo and Rio de Janeiro – both featuring national and international competition categories – enjoyed their twentieth and twenty-first editions in 2016 respectively.[2] Although clearly geared to fiction, the Festival de Cinema de Brasília created an exclusive documentary competition category in 2012, joining the Mostra Internacional de Cinema São Paulo and Festival do Rio as other major Brazilian film festivals already doing so.

Amir Labaki, founder and director of É Tudo Verdade, points to documentary as an enduring and highly accomplished area of national cinema that has produced some of Brazil's most successful films on the international festival circuit, amongst which he cites Marcos Prado's *Estamira* (2004), analysed in chapter 1 (2006: 11). Although documentary films have risen at their peak to represent a third of national films to achieve commercial cinematic

2 The É Tudo Verdade film programme simultaneously screens in two to three other major Brazilian cities each year, though São Paulo remains the principal location where the Conferência Internacional do Documentário – hosting an extensive schedule of discussion forums – runs alongside the festival.

release, Labaki also acknowledges that the economy sustaining this production is a fragile one, almost entirely reliant on government subsidies and funding programmes together with small-scale private investment (Labaki, 2006: 12). Lins and Mesquita are less optimistic regarding viewing figures, however, and posit the practical issues of film distribution and commercialisation as a serious ongoing concern (2008: 12). Unlike many other countries where television is a primary exhibition space for independently produced documentary, the relationship between the two industries in Brazil is historically tenuous, with DOCTV being a commonly cited exception (Lins and Mesquita, 2008: 13). Initiatives such as the Programa de Apoio ao Desenvolvimento do Audiovisual Brasileiro (PRODAV, National Audiovisual Development Program) fund run by the Fundo Setorial do Audiovisual (FSA, Audiovisual Sector Fund) and Banco Regional de Desenvolvimento do Extremo Sul (BRDE, South Regional Development Fund) together with the Agência Nacional do Cinema (ANCINE, Brazilian Film Agency) – which accepts proposals for series and feature-length documentaries destined for the television market – and the introduction of local production quotas are no doubt signs of significant changes to come, however.[3]

Another explanation given for the current popularity of documentary is the existence of 'uma atração cada vez maior pelo "real"' (Lins and Mesquita, 2008: 8). This phenomenon is much commented on by critic Beatriz Jaguaribe, most notably in her *O choque do real* (2007) and earlier article 'Favelas and the Aesthetics of Realism' (2004), both of which are visited in chapter 4. This is an opportune moment to turn the clocks back and examine the landmark period of Cinema Novo filmmaking in Brazil. Although this movement was born of a very particular historical moment and is greatly distanced both aesthetically and ideologically from contemporary production, it nonetheless allows us to broach and better understand the origins of some key questions relating to transformation and the representation of 'others' in documentary.

Cinema Novo and the 'Socially Concerned' Precedent

It was likewise a drive to engage with reality that propelled the Cinema Novo movement of the 1960s and 1970s. As the 'primeiro momento do documentário social, crítico e independente no Brasil', it set an important national precedent for socially concerned production (Lins and Mesquita, 2008: 20). As eminent critic Eduardo Escorel observes, the desire to make

3 For a broad outline of the initiative consult: http://fsa.ancine.gov.br/programas/prodav.

films during the 1960s was 'diretamente relacionada com o desejo de lidar com a realidade brasileira […]. E além de descobrir o Brasil, havia a ambição de transformá-lo. Nesse projeto imodesto, o documentário tinha um lugar estratégico por permitir conhecer e revelar o Brasil aos brasileiros' (Escorel, 2003: 10).

The revolution in technological equipment – including lighter cameras that allowed for handheld filming and portable sound-recording devices – paved the way for a huge transformation in documentary filmmaking between the years of 1958–1963 (Thompson and Bordwell, 2003: 483). The increased mobility and intimacy afforded by these changes opened up new possibilities for filmmakers, leading to stylistic innovation and movements such as the French *cinéma vérité* and 'observational' or 'direct cinema' in the USA (Bruzzi, 2000: 69). These movements, together with the earlier Italian neorealism and its portrayal of gritty social realities, had a key influence on Cinema Novo and Latin American film more broadly at the time (Thompson and Bordwell, 2003: 539). The ostensibly non-interventionist stance of the observational style and a newfound ability to respond to situations as and when they emerged, stimulated an 'ideological belief in the possibility of accurate representation' (Bruzzi, 2000: 69). Direct cinema simultaneously raised many ethical questions about the role of the documentary maker and the consequences of adopting more active or passive stances during filmmaking (Thompson and Bordwell, 2003: 488).

During this period of the late 1950s to the 1960s, the revolutionary fervour gripping many parts of Latin America led to the emergence of a trend of highly politically motivated filmmaking known as 'el nuevo cine latinoamericano'. The movement was focused in Argentina, Brazil and Cuba and was driven by the need to generate a 'response to the deepening underdevelopment and cultural dependency of the continent' (Martin, 1997: I, 16). In Brazil, massive foreign investment and loans for the great modernising projects of the 1950s caused an explosion of debt and destabilisation during the following decade, leading to the intervention of a military coup in 1964 (King, 1990: 106). For many filmmakers of the time, cinema became a weapon with which to fight not only social and economic injustices but to contest dominant aesthetic paradigms and the 'universal values of "good" cinema' so consistently imported from abroad (King, 1990: 106):

> O Cinema Novo foi a versão brasileira de uma política de autor […]. Aqui, atualidade era a realidade brasileira, vida era o engajamento ideológico, criação era buscar uma linguagem adequada às condições precárias e capaz de exprimir uma visão desalienadora, crítica, da experiência social. (Xavier, 2001: 57)

Cinema Novo was a Brazilian version of the politics of authorship [...]. Here, the present was Brazilian reality, life was ideological engagement, creation was to search for an adequate language for these precarious conditions, one capable of expressing a de-alienating and critical vision of the social experience.

These elements translated into legendary cineaste Glauber Rocha's manifesto for an *estética da fome* (1965) in which he demanded a 'truly revolutionary esthetic' to deal with Brazil's particular social concerns (Johnson and Stam, 1995: 68). The model of filmmaking that resulted from such philosophies was one directly influenced by documentary styles and practice and privileged low production costs, location filming and non-professional actors (King, 1990: 107).

Cinema Novo filmmakers formed part of an elite group of intellectuals that believed in their own capacity to represent and *dar voz* to other silenced groups – the 'classes populares, rurais e urbanos, nos quais emerge o "outro de classe" – pobres, desvalidos, excluídos, marginalizados' (Lins and Mesquita, 2008: 20–21). A belief in the possibility of rousing 'popular consciousness' via a filmmaking of *conscientização* (a concept developed by the educational theorist Paulo Freire) placed the filmmakers in a position of power from which they might break with the 'condition of ignorance, political powerlessness, lack of means of expression, backwardness, misery – in short, dehumanization of the popular masses' (Martin, 1997: I, 209).

The problem with this model, as Jean-Claude Bernardet highlights in the classic work *Cineastas e imagens do povo* (1985), was that it contained an intrinsically contradictory dynamic. The medium through which the revolutionary intellectual was supposed to achieve the desired liberation and activation of the *povo* or masses was one in which this same *povo* appeared passive and voiceless (Bernardet, 1985: 37). Bernardet goes on to suggest provocatively that 'se o povo não fosse visto como alienado, se o povo gerasse a sua consciência, o intelectual produtor de consciência deixaria de ter razão de ser' (1985: 29). This is an observation that continues to haunt the documentary project today.

Back to the Future

If the 1960s had been an apogee of political filmmaking, by the end of the 1970s disillusionment with the idea of social progress and the fading of the leftist Utopia caused a sharp decline in socially concerned production. A distance from and suspicion of overtly social cinema persisted during the 1980s and by the 1990s any serious belief in the potential to achieve structural political change through such artistic endeavours had drawn its last breaths.

Conscientização, if it were to take place, would do so now on a micro-level or individual basis.[4]

It is interesting to note that many of the iconic spaces that had occupied a central position in Cinema Novo continue to play a significant role in cinematic production today. As Ivana Bentes observes, though films have clearly moved away from the aesthetics of violence espoused by Glauber Rocha, the same settings of the *sertão* and *favela* consistently reappear. Only now the misery with which these spaces are frequently associated is no longer a stimulus for change, but simply a 'natural' and inevitable state of being (Bentes, 2007: 244). Fernão Pessoa Ramos highlights the same trend in his commentary on Sérgio Bianchi's *Cronicamente inviável* (2000), which he describes as reinforcing a sense of the 'unviability of the nation'. Pessoa Ramos argues that a sharp focus upon the failures and incompetence of people and organisations represented in the fictional film world ultimately serves to distance and exonerate the spectator from implication in these problematic affairs (Nagib, 2003: 72). In such films, the possibility of affirmative action is denied and passivity spreads to form the base of an overwhelming social paralysis.

The persistent ethical and aesthetic challenges that surround the decision to film poverty are clearly outlined by Bentes as follows:

> A questão ética é: como mostrar o sofrimento, como representar os territórios da pobreza, dos deserdados, dos excluídos, sem cair no folclore, no paternalismo ou num humanismo conformista e piegas?
> A questão estética é: como criar um novo modo de expressão, compreensão e representação dos fenômenos ligados aos territórios da pobreza, do sertão e da favela, dos seus personagens e dramas? Como levar esteticamente, o espectador a 'compreender' e experimentar a radicalidade da fome e dos efeitos da pobreza e da exclusão, dentro ou fora da América Latina? (2007: 244)

Bentes has been at the forefront of criticism surrounding the tendency to glamourise and aestheticise poverty and violence in recent fiction film, for which she coined the term *cosmética da fome* (2001). Applying the term most controversially to the highly celebrated *Cidade de Deus* (2002), she has also been subject to later criticisms of elitism for her 'manifestação radical do campo que prioriza o estético-político em detrimento da comunicabilidade' (Mascarello, 2004: 4). That successful contemporary films 'tenham-se apropriado de um

4 Historical synthesis provided by MAM Cinemateca curatorial director Hernani Heffner in discussion on 2 December 2010, Rio de Janeiro.

discurso sobre a pobreza ou sobre o Outro da classe media' is an observation that frequently resurfaces amongst critics (Caetano, 2005: 35–36). The nature of this radical disjuncture perhaps finds its most tangible expression in the contrast between the subject matter of the films and the spaces in which they are exhibited – the 'áreas nobres ou espaços valorizados' of the metropolis (Caetano, 2005: 42). In this respect, continuity exists with the patterns discussed above, in which a marked divide appears between the subjects commonly portrayed and the socially distinct filmmakers and audience. It is significant that most of these films make no attempt to relate the circumstances depicted to other social actors such as the 'elites, a cultura empresarial, os banqueiros, os comerciantes, a classe média', choosing to represent instead the self-contained 'espetáculo do extermínio dos pobres se matando entre si' (Bentes, 2007: 249). Poverty and issues related to it are thus portrayed in such a manner that denies relationality, allowing them to remain totally external to and separate from the wider world in which many of the viewers are likely to be situated.

Thinking about Documentary

One of the most significant contrasts between Brazilian documentary in the time of Cinema Novo and contemporary production is the latter's move away from representative social types towards the depiction of characters as singular individuals (Lins and Mesquita, 2008: 20). *Cabra marcado para morrer* (1985), directed by Eduardo Coutinho, is cited as a turning point in this history. Widely recognised as one of the country's most significant documentary makers, the late Coutinho was perhaps best known for his particular interview-based style, which has been referred to as a 'cinema da palavra filmada' (Teixeira, 2004: 180). What is highly significant about this film in terms of its impact on subsequent production is its abandonment of a pre-fabricated rhetoric or argument in favour of an emphasis upon the filmmaking *process* as a space of encounter and dialogue (Lins and Mesquita, 2008: 26).

On viewing a film for the first time, the most significant consequence of its classification as non-fiction or fiction is the expectation that this generates – itself largely based on the nature of the relationship understood to exist between the cinematic material and an external 'reality' (Plantinga, 1996: 310). John Ellis points to two key aspects that are widely seen to mark documentary apart from other art forms. These are 'truth' and 'social purpose' (2007: 59). The former may be understood as an attitude towards truth (rather than the assumption that everything that happens on screen is 'true', this means that the overall message will most likely communicate the filmmaker's own truth values), whilst the latter may be understood in most cases as a

desire to alter viewers' perceptions or change attitudes (rather than instigate radical political or social change) (2007: 59–60). Whilst both fiction and nonfiction are acknowledged as cultural constructs (long gone are the days when documentary might have been interpreted as a pure distillation of off-screen reality), the degree of self-awareness and ethical responsibility necessitated by any who wish to engage these values of 'truth' and 'social purpose' in their filmmaking endeavour inevitably alters both the production process and viewing experience. Such considerations affect not only the final output but are present in every interaction between those on either side of the camera, in moments translated onto the screen and in those that pass by unrecorded. It is this heightened sense of image-making responsibility coupled with audience expectation that operates as a differential factor between the two 'genres' and explains why we continue to mark them as such. The exclusion of works of fiction from this study reflects an intention to focus on this more ethical terrain in the approach to and experience of social difference within cultural production.

Truth becomes particularly important in a documentary context as a result of its relationship with power. As Trinh T. Minh-ha acknowledges, truth is the name given to what is often a single version or scenario among many, and truth, accuracy and fact are also difficult to isolate from economic determinants: 'on the one hand, truth is produced, induced, and extended according to the regime in power. On the other, truth lies in between all regimes of truth' (1993: 90, 92–93). Naïve viewers are, of course, increasingly few and far between. Nonetheless, those who wield cameras and create stories remain responsible for much of the information we encounter about certain topics, scenarios and people. In the domain of socially concerned production, where historically 'the silent common people […] are the fundamental referent', this makes for especially challenging territory (1993: 97). For 'in the desire to service the needs of the unexpressed, there is, commonly enough, the urge to define them and their needs' (1993: 96). Nor should we forget that those who fund films are the ones who ultimately influence which stories get made or at least determine their means of production, which can dramatically affect not only content but also style and *how* the story will reach the audience.

At this juncture it is useful briefly to summarise Bill Nichols' classification system of 'Documentary Modes'. They are: 'poetic' (often fragmentary and ambiguous, privileging tone, mood and rhythm); 'expository' (rhetorical and didactic); 'observational' (spontaneous 'fly-on-the-wall' style with no interviews or commentary); 'participatory' (based on the interview and encounter, the filmmaker may appear within the film); 'reflexive' (aims to stimulate greater awareness of the medium and issues of representation); and 'performative' (expressive and often centred on subjective experience)

(2001: 138).[5] As Stella Bruzzi observes of Nichols' attempts to create such genealogies, they ultimately over-simplify and his chronological presentation of the modes is misleading (2000: 41). This criticism is clearly validated in any attempt to place the films we will analyse under his scheme, as there are many points of overlap between categories. They do, nonetheless, provide an important point of orientation when treated not as classificatory tools but rather as documentary characteristics – in much the same way that Chanan proposes genres be regarded as flexible groupings in line with Wittgenstein's 'family resemblances' (Chanan, 2007: 5). I thus refer to Nichols' terms throughout the book where they provide a useful point of reference or discussion.

As the above schema suggests, the constructed nature of documentaries and the 'realities' that they portray is now widely acknowledged (Nichols, 1991: 10). The stylistic choices made by the filmmakers will affect whether this fact is prominently revealed (through the use of reflexivity, for example) or understated and concealed (as an observational or naturalistic aesthetic might achieve). My intention, therefore, is not to pass judgement on the authenticity of the works considered in this study and I refrain from making distinctions either between fiction and non-fiction or non-fiction and reality a point of contention. This reflects a decision to engage with the material on a level that acknowledges Bruzzi's pragmatic conclusion that 'a documentary will never be reality nor will it erase or invalidate that reality by being representational' (2000: 4). After all, the 'most tenable reality a film offers' is that of the encounter between the filmmaker and subject, itself inevitably marked by varying degrees of performance (2000: 73).

Jean-Louis Comolli reminds us that 'antes de mostrar, para melhor mostrar, o quadro começa por subtrair à visão ordinária uma parte importante do visível. […] Enquadrar equivale a fabricar um olhar fragmentário, restringido, contrafeito' (2008: 139). Fundamental to any analysis of film is the acceptance of the fact that we are always dealing with incomplete pictures. Indeed, the most suspect narratives and images are most often those that refuse to acknowledge this phenomenon.

Documentary Photography and Photojournalism

The first photograph taken in Brazil was officially registered in January 1840 (Magalhães, 2000: 41). It did not take many months for Emperor Pedro II to receive his own daguerreotype equipment and become an avid fan,

5 For an in-depth discussion of each of these modes see Nichols (2001: 102–137).

practitioner and sponsor of the medium (2000: 41). Photography was thus from the beginning the bearer of strong national credentials, affiliated with the most powerful in the land. As Liz Wells notes, during the nineteenth century the photographic medium was accompanied by a concern not with aesthetic developments but the construction of new types of knowledge (2000: 15). There is thus from the early days of photography a sense of its capacity to serve as an informative and educative tool through which to learn about the world around us. During this period photography played its part in recording new discoveries and uncharted territories in Brazil, forming an early association with such conquests (Melo Carvalho, 1996: 12). The photographer Marc Ferrez (1843–1923) was a key figure during this period, accompanying and documenting expeditions carried out by the Comissão Geológica do Império do Brasil and producing ethnographic imagery of native Indians, together with vistas of natural landscapes that played a part in constructing an exotic national portrait that was eagerly consumed by a European audience (Magalhães and Peregrino, 2004: 26, 30). Ferrez also turned his lens upon the city of Rio de Janeiro, where he produced extensive photographic documentation of everyday life and panoramas of the changing landscape of a city propelled towards modernisation (2004: 31). As the nineteenth century drew to a close, it was clear that 'photography offered an important means of documenting daily life, ethnic and racial groups, and the social classes in Brazil. The turn of the century saw a proliferation of postcards and picture magazines that documented changes in rural and urban life' (Nair, 2011: 35). A focus upon imagery that conveyed the notion of *brasilidade* or national character found support with a government eager to 'divulgar ao mundo uma visão positiva da identidade nacional' (Lauerhass and Nava, 2007: 148). It is also important to consider the role that early photography played in 'delineating social appearance, classifying the face of criminality and lunacy, offering racial and social stereotypes' (Wells, 2000: 55). The camera thus also made a useful partner for those concerned with the policing and categorising activities that worked to reinforce social norms and civil order.

Another highly influential figure to visually document the city as it entered the twentieth century was Augusto Malta (1864–1957). Considered by some to be the most important Brazilian documentary photographer of the century, Malta's urban scenes constituted 'un cronista de la sociedad brasileña en el Rio de Janeiro de inicio de siglo' (Hollanda, 2000: 274). Whilst social critique is noticeably absent from his own work, Malta is widely perceived to be the forefather of photojournalism in Brazil (2000: 274). Publishing his work in newspapers and illustrated magazines, Malta captured spontaneous moments and scenes of dramatic urban tranformation throughout the city (Magalhães and Peregrino, 2004: 52). Given the close association between

photography and documentation and the consequent lack of emphasis upon its aesthetic or artistic value (Nair, 2011: 35), it is perhaps unsurprising that the medium should have been excluded from the landmark Semana de Arte Moderna in 1922. The 1920s and 1930s were associated instead with the phenomenon of Fotoclubismo – a middle-class movement of amateur photography with little interest in social commentary (Melo Carvalho, 1996: 13). However, that did not prohibit the creation of the famous *O Cruzeiro* magazine in 1929, which, following a precedent set by Malta, was to become a pinnacle of photojournalistic practice in the country.

Key international influences on modern Brazilian photography include the Farm Security Administration (FSA) and its social project to document rural poverty in the USA during the Great Depression of 1930s, and Magnum founder and French photographer Henri Cartier-Bresson's elaboration of the 'decisive moment' (Costa, 2011). These canonical references no doubt paved the way for a tendency towards documentary and humanist photography in the 1940s and 1950s and the accompanying desire to understand better the human geography of the country (Castellote, 2003: 314). This interest in exploring social difference was expressed in some cases by a focus on the grotesque or exotic (Melo Carvalho, 1996: 16). The overriding political climate of the 1960s unsurprisingly saw a continuation of the importance attributed to formulating a 'social' vision of Brazil in the domain of photography (Castellote, 2003: 314).

Yet, as Parvati Nair observes, it was the advent of the independent photographic agencies and the greater creative and economic freedom that this implied for individual photographers emerging from the country's long period of oppressive military rule that was to lend the greatest impetus to this trend of the socially concerned:

> Since the 1980s, and in the wake of the dictatorship, photography has experienced a boom in Brazil as a vehicle for political and ideological transformation. Numerous photographic agencies have been established, and there are diverse and very interesting images surfacing that cross boundaries between documentary, criticism, politics, visual experimentation, art and commerce. (Nair, 2011: 35)

These organisational and commercial structures were instrumental in stimulating the 'aparecimento de uma produção comprometida com uma visão autoral e politicamente engajada com os principais problemas sociais do Brasil' (Magalhães and Peregrino, 2004: 89). Within the landscape of contemporary Brazilian photography, emphasis has shifted to rest upon its diversity and refusal to fit within a regime of particular schools or styles (Hollanda, 2000: 273). Ricardo de Hollanda does note, however, a continued

draw towards urban social themes, together with the presence of clear journalistic tendencies, which he attributes to the influence of the famous early twentieth-century photographer Malta referenced above (2000: 273). Photographing towards the latter half of the twentieth century into the early twenty-first century, Sebastião Salgado represents a highly prominent example of this tendency towards the generation of socially committed imagery, as we will explore in the following section.

The proliferation and vibrancy of photographic events and conferences around the country today testifies to a highly active community of photographers and critics together with a strong appreciation for the medium in its documentary and artistic or experimental forms. The numerous annual and biennial events hosting exhibitions, conferences and workshops – such as Paraty em Foco, Semana de Fotografia do Recife, the Festival Internacional de Fotografia de Porto Alegre, FotoRio and Forúm Latino-Americano de Fotografia de São Paulo – together with the creation of the Rede de Produtores Culturais de Fotografia no Brasil are a few prominent indications of this trend.

Photography as a Vehicle for Social Change

Although there is little dialogue between the worlds of photographic and cinematic production in Brazil, one point where they do meet is precisely in the area of socially concerned cultural production. In the foreword to a collection on international press photography entitled *This Critical Mirror*, Brazil's most internationally prestigious photographer and former Magnum photojournalist Sebastião Salgado makes the following statement about his profession: 'the photographer, whether he be called a press photographer, a photojournalist, a documentary or socially concerned photographer, acts not as a voyeur but as an interpellator' (Mayes, 1996: 7). The drive to use photography as an instrument for change is succinctly expressed by one of the forerunners of social documentary photography in the US, Lewis Hine: 'I wanted to show things that had to be corrected' (Hall, 1997: 86). An intention not merely to document but to *influence* the viewer clearly lies at the heart of such practices.

Salgado maintains that producing images of poverty and suffering is a means of forcing people to face up to a reality occurring around them. A singular belief in the transformative power of such imagery is reflected in his comment that 'not a single being on earth should be spared these pictures' (1996: 7). The driving idea behind this philosophy stresses the capacity of photography to serve as a 'critical mirror' for humankind. However, Salgado does not engage here with the giant leap that exists between recognising and not liking the reflection one sees and actually doing something to change it. The same view is espoused by Uruguayan author Eduardo Galeano in an

introduction to Salgado's own work, where he opines that 'images of hunger and suffering […] do not violate but penetrate the human spirit in order to reveal it' (Salgado, 1990: 8). The explanation that people accept being photographed in such a state because 'queriam que seu sofrimento fosse divulgado' is another point used to validate the use of such forms of expression (Salgado, 2000: 7).

This kind of socially concerned photography has attracted much criticism over the years. One common argument maintains that 'in the ostensible interest of revealing (and subsequently ameliorating) harsh conditions of life, photographers often rendered those they recorded into passive sufferers of poverty, rather than active agents in their own lives' (Wells, 2000: 82–83). Salgado's exquisite monochromatic images of starving children, drought and gruelling labour, amongst many other themes, have unsurprisingly been a source of much controversy within this debate. In her book on Salgado's work, *A Different Light* (2011), Parvati Nair highlights the emergence of a school of thought that deemed the aesthetically beautiful to be incompatible with politically progressive agendas (2011: 259). During the 1970s and 1980s, 'the anti-aesthetic became a mode of conveying alternative, progressive agendas. […] thus firmly planting the notion that ethics and aesthetics are opposed' (2011: 259). An earlier article by British art historian Julian Stallabrass provides further interesting reflections upon Salgado's imagery and the relationship between documentary and artistic agendas (Stallabrass, 1997).

Renowned theorist Susan Sontag is particularly sceptical about the medium's capacity to bring about positive social transformation or even change perceptions, stating that 'in these last decades, "concerned" photography has done at least as much to deaden conscience as to arouse it' (1979: 21). Sontag maintains that 'the camera is a kind of passport that annihilates moral boundaries and social inhibitions, freeing the photographer from any responsibility toward the people photographed' (1979: 41). This opinion is backed up by the equation of the photographic act with 'non-intervention' and complicity – the desire to produce a 'good' image outweighs the need to intervene in a material way in the given situation (1979: 11–12). Furthermore, she argues that 'social misery has inspired the comfortably-off to take pictures […] in order to document a hidden reality, that is, a reality hidden from them' (1979: 55). What Sontag rightfully highlights is the socio-economic position implicit in the 'socially concerned' project. Images of this kind are often selected by and appeal to an audience thoroughly external to or 'exempt' from the particular realities that they depict (1979: 168). Photography is for Sontag a medium forever trapped in the past, one that ultimately resists change and trades only in the currency of the inevitable (1979: 168).

As Pedro Meyer asserts, photography's mission is 'not to give form to the truth, but to persuade' (1995: 12). Joan Fontcuberta acknowledges this in a refreshingly direct manner with his proclamation that 'la difusión de fotografías de contenido social implica siempre un acto de propaganda, lo quiera el fotógrafo o no. Simplemente hay que asumir este proceso, que es inevitable. Sea consciente o no, el fotógrafo impregna su obra con su sensibilidad y con su ideología' (2007: 155). Under these circumstances, the personal integrity of the photographer becomes absolutely crucial in lending credibility to the work (Wells, 2000: 77; Meyer, 2006: 126) or, as Fontcuberta puts it, 'toda fotografía es una ficción que se presenta como verdadera. [...] Lo importante, en suma, es el control ejercido por el fotógrafo para imponer una dirección ética a su mentira' (2007: 15). Given its vastly exploitative potential, nowhere is this more important than in the domain of social documentary. As viewers, we are best armed with 'a permanent doubt and questioning of our ideas about what we observe' (Meyer, 2006: 86).

The conflicting views that photography inspires are a testament to the complexity of the issues it brings to light. Whilst Roland Barthes asserts that 'every photograph is a certificate of presence' (2000: 87), Sontag is keen to emphasise the tension *between* presence and absence captured within the medium: 'what is surreal is the distance imposed, and bridged, by the photograph: the social distance and the distance in time' (1979: 58). What photography achieves might be best appreciated as an intricate play between presence and absence. Whilst the photograph creates for the viewer an impression of being 'there' in a specific historic moment and place – thus breeding an entirely false sense of familiarity with the subject matter (Wells, 2000: 19) – by virtue of its location in the past it also unavoidably signals absence and/or loss. It provides us with a sense of being able *momentarily* to access the inaccessible; as with memory, it is a means of travelling imaginatively in time and space. This has important implications when we consider that much of the imagery analysed in the body of this study portrays spaces that a majority of viewers will never have experienced first hand. The photographs that we will be examining cannot serve for many as a point of comparison with an external 'reality', therefore, but instead find their place amidst an existing repertoire of imagery against which they will be compared and assimilated or rejected accordingly.

The focus upon photography as an inherently static medium means that we sometimes ignore or downplay the fact that digital photographs are today constantly travelling rapidly along multiple trajectories (Meyer, 2006: 80). Whether being uploaded, downloaded or shared via email, websites or social media sites, they are always in multiplication and on the move. Meyer's somewhat unusual interpretation of the photographic act posits it as a series of decisions, rather than a single decisive moment as it is most

commonly conceived (2006: 80). This simple act of reframing highlights the acute influence that the parameters we impose can have upon our ways of seeing: 'instead of just recording reality, photographs have become the norm for the way things appear to us, thereby changing the very idea of reality, and of realism' (Sontag, 1979: 87). Photography has changed the way we see. This has not been without its negative repercussions, as for many 'in the twentieth century [...] the dominance of vision has become suspect, causing paranoia, suspicions of voyeurism and a rejection of the mastery that sight once implied' (Brettle and Rice, 1994: 21).

The fact that 'photographic images are used most extensively to stimu-late desire for consumer goods in people who cannot afford to buy them' is not something to be overlooked in our consideration of other types of imagery (Herzog and Strauss, 2002: 167). This is reinforced by the fact that what might be considered acutely distinct image repertoires will frequently appear in the same exhibition context. Sitting in front of the television or browsing online, it is not uncommon to be faced in a short timeframe or within the same screen space with an image of chic perfumes and luxurious silks and another of an underfed child or homeless youth. How is it that most of us appear able continually to reconcile such radically conflicting juxtapositions on a minute-by-minute, hourly and daily basis? And how do such factors influence the way we perceive and react to socially concerned material?

A Common Dynamic

> What consequences follow from different forms of response to and engagement with others? How may we represent or speak about oth-ers without reducing them to stereotypes, pawns, or victims? These questions [...] suggest that the issues are not ethical alone. To act unethically or to misrepresent others involves politics and ideology as well. (Nichols, 2001: 139)

Now that the theoretical 'straight line between perception, affection, com-prehension and action' has been widely discredited (Rancière, 2009: 103), how might we interpret the continued practice of socially concerned film and photography? Dutch filmmaker Renzo Martens, whose film *Episode 3 'Enjoy Poverty'* (2009) engages with precisely this issue, has a particularly strong position on the representation of subjects such as poverty. Martens maintains that the proliferation of images surrounding various forms of suffering has little positive impact upon the lives of those experiencing hardship and certainly cannot be understood to 'create a way out' of these

situations (Museum of Modern Art in Warsaw, 2012: 37). Martens goes on to opine that 'in fact, the industry of making pictures of terrible circumstances is integrally part of the terrible circumstance itself' (2012: 48). His above-mentioned film is a reflexive take on a journey through the Democratic Republic of the Congo, where he encourages locals to take ownership of their poverty by using it to extract financial gain in the same way that international organisations such as press agencies do. The film is not without its flaws, as the director acknowledges. Martens' key point, however, is that there is no legitimate 'outside' or external viewpoint from which to represent or interrogate such matters. We are all implicated in different ways and to varying extents *within* these pictures. Such questions are attracting an increasingly candid interest and response within 'developed' countries, as demonstrated by the BBC television series *Why Poverty?* (2012).[6]

The distanced consumption of images of poverty exemplified by a culture of phone and online donation, reflects a dynamic whereby 'preferimos, tantas vezes, nos solidarizar com as misérias alheias, estrategicamente colocadas na tela ou na página impressa' (B. Jaguaribe, 2007: 124). Stuart Hall draws our attention to the fact that 'an argument about power/knowledge can be articulated around exhibiting and displays, particularly in terms of *visibility*' (1997: 198–199, original emphasis). Pointing to the example of museums, Hall suggests that the act of displaying certain cultures simultaneously results in exposing them to what he terms 'the scrutiny of power' (1997: 198–199). This has revealing implications when we consider the role that art galleries, cinemas and television screens continue to play in exhibiting the foreign or 'other'. As Robert Pogue Harrison observes:

> Moral ideals in the modern era remain for the most part fictions we pretend to believe in, whether we are aware of our pretense or not, and this holds true for the assault on nature that is presently unearthing the earth and unworlding the world in the name of eliminating poverty and suffering. […] The unmasking of society's self-serving fictions, as well as the destruction of its false idols, has been the principal task of the artists, poets, and philosophers of the modern era. (2008: 158–159)

A highly significant response to this call is found in the current movement of *inclusão visual*, which has a strong presence in both film and photography

6 Of particular relevance to this discussion is an episode entitled 'Give Us the Money', which interrogates the celebrity fronted charity mission to 'end poverty' that began with the 1985 Live Aid concert led by rock stars Bob Geldof and Bono.

throughout many parts of Brazil and particularly in Rio de Janeiro. Taking into account 'the specifically human need to act, speak, and be heard, all of which are "political" in the most essential sense of the term', it is difficult to see these initiatives of self-representation as anything other than highly political acts (Harrison, 2008: 46). This trend has been stimulated by workshops and a growing number of organisations and events, some prominent examples of which include Vídeo nas Aldeias, Nós do Morro, the Escola Livre de Cinema, the Imagens do Povo collective (analysed in chapter 4), and the Encontro sobre Inclusão Visual and Visões Periféricas events, both held in Rio de Janeiro. Such actions have not escaped criticism, however, with some emphasising the fact that the projects are often initiated and run by middle-class 'outsiders' and thus reproduce dominant visual paradigms and methodologies. The film *5 x Favela: agora por nós mesmos* (2010), itself a reframing of a series of shorts by a group of Cinema Novo directors entitled *Cinco vezes favela* (1962), has been criticised precisely for a lack of aesthetic innovation (Diaz Camarneiro, 2010). This is a train of thought pursued by the documentary filmmaker and producer João Moreira Salles (co-director of the landmark *Notícias de uma guerra particular*, 1999), who asks to what extent 'um modo de produção gera uma certa forma de representar?' Citing the Vídeo nas Aldeias project (a long-standing initiative to encourage filmmaking and self-representation amongst native Indian groups), he further challenges 'até que ponto é necessário o índio se filmar?'[7] A continual questioning of the impact and underlying values behind such developments is crucial to furthering our understanding of the complex web of interests and desires that crosses these and other representational activities.

There are indeed a great many questions we might ask of these flourishing tendencies. For instance, what does it mean to find representation within a cultural circuit but to continue to be denied agency or recognition in social or legal terms? Is self-representation in visual culture a step in a longer process towards empowerment (as is often the claim) or is it in fact a form of social pacification, a 'containing' mechanism? Sociologist Muniz Sodré points to the way in which the issue of underdevelopment is frequently expressed as a cultural problem, thus inevitably distracting from the economic and political factors at stake (1999: 30). It should not go unremarked that Brazilian governmental entities and corporation giants remain the chief sponsors of a wide variety of cultural organisations and projects including those centred upon

7 Citations from an interview with João Moreira Salles on 7 December 2010, Rio de Janeiro.

inclusão visual.[8] The role played by these bodies in the cultural field is clearly a significant one and invites us to reflect upon the methods by which 'the state and political power seek to become, and indeed succeed in becoming, reducers of contradictions' (Lefebvre, 1991: 106). An acceptance and celebration of difference at a cultural level, after all, does not require that economic or political differences enter the frame.

Scepticism surrounding cultural and artistic expression can itself be incredibly disempowering of course. Rancière associates a postmodern disbelief and suspicion of art's role in political projects with what he terms an 'ethical turn' (of which he is profoundly suspicious) in artistic and political practice and theory (2010: 21).[9] This leads him to conclude that 'the postmodern carnival was basically only ever a smokescreen hiding the transformation into ethics and the pure and simple inversion of the promise of emancipation' (2010: 21). In accepting that 'nothing is more favourable to the established powers than the "loss" of the thought and practice of emancipation' (2010: 3), we acknowledge the significance that this shift and its subsequent impact bears upon the discussions that follow.

Drawing Boundaries

As observed above, the idea that it is possible to capture or at least interact with 'reality' in documentary relies upon a belief in the existence of an external domain that one can faithfully represent on an artistic level. The definition of such borders continues to play a crucial role in our lives, essentially determining the way we comprehend the world and how we act both as ourselves and towards others. As García Canclini notes:

> Cuando se pierden la distinción entre lo real y lo simbólico, y la pregunta por la legitimidad de las representaciones – cuando todo es simulacro –, no queda lugar para la confrontación razonada de posiciones, ni para el cambio, ni por supuesto para la negociación. Desaparece la disputa por la identidad porque no existe un discurso en relación con algo que se postule como realidad propia. (1995: 182–183)

8 Examples of regular high-profile sponsors include local governmental prefectures and the federal Ministério da Cultura, telecommunications giant Oi, energy company Petrobras, mining company Vale and the banks Caixa and O Banco Nacional do Desenvolvimento (BNDES).

9 For Rancière, the 'ethical turn' represents a collapse of radical democratic politics into an unarguable fundamentalism. He is not at all positive about the term 'ethics', in contrast to Levinas and Derrida.

The boundaries that we create are fundamental to the construction of social identities, which are themselves based on differences. The concept of difference may be understood to have a highly ambivalent presence in our lives. It is necessary for the production of meaning, the formation of language and culture and of social identities, and a sense of the self as a sexed subject, but it is also threatening – a site of danger and negative feelings, hostility and aggression (Hall, 1997: 238).

One of the most important distinctions in determining the way in which a society is structured is the difference between those with power and those without, those who create the rules and those who obey them or pay the price. In his *Ten Theses on Politics*, Rancière draws attention to the original meaning behind the term democracy as designating a group of people defined precisely by their illegitimacy to be rulers: 'before being the name of a community, the demos is the name of a part of the community: the poor. But the "poor", precisely, does not designate an economically disadvantaged part of the population, but simply the people who do not count, who have no entitlement to exercise the power' (2010: 32). Anthropologist Roberto DaMatta explains the persistent strength of the status quo in Brazil by the fact that the nation's independence came about via the dominant classes (as opposed to a bottom-up or popular revolution) (1987: 68). The social 'harmony' that Brazilians have historically been so proud of is not a result of soft Lusotropic colonisation, he argues, but rather of the clarity with which lines have been drawn between different groups, leaving little room for threatening ambiguities (1987: 79). The questioning and renegotiation of such boundaries – caused by social mobility, violence or a sense of insecurity amongst other factors – forms an obvious source of conflict.

The concept of a boundary or frontier is, of course, intrinsically spatial and begins at the level of the individual:

> Space – *my* space – […] is first of all *my body*, and then it is my body's counterpart or 'other', its mirror-image or shadow: it is the shifting intersection between that which touches, penetrates, threatens or benefits my body on the one hand, and all other bodies on the other. Thus we are concerned, once again, with gaps and tensions, contacts and separations. (Lefebvre, 1991: 184, original emphasis)

If we appreciate that 'any struggle to reconstitute power relations is a struggle to reorganize their spatial bases', we may also appreciate the important and sensitive nature of the contrasting rights and access to urban spaces experienced by different socio-economic groups (Harvey, 1990: 238). The shattering of urban space resulting from capitalist practices has had a highly significant impact in this regard:

> Rendered artificially scarce anywhere near a centre so as to increase its 'value', whether wholesale or retail, it is literally pulverized and sold off in 'lots' or 'parcels'. This is the way in which space in practice becomes the medium of segregations, of the component elements of society as they are thrust out towards peripheral zones. (Lefebvre, 1991: 334)

Spatial considerations thus form an important and revealing sphere of exploration within any study of social difference.

This study is structured around three spatial types historically and presently associated with varying degrees of social 'marginality', namely: wasteland, carceral space and *favelas* or other 'informal' settlements, each considered in their relation to the city as a whole. Of course, 'marginality is a multidimensional phenomenon in that a given person may be simultaneously integrated with one or more centers while being marginal from one or more other centers' (Dennis, 2005: 15). For this reason I use the term with caution throughout and most often in a manner designed to reflect upon its potentially disempowering nature. These are spaces that feature heavily in cultural production across both the domain of documentary and fiction and the discourse that surrounds them often centres upon notions of exclusion, absence and lack. Within each chapter my objective has been to select and explore three to four filmic or photographic works that destabilise this paradigm in different ways and to varying degrees, exposing alternative viewpoints from which to interrogate common observations and prejudices. The fact that many of the artists have also engaged with several of these spaces across their individual bodies of work suggests the presence of common threads of discussion. In the interests of privileging a diversity of expression, however, I have opted to engage with a maximum of two works by any single artist or collective and to do so within a single chapter. It is important to note that the decision to embrace multiple spatialities within the book (as opposed to a focus upon a single locus or spatial type) does not reflect an intention to draw direct comparisons or equations between them. Instead, it allows us to recognise certain points of thematic and theoretical overlap, facilitating in the process new and unusual ways of engaging the relationships these spaces bear to questions of social difference.

Whilst many studies of contemporary Brazilian cinema take the *retomada* beginning in the mid-1990s as their departure point in selecting materials for analysis, such a delimitation would be less appropriate in the context of this study, as the marker is specifically relevant to film (designating the point when cinematic production picked up again with the aid of incentivising initiatives such as the Lei do Audiovisual, having ground to a virtual standstill with the closure of the state-funded production and distribution company Embrafilme in 1990 (Nagib, 2002: 13)) rather than to photographic

production. Given the prolific output and the strengthening of many important cultural funds and forums for exhibition and debate across both film and photography over the last decade in Brazil, I have opted to select material originating from the turn of the millennium onward. The timeframe in question may thus be considered highly contemporary. The fact that documentary film production has been so prolific during this period has in some respects made this the more challenging area for selection. On the other hand, although many of the photographers whose work I examine have exhibited internationally, most are little known outside Brazil beyond these rather specific cultural circuits. It has, therefore, required careful and extensive research in order to uncover the most fruitful of comparisons. Periods of fieldwork conducted in Brazil – predominantly in Rio de Janeiro, Recife and São Paulo – have formed an essential part of this process. The artists whose work forms the backbone of this study are at markedly different stages of their careers, though all are recognised and acclaimed to varying degrees – some in broad international contexts and others within more niche or localised cultural circuits. Some received their technical training outside Brazil and have spent extended periods abroad; others now live abroad permanently, returning to their motherland to carry out particular projects.[10] Given that, today more than ever, a great number of influences and interactions occur via international networks regardless of one's territorial base, this is neither surprising nor of any groundbreaking consequence. My intention is not to privilege any one group as possessing a greater authenticity of expression, but to acknowledge the many different vantage points and contextual layers that contribute to this discussion. Uniting this group of artists, and more specifically the works selected for analysis, is a clear preoccupation with questions of social difference and a degree of self-awareness that results in reflexive tendencies at either a thematic or technical level.

The decision to encompass both cinema and photography is an unusual one and constitutes a distinguishing feature of the book. Each medium brings its own set of historic and contemporary reflections upon and relationships with the concepts of temporality, spatiality, stasis and flux. Working across the different media thus illuminates a variety of ways in which to approach the theme of transformation within the realm of documentary, revealing in the process points of contagion that remind us of the media's shared photographic DNA. As suggested above, the negotiation of boundaries forms an important area of analysis on both a thematic and an aesthetic level. For it is in

10 The only artist not originally from Brazil is Lucy Walker, who is responsible for the co-direction of *Lixo extraordinário* (2010) alongside well-known Brazilian film-makers João Jardim and Karen Harley.

these contiguous areas that the struggles around power and identity are most urgently enacted and the relations between different social groups, filmed or photographed subjects, image-makers and spectators, are most poignantly questioned, strengthened or, indeed, reframed.

In chapter 1, 'Wasteland', I analyse three works set in Latin America's largest landfill site, Jardim Gramacho, located in the state of Rio de Janeiro.[11] Beginning with an exploration of the social and symbolic values historically attributed to waste, I argue that, contrary to a common focus upon its status as external matter, it in fact performs functions that attest to its centrality within the system that purportedly excludes it. I move on to explore the significance of waste in an artistic context, focusing on its role in the development of a fragmentary aesthetic and a philosophy of *antropofagia* in the frameworks of western European and Brazilian modernism respectively. I argue that both of these trends employ inclusive gestures, in contrast to the Brazilian *Udigrudi* film movement of the late 1960s, whose *estética do lixo* aggressively focused on exclusion and marginal characters in a manner suggestive of the irremediable nature of the country's poverty, violence and misery (Xavier, 2001: 68).

We begin our analysis with Marcos Prado's black-and-white photographic series, 'Jardim Gramacho' (2004), featuring portraits of *catadores* or rubbish pickers working on the landfill site together with apocalyptic visions of the landscape. Reflexive techniques play an important role here in resisting common representations of the rubbish pickers as passive objects of spectacle. Referring to photographic images from the first half of the twentieth century, I argue that Prado's work forges an association with the historic figure of the worker that allows for a reconfiguration of existing stereotypes surrounding the *catadores*. Moving on to the internationally acclaimed film *Estamira* (2004), also by Prado, I examine critics' mixed reactions before focusing on the director's negotiation of potentially disempowering facets of the medium. Centred on an elderly female *catador* named Estamira, the film successfully navigates away from the presentation of social typecasts, ultimately using her singular worldview as a lens through which to question a wider set of social values. A reflexive emphasis on cuts within the filmic medium highlights tensions between other boundaries such as the public and private spheres, also serving to distance the character from viewers. Finally, we address a film that adopts transformation as its explicit and overriding mission, *Lixo extraordinário* (2010). Centred on a social project led by artist Vik Muniz, the film places a group of *catadores* within a problematic and highly seductive

11 The second section on *Estamira* (2004) draws on material from my article published in the *Bulletin of Latin American Research* (Allen, 2013).

'rags to riches' narrative. Although the film clearly uses the motifs of recycling and labour in an attempt to shift common perceptions about the *catadores'* social identities, I question whether it ultimately replicates many of the hierarchical structures it ostensibly strives to undermine.

In chapter 2, 'The Human Warehouse', our focus shifts to the prison and its common interpretation as a dumping ground for those who have moved beyond the bounds of accepted social conduct. It is a space thus placed in direct contrast to the city as the locus of dwelling and citizenship. I begin by exploring the relationship between control and (hyper)visibility through an engagement with Foucault's appraisal of the prison as a control mechanism within the model of the 'disciplinary society'. Examining links between prison and poverty, I address the notion of incarceration as a form of historic social discrimination, before exploring some of the key philosophies and objectives that have been put forward to justify the existence of this system.

After examining the significant role played by prison narratives in Brazilian cultural production over the last century, the body of the chapter focuses initially on two works set in the highly controversial Carandiru penitentiary. We begin with director Paulo Sacramento's *O prisioneiro da grade de ferro: auto-retratos* (2004), in which self-representation and other reflexive techniques are used to explore the quotidian experience of incarceration. I suggest that the film posits imprisonment alternately as a vehicle of negative transformation and a space of immobilisation. Through an engagement with the medium of still photography it explores both the idea of wasted time and the use of imagery as a means of reaching beyond the prison walls using memory and/or desire. A play on perspective and contrasts between different degrees of internal and external space creates an unresolved tension between ever-shifting boundaries. The second section examines a photographic series by Pedro Lobo entitled 'Imprisoned Spaces' (2004). Here prison space is emptied of bodies and voices, echoing the period of change and evacuation underway prior to Carandiru's destruction. Lobo's imagery brings many unexpected qualities to the fore, focusing not on the familiar theme of suffering but the defiant manner in which inmates express themselves via the transformation of institutional cells into personalised living spaces. I propose that the particular technical and aesthetic choices made by the photographer provide a means of asserting his own presence within the framework of the final product. Finally, I explore the manner in which certain influences upon the artist's work expose the connection between prisons and the modern project of cataloguing, also drawing attention to the way in which his own work defies such classificatory boundaries. The subject of the last section is Maria Ramos' *Juízo* (2007). In contrast to the two previous works, this film explores early encounters between adolescents and a flailing legal system. Although circulating in exhibition contexts that testify to the film's intended

use as a tool to raise social awareness and stimulate change, the impression of overwhelming helplessness conveyed constitutes a clear point of internal conflict. The periodic substitution of the actual offenders for stand-in youths (ostensibly due to laws against the representation of minors on film in Brazil) creates interesting reflexive and performative counter-currents in what initially appears to be a straightforward observational documentary. I suggest that by emphasising the interchangeable nature of the youths' bodies, Ramos builds an impression of a legal system mired in absurd theatricality.

Chapter 3, 'Zones of Contestation', opens with a commentary upon the overlapping discourse between carceral space and *favelas* that occurs as a result of a common association of the latter with criminality. Focusing in the first instance upon the housing needs generated by a huge rural to urban shift occurring over the last century, I explore the principal terminology employed to describe these 'informal' living spaces, together with the consequences that such linguistic choices entail. After exploring the particular history surrounding the emergence of *favelas* and squatter settlements and the fight for land rights in Brazil, I move on to question the role played by such spaces in the national imaginary today.

Each of the works examined in this chapter centres upon urban spaces in transition, beginning with an analysis of Gabriel Mascaro's film *Avenida Brasília Formosa* (2010). This hybrid of documentary and fiction depicts the daily routines of four protagonists in the north-eastern city of Recife. I argue that the use of fictive elements performs an important role in transforming the characters from documented subjects to complicit agents in the filmic construction. Not only does the film clearly reflect upon the image-making process via the use of *mise en abyme*, it creates a complicated web of gazes and desires that refuses to provide any consistent or stable sense of perspective for the viewer. Performance and spectacle are both prominent elements in the film that lead us ultimately to dwell upon the implausibility of faithful or accurate representation. Mascaro creates an intriguing play between stasis and flux that supports the notion of dynamism and heterogeneity in 'informal' spaces, simultaneously evading any straightforward conclusions about the positive or negative implications of the shifts underway in the surrounding environment. In the next section I consider two photographic essays that document apartment buildings in central São Paulo occupied by low-income groups, both of which are on the brink of evacuation. Cia de Foto's '911' (2006)[12] and Garapa's 'Morar' (2007) provide an interesting

12 Cia de Foto no longer exists as a collective – its former members Rafael Jacinto, Pio Figueiroa, João Kehl and Carol Lopes disbanded in 2013 after ten years in collaboration.

stylistic contrast through which to examine the relationships established between the photographers and the photographed. Where the former uses digital manipulation and layering effects to create an intensely theatrical space that distances the project from notions of authenticity, the latter uses a naturalistic documentary aesthetic to ground the series as a social project. I argue that where the inward-looking focus upon interstitial spaces in '911' highlights the transitory nature of the building's occupation, 'Morar' creates a memory-laden and heavily contextualised space that underscores the project's political aspirations. The last section looks at a further photographic series by Garapa entitled 'O muro' (2010), which documents the recent controversial acts of government wall-building in Rio de Janeiro. Here the problematic association of the walls with ostensibly peace-driven initiatives stimulates existing suspicion and mistrust between the *favela* residents and the authorities. Exploring the relationship between the wall and the natural environment, I examine the impact of this violent gesture upon the concepts of civilisation and citizenship.

As its title suggests, the fourth and final chapter, 'Shifting Perspectives on/from the *Morro*', focuses exclusively on the *favelas* of Rio de Janeiro.[13] As a highly visible symptom of economic disparity, these spaces have become a focal point of the fears of a society perceived as ever more divided, hostile and unjust, serving for many as a symbol of Brazil's continuing struggles with underdevelopment. The complex overlapping of a perceived outsider or 'marginal' status with an oscillating pattern of cultural and social invisibility/hyper-visibility sparks important questions about the channels through which certain dynamics of power operate.

Claudia Jaguaribe's series of images 'Rio – entre morros' (2010) provides a dramatic and stimulating point of initial engagement with these issues. Although at first glance the jostling competition between the built and natural environments reinforces a familiar impression of the city, the images soon reveal their constructed and fragmentary nature. Shattering the conventional stability of a singular vantage point, the photomontages juxtapose conflicting perspectives that dialogue with the idea of the city as an imagined landscape, traversed by difference. A play between the horizontality of the landscape tradition and the verticality of the city draws attention to both natural and artificial borders, from which the images themselves appear ready to burst. In the next section I analyse a film that establishes a radical break with conventional representations of the city's *favelas* in both documentary and fiction cinema, Eduardo Coutinho's *Babilônia 2000* (2000). Set on the eve of

13 The second section on *Babilônia 2000* (2000) draws on material from my article published in the *Bulletin of Latin American Research* (Allen, 2013).

the millennium it provides a self-conscious window upon the hopes, fears and desires of those living on the slopes overlooking the iconic neighbourhood of Copacabana. Through the creation of a dynamic and shifting visual perspective, Coutinho moves away from totalising aerial viewpoints and the relations of power traditionally associated with them. A space of encounter is created in which the relationship between the filmmakers and those caught on camera is problematised as one of irreconcilable difference. This is a consequence, I argue, which in fact performs its own gesture of erosion. In the concluding section, we turn to a selection of images produced by photographers who have worked within the Imagens do Povo collective.[14] After exploring some of the key philosophies upon which the organisation is founded, I turn to examine the methods used by photographers to engage the complex relationship between conceptual boundaries and the formation of stereotypes surrounding *favelas*. The aesthetic techniques employed to interrogate subjects such as limitation, the threshold as a point of radical destabilisation, the resistance of the gaze and the renegotiation of perspective, illustrate a series of innovative and thought-provoking reactions to a set of well-established visual paradigms.

The process of selection and the setting of parameters necessitated in a study of this nature inevitably involve the exclusion of some works that might have provided additional lines of inquiry and comparison. For those interested in exploring further, such works produced outside our specified timeframe include Coutinho's *Boca de lixo* (1993) and André Cypriano's photographic series *O caldeirão do diabo* (2001).[15] Works that were very pertinent in some respects, but that exceeded the geographic or thematic breadth of the study, were Iatã Cannabrava's *Uma outra cidade* (2009) – a collection of photographs taken of informal living spaces throughout Latin America – and José Padilha and Felipe Lacerda's *Ônibus 174* (2002) – documenting the hijack of a public bus in Rio de Janeiro in the year 2000. In the domain of fiction film, *5 x favela: agora por nós mesmos* (2010) is a work whose evident drive to achieve an authentic portrayal of *favela* space might also offer many interesting points for analysis.

Interpreted in a positive light, the creative endeavours that we shall examine in detail below may be seen to function as a shared public space or meeting point between different social groups. This suggests their role in facilitating encounters that are unlikely to occur (or not on such terms) in the day-to-day

14 The majority of these photographers are no longer affiliated with Imagens do Povo, having moved on to work independently or for other organisations.

15 Although published in book form in 2001, the photographic project itself was carried out in 1994.

life of the city and its inhabitants – here I refer both to the physical encounters between participants at the time of filming or photographing and to the later visual encounter between the portrayed subjects and their audience. Increasingly, however, interpretations highlight the questionable benefit to those represented or the ethical implications of such narratives when they are most frequently composed from external and dominant social positions (Williams, 2008). The nature of the space constructed for viewers and the manner in which they are encouraged to engage with or relate to filmed subjects thus acquires a heightened charge and significance.

Some of the key issues we shall encounter are addressed by João Cezar de Castro Rocha in his article 'The "dialectic of marginality"', where he challenges the reader to question the success that narratives of social difficulty have experienced as cultural products both within Brazil and internationally (2004: 29). He observes a transition from the production of narratives of reconciliation to those of conflict in the artistic or creative approach to social difference in Brazil, highlighting a growing tension that is useful to consider during analysis. In this light, we might ask the following: do the works discussed draw attention to segregation and difference or to interrelatedness and interdependence amongst social groups, and what might be the consequences of such representations in a broader social and political context? How do the artists negotiate the problematic yet driving ambition for change embedded in the documentary tradition and is there indeed still a valid space from which to think about transformation in the context of contemporary documentary? If not, how might we interpret the role and persistence of a prevailing image currency of the 'social' in a global environment of starkly uneven economic development? These and other questions will be contemplated as we explore the works in the chapters that follow.

Wasteland

As the overdetermined depot of social meanings, as a concentration of piled-up signifiers, garbage is the place where hybrid multichronotopic relations are reinvoiced and reinscribed. Garbage defines and illuminates the world; the trash can [...] is history. (Stam, 1999: 75–76)

Introduction

A symptom of all that falls outside the boundaries of social acceptability, humankind's endless generation of 'useless' material has continued to fascinate, shock and inspire artists, intellectuals and, with increasing urgency towards the latter half of the last century, environmentalists. So what do we understand when we talk about 'waste'? It is interesting to note the spatial dimension that is alluded to in definitions from the Oxford English Dictionary (OED). In addition to being 'useless expenditure or consumption', 'refuse matter', 'unserviceable material [...]; the useless by-products of any industrial process', and figuratively 'dregs' or 'worthless people', it is also understood as a 'piece of land not cultivated or used for any purpose' or a 'wild and desolate region'. The waste*land* is thus a space, one might reasonably conclude, absent of labour. In the analysis that follows, I will be asking what kind of dialogue the chosen documentary works establish with the above conceptions of waste, and to what effect.

The social and symbolic values that have come to be associated with waste label it as a polluting, abject and potentially dangerous substance and consequently one that we are quick to banish from sight and consciousness: 'we dispose of leftovers in the most radical and effective way: we make them invisible by not looking and unthinkable by not thinking' (Bauman, 2004: 27). Historically, 'those who have power make more litter, directly or indirectly, than those who do not, and clear less of it up' (Trotter, 2000: 30). The experience of waste disposal thus constitutes for many a 'disappearing act' in which unwanted materials enter a system designed to transport them to faraway places where the consequences of the decision to discard may play

out far from sight and mind.[16] In many societies, the individual responsible for generating the matter commonly plays no further role in the disposal process beyond this initial act of discarding. What is it that triggers the labelling of certain matter as waste and a consequent reaction of repulsion and distancing? Or rather, what important social functions may waste be understood to perform?

As sociologist Zygmunt Bauman notes, 'it is human design that conjures up disorder *together with* the vision of order, dirt together with the project of purity' (2004: 19, original emphasis). Although frequently envisaged as 'excluded' matter, waste in fact plays an integral role in the way we define our values and our sense of self and in this respect may be regarded to lie entirely *within* the system. The conception and treatment of waste is both relative and dynamic, having already altered significantly over the last hundred years:

> Between the late nineteenth and the late twentieth century there have been four clearly different articulations of this rubbish imagination: waste as an elemental foundation of life, waste as a loss or deficiency of life's value, waste as a menacing threat to life, and waste as life's ever-present and inevitable shadow. (O'Brien, 2008: 57)

In *A Crisis of Waste?*, Martin O'Brien is careful to remind us of the pitfalls of subscribing to the thesis of a 'throwaway society' when available evidence suggests that we are not a great deal more wasteful today than our immediate predecessors (2008: 83). What has shifted in no uncertain terms is the *perception* of waste – once seen as 'a resource that had the potential to generate limitless benefits', it is now considered 'a source of potentially limitless social and environmental costs' (2008: 75). Rather than conceiving of waste as the incidental residue of productive processes, the author suggests that it should be understood in its very centrality as '*what* modern society produces and consumes' (2008: 10). He is not alone in observing that 'waste – however deplorable – is intrinsic to an expanding consumption-driven economy' (Trotter, 2000: 23).

The marginalisation of waste thus clearly reflects concerns beyond the practical. Paraphrasing anthropologist Mary Douglas, whose *Purity and Danger* (1966) remains a landmark work on the subject, Elizabeth Grosz observes

16　An obvious example of this phenomenon is the shipping of discarded plastics from the UK and other European countries for recycling in China, where this poorly regulated industry wreaks devastating effects upon local environments (Watts and Cartner-Morley, 2007).

that 'dirt signals a site of possible danger to social and individual systems, a site of vulnerability insofar as the status of dirt as marginal and unincorporable always locates sites of potential threat to the system and to the order it both makes possible and problematizes' (1994: 192). Yet, as observed above, the category itself is unstable and changeable; subject to a collective or individual value judgement, it is one that any unsuspecting object might wander into. For 'it is not lack of cleanliness or health that causes abjection but what disturbs identity, system, order. What does not respect borders, positions, rules. The in-between, the ambiguous, the composite' (Kristeva, 1982: 4). Although it possesses no intrinsic qualities – being defined only in the very act of discarding – waste clearly performs a crucial function in establishing boundaries, norms and levels of social acceptability.

Modernism, Waste Materials and an Aesthetic of the Fragment

As many of the perceived boundaries governing everyday existence faced the aggressive challenges of modernity in the early twentieth century, so too the symbolic charge of waste began to capture the imagination of numerous Modernist artists and intellectuals in Europe. Of course, it is important to note that the currents of thought I shall shortly describe are rooted in this particular context. Nonetheless, given that all of the artists involved in Brazil's own Modernist movement invariably took part in *um longo estágio fora* (a lengthy phase abroad), leading critics to observe that *paradoxalmente, foi da Europa que enxergaram o Brasil* (paradoxically, it was from Europe that they observed Brazil), they remain highly relevant to this discussion (Milliet, 2005: 28).

If man's position in the workplace was threatened by the productivity of newly incorporated machines, it was machinery's destructive capacity that took centre stage to devastating effect during World War I. Waste materials, as the inescapable residue of both productive and destructive activity, provided in some respects a natural resource for artists seeking creatively to negotiate a profound 'feeling of despair with regard to order, predictability, and construction' (Reynaud, 1998: 176). The use of *objets trouvés* (found objects) and collage and assemblage techniques might thus be interpreted as a reaction to disillusionment with the totalising narratives that had formed the backbone of hitherto widely accepted structures of knowledge and reason. The fragmentary aesthetics that emerged privileged the piece(s) over the whole and re-contextualised everyday objects to create new and ambiguous meanings. Iconic examples are found in Marcel Duchamp's 'readymades', including his infamous *Fountain* (1917) – a urinal transformed into a piece of 'art' via the artist's mark and its relocation to a gallery context – and Paul Klee's *Angelus Novus* (1920). Walter Benjamin's famous interpretation of this latter artwork describes an angel turned to the past, causing him to speculate that 'where

we perceive a chain of events, [the angel] sees one single catastrophe which keeps piling wreckage upon wreckage and hurls it at his feet' (1999: 249).

If Duchamp's *Fountain* involved embracing a previously unthinkable object within the artistic domain, this desire to include was similarly expressed in a Brazilian context where *buscou-se integrar na modernidade o que dela parecia irremediavelmente excluído: a natureza, o primitivo, o artesanal, o caipira, o negro etc.* (efforts were made to integrate within modernity that which seemed irremediably excluded from it: nature, the primitive, the artisan, the hillbilly, the black etc.), (Milliet, 2005: 29). This sentiment found its climax in the hallmark *Manifesto antropófago* (1928), whereby Oswald de Andrade proposed that foreign elements and characteristics previously seen as threatening to national culture might be 'ingested' and reconstituted to form unique expressions of *brasilidade* that would defy attitudes of cultural imperialism. This philosophy paved the way for a national discourse that placed value upon the quality of hybridity, the results of a mixing of ethnic and cultural elements in the belly of Brazil.

As Bauman observes, 'For something to be created, something else must be consigned to waste', making it an indispensable part of any artistic process (2004: 21). The sociologist is also quick to emphasise the parallels between materials deemed 'useless' and people labelled redundant for lacking the skills or means to participate in labour and consumer markets (2004: 12–13). This is a phenomenon he sees as symptomatic of modernity itself and is nothing less than a disturbing reflection upon the disposability of people in today's world. The motif of waste made a name for itself in Brazilian cultural production with the *Udigrudi* filmmakers of the 1960s who coined the term 'aesthetics of garbage', using this as a metaphor to refer to the subsistence of peripheral groups on leftovers from a 'dominant culture' (Stam, 1999: 70). Stam acknowledges the ambivalent significations of waste together with its symbolic function as a marker of social standing: 'wealth and status are correlated with the capacity of a person (or a society) to discard commodities, that is, to generate garbage' (1999: 70). In addition to the recent works under discussion in this chapter, landmark texts within Brazilian cultural production to engage with the subject of waste in a social capacity are Carolina Maria de Jesus' *O quarto de despejo* (1960), Jorge Furtado's ironic short film *Ilha das flores* (1989) and Eduardo Coutinho's feature-length *Boca de lixo* (1993).

The rather misleadingly named Jardim Gramacho, a vast landfill situated to the north east of Rio de Janeiro, is the setting for all three of the works examined in this chapter. Historically the largest landfill site in Latin America and dumping ground for the approximately 9000 tons of refuse that customarily arrived each day from five different municipalities in the Rio de Janeiro state when the site was fully operational, the location represents not only a highly

contentious environmental issue but is a sinister reminder of the social implications of intense global consumerism (Castro, 2008). The first two sections of this chapter examine two projects by the photographer and director Marcos Prado. The first is a selection of photographs drawn from 'Jardim Gramacho' (2004), an extensive series of black-and-white images of the site and those working on it that were taken during a long period of contact with the locale in the run up to the production of the second project, the film *Estamira* (2004). Both are more than a little controversial in their aesthetic approach to the subject matter, and form highly evocative and authorial responses to the environment and characters encountered. Where the first work is broader in scope, the latter frames an individual protagonist, Estamira – an elderly, mentally disturbed, refuse collector – and combines interviews and lyrical depictions set in both her working and domestic environs.

The subject of the final section is *Lixo extraordinário* (*Waste Land*, 2010), a Brazil/UK co-production featuring a 'transformational' encounter between renowned artist Vik Muniz and a small group of rubbish pickers recruited to feature in and work on a series of huge assemblage portraits made out of materials collected for recycling. As we contemplate the circuit of both materials and images that touch upon and impact our lives, questions surrounding media multiplicity, exchange and (artistic) reproduction assert themselves. Within this framework, I explore motifs of visibility, fragmentation and redemption, asking how we can better understand the tension between ethics and aesthetics in a domain that lies all too uncomfortably close to home.

'Jardim Gramacho'

> Any assessment or critique of waste, I suggest, is always a form of social criticism that espouses an evaluation of the society in which the alleged waste is situated. (O'Brien, 2008: 35)

It seems fitting to begin our analysis with an artist whose experience and output straddles many of the conventional parameters used to define cultural products. Practising in turn as a photographer, cinematographer, director and producer during the course of his career thus far, Marcos Prado has produced acclaimed works in the media of photography and film across both the realm of documentary and fiction. In addition to the works examined in this book, he has partnered with director José Padilha to produce the highly acclaimed documentary *Ônibus 174* (2002) and the blockbuster action film *Tropa de elite* (2007) and its sequel. Having trained initially at the Brookes Institute of Photography in California from 1983 to 1986, Prado's photographs have since featured in a journalistic context within publications such as *Veja*, *Folha de São Paulo* and

O Globo, and in an artistic context within the permanent collections of prestigious Brazilian institutions including the Museu de Arte Moderna do Rio de Janeiro (MAM), Museu de Arte Moderna de São Paulo (MAM) and Museu de Arte de São Paulo (MASP). *Estamira* (2004), the first film that Prado has directed alone, was the documentary that drew the largest cinema audiences in 2006 (Zazen Produções, 2016).[17]

Published in 2004, his book *Jardim Gramacho* comprises a collection of 87 black-and-white photographs taken over a period of eleven years (from 1993 to 2004) during which he frequented the landfill site. Although the work is little known in an international context, in 1996 Prado received the *IX Prêmio Marc Ferrez de Fotografia* as a direct result of the project. The book also features texts by specialists from a variety of fields, including scientific researchers in biology, engineering, sanitation, sustainable development and sociology, together with statements from numerous men and women working as *catadores de lixo* (rubbish pickers) (and in some cases living) there during this time. Although the pictures themselves are unlabelled, portraits are often accompanied by, or in close proximity to, these latter statements. For the purpose of this analysis, my focus will be on the photographic rather than textual elements. It is important to note, however, that the texts selected to accompany the photographs by no means create or communicate a uniform or single-minded message. Instead they capture effectively a series of contradictory and fundamentally ambivalent attitudes to waste and recycling. Should we interpret recycling as a positive contribution that lessens the environmental impact of human practices of consumption and disposal? Or does it in fact make a negligible or even negative impact whose only significant contribution is to alleviate our collective conscience? The photographs thus appear in a domain where a multiplicity of information and opinion triumphs over any overarching narrative or argument.

As Dipesh Chakrabarty observes, 'dirt can only go to a place that is designated as *outside*' (2002: 69). The relationship of this space to the city seems to be less that of border or limit *to* (though its inhabitants may be perceived as 'marginal') than that of a thorough exclusion *from*. However, the notion of exclusion and separateness fostered by its physical remove from the city is belied by its very nature. As a direct product of the society that alternately ignores or abhors it, Jardim Gramacho is intimately connected to each household and public building in a large surrounding area. Historically, 85 percent of the rubbish from the city of Rio de Janeiro makes its way there each day and it is in fact precisely the recognition of this personal connection to the site

17 Biographical information has been drawn from the following online sources: Eye On Films (2013), Coleção Pirelli/MASP (2013) and Filme B (2016a).

through the chain of waste disposal that prompts Prado's initial desire to visit (Prado, 2004: 9). The images document a period of discovery and in this sense they clearly embody the spirit of an encounter with the unknown. Nonetheless, through the explicit acknowledgement of his complicity in the system (a complicity that in any case would be challenging to deny) Prado accepts a level of responsibility that results in a respectful, if at times controversial, treatment of the landfill and its occupants, as the images themselves attest.

The first image revealed on opening the book is a cluster of furniture isolated in the midst of an expanse of rubble, stones and odd pieces of junk. There are no human figures in sight. A tall door stands propped against a sofa and takes centre frame. Precarious and barely supported, this door is our symbolic entrance to a foreign world, yet one that, as the image suggests, holds many wholly familiar objects. The sense of incongruity established by this 'matter out of place' prepares the viewer for an oscillation that occurs throughout the series between what might be considered familiar, strange or even strangely familiar objects, expressions and situations (Douglas, 2002: 50). In displaying objects commonly found within the home in a situation of public exposure, the photograph also invites reflection on the relationship between private and public within the realm of documentary representation, raising questions about where these frontiers might lie on a scale of socio-ethical acceptability. The image that accompanies the first full text – a statement from the photographer – is likewise highly pertinent to the viewing of the series as a whole. Here we see a rubbish picker in the act (or simulated act) of photographing Prado himself (Figure 1.1). This brings to the fore not only awareness of the discourse surrounding the disposability of images and image-making equipment in the contemporary world (the camera the man uses has clearly been found discarded on the tip and reminds us of the increasing speed with which devices are rendered obsolete through technological innovation) but also explicitly focuses our attention on the act of spectatorship. As secondary spectators in the documentary process we are perennially confined to looking through the photographer's eyes or lens. In this case, Prado and (by default) the later viewers are re-positioned as the photographed subjects. This dispels the notion of the *catador* as a passive object of the gaze and aligns him instead with a position of agency, additionally acting against the idea of the fixity of such positions or roles. It is hardly a subtle point, but in its symbolic importance perhaps one that may be forgiven a somewhat heavy hand.

Contemplating your Rubbish's Home away from Home

The most immediately striking and pervasive aesthetic decision taken by Prado in his approach to the subject is that to render the entire series in black and white. One obvious effect of this choice is to set the images apart from the

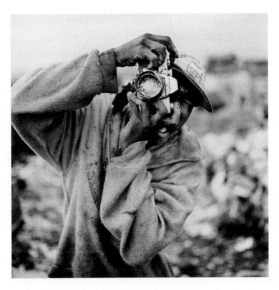

Figure 1.1. 'Jardim Gramacho' series (2004), © Marcos Prado

colour photography of newspaper journalism, which is often subject to accusations of sensationalism in its treatment of poverty and 'marginal' subjects and spaces. Wells observes of the use of black and white that 'originally a necessary condition for the reproduction of their photographs, it became a guarantor of the integrity of an image for many photographers' (2000: 111). Whilst of course colour photographs are no longer devalued in this way in the context of art or documentary (domains that in any case continue to overlap to an ever greater degree), black-and-white photography nonetheless retains the traces of such a history. As the possibilities for the technical manipulation of images have definitively abandoned the realm of potential to become an everyday reality for many contemporary photographers – whether simply adjusting colours and 'touching up' photographs using editing software or carrying out more drastic alterations – so our evaluation of a documentary work increasingly constitutes an act of faith in the integrity of the photographer in question and the manner in which this is underscored thus rises in importance (Fontcuberta, 2007: 50).[18]

18 It should be noted of course that the manipulation of images is anything but a recent phenomenon and that from photography's earliest days image-makers became interested in the possibilities of altering the 'reality' captured by the camera to create enhanced effects. The manipulation of landscape photographs carried out by hand during the mid-nineteenth century is one example of this phenomenon (Rosenblum, 2007: 105).

In addition to the expansive gesture harboured in the allusion to earlier traditions and values, using black and white also conversely performs a limiting and abstracting function. Stripping the image of additional information allows for a greater appreciation of form, erasing a visual hierarchy that would otherwise lead the eye to rest naturally on other prominent features such as bright colours, for example. Colour is obviously not the only vital characteristic missing from our appraisal of the landfill in this case. Deprived of the sense of smell, the viewer can only imagine the offensive and pungent odour that would accompany such scenes when experienced in the flesh. The fundamental 'absence' that black-and-white photography represents is thus a constant reminder of the distance between the image we contemplate and any notion of its capacity to fully capture a certain 'authentic' reality.

Prado's images – particularly those of an earlier series, *Os carvoeiros* (1999), depicting charcoal producers in various rural locations throughout the interior of Brazil – are reminiscent in some respects of the work of renowned photographer, Sebastião Salgado, whose work I touched on in the introduction. Both photographing exclusively in monochrome, they are united by a common interest in the fate of poor and exploited labourers in Brazil. However, whilst Salgado's infamous pictures of the now abandoned Serra Pelada gold mine in the north of the country often strive to capture the vast scale of scenes totally abstracted from the realm of common human experience (Stallabrass, 1997: 132), in 'Jardim Gramacho' Prado steers entirely clear of aerial or high-angle shots. So while Salgado's workers sometimes take the appearance of swarming ant-like figures, Prado's rubbish pickers, even when gathered together, are always photographed so as to remain distinctly human. Using a telephoto lens in some instances, the effect is to bring more distant figures closer, to compress in-between spaces rather than further miniaturise its occupants (see Figure 1.2). This in itself may be said to constitute an ethical decision: photographing in an environment where a strong discourse exists on the inhuman nature of the activity that takes place – with common imagery focusing on animals scavenging alongside people in deplorable conditions – Prado is mindful not to reinforce a dehumanising vision of the *catadores*.

(In)visible Labour

Working on the dump effectively constitutes socially invisible labour, as it occurs within the informal economy. This also contributes to a lack of recognition in economic terms, due to the fact that there is no official or external regulation of the prices workers receive for the materials they collect and sell. These rates remain low to serve the interests of the *sucateiros* or site owners who, in the absence of state intervention, have effectively monopolised this

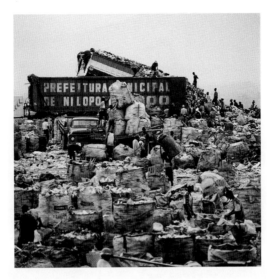

Figure 1.2. 'Jardim Gramacho' series (2004), © Marcos Prado

highly lucrative industry (Prado, 2004: 41). As sociologist Lucia Luiz Pinto notes, the image and characteristics attributed to *catadores* within the social imagination are that of *marginalidade, degradação, delinqüência, mendicância, sujeira e loucura* (marginality, degradation, delinquency, beggary, filth and madness), (Prado, 2004: 41). Labelled as poverty-stricken outcasts, it is little wonder that issues of low self-esteem often permeate such groups despite the potential ecological import of the jobs that they perform.

Numerous images convey workers quite literally bearing the burden of society's waste produce on their shoulders. With their heads obscured by the large sacks of materials they carry, some of these people remain completely anonymous. One such woman peeking out from the side of her load, however, suggests that these subjects are not photographed unawares (Figure 1.3). What may also be at stake, therefore, is an active desire to withhold identity, quite possibly to avoid a prejudicial association with the values society commonly attributes to *catadores*. It is an image reminiscent of earlier photographs of workers such as *Delivering Coal*, taken around 1916 (Figure 1.4). In this latter image, the woman expresses her efforts (and possibly displeasure at being caught on camera) plainly to the viewer, leading Rosenblum to observe that 'one of the basic tenets of the developing documentary style was that images should not only provide visual facts, they should be as unambiguous as possible in tone' (2007: 354). Prado's photograph is a clear example of the way in which the documentary mission has since shifted, as it is obviously difficult to discern anything about the subject. Here the bag, quite as big as the woman's body, literally takes the place of her head and face. Although she sees and

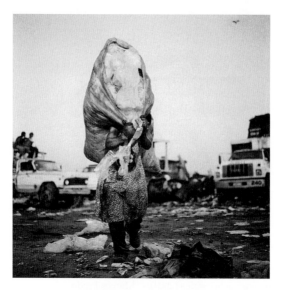

Figure 1.3. 'Jardim Gramacho' series (2004), © Marcos Prado

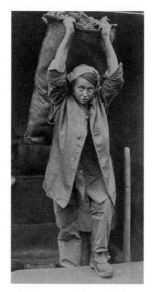

Figure 1.4. *Delivering Coal* (c.1916), Horace W. Nichols, © Royal Photographic Society/Science & Society Picture Library

gazes directly at the photographer through her one visible eye, as viewers we see no features that would help to define her as an individual. The woman's identity becomes bound instead to the load that she bears, its signifying value conveying her status and identity as a worker.

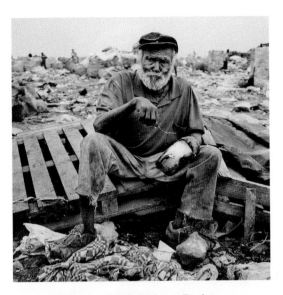

Figure 1.5. 'Jardim Gramacho' series (2004), © Marcos Prado

The growing presence of workers depicted in European art and literature produced from the 1850s onwards has subsequently been interpreted as an indication of 'mounting concern among elements of the middle class for the social and ethical consequences of rampant industrialization – a concern that helped prepare for the role of the documentary photograph in campaigns for social change' (Rosenblum, 2007: 351). A photograph of a rubbish picker sitting down to lunch likewise harks back to an earlier time, further strengthening ties with historic depictions of the worker (see Figures 1.5 and 1.6). In both photographs the men occupy a central space in the frame and engage directly with the viewer via clear eye contact. The seemingly open nature of the images suggested by their poses is belied in both cases by the rather secretive expressions that the men harbour. These might be interpreted in innumerable ways, though we would not be stretched to read in their faces a hint of pride and satisfaction at rest well earned, or perhaps at the act of recognition embodied by the decision to photograph. It seems in any case that one of the major contributions of 'Jardim Gramacho' is to pull the *catadores* out of the designated heap of *marginalizados* and, through the use of associative imagery, to insert them instead into a visual discourse of labour. In this way the 'outcast' *catador* is reconfigured as worker and becomes eligible for inclusion within the social body.

That is not to say that Prado romanticises the work of the *catadores*. The sense of invisibility and desire for anonymity that is communicated in some photographs finds a counterbalance in others where *catadores* stare defiantly back towards the camera. These are gestures that unmistakeably challenge

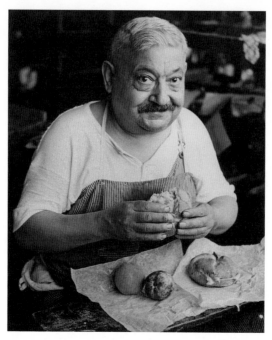

Figure 1.6. Shoemaker's Lunch, Newark (1944), Bernard Cole, © and courtesy of Bernard Cole
Archive

and provoke a form of exchange with the viewer's gaze, which is not avoided
but returned forcefully or inquisitively, unabashedly. In Figure 1.7, the down-
turned mouth and furrowed brow of a woman walking towards the camera
is suggestive of pensiveness, determination and anger. The use of bokeh, or
aesthetic blurring, lends the woman a definitive clarity that contrasts with the
mounds of rubbish that rise up behind her in an expansive haze. As our gaze
drifts down her arms to take in the empty plastic Coca-Cola bottles she holds,
they become at once the focus of the woman's concentration and a symbol of
the mass consumerism that has led us to seek solutions for waste disposal in
such enormous and hazardous landfills.

Images such as Figure 1.8, in which we glimpse a boy through a gap
between two large trucks, may appear at first glance to paint the *catadores'*
situation in a precarious light. The contrast between flesh and metal is
reinforced again via focusing techniques. However, the sharp definition of
the boy and the blurred edges of the vehicles lends his figure an element
of strength. Prado emphasises this refusal of vulnerability via a certain
visual rhyming, with the two humans occupying the vertical axis whilst
the machines remain confined to the horizontal plane. The series also fea-
tures images that are more playful in nature, acting against the idea of such
spaces as home exclusively to hardship and misery. Figure 1.9 shows a pair

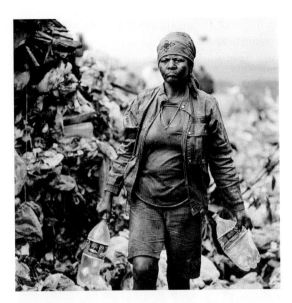

Figure 1.7. 'Jardim Gramacho' series (2004), © Marcos Prado

of *catadores* passing in front of the camera, which they take in with rather ambiguous expressions resting somewhere between apparent disdain and amusement. The woman is adorned in various necklaces and bracelets and holds up a plastic bag in a rather theatrical gesture that would look more at home on somebody returning from a shopping trip than the rubbish dump. Of course, this is an added reminder that here 'waste' is not actually waste, but a consumable product collected for resale and re-use.

Nature and the Apocalyptic Landscape

Surprising though it may seem to us today, it was not until the 1970s that waste came to be seen as a worldwide environmental concern:

> Somente a partir da década de 1970, o lixo começa a ser considerado uma questão ambiental. A preservação do meio ambiente foi assumindo caráter global, com as conferências de Estocolmo, em 1972, a ECO 92, no Rio de Janeiro e a de Tibilisi, em 1997. A crescente participação da mídia também contribuiu significativamente para esse processo, devido à rapidez com que as informações são transmitidas, de um lugar a outro do mundo. (Velloso, 2008: 1962)

> Only from the 1970s onward did rubbish begin to be considered an environmental question. Preservation of the natural environment assumed a global character with the conferences in Stockholm 1972, ECO 92 in

Rio de Janeiro and Tbilisi in 1997. The growing participation of the media also significantly contributed to this process, due to the speed at which information could be transmitted from one place in the world to another.

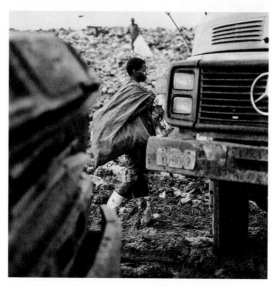

Figure 1.8. 'Jardim Gramacho' series (2004), © Marcos Prado

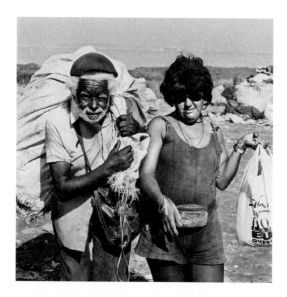

Figure 1.9. 'Jardim Gramacho' series (2004), © Marcos Prado

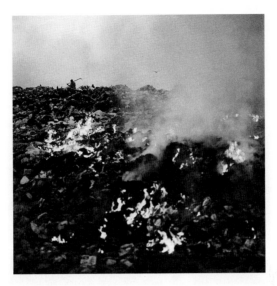

Figure 1.10. 'Jardim Gramacho' series (2004), © Marcos Prado

The mountains of rubbish featured in Prado's photographs of the landfill make for eerie and apocalyptic landscapes in which natural materials are substituted by the discarded products we consume. The landscape tradition in western European art and photography speaks of humankind's relationship with nature, which has often been visualised, particularly by the Romantics, as one marked by contemplative awe. In Figure 1.10, Prado presents us with a scene that operates at the other end of the spectrum. The dark and lumpy surface of the dump fills three-quarters of the frame, broken only by light patches of burning flames. Smoke rises from the ground to blot out a portion of the grey sky. On the thin sliver of horizon we glimpse part of a single human figure. The implement slung over the distant shoulder forms an uncanny resemblance with a scythe, lending the figure a Death-like air that reinforces the impression of gloomy destruction already oozing from the frame. This is a space that appears to hover at the end of time.

Although in other images the landscape becomes once again a scene of contemplation (Figure 1.11), the flattened wasteland that greets the viewer situated within and outside the image is far from the traditional subject matter of the genre. Rather than the beauty of nature, it seems that what we are called to witness is its terrifying demise. Photographs of dead animals amidst the rubbish find their uncanny counterpart in images of objects that resemble human figures and body parts – a plaster cast torso or a doll's head for instance (see Figure 1.12). As Sophie Gee notes in *Making Waste*, 'disgusting objects provoke defensiveness by being linked to death and decay' (2010: 7). The notion that photography may function to preserve life by capturing a person or scene and

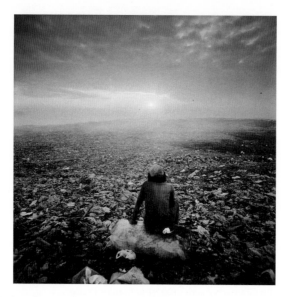

Figure 1.11. 'Jardim Gramacho' series (2004), © Marcos Prado

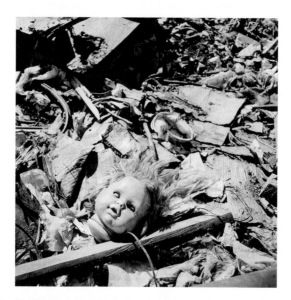

Figure 1.12. 'Jardim Gramacho' series (2004), © Marcos Prado

rendering it accessible through memory long after it has disappeared creates an interesting tension on one level, although of course the photograph is also a *memento mori* and in this sense constitutes a very apt medium through which to depict processes of decay, death and abjection (Sontag, 1979: 15).

Roland Barthes tells us that 'ultimately, Photography is subversive not when it frightens, repels, or even stigmatizes, but when it is *pensive*, when it thinks' (2000: 38). 'Jardim Gramacho' by no means avoids the problematic aspects of documenting a group of people who quite clearly occupy economic and social positions entirely distinct from that of the photographer. It seems appropriate to refer here to Stallabrass' pragmatic question: 'who or what can avoid complicity in the systems they inhabit?' (1997: 145). Without refusing his own implication within this documented terrain, Prado creates his own particular, and not uncontroversial, vision of Jardim Gramacho. Distancing the imagery aesthetically from any notion of objectivity or authenticity, Prado privileges in turn a vast, dense and complex landscape and the human lives that occupy and endure it. A desire to resist common discourse and avoid dehumanising the photographed subjects clearly permeates the project at large. The images that result are highly considered and self-aware. Many, as we have examined, successfully undermine conceptions of vulnerability and passivity that have been associated with the *catadores*, placing emphasis instead upon their contribution of (undervalued) labour within an established economic system. Although often rendered in apocalyptic tones, this domain is also intensely human and quotidian, as demonstrated by photographs of the workers eating lunch, chatting or playing cards. Prado's imagery creates a fundamentally ambivalent space that ultimately questions the fixity of roles of those both within and outside of its borders.

Estamira

Estamira is Prado's directorial debut in the world of feature-length documentary film. However, it is not the first film in which he has been involved to take inspiration from one of his photographic essays. His aforementioned images of *Os carvoeiros* (1999) showed people working in desolate conditions to produce charcoal for the metallurgic industry in Brazil and inspired the documentary film of the same name released in 2000, directed by Nigel Noble and endorsed by Amnesty International.[19] Given that Prado was also responsible for the cinematography of *Estamira*, it is not unreasonable to assert that the production's success – it received around 33 awards on international and national festival circuits including Best Brazilian Documentary in the Rio de Janeiro International Film Festival – is based largely upon his particular vision of the site that he spent many years documenting as a

19 See DVD cover. Prado also won second prize for images from his *Os Carvoeiros* series in the 'Nature Stories' category of the World Press Photo competition in 1992.

photographer and, more specifically, in the relationship cultivated with the film's protagonist, Estamira.

The film has stirred up very mixed reactions from critics in this regard. Under Nichols' 'Documentary Modes' *Estamira* might be defined as intensely 'poetic', at times 'observational', and at others 'participatory' in its approach (Nichols 2001: 138). Cléber Eduardo notes that it is aligned with a current trend he observes in Brazilian documentary filmmaking to focus on singular or exceptional and 'inspired' characters (in some manner anomalous) perceived to possess a unique *sabedoria autista* (autistic wisdom) worthy of an audience (Eduardo, 2004). What can be in no doubt, as Mariana Baltar highlights in her essay 'Cotidianos em performance: *Estamira* encontra as mulheres de *Jogo de Cena*', is the subject's acceptance of the camera and desire to perform for her intended audience (Baltar, 2010: 230). Although of course there are extremely polemical ethical issues surrounding the filming of someone perceived to be mentally disturbed, Prado's testimony of his encounter and ensuing friendship with Estamira states that *she* summoned *him* to document her message in the following words: *a sua missão é revelar a minha missão* (your mission is to reveal my mission), Estamira's mission in turn being expressly to *revelar e cobrar a verdade* (reveal and reclaim the truth), (Folha Online, 2011). In this light, his decision to film her begins to look less like preying on a potentially vulnerable person and more like the resolution to acknowledge and provide a forum for a voice that very much wanted to be heard. The artistic freedom that Prado has allowed himself in his endeavour to realise this mission has led Fernão Pessoa Ramos to criticise what he terms a heavy-handed aestheticisation of both rubbish and the film's protagonist in order to *extrair o sublime do disforme* (to extract the sublime from the deformed), in yet another example of increasingly grim *miserabilismo* infesting contemporary Brazilian documentary (2008: 222–223). Interestingly, it is precisely in this *'poetic excess'* that Beatriz Jaguaribe locates an intention to empower the protagonist aesthetically (2010: 271, original emphasis).

If the reactions to the film share any common ground, it is an acknowledgement of the complex ethical issues that surround the project and the provocative aesthetic approach that its director has taken to the subject matter. Although Eduardo draws attention to a directorial absence implied by the construction of an 'olhar sem o ponto de vista assumido de quem filma' (2004), I would argue that choosing not to appear physically within the film by no means constitutes an erasure of Prado's presence or 'point of view' as filmmaker – this is made apparent precisely in the aesthetic decisions that have inspired critiques such as those cited above. Rather than debate the integrity of the filmmaker's intentions (which I do not believe can be legitimately criticised for lack of transparency), what I propose here is to analyse the subtler

ways in which Prado negotiates ethical questions relating to the empowering/disempowering potential of the medium. Addressing aspects such as the position constructed for the viewer in relation to Estamira and her world, mediation, and the representation of corporeality, I explore how these devices operate to create a radically open subject who herself resists both social and filmic capture.

Dynamic Marginality

Given the subject of his film – an elderly, dark-skinned woman in a precarious mental condition – it would seem that Prado has chosen to focus upon the social grouping most vulnerable to prejudice and discrimination in a manner that reflects Stam's observation of the common 'feminization, and the racialization, of social misery' (1999: 72). The fact that Estamira's death from septicaemia in July 2011 was accompanied by accusations of hospital negligence is perhaps a sad indication of the gravity of these ongoing concerns (Globo, 2011). It should be noted, however, that the title of the film immediately alerts viewers to an intention to avoid generalisations or typecasts of people living and working in such conditions, indicating instead a clear focus on a chosen character, Estamira, and the individual circumstances that surround her mode of existence.

Sight and visibility are key motifs in the film and Estamira herself dwells upon the presence of the word *mira* (look at or gaze) within her own name. Likewise *Esta* is suggestive both of temporary existence (*estar* 'to be') and individuality or singularity (*esta* 'this'), both notions that are clearly captured in the protagonist's megalomaniacal assertions: 'eu, Estamira, sou a visão de cada um' and 'ninguém pode viver sem mim'. These statements not only conjure up the image of a prophet-like figure, but may also be seen as a form of symptomatic resistance to the overarching state of invisibility that marginalised populations such as those living and surviving on the rubbish dump experience in relation to dominant social groups. The desired effect is clearly achieved, for as B. Jaguaribe emphasises, Estamira is the very antithesis of a 'nobody' (2010: 275). As a personal portrait the film permits a greater degree of interpretive freedom than a sociological study and this is reflected in its much commented upon poetic style and the dramatic manner in which Prado renders the landscapes and environment that Estamira inhabits.

Although a landfill – understood as a final resting place for innumerable unwanted objects – might reasonably be coupled with the idea of stagnation as the cessation of flow and movement, *Estamira* conversely demonstrates the dynamism at the core of the site's daily workings. The flow of traffic in and out of the landfill together with the pickers' incessant churning and sifting of

newly arrived materials (when it was active the site operated 24 hours a day (Globo – Ação, 2011)) serve as a clear testament to this vision. The shifting and unstable nature of Estamira's psychological state thus becomes intertwined with a physical and visual momentum that is established early in the film and is echoed in the crescendos and diminuendos of a haunting soundtrack of wailing voices and twanging instruments composed by Décio Rocha especially for this context (Zazen Produções, 2016).

In choosing to open the film with a sequence of shots exploring Estamira's *casa* (shack), Prado carefully places the film into a dialogue between interior and exterior space that lies at the heart of questions of waste, refuse and the socially abject or Other. The black-and-white montage of Super 8 mm footage taken from an unsteady handheld camera shows various discarded objects surrounding the abode before continuing its restless exploration within the shack. The shots often show only fragments of objects – a tin bowl containing a dead lizard; a knife; a gaggle of hungry puppies suckling at a bitch; a cross; a dangling crescent moon ornament – and are symbolically suggestive of a complicated co-existence of death and regeneration, stagnation and persistent survival, which echoes the recycling process to which Estamira's own life and livelihood are bound. The knife may also allude to the traditional cutting and editing process within filmmaking and as such is a reminder of the representational limitations of the medium in its necessary partiality (in the sense of both incompleteness and bias).

Despite being the protagonist of the film, it is interesting to note that during this sequence Estamira entirely eludes the camera's gaze; hovering in darkness or passing through a door as it swings shut in the face of the camera, she remains always ungraspable, beyond reach and beyond sight. The position constructed for the spectator is, therefore, thoroughly external to Estamira's world and the subsequent sequence emphasises this first impression as the grainy black-and-white images that document the journey from her abode to the landfill hover always on the point of disintegration, prolonging a visual shrouding of the character (Figure 1.13). The idea of an unknowable and thus incomprehensible nature is reinforced during interviews, the camera frequently cutting from a conventional medium close-up 'talking head' shot to a close-up of an isolated body part such as a hand, a foot, or her moving lips. With the periodic separation of voice from image, an effect of fragmentation and rupture is achieved that both prohibits totalising and possessive gestures on the part of the viewer and echoes the nature of her own mental deterioration.

The shifts from grainy black-and-white footage to vibrant colour-rich images further highlight borders and cuts, and operate reflexively as an ongoing reminder of the mediation upon which the film's existence depends. Panoramic shots of bright red sunsets and yellow-blue dawns over the open

Figure 1.13. *Estamira* (2004), dir. by Marcos Prado. Zazen Produções

Figure 1.14. *Estamira* (2004), dir. by Marcos Prado. Zazen Produções

expanse of the dump or – as the camera tilts upward – a bright blue sky in which rubbish and vultures dance around each other, create at times an ironic picture postcard and at others a sense of otherworldliness or apocalyptic suspense (Figure 1.14). Whilst this aestheticisation is not unproblematic and, as we have witnessed, may invite criticisms of what Ivana Bentes terms a 'cosmetics of hunger' (2006: 124), it may at least be said to create an aura of dignity that works against the voyeuristic *pornomiseria* (poverty porn) approach to representing poverty where misery and squalor take centre frame at the expense of respect for filmed subjects (León, 2005: 77).

A refusal to comply with aesthetic expectations is mirrored in the messages conveyed orally by the film's characters in which stereotypes, prejudices and common perceptions are consistently undermined. Estamira's statement as we observe the sprawling windswept debris around her, *eu adoro isso aqui. A coisa que eu mais adoro é trabalhar* (I adore it here. The thing I adore most is working), together with the long hours that the refuse collectors observe, subvert notions about laziness among the poor and officially unemployed. Likewise, her friend Teobaldo's comment on the sense of community and familiarity amongst those working at the tip disrupts a dehumanising view of those reduced to making a living from discarded objects and food. Of course, it is essential to recognise the performative nature of all that is stated in front of the camera. This does not, however, reduce the impact or significance of such representations. Through both imagery and discourse that counter prevalent stereotypes, the space becomes defamiliarised and the viewer is thus encouraged to engage with the film in a manner that looks beyond such conventional parameters. Rather than a freak show of marginality or a consolidation of existing views upon those 'socially excluded', the message that the film ultimately conveys relates not so much to Estamira, who despite her diegetic centrality remains visually – and increasingly linguistically as her mental health deteriorates – elusive and unknowable, but to the reflection upon mainstream values that her views elicit. Whether on the necessity to respect, economise and recycle material resources or on the value of helping others, it is Estamira's uncompromising judgement that is passed on to the rest of society through the camera rather than the reverse.

From a position external to dominant society Estamira is able to take a stance against hegemonic power structures, and footage of her outbursts and forceful criticism of institutions such as the Church, education system and health services becomes increasingly frequent as the film progresses. The subversive and 'dangerous' aspect of such libertine opposition is recognised and validated in the repeated attempts by Estamira's son, an evangelical Christian, to intern her in a mental asylum; despite the lucidity of many of her statements and the lack of (physical) harm she poses to others, she apparently constitutes an open threat to the stability of his religious belief system. Paranoia, as a disordering and disruption of reason, is itself inherently subversive, as Daniel Paul Schreber – the schizophrenic subject of Freud's 1943 analysis *The Schreber Case* – notes (1988: 13). Although I do not examine Schreber's case of psychosis or Freud's later study here, it would no doubt provide an interesting point of comparison through which to further explore Estamira's relationship to religion and fantasies of bodily possession.

The Body as a Battle Ground

In her anthropological study of violence in Brazil, *Death Without Weeping*, Nancy Scheper-Hughes draws attention to a shift in the nature of institutional violence in the western world – from physical punishment exacted on the body to measures of surveillance and discipline inflicted upon the mind (1992: 221). However, in a Brazilian context it is clear that certain populations – notably the poor and socially marginalised – continue to be exposed to the threat of a very physical institutional violence (particularly from the police forces), their bodies being 'discounted and preyed on and sometimes mutilated and dismembered' (1992: 231). Scheper-Hughes uses this to illustrate the heightened significance of the body in poorer communities in which a constant fear of assault, dispossession and loss of control of one's own body prevails. Estamira's particular case of psychological disturbance thus not only touches upon the historic controversy surrounding mental asylums and (the violation of) human rights in Brazil but also demonstrates a clear and pertinent preoccupation with persecution of the body by external and untouchable powers. (A poignant example within fiction film to engage with such issues of institutional abuse and bodily control – here from the perspective of a middle-class protagonist – may be found in the acclaimed *Bicho de sete cabeças* (2001), directed by Laís Bodanzky.) Occasionally flinching during interviews at a burning pain that she describes as being inflicted by a *controle remoto* (remote control), Estamira creates her own powerful metaphor for the violence inflicted upon the bodies of the poor by distant, largely unaccountable, forces.

The vulnerability of her body throughout the course of her life is readily demonstrated through reference to the sexual abuse she suffered at an early age, enforced prostitution and multiple rapes, all of which add a clearly gendered dimension to her experience of bodily disempowerment. The narration of these events by her older daughter is followed directly by an allusion to Estamira's turn away from religion and her development of a fiercely anti-Christian sentiment. The angry exclamation provoked by the religious attitude of her grandson: *não foi Deus que pariu sua mãe, não! Foi eu! Foi eu que pari!* (God didn't give birth to your mother, no! It was me! It was me who gave birth) , could in this light be construed as a reaction to the persistent devaluation and denial of women's agency through traditional patriarchal values. Estamira's emphasis on her own active female role in the process of creation as biological (re)production fundamentally subverts the entire system of (divine) male authority upon which western Christian society – and its derivative ideals of the family and nation – is based. The frequent close-up shots of her hands, face, legs and other body parts throughout the film thus draw attention not only to the body as a source of preoccupation and potential

Figure 1.15. *Estamira* (2004), dir. by Marcos Prado. Zazen Produções

Figure 1.16. *Estamira* (2004), dir. by Marcos Prado. Zazen Produções

vulnerability, but to the persistent and defiant challenge that such material-
ity poses to patriarchal discourse (Figures 1.15 to 1.18). Baltar has alterna-
tively interpreted the intrusive shots of a camera that *invade a geografia do corpo*
(invades the geography of the body), as instrumental in forming a *pacto de
intimidade* (pact of intimacy), that stimulates a continued sense of engagement
between the protagonist and her audience (2010: 230).

It is significant that, in the film's imagery, Prado chooses to foreground the
elements – earth, air, fire and water – so strikingly in his representation of
Estamira and her surroundings. For it is under these 'universal' signs that
nature, spirituality, femininity and power have traditionally been brought

Figure 1.17. *Estamira* (2004), dir. by Marcos Prado. Zazen Produções. Original in colour

Figure 1.18. *Estamira* (2004), dir. by Marcos Prado. Zazen Produções. Original in colour

together. Despite the sense of empowerment that this lends to the protagonist (at one point Estamira is filmed as if conjuring the forceful winds that rage across the vast dump), it reinforces a problematic association with material nature that lies at the core of a fundamental historic dispute between essentialist and constructivist feminist thought. Essentialists maintained that women have a special relationship to nature and the earth, including an increased propensity to care and preserve; however, these qualities were placed in direct opposition to what Luce Irigaray terms 'male reason […] male power and male concepts' (in Rivkin and Ryan, 2004: 767). Prado's decision to engage with these historic associations in his portrayal of Estamira reinforces a sense

of her inner tension and conflict at the same time as it undermines the simplifying effect of such dualisms. Although Estamira's state of mind clearly falls outside common definitions of rationality, her proposed values of recycling and her ethics of care are far from irrational concepts.

Estamira's worldview, her beliefs, and the actions that constitute her way of life, are in many respects both radical and progressive. It is appropriate, then, that the final sequence of the film should gesture to the revolutionary Brazilian Cinema Novo of the 1960s through the familiar trope of the sea, which since Glauber Rocha's *Deus e o diabo na terra do sol* (1964) has been associated with the class struggle and a desire for the disruption of an existing social order of inequality (Johnson and Stam, 1995: 146). In this case, however, the effect of such imagery is mixed. For though the long shots that frame Estamira against the raging ocean and close-ups of her playing in the water, buffeted by waves, might evoke a collusion with powerful natural forces, they also highlight her own comparative frailty. Although in the opening sequence we see numerous shots of Estamira dwarfed by refuse trucks as they sweep past her on her walk to the tip, these are interspersed with shots in which she appears to confront these obstacles head-on (Figures 1.19 and 1.20). What Prado successfully conveys is her attitude of defiance and resilience rather than victimhood. Yet her marginal position does remain fundamentally ambivalent. Whether construed as an indication of disempowerment and social exclusion, a source of liberation from the constraints and conventions of a dominant society, or indeed both, is for the viewer to decide.

As journalist and sociologist Muniz Sodré observes, it is precisely through the conflict generated by difference that successful challenges are raised to existing states of being (1999: 204). It is in the rubbish dump – a place that has been associated with voracious consumerism, ecological disaster, and social

Figure 1.19. *Estamira* (2004), dir. by Marcos Prado. Zazen Produções

Figure 1.20. *Estamira* (2004), dir. by Marcos Prado. Zazen Produções

depravation among other things – that Prado's *Estamira* appears to uncover the forceful remains of hope and potential for those seeking to interrogate societal values and dispute the oppression of those located outside dominant social and economic circuits.

Lixo extraordinário

> Theologically speaking, the value of wasteland was clear. Desolation is the condition of salvation; without waste, resurrection is impossible. (Nigel Smith in Gee, 2010: 20)

Entitled *Waste Land* in the English language version, the film *Lixo extraordinário* was initially conceived by its UK production team as a portrait of the internationally acclaimed Brazilian artist, Vik Muniz. However, it soon became clear that Muniz himself had very different aspirations for the film. The combination of Muniz's practice of working with everyday materials (dust, sugar, chocolate and junk to name only a few) and his desire to create an artistic project that would simultaneously benefit and 'transform' a group of socially disadvantaged collaborators, led the filmmakers away from the artist's New York studio to the Jardim Gramacho landfill. Here, what has been described as an encounter between two worlds occurs: 'the cosmopolitan world of artists, their patrons, collectors, galleries, museums and auctions in Rio, New York and London and the everyday life of the garbage pickers of Gramacho' (Scheper-Hughes, 2010: 41), as Muniz meets the *catadores* who work there collecting recyclable material and begins a collaborative process of creating their portraits out of these same objects.

The process of the portraiture itself features many layers of reproduction. These may be described as follows: first, the historical or reference artwork on which the pose is based (this is sometimes shown to us as viewers as in the case of Jacques-Louis David's *The Death of Marat* (1793), which is held up for the camera as it appears printed in an art book); second, a re-staging of the art piece featuring a *catador*, which is photographed by Muniz (see Figures 1.21 and 1.22); third, this image is projected onto the floor of a large warehouse where construction of the assemblage will take place (Figure 1.23); fourth, the portrait physically reconstituted in recyclable materials; and fifth, a photograph of the finished reconstruction forms the final piece and sellable

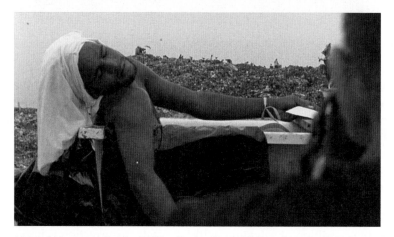

Figure 1.21. *Lixo extraordinário* (2010), dir. by Lucy Walker, João Jardim, Karen Harley. O2 Filmes/Almega Projects. Original in colour

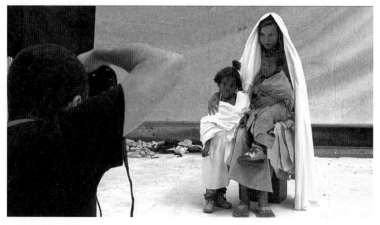

Figure 1.22. *Lixo extraordinário* (2010), dir. by Lucy Walker, João Jardim, Karen Harley. O2 Filmes/Almega Projects. Original in colour

Figure 1.23. *Lixo extraordinário* (2010), dir. by Lucy Walker, João Jardim, Karen Harley. O2 Filmes/Almega Projects. Original in colour

artwork – as pictured on the DVD cover for Brazilian release. The film accompanies the project from the germinative stages of discussion through to its full practical realisation: the sale of one of the completed and photographed portraits in a London auction house, with proceeds directly reinvested in the Associação dos Catadores do Aterro Metropolitano de Jardim Gramacho (ACAMJG) and its recycling community.

Lixo extraordinário was explicitly made for an international audience and was very successful on the festival circuit where it was nominated for an Oscar in 2011. Although it lost out here to the highly topical documentary *Inside Job* (2010), on the financial crisis in the USA, it did win around 22 other prizes, many of which came under the category of 'People's Choice' or 'Audience' awards. It seems reasonable on this basis to state that the film was clearly a crowd-pleaser. This is precisely the term used on the DVD cover for the UK release, which also describes the film as 'The *Slumdog Millionaire* of documentaries'. Prompted by these statements, I ask what exactly the implications are of these associative labels and indeed how a film that ostensibly showcases a topic that we try our hardest to ignore – as an audience of fully fledged consumer citizens who contribute regularly to the global accumulation of vast quantities of rubbish – how does *this* film become a 'crowd-pleaser'?

The two answers may be said to boil down to one and the same essence, the key lying in a question posed by Muniz near the beginning of the film: 'can art change people?' The wide appeal that the film seems to have captured may be partially recognised in the powerful allure of the concept of transformation. An 'ideal marriage' thus brings art and the social documentary together in a shared objective and process. This is particularly poignant in the context of Brazilian cinema where, as commented in my introduction, filmmakers from

the mid-1950s onward were strongly motivated by a desire not only to *reveal* a Brazilian reality but ideally to *transform* it in the process (Escorel, 2003: 36:10). The 'rags to riches' story has, of course, a well established appeal spanning various genres including fairy tales, literature, films, video games and television game shows. Our current obsession with celebrity status and a cult of instant fame fuelled by the international explosion of reality TV shows during the last decade – *Big Brother* (*Brasil*), *Pop Idol* or *Ídolos* to name only a couple of formats successful in both the UK and Brazil – attest to a ferocious desire to believe in the possibility of rapid socio-economic transformation via media exposure and public visibility. So whilst *Lixo extraordinário* may be said to reflect this reality to a certain extent (there is a sense of rising potential for the *catadores* who rub shoulders with Muniz during the two years of filming), this is far from unproblematic in a country like Brazil where celebrity status runs the risk of operating as a substitute for basic citizenship (Leu, 2009).

Establishing Perspective and Identification

> Boundaries do not so much define the routes of passage: it is movement that defines and constitutes boundaries. These boundaries, consequently, are more porous and less fixed and rigid than is commonly understood. (E. Grosz, 1995: 131)

I would like to suggest that what renders this story 'acceptable' to and popular with viewers at large, is the fact that its subject matter is *not* in fact waste as may initially appear (despite the English title), but is better understood in terms of its Portuguese title as a narrative about *lixo extraordinário*. That is literally 'out of the ordinary rubbish', or 'spectacular rubbish', to capture the notion of spectatorship that lies at its core. The space is rendered visible through the lens of recycling rather than waste *per se* and it is thus the potential for re-use and transformation that takes centre stage. Film is intrinsically fragmentary – multi-spatial and multi-temporal – and its viewing, as we are all aware, presents only an illusion of coherence experienced via the rapid projection of a succession of images or frames. Its composite nature is further reinforced in *Lixo extraordinário* due to the fact that the film is a hybrid of three directors' successive visions and involvement in the project – Lucy Walker, João Jardim and Karen Harley respectively. What I would like to draw attention to, however, is the way in which perspective and media multiplicity are used to create a coherent narrative that stimulates identification between the characters and viewers.

Muniz is without question the viewer's primary point of contact in the film as the first character to which we are introduced and our guide as we journey

from New York where the artist resides to Rio de Janeiro and Jardim Grama-cho. He is, of course, also the vehicle of change that drives the entire initiative. Through Muniz's personal 'rags to riches' narrative the viewer is also led to identify with the *catadores* – the idea that the artist could easily have ended up in their position had fate not played its part, is explicitly presented to us. The opening and close of the film also hammer this point home. Bookended by two extracts from the famous Jô Soares chat show (a David Letterman figure of Brazilian television), it opens with the host interviewing Muniz and closes as he interviews Tião – the president of the ACAMJG and an inspir-ing community leader who becomes a leading protagonist in Muniz's project (Figures 1.24 and 1.25). The intended message is resoundingly clear: Tião the activist moves into Muniz's privileged position as a new agent and celebrity,

Figure 1.24. *Lixo extraordinário* (2010), dir. by Lucy Walker, João Jardim, Karen Harley. O2 Filmes/Almega Projects. Original in colour

Figure 1.25. *Lixo extraordinário* (2010), dir. by Lucy Walker, João Jardim, Karen Harley. O2 Filmes/Almega Projects. Original in colour

Figure 1.26. *Lixo extraordinário* (2010), dir. by Lucy Walker, João Jardim, Karen Harley. O2 Filmes/Almega Projects. Original in colour

thus testifying to the plausibility of such 'rags to riches' transformation. Television, it should be mentioned, is both a zone of aspiration and suspicion in the film, viewed as a measure of success but also as the Mecca of advertising and irresponsible consumerism.

Muniz's approach to the project takes art as an explicit tool for achieving social change and this invariably marks his relationship with the *catadores* in a particular way. Early on in the film and shortly after Muniz's first encounter with Jardim Gramacho, he takes a helicopter ride to familiarise himself with the site from the air. This results in the production of a privileged master gaze directly associated with the artist – it is extremely unlikely that those who work on the site will ever have had access to this vista whereby they themselves become tiny ant-like specks on a vast lunar landscape (see Figures 1.26 to 1.28). The premise for the aerial photographs is to aid Muniz in determining the most appropriate angle for the project and leads to his decision to steer away from such all-encompassing landscapes in favour of magnified 'blow up' portraits of individuals who work on the site.

As Mark Dorrian observes in an essay on the construction of the Ferris wheel in the late nineteenth century and its effects on passengers, a 'thinning of the ethical relationship through distance' occurs when objects are viewed from afar (in Lindner, 2006: 17). It is this distancing that Muniz clearly hopes to avoid in his methodology and aesthetic approach to the subject. The filmmakers themselves clearly play on such contrasts between proximity and distance during the film, establishing a dynamic gaze that effectively highlights this tension between ethics and aesthetics. This is demonstrated in a 'centrepiece' or axis sequence occurring almost exactly at the midpoint of the film. Sandwiched between two 'talking head' interviews with *catador* protagonists, the

Figure 1.27. *Lixo extraordinário* (2010), dir. by Lucy Walker, João Jardim, Karen Harley. O2 Filmes/Almega Projects. Original in colour

Figure 1.28. *Lixo extraordinário* (2010), dir. by Lucy Walker, João Jardim, Karen Harley. O2 Filmes/Almega Projects. Original in colour

sequence begins with an aerial shot of a single woman collecting materials on the tip before the camera pulls away to take in a whole group of workers and the wider scenery. This movement is repeated several times during the sequence: at one moment we are placed in amongst the collectors and, at another, we observe them from above and afar (Figures 1.29 and 1.30).

The use of slow motion and the euphoric and haunting soundtrack, composed by American musician and DJ Moby, are devices evidently used to elicit emotional responses from the audience. Indeed, the film relies heavily upon music throughout for this function. *Lixo extraordinário* documents an artistic project that depends on the generation of public, and specifically investor,

Figure 1.29. *Lixo extraordinário* (2010), dir. by Lucy Walker, João Jardim, Karen Harley. O2 Filmes/Almega Projects. Original in colour

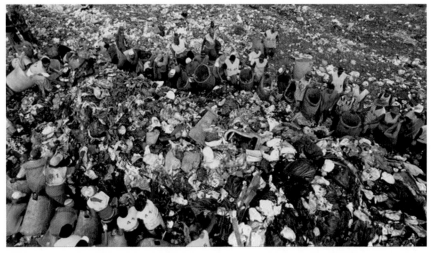

Figure 1.30. *Lixo extraordinário* (2010), dir. by Lucy Walker, João Jardim, Karen Harley. O2 Filmes/Almega Projects

interest in order to deliver the material gains it sets out to achieve – generated in the first instance through the sale of portraits in the contemporary art market and bolstered by the film's capacity to raise the public profile and future value of the artworks further. The stimulation of audience identification via the manipulation of emotion thus represents a synergy of ethos and aesthetic geared to seduction. In this regard, the didactic currents that move through the film place it far closer to the traditional expository or rhetorical function of documentary than any of the other works examined in this book.

Fertile Images: A Productive Revelation

> Unlike mess, waste can often be recycled, or put to alternative uses; if the system which produced it cannot accommodate it, some other system will. Waste remains for ever potentially in circulation because circulation is its defining quality. (Trotter, 2000: 20)

The tendency of products and works to conceal and detach themselves from the productive labour upon which they rely is a phenomenon that has been commented on by theorists from Karl Marx to Henri Lefebvre and beyond. It finds a clear example in the realm of advertising in which any suggestion of the manufacturing origins of a product is wiped from the slate in favour of the construction of a fantasy realm through which certain values – exclusivity, desirability and hyper-functionality, for instance – may be attached to the product. Consumerism, as a driving force for disposal, is the other side of this invisible coin. The documentary genre has unsurprisingly been at the forefront of engaging with rising ecological and social concerns surrounding waste. A prominent international example of a project that aims to render visible these largely invisible processes of labour is *Manufactured Landscapes* (Jennifer Baichwal, 2006), featuring the work of Canadian photographer Edward Burtynsky. The use of artworks to draw attention to this context – Burtynsky's photographs have an obvious aesthetic value well beyond their documentary function – simultaneously highlights the way in which art additionally operates as a product for consumption.

In the same vein, *Lixo extraordinário* does not shy away from the productive labour or commercial value of the artworks, which is revealed through the intense visualisation of the artistic process in its numerous stages. As viewers we witness part of the process of construction of numerous pieces and these sequences make no attempt to hide the very different roles played by Muniz and the *catadores* in their elaboration. Shots taken from over Muniz's shoulder as he stands on a scaffold above the warehouse floor directing the *catadores* who physically construct their portraits below, feature repeatedly and clearly reflect the hierarchical relations at stake (Figure 1.23). Interestingly, though the vertical relationship is clear in this image and the *catadores* take the form of small crouched figures, Muniz's dimensions and the photographed faces of the *catadores* appear equal in scale. We might even interpret this gesture as an attempt by the filmmakers to neutralise the master gaze of the artist. It should also be noted that the platform is not an entirely restricted viewpoint (the *catadores* are invited to share it on various occasions), though it is unquestionably a position of privilege, as it is only from this point of elevation that the portrait becomes recognisable to the human eye as an image.

Whereas the process of representation or mimesis is frequently and historically understood as an endeavour to reproduce a scene from reality (i.e. an element external to the art world and domain of representation), in *Lixo extraordinário* the subject of representation is art itself. Rather than the creation of an illusion that mimics a reality or set of 'real' objects, what we witness is the use of everyday objects to refer to an already established illusion or artifice. The sense of contagion conveyed in these cycles of reproduction and replication draws us back to the concept of *antropofagia* (cannibalism), so central to Brazilian modernism. That all of the references are drawn from western European art (other images used are Millet's *The Sower* (1850) and Picasso's *Woman Ironing* (1904)) echoes the idea that an ingestion of foreign cultural elements may form a step in the process towards the creation of novel expressions intimately linked to a Brazilian context. The process documented in *Lixo extraordinário* is likewise centred upon a fundamental revaluation: the final photographic image has a far greater economic exchange value as a cultural product (stamped with the Muniz brand of course) than the actual materials have in their value as a resource for the creation of further consumer products. The main contribution of the process, however, is its revaluation of labour itself. In visualising the labour of the *catadores*, both in their daily jobs and in the generation of art, a domain commonly associated with stagnation and neglect is transformed into one of productivity and potential, a function we observed above in respect of Prado's 'Jardim Gramacho'.

Linked to this idea of (re)production is the theme of redemption, which arises in the three recycling processes that come to the fore during the film: the material recycling documented on the landfill (of ecological benefit and carried out for economic survival); the above-mentioned recycling of iconic images from the history of western European art (and its role in the revaluation of labour); and finally, the recycling of human lives. Can art change people? The question posed near the beginning of the film is revisited in the final sequence when we are presented with a 'what happened next?' for each of the main characters: Muniz, and the collectors Zumbi, Isis, Magna, Irmã, Suelem and Tião. In all but the case of Irmã (who, we learn, is too attached to her working environment and her former community to give it up), indications of change of a more or less drastic nature suggest to viewers that the project has achieved an at least partially positive impact upon its participants. Such well-intended artistic interference in the lives of the poor has an extremely problematic legacy within Brazilian cinema, of course, as demonstrated by Hector Babenco's *Pixote: a lei do mais fraco* (1981) and José Joffily's *Quem matou Pixote?* (1996). In this case, the latter biographical film explores the devastating effects that starring in the former had upon the impoverished child and non-actor, Fernando Ramos da Silva, ultimately resulting in his death when

he turns to crime after failing to fulfil the aspirations inspired by his early brush with the film world.

Despite a certain porosity of boundaries demonstrated via the amicable interaction of Muniz and the collectors, a clear distinction between 'us' (the artist/viewer) and 'them' (those working on the landfill) is established from the beginning of the film. This frontier is also emphasised through language: interviews with the artist and associates occur primarily in English whilst interviews with the *catadores* and site managers are in Portuguese. The fact that the film aligns itself initially with Muniz's perspective does allow for a certain freedom of representation, of course, permitting the aesthetic choices during filming to follow the artist's own search for beauty and transformation.

This does not mean that ethical dilemmas are glossed over, however. These are clearly addressed in punctuating discussions between Muniz, his wife Janaína and artistic consultant Fábio. The fact that these dialogues take place in English (between native Brazilian Portuguese speakers) makes them all the more uncomfortable and strained for both participants and viewers, additionally emphasising their performative dimension. These highly artificial sequences clearly detract from the sophisticated quality of other scenes and may at face value appear to simplify the ethical issues at stake. However, I would contend that including the uneasy expression and reception of such ideas as 'giving back' to society, 'helping the unfortunate', and most importantly the paternalistic debate on the possible negative implications of *allowing* the *catadores* temporary access to a privileged lifestyle that they may be unable to replicate independently, constitutes an ethical decision. In allowing this framework to remain visible to the viewer, the representation of the *catadores* is ultimately privileged over that of the artist and his associates, which suffers as a consequence, leaving them to appear at times egotistical, condescending and insensitive.

As Muniz commented in a presentation on 'Creation' given at a Technology, Entertainment, Design (TED) conference in 2003, 'it's not about fooling somebody, it's actually giving somebody a measure of their own belief: how much you want to be fooled' (TED 2013). Ultimately, as viewers we see what we want to see and must bear responsibility for our own interpretations. Cinema as a creative act is also one of illusion and documentary cinema, though bounded by its own set of ethical issues and codes, remains a filmic construction. Scheper-Hughes' comment 'that the scene of so much daily struggle is so seamlessly transformed by the filmmakers into a beautiful human ballet is a bit disconcerting', might be considered by some a gross understatement (2010: 41). It is not difficult to see why the film has been referred to as the '*Slumdog Millionaire* of documentaries', as mentioned in the opening of this analysis. The two films present glowing and comforting

narratives in which all manner of hardships are overcome by a firm belief in, and projected outcome of, social transformation. To what degree the viewer wishes to buy into such seductive messages is, of course, a matter of personal discretion. *Lixo extraordinário* does succeed in creating empathy between viewers and subjects, though the latter ultimately remain pawns within this particular socio-artistic experiment. Although the film is rescued from its own glossy self-promotion by the intensely awkward ethical discussions referenced above, it does very little to dismantle the firm hierarchies it purportedly seeks to overcome, indeed using these to build its own narrative and aesthetic structure.

Waste is a concept used in each of the above works to engage with various forms of social criticism. Although a wasteland – as the destined space for this material – may initially appear to be a domain of rigid and clear-cut boundaries, the divisions between inside and outside and consequent understandings of exclusion are demonstrably complex. The qualities of agency, circulation and visibility are engaged by the artists to interrogate common perceptions of the passivity and victimhood of those at the 'end' of this food chain. In each case, controversial aesthetic decisions are made that distance the works from the historic trend of realism within documentary, bringing their own set of difficulties as the artists contend with tensions between visual pleasures evoked by their material and wider ethical issues at stake. In the following chapter we move on to consider the ways in which artists negotiate some of these themes in an environment where the qualities of waste are applied directly to human beings and exclusion appears to be an irredeemable feature of the social landscape.

The Human Warehouse

> When it comes to designing the forms of human togetherness, the waste is human beings. Some human beings [...] do not fit into the designed form nor can be fitted into it. (Bauman, 2004: 30)

> The carceral network, in its compact or disseminated forms, with its systems of insertion, distribution, surveillance, observation, has been the greatest support, in modern society, of the normalizing power. (Foucault, 1991: 304)

Introduction

Chapter 1 examined diverse representations of the material waste disposed of by society, the people who make their living from it and the transformative potential and influence of art as it comes into contact with such environments. In the last section we observed how *Lixo extraordinário* (2010) communicates, albeit in a problematic way, a belief in the possibility of constructing new perspectives and directions for those who find themselves positioned on the margins of society. In this chapter we turn to a space that, for many, represents a final dumping ground for those who have already stepped too far beyond society's legal and moral bounds: the prison.

The practice of imprisonment, understood in broad terms as the 'public imposition of involuntary physical confinement', is in fact an ancient one with references to be found in both Greek myth and the Book of Genesis (Morris and Rothman, 1995: 3). Prisons in their modern form now exist in most countries across the world and are perhaps one of the most explicit authorised mechanisms of social exclusion and control present in contemporary society. However, as Michel Foucault underlines in his landmark *Discipline and Punish* (1991), the relationship of visibility to punishment, authority and control has altered dramatically over the last few centuries and the inversion of its status provides key insights into its social significance. Highly spectacular forms of punishment such as public torture or execution, designed to demonstrate the absolute power of a monarch, have given way to the 'representative' but hidden punishment of incarceration,

an essential tool for maintaining state authority within a disciplinary model of society:

> Traditionally, power was what was seen, what was shown and what was manifested […]. Disciplinary power, on the other hand, is exercised through its invisibility; at the same time it imposes on those whom it subjects a principle of compulsory visibility. In discipline, it is the subjects who have to be seen. Their visibility assures the hold of the power that is exercised over them. (Foucault, 1991: 187)

The principles of disciplinary power developed by Foucault are perhaps most famously embodied in the idea of the Panopticon, a prison model designed by the English social theorist Jeremy Bentham in the late eighteenth century (see Figure 2.1). The Panopticon model is also understood to have exerted an influence upon the penitentiary systems of many Latin American countries including Brazil (Salvatore and Aguirre, 1996: 9). Based on the principle of a central watchtower from which an invisible and unexposed figure of authority might constantly observe inmates in the surrounding cells, this model 'assures the automatic functioning of power' as the ever present threat of discipline stimulates a mechanism of self-surveillance and regulation (Low and Malacrida, 2008: 21). This system was not envisioned to be exclusively applicable to prisons and, as Foucault stresses, similar mechanisms are embedded within other institutions such as hospitals and schools, creating a widespread gradation of carceral elements throughout society (1991: 303). The heightened sense of self-consciousness that such systems provoke is, after all, a 'hallmark' of modern times (Low and Malacrida, 2008: 22).

It is important to recognise, of course, that although Foucault's theories provide an essential point of historical reference and elucidate many significant aspects of the relationship between punishment and order in the social body, they are ultimately rooted in a European frame of reference and as such cannot be expected to engage fully with the particular complexities of other social environments. As Salvatore and Aguirre observe in *The Birth of the Penitentiary in Latin America*, 'unlike European and North American reformers, who posited the penitentiary as the institutional foundation for a democratic society, reformers in Brazil saw in the penitentiary first a symbol of modernity and later an instrument of social differentiation' (1996: 24).

As a former colony, built on a booming slave economy, a complex legacy of brutally hierarchical racial and social relations is unavoidably woven into the historical fabric of Brazilian society. As observed in my introduction, anthropologist Roberto DaMatta has argued against the theory of 'Lusotropicalism' espoused by Gilberto Freyre, in which a particular type of racial harmony allegedly exists in Brazil as a consequence of miscegenation and

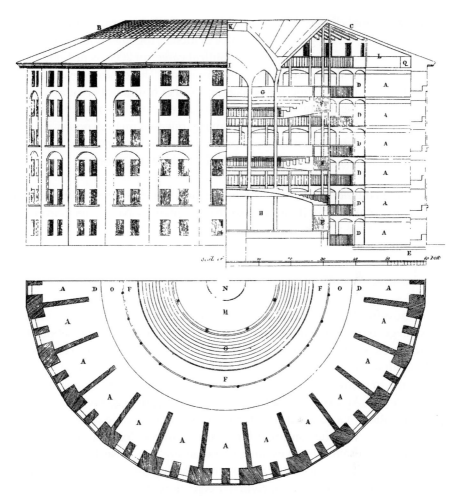

Figure 2.1. 'Panopticon' (1843, originally 1791), Jeremy Bentham. *The works of Jeremy Bentham* vol. IV, 172–3. Source: Wikimedia Commons

a softer Portuguese colonisation (in contrast to the harsher methods of domination exerted by the Spanish in other regions of Latin America). He draws attention instead to the clearly defined hierarchies already existing in Portugal where each social category had 'inclusive direitos de terem punição diferenciada para seus crimes' (DaMatta, 1987: 66). In Brazil, widespread corruption is acknowledged to exist across different social levels, including – worryingly – the nation's governing political and economic elite. This, coupled with low conviction rates for crimes amongst these groups, points to differential treatment in the prosecution of crime and the delivery of punishment, which takes on the appearance of colonial legacy. The impeachment of ex-President Fernando Collor de Mello in 1992 and his subsequent acquittal of

ordinary criminal charges (which would have resulted in imprisonment were he found guilty) on the grounds of lack of evidence, together with his election to the Senate and continuation of his political career in 2006, is just one clear demonstration of this relative impunity in action. The controversial case of Daniel Dantas, a well connected banker accused of fraud, bribery and money laundering amongst other charges, is a more recent high-profile example. Arrested several times in 2008, he was rapidly released on both occasions and after being convicted to ten years' imprisonment was subsequently acquitted in 2011 (R. Valente, 2011). As Teresa Caldeira poignantly observes:

> White-collar crime, mainly corruption and fraud, is frequently reported in newspapers, but it rarely leads to jail sentences. Newspaper coverage of this crime is often more expansive than reports from the police. This situation is an indication of the level of impunity existing in contemporary Brazilian society and the lack of accountability of the judiciary institutions. (2000: 111)

At its most fundamental level, the law and its penitentiaries may be understood as geared to containing certain sectors of society: 'concerns about the unrestrained or unwise use of political rights by groups that had been kept at the bottom of the social structure during the Empire underlined reformers' efforts to identify the problem of crime with lower-class/ethnic culture' (Salvatore and Aguirre, 1996: 24). Salvatore and Aguirre go on to argue that the segregation of a criminal class from 'decent' law-abiding citizens and the preoccupation with the control of the former group reflects earlier struggles to maintain and reinforce an existing social order: 'in a sense, the description of the criminal has replaced that of the slave, sharing his docility and his incapacity to learn or change his uncivilized behaviour. If the task of controlling the slave was mainly in the hands of the owner, now the task of controlling the criminal was given to the state' (1996: 118).

In *As prisões da miséria*, Loïc Wacquant highlights a generic shift underway during the last century from a welfare state – whose primary emphasis rested on providing for the collective wellbeing of its citizens – to a penal state, driven to reinforce the concept of individual responsibility through the punishment of errant citizens (2001: 44).[20] Wacquant stresses the influential role of the United States of America in its zero tolerance policing strategies, suggesting also that the aggressive policing and high emphasis on increasing

20 I refer to the Portuguese language edition of Wacquant's publication as his work is not only well known in Brazil but also includes analyses of Brazilian prisons and poverty-related issues.

public security (which he observes in both New York and in Brazil) operates as a mask for reinforcing old racial and social hierarchies (2001: 37). What can be in no doubt are the disputes and contrasting opinions that most often surround the way in which crime is dealt with by authorities and perceived by society as a whole. The differing philosophies and theoretical and methodological principles of incarceration have stimulated recurrent debates over the years since the early nineteenth century when the penitentiary as we understand it today first emerged. These may be broadly defined as: 'incapacitation' (the individual is prevented from committing further crimes for the period of incarceration), 'deterrence' (the prison system acts as a mechanism to discourage citizens from turning to crime in the first instance), 'retribution' (incarceration as a form of revenge) and 'reformation' (the use of the incarceration period to prepare prisoners for an honest life on release) (Morris and Rothman, 1995: ix–x).

It is significant here to draw attention to the shift in vocabulary that has occurred in the São Paulo prison system over the years: the early label of *casa de correção* (supporting the objective to reform) giving way to the *penitenciária* (embodying the Christian idea of penance and punishment for wrongdoing) and finally settling as *casa de detenção* (echoing a resigned emphasis upon the utilitarian function of the physical containment of criminals). These changes in designation signal a lack of clarity in the acknowledged purpose of the prison and the criminal justice system of which it is a tool, just as shifts in its administration by different governmental departments suggest the reluctance of any fully to assume responsibility for it.[21]

Should the prison's primary emphasis be on the reform or punishment of offenders? On protecting wider society from the threat of criminality, or controlling it through the spread of the disciplinary ethos? These contrasting discourses traverse prison space, creating a mesh of contradictory systems and forces that often come into conflict.

The Prison in Cultural Production

As spaces rarely accessed or experienced first hand by the felicitous majority of the population, it is fair to say that most of our impressions and ideas about prisons are fed by representations provided by the media, sociological studies and cultural production of a literary, photographic or filmic nature. The proliferation of literary and cinematic works set in the prison milieu is unmistakably pertinent in Brazil where, as Eduardo Escorel observes, 'o cárcere tem sido imagem comumente usada no cinema para representar a

21 For further detail consult Bisilliat (2003: 250–257).

dinâmica da sociedade brasileira' (2003: 196). The narratives of reporters and political prisoners that the Brazilian public had encountered in the early twentieth century meant that 'by the late 1920s, there was already a public avid for stories about prisons and prisoners, and, more important, readers had acquired some familiarity with and understanding of the strange land behind the prison walls' (Salvatore and Aguirre, 1996: 105). Attitudes towards incarceration were by no means constant; whereas nineteenth-century reformers painted a world in which the rehabilitation of the prisoner was distinctly possible, by the first decades of the following century the overriding narrative themes '(re)established only the belief about the existence of difference, that is, about subjects irredeemable for society, warped either by biological or social factors and destined to fill the prisons' (1996: 106).

Whilst earlier works such as Graciliano Ramos' biographical novel *Memórias do cárcere* (1965) dealt with the theme of political imprisonment during the dictatorial years – though first published posthumously in 1953, it details Ramos' experience in various Brazilian prisons between 1936 and 1937 and was later made into an eponymous film by Nelson Pereira dos Santos (1984) – more recent examples embrace a wide variety of perspectives centred around criminal life.[22] Perhaps one of the best known is the blockbuster fiction film *Carandiru* (2003, directed by Héctor Babenco), based on the biographical accounts of a prison doctor working to fight an AIDS epidemic in *Estação Carandiru* (Varella, 1999). Less high-profile and smaller budget documentary films to tackle related matters are *O cárcere e a rua* (2005, directed by Liliana Sulzbach) and *Leite e ferro* (2009, directed by Cláudia Priscila), the former exploring the transition process of female prisoners adapting to life upon release and the latter documenting the experience of incarcerated mothers bonding for a restricted period with their newborn children in a maternity prison wing. Continuing on the biographical front are novels by former inmates Luiz Alberto Mendes (*Memórias de um sobrevivente*, 2001) and Jocemir Prado or 'Jocenir' (*Diário de um detento*, 2001). More recently, an account by sociologist Julita Lemgruber of her experience as the first woman director of the Rio de Janeiro penitentiary system in *A dona das chaves* (2010) has attracted much attention. Documentation of a more artistic nature finds a voice in *O caldeirão do diabo* (2001), a black-and-white photographic series by André Cypriano depicting the Instituto Penal Cândido Mendes on Ilha

22 It was the contact between political prisoners and common criminals that occurred in the notorious Instituto Penal Cândido Mendes prison on Ilha Grande (destroyed in 1994), where Ramos was for a time detained, that allegedly inspired and equipped the latter group with the necessary knowledge to form factions and build the now established networks of organised crime such as the Comando Vermelho (Cypriano, 2012: 2).

Grande prior to its evacuation. The lived experience of being an inmate also finds numerous expressions in rap music. Prominent examples include Racionais MC's hit song 'Diário de um detento' (written by the author of the above book of the same name) and the group 509-E. The latter's members, Dexter and Afro-X, were both prisoners in the infamous (though now defunct) Casa de Detenção de São Paulo, or 'Carandiru' as it is popularly known, and the subjects of a documentary following their unique trajectory in *Entre a luz e a sombra* (on the Edge of Light and Shadow) (2009, directed by Luciana Burlamaqui). The examples highlighted above are but a select few and demonstrate the strength of an ongoing public interest in prison space, stimulated perhaps by heightened preoccupations surrounding violence and the threat of criminality on city streets.

The works that I focus on in this chapter each take distinct approaches to the subject and space in question, prompting in turn different questions and considerations relating to the ethics of its representation. Director Paulo Sacramento's *O prisioneiro da grade de ferro: auto-retratos* (2004) is located in the above-mentioned Carandiru penitentiary. Composed of footage taken by a professional film crew and by prisoners who participated in video workshops organised within the prison, it raises important issues regarding authorship and perspective in documentary filmmaking. A symbol of the failure of the Brazilian prison system and by extension a reflection of the gravity of many current social concerns, Carandiru becomes here the setting for an exploration of control, diversity and personal and collective meditation on the quotidian experience of incarceration. I move on to analyse the photographic series 'Imprisoned Spaces' by Pedro Lobo. Although the collection is comprised of photographs taken in Carandiru and across several prisons in Medellín, Colombia, for the purpose of this study my focus will be restricted to the former location. These images are centred on the personal space of the prison cell and, through their unusual aesthetic approach, invite reflection upon the experience of carceral time and space together with the existence of self-expression and creativity in what are oppressive and incapacitating circumstances. The chapter concludes with an analysis of the film *Juízo* (2007) by Maria Augusta Ramos. This ostensibly observational documentary follows the process of tribunal hearings and sentences passed on a series of juvenile offenders in which issues of representation necessarily take centre stage due to laws prohibiting the identification of minors. The prominence of performativity and substitution raises questions about authenticity as well as pointing to the ineffectual and inadequate nature of the youth justice system in Rio de Janeiro and Brazil at large.

My objective is neither to debate whether offenders deserve particular forms of punishment such as confinement nor to excuse those who have committed crimes. First and foremost, my aim is to examine new ways of

looking at a space that is frequently side-lined or excluded in any proactive manner from highly relevant and interlinked forums of discussion – such as access to education and employment opportunities – via a dehumanising gaze. Prisons remain overwhelmingly occupied by poorer members of society and have become in many instances notorious zones of neglect. Whilst some governing bodies operate periodic prison inspections, others fail to prioritise such safeguards, showing in some cases a flagrant disregard for human rights. With the Brazilian prison system stretched to house an alarming 165.7 percent of its official capacity (Walmsley, 2011), overpopulation and poor conditions suggest that such institutions are likely to remain in the spotlight of controversy for some time to come. Focusing on the dialogue between the chosen works and the discourses surrounding prison space referred to above, I question such works' negotiation of the transformative desire embedded in documentary's make-up as they engage with an environment that frequently provokes reactions of hopelessness and despair.

O prisioneiro da grade de ferro: auto-retratos

Drawing inspiration for its title from journalist Percival de Souza's 1983 book on Brazilian prison life – which included his experiences visiting Carandiru penitentiary (Armstrong, 2009: 103) – Sacramento's additional subtitle *auto-retratos* introduces the audience to one of the film's pivotal mechanisms and points of contention. The film quite clearly locates itself within what Bill Nichols describes as the 'participatory' mode of documentary and is largely interview-based, with occasional recourse to more observational techniques (2001: 116). Actively engaging with the experience of the filmmaking process it thus unavoidably raises questions surrounding the ethics and politics of the encounter between the professional film crew and the prisoners who volunteer to participate in the project. *O prisioneiro* is not only Sacramento's directorial debut in feature-length film but also his first documentary work, having previously acted primarily as a *montador* and producer in fiction film.[23] His relative inexperience in this area does not appear to hamper the film, however, which was a resounding success with screenings at approximately 47 festivals across Latin America, North America and Europe, winning around thirteen awards since its release onto the festival circuit in

23 Note that in Brazil a historical distinction exists between the terms 'editor' and 'montador'. The latter role is understood to embody the artistic and conceptual crafting of the film's final form and the former its technical realisation. In reality, with the accessible editing software available today, these terms have become almost interchangeable, although most professionals understandably prefer the label 'montador'.

2003. Its positive reception by academics and critics of cinema was likely due in no small part to the time and care dedicated to the preparation, research and implementation stages of the project. Sacramento first began working on the idea in its original form in 1996 and spent a total of seven months filming in Carandiru from the point at which the initial video workshops were held to train prisoners in basic recording techniques. Approximately fourteen months were then spent editing the 170 hours of footage down to the final cut of 123 minutes (Gardnier, 2004). Before embarking on a closer analysis of this dense and highly detailed piece, I shall first contextualise the discussion with a brief introduction to the particular historic location that is Carandiru.

Although it is possible to trace its carceral roots back to an old Casa de Correção, operating in São Paulo almost a century earlier, the first prison site in the Carandiru neighbourhood was inaugurated in 1920 under the name Penitenciária do Estado. However, owing to insufficient capacity to hold the growing number of prisoners, further buildings were constructed and the prison as it is recognisable today began functioning in 1956 under the new name of Casa de Detenção de São Paulo. With numerous rebellions occurring within its walls over the years, it gained particular infamy in 1992 when 111 inmates were killed during a military police invasion responding to such an uprising. This occasion became known as the *massacre do Carandiru* and led to the recommendation that it be deactivated.[24] Until its closure and partial destruction in 2002, Carandiru housed approximately 7000 prisoners at any one time (about double its official capacity), staking its claim as the largest prison in Latin America. Despite the demolition of buildings and the physical transformation of the space into its current form of *Parque da Juventude* – a cultural complex housing a library and recreational facilities – the former prison continues to occupy a vivid place in the national consciousness. A strong symbol of both state brutality and administrative inefficacy, it remains an explicit testament to failures both within and beyond the penitentiary system. The unique access gained by Sacramento and his team allows the film to explore less well-trodden terrain, however, as the prisoners themselves introduce us to 'um Carandiru mais cotidiano, menos exótico e menos violento do que conceberíamos' (Lins and Mesquita, 2008: 39).

Exercising Control

It is not uncommon for those who end up in prison to be identified with the 'waste' of society, discarded for being of no use to the social body or parasitic

24 All historical references given in this paragraph are obtained from a chronology of the prison compiled by Ribeiro and Massola and featured in Bisilliat (2003: 250–257).

and dangerous to its health and thus requiring isolation. Yet the notion that has accompanied the penitentiary more or less prominently during almost two hundred years of existence is its purpose to rehabilitate such people back into society as productive contributors with the successful adoption of mainstream social values.

The presence of religion, and particularly Christianity, in the film brings to the fore the idea of a possible redemption for prisoners and the ritual playing of the song 'Ave Maria' over the prison loudspeakers every evening is captured in numerous sequences. The notion of cleansing sins and finding a spiritual path to new beginnings is also conveyed in a rather obvious manner by the focus upon cleaning processes such as the *faxina*, which takes place in advance of visiting day. In a scene documenting this regimented occurrence, an inmate introduces the action with a proclamation to the camera: 'nós somos seres humanos, somos trabalhador'. These cleaning rituals are also both an assertion of control over one's immediate physical environment and a symbolic assertion of belonging to a wider set of 'civilised' values (Varella, 1999: 51). Salvatore and Aguirre observe: 'as Foucault has argued, the penitentiary created the delinquent as the subject of criminology, penology, psychology, and other sciences in opposition to a normality defined by the figure of the honest and obedient worker' (1996: 29). The inmate's declaration appears explicitly to address this contrastive relationship and might even be understood to be directed to an assumed public audience of middle-class citizens – invisible bodies on the other side of the screen and outside the concrete walls – much in the same vein as the declarations of honest labour from *catadores* in *Lixo extraordinário* (2010) or *Boca de lixo* (Coutinho, 1993). Such instances demonstrate an acute awareness of this social opposition and consequently of the redemptive potential contained in identification with the figure of the worker, as explored in chapter 1.

As highlighted near the beginning of this chapter, the concept of control is central to the exercise of imprisonment and the wider disciplinary model of society. Where bodies were once the principal targets of punishment in the form of the public spectacle of torture or execution, now dominion over the mind and the inflicting of psychological suffering is to bring order to unruly individuals and, by extension, to the social body as a whole. As the inmate Celso explains whilst preparing the morning coffee in his cell, despite all the material hardships 'fisicamente também a gente não tem tanto sofrimento né, tem o sofrimento maior mesmo é o sofrimento da solidão, do isolamento'. He goes on to say, 'uma coisa vai mudar na vida de quem passa por essa experiência. Não dá ser o mesmo, não dá'. That imprisonment is a transformative process there can be no doubt; that Celso, as his voice fades to barely above a whisper, is referring to the positive 'reformation' of the individual seems somewhat less plausible.

Figure 2.2. O prisioneiro da grade de ferro (2004), dir. by Paulo Sacramento. Olhos de Cão Filmworks. Original in colour

With the primary mechanism of control understood to be hyper-visibility and constant exposure to an authoritarian eye, such procedures are conveyed in no uncertain terms early in the film. During an induction to Carandiru for newly arrived prisoners we witness an official warning that they will be 'observados vinte e quatro horas por dia'. The footage itself appears to validate this claim as the camera rests its gaze on the men collectively and individually in turn, focusing on the backs of recently shaven heads, restless rows of legs or staring faces as it moves impassively about the room (Figure 2.2). However, as the film progresses, what comes into focus is the very deterioration of these methods of control. A sequence of clips juxtaposes discussions about prostitution among transvestites, the production of *maria-louca* (a rough homebrewed spirit), the distribution of marijuana and crack cocaine and the fabrication of *facas de cadeia* (large knife-like iron weapons) all occurring within the gaol. One prisoner even voices the fact that closer attention from the state would certainly expose these illegalities. But the sheer number of inmates makes their observation by the limited number of prison staff a near impossible task, leading to an inevitable breakdown of the rigid disciplinary model that the institution supposedly embodies.[25]

However, lest we forget who is ultimately in charge of these bodies, as the camera tracks inmates who seem to wander freely around the prison

25 In his memoirs, prison doctor Varella refers to ratios of approximately twelve guards to supervise a pavilion of more than 1500 prisoners, with the ratio being even more extreme during overnight duty: six or seven guards responsible for the same number of inmates (1999: 111).

pavilions, the hammering against a metal door that signals they must return to their cells and the click after click of padlocks closing around cell doors is a sharp reminder of where our documentarians are. Indeed, the numerous forms of physical activity that inmates are filmed performing – from football and boxing to *capoeira* and bodybuilding – may be interpreted as an attempt to re-assert a sense of control that at other times is thoroughly lost. As Sassatelli maintains in her analysis of fitness culture, 'the body is seen as the only area over which subjects think they can keep control in an uncontrollable world' (in Fraser and Greco, 2005: 286).

Just as effective as solid doors, however, are the immobilising bureaucratic systems that prisoners encounter during their stay. These powerful mechanisms resist change and hinder attempts at progress or recovery. One poignant example is an examination conducted by the Comissão Técnica de Classificação (CTC, Committee of Experts on Classification) to assess whether an inmate, William Guimarães de Souza, should be granted a transfer to a *semi-aberto* prison regime. With the camera situated behind the interviewer conducting the exam, we peer over his shoulder at the prisoner's uncertain and somewhat bemused face as numerous questions are fired at him: 'tinha muito pesadelo?', 'já fez algum tratamento psiquiátrico, neurológico ou psicológico?', 'você já teve alguma experiência fora do normal?', in addition to questions about previous education, employment and involvement in criminal activities. After the first couple of simple 'no's' the remaining responses are edited out of the scene, suggesting their insignificance. The result is more or less predetermined, as supported by the subsequent letter of denial (detailing ostensibly worrying characteristics such as egocentrism and mental immaturity) and the revelation that only about three in every two hundred applications are successful.

In more dramatic terms still, a sequence shot in Carandiru's hospital wing shows an indisputable lack of medical care and brutal neglect. Images of queues of ailing prisoners waiting to be seen by a single doctor mirror the queues of relatives filmed at the entrance of the prison on visiting day. Such echoes hint at an institution that simply imitates and amplifies relations already formulated outside its confines (Figures 2.3 and 2.4). After all, if the state does not provide adequate healthcare for the working classes at liberty, why should we expect it to do so within a prison?

> Nowadays, all waiting, any procrastination, all delays turn into a stigma of inferiority. The drama of power hierarchy is daily restaged [...] in innumerable entrance lobbies and waiting rooms, where some (inferior) people are asked 'to take a seat' and kept waiting until some other (superior) people are 'free to see them now'. The badge of privilege (arguably,

Figure 2.3. O prisioneiro da grade de ferro (2004), dir. by Paulo Sacramento. Olhos de Cão Filmworks. Original in colour

Figure 2.4. O prisioneiro da grade de ferro (2004), dir. by Paulo Sacramento. Olhos de Cão Filmworks. Original in colour

one of the most potent stratifying factors) is the access to shortcuts, to the means of making the gratification instantaneous. (Bauman, 2004: 104)

Needless to say, prisoners are highly accustomed to waiting. In a system that gives little room for practical measures for reform, it in fact constitutes the very nature of their punishment. The implications of this power game are, as suggested in the above quotation, a lasting impact upon an individual's sense of value in a social scheme.

It is revealing to consider the role of photography and its relation to control in the film, which often plays out in intriguing ways. Photography's employment in the service of disciplinary forces of 'surveillance, identification, classification, labelling, analysis and correction' is, after all, longstanding (Wells, 2000: 221). Shortly following the opening sequence, and prefaced with the intertitle 'documentário', we are shown a series of black-and-white identification photographs of the fourteen principal characters whose footage appears in the film. White numbers on black plaques indicate the entry date, identification number and penal article violated by each individual and the images are supplemented with their voiceovers stating the same information with the addition of a full name (Figure 2.5). As Arjun Appadurai notes of classificatory methods, 'number, by its nature, flattens idiosyncrasies and creates boundaries around these homogenous bodies as it performatively limits their extent' (1996: 133). In addition to facilitating disciplinary mechanisms used to track and monitor, numbers emphatically depersonalise the prisoners. Nonetheless, this is not the only dimension in which photography appears during the film. The video camera accompanies the prison photographer (himself an inmate making a living from this activity) on visiting day and is positioned at his side to register its own 'photo-portraits' of the prisoners, which last several seconds, as they pose for snapshots with family members (Figure 2.6). Similar 'portraits' are featured at various points throughout the film and this overflowing of conventional borders with duration resists the photographic act of fixing people and moments. The fact that the men remain motionless alludes not only to photography but hints also at the experience of imprisonment as immobility in time, or time lost.

Inside Out/Outside In: Perspective and Connectivity

One prominent debate in Brazilian documentary circles during the last decade centres on the capacity of films to create perspectives formed either *de dentro* or *de fora* and the supposed authenticity of the former viewpoint. As Escorel points out, this is hardly a new phenomenon and the search to produce 'bottom-up' authentic portrayals, particularly of subjects of popular origin (with most filmmakers historically from middle-class backgrounds), has been underway since the 1960s (Escorel, 2010). One example of such endeavours that is often cited for its success is the above-mentioned Vídeo nas Aldeias project (www.videonasaldeias.org.br), which from the late 1980s onwards has been instructing members of Brazil's indigenous communities in the art of video making, in order for them to preserve and strengthen their particular identities and ways of life and to communicate them to other such communities and to non-Indians alike. Whilst *O prisioneiro* clearly enters this territory of self-representation with its *auto-retratos*, it does so in

Figure 2.5. O prisioneiro da grade de ferro (2004), dir. by Paulo Sacramento. Olhos de Cão Filmworks

Figure 2.6. O prisioneiro da grade de ferro (2004), dir. by Paulo Sacramento. Olhos de Cão Filmworks. Original in colour

a rather complex manner. Although some footage is taken by prisoners and other material by Sacramento's professional crew, both appear interwoven indiscriminately during the film. There is no attempt to separate or distil an 'insider's perspective', using intertitles to identify the prisoners' work, for instance; these labelling devices are reserved for other purposes such as introducing viewers to individual characters, spaces and themes. The result is an intermingling of perspectives with this mixed authorship acknowledged

only in the end credits, although filming procedures are clearly revealed throughout in the inclusion of footage of prisoners filming and receiving instruction in camera operation.

The decision to compose the film in this manner has attracted very diverse reactions from critics. These range from the appraisal of its overlapping viewpoints as a valued privileging of 'experiência compartilhada' (Lins and Mesquita, 2008: 40), to the opinion that a lack of clear distinction and failure to properly elaborate the methodology of collaboration within the film constitutes an ethical and aesthetic shortcoming (F. P. Ramos, 2008: 245). Conversely, other critics point precisely to this lack of definition as a sign of Sacramento's commitment to questioning his own directorial authorship, allowing the final product to emerge as a unified but multifaceted whole (E. Valente, 2003). The fact that Sacramento also acted as editor might be seen as an attempt to regain control relinquished during the process of filming. However, as Migliorin asserts in a video recorded debate discussing *O prisioneiro* and other documentaries of the last decade entitled 'Obra em processo ou processo como obra?', 'quando a gente está falando dessa idéia de obra-processo o desafio da montagem é a manutenção da exterioridade' (Migliorin and Mesquita, 2011). That Sacramento does not attempt to convince us of a perspective formulated singularly *de dentro para fora* is apparent in the tension between 'inside' and 'outside' that occurs not only at the level of authorship, but pervades the spatial dynamic of the entire film.

The beautiful and ominous opening sequence portrays the implosion of the prison buildings in reverse motion – eerily reconstructing pavilions from different angles and degrees of proximity, it implies that physical destruction has erased neither the memories nor problems associated with Carandiru. With the professional crew free to film from outside the prison complex, the continuously shifting vantage points of the camera draw attention to varying degrees of interiority and exteriority. At times we see the entire prison from outside its walls; at other times we observe the city of São Paulo through metal bars, beyond the crouched silhouette of a prisoner; we rest our eyes on individual cell windows or whole façades from exterior pavilion courtyards below; or we peer into closed cells through small hatch openings as its occupants gaze back silently at the camera positioned in the corridor.

One sequence that highlights this tension particularly effectively begins amidst running football players as the handheld camera accompanies a prison game. On nearing the pavilion we see a spectator in his cell above and the filmmaker responds to his request to 'traz a câmera aqui'. Cutting to the interior of the cell the camera attempts to continue following the action below, but is frustrated by the window bars and the cell's restricted field of vision as players move to the far end of the pitch (see Figures 2.7 and 2.8). This abrupt shift from an outdoor, mobile, ground-level perspective to one that is

Figure 2.7. O prisioneiro da grade de ferro (2004), dir. by Paulo Sacramento. Olhos de Cão Filmworks

interior, static and aerial, emphasises the sharp spatial contrasts and degrees of confinement that exist within this environment. Some prisoners are evidently acutely aware of the relationship between space, vision and perspective, as we witness on one occasion when characters Joel and Marcos hold the camera outside the window bars and turn it back upon their own faces, stating that they are 'gravando de fora para dentro'. They also demonstrate techniques using mirrors to extend their otherwise inhibited vision to areas to the left and right of the cell window, stretching the physical limitations that are imposed upon them (Figures 2.9 and 2.10).

Although we do witness the inmates' creative negotiation of limits as above, the documentary successfully conveys the restrictive and controlling nature of the environment. The moment when one prisoner hands a camera through the bars to another who is locked in the *celas de seguro* within Pavilhão Cinco registers a further shift in viewpoint. This isolated section is a last resort for prisoners whose lives are threatened by others. Described as 'o inferno dentro da cidade grande', its severe overcrowding and degraded conditions make the rest of the prison appear spacious and comfortable in comparison. At the opposite end of the spectrum, the film shows the process of temporary release or *saidinha* for a prisoner nicknamed Pernambuco. As we accompany his anxious wait inside the outermost door of the prison, suddenly a space so close to the outside world seems agonisingly far away, as the bureaucratic signing and stamping of papers delays the exit process and the reunion with loved ones. His return to Carandiru some days later (essential proof of good conduct and responsibility) is similarly emotionally

Figure 2.8. O prisioneiro da grade de ferro (2004), dir. by Paulo Sacramento. Olhos de Cão
Filmworks. Original in colour

Figure 2.9. O prisioneiro da grade de ferro (2004), dir. by Paulo Sacramento. Olhos de Cão
Filmworks. Original in colour

charged, as Pernambuco tells the camera of the harsh truth of being an
inmate: 'você sabe que nesse lugar você não vale nada'.

Despite the physical segregation that prison imposes, many inmates
remain connected with those outside – as demonstrated in a sequence show-
ing messages of love and affection written on the envelopes of received
letters. The embraces and handholding of visiting day likewise reinforce the
presence of such ties and show that many of these people have not been
'discarded' but instead remain part of a network of relatives, friends and

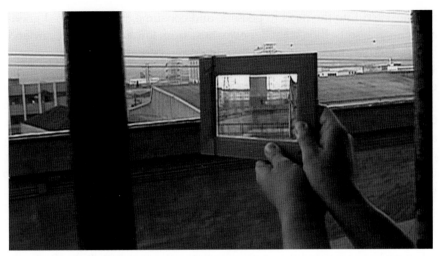

Figure 2.10. O prisioneiro da grade de ferro (2004), dir. by Paulo Sacramento. Olhos de Cão
Filmworks. Original in colour

partners who value them highly: 'worthlessness' too is, of course, a matter
of perspective. Those not lucky enough to be granted a *saidinha* use other
methods to transport themselves metaphorically beyond their cells. Desire
and memory are strong tools providing temporary escape for an artist who
describes his principal interest as depicting 'momentos onde eu queria estar'
and for another inmate who allows the viewer a tour of his photographic
collection as he recounts memories of happier times spent at liberty.

Of course, most viewers are many steps further removed and exterior to
the scenes that we witness here. The intertitle 'inclusão' preceding the induc-
tion meeting can serve as a reminder of our own position. So common is it to
hear about criminality in terms of exclusion that the fact that imprisonment
is simultaneously an act of inclusion – of incorporation into an imprisoned
community – is sometimes overlooked. Likewise, the idea that many of these
people will have experienced varying levels of social and economic exclusion
prior to their conviction is emphasised in a reflective scene entitled 'A noite
de um detento'. With the intention to 'mostrar a nossa visão que a gente tem
aqui da cela' the prisoners film and comment on the nocturnal urban scene
witnessed from their windows. The lit metro train that pulls past is a painful
reminder of mobility and lost freedom, and the high-rise buildings and glow
of the bustling Avenida Paulista reinforce the prison's location *within* the city.
The camera rests its gaze on the tall spire of the Banespa bank building: 'o
símbolo do capitalismo', and then on the dazzling lights of a shopping cen-
tre: 'coisa de rico. A gente não tem acesso a isso não'. If fulfilment in the late
capitalist era is measured by access to material wealth and 'individual needs
of personal autonomy, self-definition, authentic life or personal perfection are

all translated into the need to possess, and consume, market-offered goods' as Bauman asserts, then what hope do those from low economic backgrounds have either within or without the walls of the prison (1987: 189)? Foucault states that 'it is not crime that alienates an individual from society, but that crime is itself due rather to the fact that one is in society as an alien, that one belongs to that "bastardized race"' (1991: 275). Many of those living in Carandiru will have been punished for trying to access an exclusive domain, attempting – however illegitimate their means – to shift away from the margins to more central economic positions. Without attempting to excuse crime, *O prisioneiro* thus draws attention to its complex and intimate relationship with poverty.

Inverting Myths

If history has associated the prisoner with the slave and attributed both with the values of laziness, ignorance and animal-like qualities, Sacramento's film sharply undercuts such negative associations. Instead, what we do find are many examples of diligence, ingenuity and creativity in the exercise of occupations and artistic enterprise (in many cases the manner in which prisoners finance and improve their living conditions in gaol). The deft weaving motion of a man fabricating tasselled kite tails in a production line is so fast that it appears artificially speeded up; a large and intricately detailed model Portuguese galleon and the homemade tool of a tattoo artist compiled from miscellaneous objects bear testimony to skill, intelligence and resourcefulness.

Moments of shared joy and pleasure are also captured on several occasions and mark a counterpoint to categorical understandings of such environments that look no further than examples of misery and squalor (which of course are easily found). Numerous scenes depict inmates' rap performances to enraptured audiences, accentuating the cohesive effect of a musical form that successfully unites and identifies life experiences and aesthetic appreciation. The ecstatic reaction of a player as he scores the winning goal for his team in the prison football tournament is likewise a reminder that life within reflects some tendencies lived at large. Examples of informal commerce such as small clothes stalls or betting lists for professional football matches and an introduction to the prison's unit of currency – one packet of cigarettes to one real – paint Carandiru as a microcosm of a portion of wider society rather than an alien nation.

If prisons exist, nominally at least, to serve the forces of justice there is no shortage of opinion countering or at least questioning this notion. The existence of prisoners that have been detained pre-trial and others whose official release date has already passed to no avail, amplify the vision of the prison as the home also of grave injustices. Nothing here, it seems, is

clear-cut or easily resolved. One inmate addresses the camera describing the widespread anger provoked by the slowness of the justice system and flatly affirms that Carandiru 'não reeduca', making the assertions of re-education proclaimed during induction ring hollow and false. In fact, 'a general consensus prevailed among administrators about the inability of existing prisons to reform delinquents' as early as the late 1800s (Salvatore and Aguirre, 1996: 9). If there should be any doubt as to the flailing status of the disciplinary model here, that a pastor (inmate) should openly credit the criminal gang Primeiro Comando da Capital (PCC) with bringing order to the prison and curtailing corrupt practices such as extortion brings this into stark relief. It is important to note, lest we believe we are falling prey to a one-sided argument, that it is not prisoners alone who hold these negative views. This is clearly underlined in a penultimate sequence comprising interviews with ex-prison directors.

The myth that incarceration could possibly be an effective solution for the problems of criminal behaviour and poverty in society is eroded throughout the film and finally completely destroyed. We meet former *pavilhão* directors and ex-secretaries of state during different periods of Carandiru's history in a sequence that works backward from the most recent to earlier occupations of the position, mirroring the inverted sequence at *O prisioneiro*'s opening. The decision to include this footage and its location at the end of the film is crucial, as Sacramento might easily have opted to exclude the voice of authority represented by these administrative figures. The effect of viewing the directors' opinions *after* having witnessed the vision created in the cameras' wanderings throughout the prison – as opposed to their voices being either removed entirely or positioned at the opening of the film as a prelude to the exploration of carceral space – is to relegate them to the position of incidental figures, points of articulation in a clearly disintegrating, if not defunct, system. Just as Carandiru's inmates are not typesets of criminal monstrosity, neither are its gaolers malicious despots. Carandiru is referred to as a 'depósito de presos' and the functionality of the prison system is described as a Utopian dream that only masks the fundamental problem – grave injustices within Brazilian society. Their statements are poignant, at times poetic and ultimately devastating when we consider the impact that this ineffectual system has had on the lives of so many inside and outside its immediate clutches (during its existence it is estimated that more than 175,000 prisoners passed through Carandiru alone).

Wacquant's observation that '*o desinvestimento social acarreta e necessita do superinvestimento carcerário*' (2001: 139, his emphasis) is nowhere more apparent than in a jarring scene documenting the state governor's inauguration of a new prison. His celebration of his party's achievement in increasing prison capacity in São Paulo (creating 25,666 places in only six-and-a-half years) seems to counter all that past experience would deem a worthwhile investment of time or money, representing a regression rather than any sense

of progression. Although his attitude constitutes a grotesque dehumanisation of the situation of imprisonment that we have been following throughout the film, it is nonetheless a reminder of the fact that we are witnessing the products of systemic relations.

The final sequence takes us back to the black-and-white photographs featured near the opening. Recognisably the same images, they have nonetheless been cropped and in place of the black identification boards of convicts are subtitles featuring their nicknames. The first step in successfully combating the tendency to think about criminals in terms of dehumanising numbers is to allow space for individual expression, a process that *O prisioneiro* has executed with remarkable results.

'Imprisoned Spaces'

If *O prisioneiro da grade de ferro* is a bubbling cauldron from which multiple voices and characters burst forth to tell their individual stories, 'Imprisoned Spaces' depicts a prison space unsettlingly emptied of human presence. The cells that Pedro Lobo photographs are devoid of the bodies that they were designed to enclose. Is this perchance the prison as we should wish it to be: unpopulated and finally superfluous? It was during his project 'Arquitetura de sobrevivência', in which he photographed popular architecture in a number of Rio de Janeiro's *favelas*, that Lobo was invited to participate in an initiative to document Carandiru prior to its imminent destruction at the end of 2002 (as witnessed in the opening sequence of *O prisioneiro*). The book that resulted from this enterprise, *Aqui dentro: páginas de uma memória: Carandiru* (Bisilliat, 2003), compiles numerous testimonies from its inmates, their relatives, prison guards, prison directors, and authors, together with photographs by Lobo and several other photographers. The topics covered include the *faxina* or cleaning routines, religion, education, illegality, isolation and sport, amongst more general commentaries and reflections upon the nature of imprisonment and the carceral system in Brazil. Many of the 'characters' we encounter in these pages will be familiar to those who have seen *O prisioneiro* and the recurring presence of numerous people, references and terminology reinforces the understanding that we are not dealing here with prison space in the abstract – with its principles and mechanisms of depersonalisation and homogenisation – but with a heterogeneous community involuntarily bound together by a shared experience. Even the different prison buildings or *pavilhões* have their own unique and notorious personalities: certain attributes that have, over years of practice and folklore, crystallised into commonly accepted facts. Held at a distance from the social body, hugely overpopulated and neglected, Carandiru had developed its own idiosyncratic and extremely complex social environment.

The eagerness of numerous prisoners to participate in cultural projects like those discussed in this chapter indicates not only a desire for personal expression and the assertion of individual presence, but also points to the significance of collective memory for a group of people who often consider themselves abandoned and forgotten by society. The act of commemorating Carandiru's history, of documenting the stories of people whose lives have been affected by their passage through and within its walls, is of course itself a response to the highly symbolic act of its destruction. The effort of the authorities to suppress through its erasure what the place had come to embody – chaotic and uncontrollable criminality, violence and necessity – is yet another expression of an ongoing incapacity to resolve the sharp conflicts of interests brought about by extreme economic and social differences. That Lobo chooses to focus upon the prisoners' cells almost exclusively in the absence of their usual occupants allows the images to participate in an existing narrative framework as documents of a particular historic moment: Carandiru in a state of transformation as its previously overcrowded buildings are gradually emptied of their residents and it lies on the brink of a final evacuation. However, most of these cells appear to be occupied still and closer analysis reveals that Lobo's decision to approach the space in this manner engages with many other complex issues, not solely those linked to the closure of the prison.

As with 'Arquitetura de sobrevivência', his focus is not directly upon the people who find themselves in these 'marginalised' conditions, but upon the structures in which they live. Given his extensive work photographing buildings, monuments and world heritage sites throughout Brazil for the National Centre for Cultural Reference (CNRC) and the Monuments and Sites National Institute (IPHAN), it is not surprising that architecture should remain a primary interest for Lobo. That prisoners refer to their cells as *barracos* intrinsically links them to the *favelas* where the term, literally denoting 'huts' or 'shacks', is regularly used to refer to people's housing, as Lobo himself notes. Likewise, Jocemir Prado – an ex-prisoner of Carandiru and author of the book *Diário de um detento* (2001) and the hit song of the same name – observes: 'a verdade é que não tem rico na cadeia, só tem pobre e miserável, tanto é que a própria gramática usada dentro das cadeias é justamente a gramática das periferias e das favelas' (Bisilliat, 2003: 244). Language, terminology and the sometimes rustic or rural decor of the cells reinforce the connection between these spaces, betraying not only the *favelas* as the origin of the vast majority of the prison population, but alluding also to the rural roots of many *favelas* – with large numbers of residents being migrants (or descendants of migrants) from the impoverished north east of Brazil and from the country's other rural areas.

It is clear that Lobo does not photograph these spaces to capture misery or squalor, revealing instead his intention to treat them in the same way as he would a monument or the houses of the wealthy that he has undertaken to photograph in other assignments.[26] The effect of this democratising tendency – overriding the conventions that would presume certain spaces (un)worthy of a particular aesthetic approach – is to register dignity rather than to exploit suffering, stressing common human elements rather than alienation in the state of imprisonment. The idea that beauty should not be limited to the subjects and spaces of the wealthy, to works of fine art and chic fashion advertisements, has found many prestigious defendants – including Salgado whose work we mentioned in the introduction and the photojournalist and human rights defender, João Roberto Ripper. The influence of the latter figure has also made this ethos central to many photographers who have participated in the Imagens do Povo collective and whose work I will be exploring in chapter 4. The fact that we are not able immediately to identify the environment featured in 'Imprisoned Spaces' – the images might appear in the first instance to be low-income home interiors and only one image shows metal bars – demonstrates that the photographs do not fit within common perceptions of carceral space. In this way Lobo has succeeded, it might be said, in warding off the rapid judgements that we often make when presented with familiar scenarios. His photographs instead exude warm or meditative colours and light: they are not only documents but also objects of aesthetic value, pleasing to the eye though no less disturbing upon reflection because of this fact. This unusual approach to the subject matter creates a disjuncture that foils expectations at the level of immediate interpretation: rather than a dehumanised and institutional atmosphere the images conjure spaces that are intimate and personal, effectively engaging the viewer on both an emotive and intellectual level.

It is possible to discern four prominent themes or spatial types represented in the series. First, the doorway: a delimitation or boundary between the 'public' transitory space of the corridor and the static 'private' space of the cell. Second, the 'living room': a semi-public or communal space constituting the central body of the cell and kitchen area. Third, the 'bedroom': the private and reflective space of the bed where personal possessions and decor are most intimate and apparent, each often partitioned with curtains. Lastly, the space devoted to imagery and art: the paintings on cell doors and walls that transform otherwise uniform environments, often replicating familiar icons from cartoon characters to religious or political figures, or creating zones of fantasy and escape in the form of landscape paintings or erotic posters. Although

26 Conversation with the artist, 24 April 2012, via Skype.

Figure 2.11.　Carandiru cell, 'Imprisoned Spaces' series (2004), © Pedro Lobo, courtesy of the artist. Original in colour

each image may prioritise one of these aspects, in reality the cell is a single room in which all of these spaces mingle with no absolute or clear-cut boundaries. These groupings, nonetheless, provide pertinent insight into several key issues raised by the photographs.

Access, Territory and Control

The photographs of doorways reveal to differing extent the space inside the cells. Whether the camera gazes directly in or is positioned at an angle to an open doorway, the glimpse that we have inside the cell is always emphatically partial (see Figures 2.11 and 2.12). These images place the photographer and viewer outside the cell, quite fittingly in the position of a transient and external or foreign observer. The fact that the images deny full visual access, hiding more than they disclose, not only acts as a statement about the nature of the medium itself, but also raises questions about the physical access given to the photographer. Did some prisoners perhaps object to the intrusion of a camera into the interior of their cell? This highlights in turn questions surrounding control and territory, both crucial in theory and in practice to the incarceration model. As a quotation from a prisoner in *Estação Carandiru* emphasises, a cell here is considered to be a sacred space, 'sem o proprietário estar lá, você

Figure 2.12. Carandiru cell, 'Imprisoned Spaces' series (2004), © Pedro Lobo, courtesy of the artist. Original in colour

não entra' (Varella, 1999: 43). The prisoners had developed their own rigid internal code of discipline quite apart from any official sanctions, and trespassing in another's cell uninvited or borrowing their belongings would be likely to incur severe repercussions.

These photographs also document the fact that in Carandiru, prisoners' doors remained open during a large part of the day and prisoners were therefore free to wander about their *pavilhão* and its courtyard. This regime explicitly contrasts with the dominant European prison model that prescribes confinement and tight control over the bodies within its walls and under its surveillance. Indeed, it is exactly the uncontrollability of the space and its inhabitants that placed Carandiru in the limelight on numerous occasions – another example being the rebellions that erupted across 29 prisons in the state of São Paulo in February 2001. These were reportedly coordinated via mobile phones by members of a criminal gang (the above-mentioned PCC) who were inmates at the time and therefore supposedly unable to access such communications devices (Folha Online, 2006). Instead of being diminished through dispossession, property and territory appear to take on a heightened significance in the prison environment. The doorways featured in Lobo's work consequently refer not only to the mechanism of confinement

but also to the control that prisoners exercise over their personal space. Signs painted with the words 'com visita' hang on each door, reminding us of the right, gradually conceded to prisoners in Brazil from the late 1980s, to receive intimate conjugal visits on a monthly basis (Bisilliat, 2003: 18). This is another aspect in which the prison differs from regimes in the USA or the UK for instance, where no such allowances are made.

Visible Absence/Invisible Presence

Although these images of Carandiru were taken over a period of only four days prior to the prison's final evacuation and destruction, they bear no traces of such hurried time constraints. The deliberate and considered air captured in the photographs is no doubt partly a result of the mode of representation chosen – Lobo uses a four-by-five-inch, large-format camera.[27] In pictures of the 'living' and 'bedroom' space the camera is most often positioned inside the cell door, facing towards the window (see Figures 2.13 to 2.16). This removes the reference points of the metal door and window bars (photographing directly towards the light that filters in from outside obscures the bars if they are not already veiled by curtains) which would otherwise serve as visual signifiers or 'framing devices' that would immediately locate us within a prison. It is in these images that the prisoners are most conspicuously absent. However, the fine amount of detail permitted by the large format allows the camera to portray their possessions and the decor of the cells as intimate traces and details of their existence. Thus, despite an apparent absence, both photographer and prisoner are in fact registered in the images in different ways. Donna Haraway concisely underlines the acute play that occurs between power and visibility: 'to be the object of vision, rather than the "modest", self-invisible source of vision, is to be evacuated of agency' (1997: 32). Here the prisoners are neither the direct object nor the straight subject of the photographer's vision. Likewise, the format of the images – the large, bulky camera and the tripod that is required to photograph – testifies not to an absence but to the physical presence of the photographer on the scene. With an exposure time of between one and four seconds, Lobo operates at the opposite end of the spectrum from Cartier-Bresson's decisively snatched moment.[28]

There is a sense also of the fragility of these personal spaces – as a caption states, prisoners are allowed to take with them only clothes and any authorised televisions or radios. All the decor and additional furnishings,

27 Conversation with the artist, 24 April 2012, via Skype.
28 Conversation with the artist, 24 April 2012, via Skype.

Figure 2.13. Carandiru cell, 'Imprisoned Spaces' series (2004), © Pedro Lobo, courtesy of the artist. Original in colour

expressions of individuality thoughtfully constructed and carefully main-tained (as we see in the laborious colour coordination, order and cleanliness and the numerous cabinets and framed pictures in Figures 2.15 and 2.16 respectively), will be lost or destroyed upon transferral. Of course, the fact that they existed in the first place shows to what extent some prisoners had invested in and committed to these personal spaces, acknowledging the length of their stay within Carandiru.

Although one imagines the cells might be dim or poorly lit, in fact lumi-nosity radiates clearly from within (in reality the daylight filtering in from outside). Rays of light historically possess a strong symbolic resonance in works of art, often suggestive of purity, spirituality and hope. Light is, of course, also an expression of time and it is the contemplative glowing texture that contributes to the painterly quality of these images. That Lobo trained originally in fine art before dedicating himself to photography will come as little surprise to viewers. A rustic domestic scene capturing a stove from a low angle near the entrance of the cell (Figure 2.17) is reminiscent in its luminous intensity of Vermeer's seventeenth-century painting *The Milkmaid* (Figure 2.18). The static and painterly quality of Lobo's photographs also

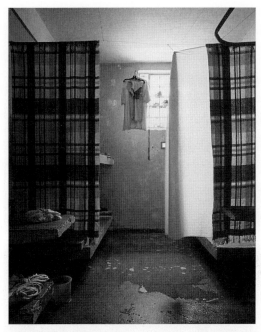

Figure 2.14. Carandiru cell, 'Imprisoned Spaces' series (2004), © Pedro Lobo, courtesy of the artist. Original in colour

suggests that time here flows at a different rate from that outside the prison walls. In one respect an awareness of the passing of time might be heightened by the precise markers of routine; in another sense, this cyclical repetition serves to erase difference and with it the very meaning of time. If the days merge with the unbearable slow ticking of a watched clock, it is only a fixed point – the point of release – that matters and any time in-between is in a sense 'non-time', wasted or under the control of others. Joan Fontcuberta, contemplating the nature of photography, observes that 'la fotografía […] inmoviliza nuestra imagen para siempre […]. Una inmovilización y un aprisionamento que nos acercará ineluctablemente a la idea de la muerte' (2007: 30). The title that Lobo attributes to his series is thus doubly pertinent. The spaces that we see are imprisoned not only in the sense of being restricted from the outside world, but are also locked in time by the photographic act itself: memories of a space that no longer exists, and that many would wish to forget.

Lobo refers to the influence of German photographer Candida Höfer on his work.[29] Likewise an avid admirer of architecture, Höfer directs her attention

29 Conversation with the artist, 24 April 2012, via Skype.

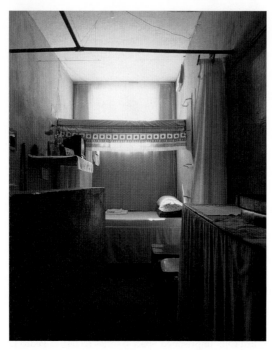

Figure 2.15. Carandiru cell, 'Imprisoned Spaces' series (2004), © Pedro Lobo, courtesy of the artist. Original in colour

to grand public spaces such as theatres, libraries, hotel lobbies and museums and was a student of photographers Bernd and Hilla Becher in the 1970s. This influence elucidates another interesting aspect of Lobo's work: its relationship to the concept of cataloguing. The Bechers were best known for their photographic series or typologies of industrial structures such as *Water Towers* (1988) or *Blast Furnaces* (1990). The idea of cataloguing and classifying is closely tied to the development of prisons in Latin America, to the sciences of 'criminology' and 'penology' and to the positivist strains of thought prevalent in Brazil at the turn of the nineteenth century (Salvatore and Aguirre, 1996: 5). Indeed, Salvatore and Aguirre suggest that one way to interpret the history of the penitentiary is to see it as being 'located at the intersection of modern ways of looking, classifying, isolating, and understanding the poor, the working class, the colonial subject, or the subordinate' (1996: 3).

It is interesting also to compare Lobo's photograph of the living area of a simple cell, featuring a landscape mural, guitar, several wooden benches and the bare surface of a table (Figure 2.19), with a famous image by Walker Evans, who was charged with capturing scenes of rural poverty by the Farm Security Administration (FSA) during the USA's Great Depression of the 1930s (Figure 2.20). Both exude the impression of a carefully

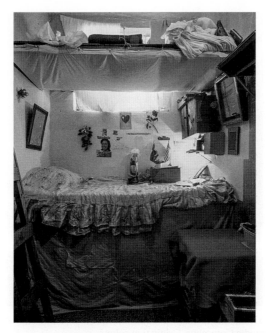

Figure 2.16. Carandiru cell, 'Imprisoned Spaces' series (2004), © Pedro Lobo, courtesy of the artist. Original in colour

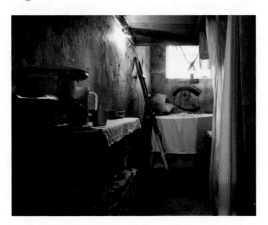

Figure 2.17. Carandiru cell, 'Imprisoned Spaces' series (2004), © Pedro Lobo, courtesy of the artist

crafted *mise-en-scène*, though Lobo's setting at least has undergone no such interference.[30] Although at first glance Lobo's photographs might appear to perform a cataloguing function, further reflection suggests that in practice

30 Conversation with the artist, 24 April 2012, via Skype.

Figure 2.18. The Milkmaid (c. 1660) Johannes Vermeer. Rijksmuseum Amsterdam. Source: Wikimedia Commons. Original in colour

they lie closer to the notion of an 'anti-catalogue'. Whereas catalogues are designed for comparing large numbers of similar items and necessitate a relatively small size of reproduction to facilitate this exercise, Lobo's exhibition prints for this series are defiantly large (approximately 120 cm × 150 cm).[31] Whilst the catalogue is driven by a desire to classify and a pleasure in containment and order, these images resist such narrowing actions, instead asserting in their sheer physicality the values of difference and individuality where official lines of discourse are least apt to find them.

Likewise, in the discussion that often erupts around art versus documentary photography or photojournalism, Lobo's work deftly eludes categorisation. Situating itself in an interstitial space that makes no issue of such matters, his work instead looks to ruffle the feathers of individual response and responsibility. If we do not look at certain spaces and problems in their diversity, can we expect to address them in a meaningful way? Showing the cells in an aesthetically pleasing manner and choosing to distance the series from more common representations of dire and degrading conditions might be an alternative bait or 'lure' in stimulating both intellectual and emotional engagement. If creating a degree of recognition for viewers, rather than estrangement, encourages the acknowledgement of prisoners as

31 Conversation with the artist, 24 April 2012, via Skype.

Figure 2.19. Carandiru cell, 'Imprisoned Spaces' series (2004), © Pedro Lobo, courtesy of the artist. Original in colour

Figure 2.20. Washstand with View Into Dining Area of Burroughs Home, Hale County, Alabama (1936). Metropolitan Museum of Art, Walker Evans Archive, 1994 (1994.258.393), © Walker Evans Archive, The Metropolitan Museum of Art

humans rather than statistics, it can only be a positive quality. The glare of television sets, light infiltrating through cell windows and signs waiting to be turned over on the arrival of an intimate visitor show a world not completely severed from its external counterpart. After all, just as concrete walls can imprison a person, so circumstances and lack of opportunity can perform a similar role, a sensation with which many prisoners may have already been familiar prior to their incarceration.

Juízo

Whilst *O prisioneiro* and 'Imprisoned Spaces' document prisoners and environments at one extreme of the criminal justice system, *Juízo* takes for its subject adolescent minors caught up in their first or an early encounter with the law. This does not prohibit it from being the most desolate of the three works, as no other embodies quite so pervasively the sense of futility that can invade such topics. *Juízo* has gained an audience at film festivals worldwide and, with many of these specifically orientated towards human rights issues, its intention to exist not only as an aesthetic object or film product but also as a tool for stimulating social awareness and change is evident. An understated but powerful piece, it lends insight into the collisions that are occurring continually in many urban regions of Brazil between young people of a low socio-economic background and the authorities. Although perhaps not as high profile as *O prisioneiro*, the film has been well received by both film specialists and those more directly involved as researchers or functionaries of the country's social and legal systems.

On graduating with a degree in music from the Universidade de Brasília in her home town, director Maria Augusta Ramos subsequently emigrated to Europe and began her studies in editing and directing for documentary at the Netherlands Film and Television Academy after settling in Holland in 1990. It is through her filmmaking that Ramos often returns to explore subjects within her homeland. This is the case with her first feature-length film *Brasília, um dia em fevereiro* (1996), winner of the Jury Award at the É Tudo Verdade documentary film festival, which returns to Brazil's capital 36 years after it was built to examine the effects of utopian urban planning on a number of its inhabitants. After directing an award-winning series of six short films entitled *Butterflies in Your Stomach* (1999) and a further feature documentary set in Holland, *Desi* (2000), for Dutch television, Ramos decided to revisit Brazil in the form of an exploration of the country's notorious justice system.[32]

32 Biographical information has been drawn from the following online sources: Diler and Associados (2013), Filme B (2016b), Academia Brasileira de Cinema (2013) and Harazim (2007).

Ramos' decision to turn her camera on youth justice reflects an interest already developed in her earlier *Justiça* (2004) – a straight observational style documentary following adult court hearings in a Rio de Janeiro tribunal. *Juízo* is also set in Rio de Janeiro and straddles three principal spaces over its duration: the Tribunal de Justiça (Courthouse) – where hearings take place, testimonies are given and judgements are passed on young offenders; the Instituto Padre Severino (IPS, Father Severino Institute) – a young offenders' institute where those sentenced to internment carry out their punishment; and several *favelas* where, during the penultimate sequence of the film, we see some of the protagonists in their homes or local neighbourhoods following their legal ordeals. Again using Nichols' documentary modes as a point of orientation, *Juízo*'s principal form of address appears to follow the same 'observational' style as that employed in *Justiça*. This style is based on minimal interference by the filmmaker who supposedly largely relinquishes control during filming, allowing events to unfurl unaffected before the camera (Nichols, 1991: 38). However, the complications brought on by Ramos' decision to document adolescent offenders – who by Brazilian law cannot have their identities exposed – undermines the 'non-intervention' characteristic of the observational mode, creating strong reflexive undercurrents that unsettle paradigmatic conceptions of authenticity and realism in documentary.

Interchangeable Bodies: Authenticity and Performance

The methodology Ramos chooses in order to circumnavigate the constraints imposed by restrictions on capturing her protagonists' identities on camera is clearly presented via intertitles at the film's opening: 'neste filme, eles [os adolescentes infratores] foram substituídos por jovens de três comunidades do Rio de Janeiro habituados às mesmas circunstâncias de risco social'. We are assured, however, that all other characters – both those from the legal system and the relatives of the minors – are *verídicos*, that is to say that they 'play' themselves during the film. In this manner, 'authentic' footage is mixed and interspersed with re-enactments by young stand-ins from poor communities, none of whom are trained actors. There can be no accusations of Ramos misleading viewers regarding this substitution of bodies, despite the skill with which she negotiates this factor to the effect that 'oscilamos permanentemente entre a dúvida e a crença, entre o distanciamento e a identificação, entre o artifício e a "impressão de realidade"' (França, 2012: 9).

In the hearings, we are presented with an establishing shot of the small court room in which the seated judge, Luciana Fiala, faces us head on with a defence lawyer and prosecutor seated at nearby tables either side. From this viewpoint we discern only the back of the defendant who sits facing the judge and appears to the very left of the screen (Figure 2.21). The layout of the room

Figure 2.21. *Juízo* (2007), dir. by Maria Augusta Ramos. Diler & Associados. Original in colour

Figure 2.22. *Juízo* (2007), dir. by Maria Augusta Ramos. Diler & Associados. Original in colour

and positioning of the camera thus collaborate to mask the youth's identity and with the scene having been set, the rest of the sequence is built upon the shot reverse-shot structure more common in classical narrative film. In this manner we cut from Judge Fiala's reprimanding or disbelieving expression to the apathetic face of a teenager, listening mutely or attempting to explain the events that have led to the current predicament (Figure 2.22). These sequences are most often sutured with the judge's ringing voice, which lends the impression of the stand-in's presence before her, although the footage of the youths performing their part of the exchange (only minimally altered, if at all, from the actual defendant's utterances) was obviously filmed on a later occasion.

The result is a complex tension between presence and absence, visibility and invisibility, involving not only the triangle of principal characters – the

judge who addresses an interlocutor absent during the film; the original interlocutor who though physically absent is present as author of the verbal responses; the double or stand-in whose identity resonates authenticity but who speaks the words of another (invisible) person – but also the filmmaker herself. As Nichols observes, the reality effect that we glean from an observational documentary 'hinges on the presence of the filmmaker or authoring agency as an absence, an absent presence whose effect is noted (it provides the sounds and images before us) but whose physical presence remains not only unseen but also, for the most part, unacknowledged' (1991: 43). Ramos' presence might of course be said to resonate more forcefully than in a purely observational film as a result of the reflexive techniques that she employs to navigate the legal restrictions surrounding her subjects.

Due to the very restrictions designed to protect young offenders, Ramos may be credited with giving visibility to scenes that will be unfamiliar to all but those with first-hand experience of the youth judicial system. With 50 hearings recorded over the course of about four days, the rapid exchanges between Judge Fiala and the defendants presented in the film replicate real-life time constraints as judges were expected to deal with at least twenty cases per day (M. A. Ramos, 2012:22). What is also implicitly documented in the film, then, is the lack of time and attention that these young people receive, whether from authorities in court or those at home. In the press pack provided on the film's official website, Judge and Vice-President of the Instituto Brasileiro de Ciências Criminais (Brazilian Institute of Criminal Sciences), Sérgio Mazina, notes that 'atravessando todos os segmentos da sociedade, temos uma profunda crise: é como se os adultos não tivessem autoridade sequer sobre si próprios e, por consequência, também já não sabem exercê-la sobre seus filhos' (Juízo, 2012: 10). Many of these children come from large single parent families and thus a mother or father, when not absent from their children's lives entirely, may be severely overstretched. This is painfully apparent in one sequence when a young girl teeters on the verge of refusing an official pardon for a minor crime because even at the prospect of internment, 'voltar para casa é pior'. Her mother explains the frequent occurrence of domestic conflict as a product of the confusion caused by the need to play multiple roles: 'eu tenho que fazer o papel da mãe e o papel do pai: dar carinho, dar amor e dar corrigir'.

In addition to presenting a practical solution, Ramos' replacement of the minors with other adolescents is clearly symbolic. Rather than fighting the mechanisms of anonymity and depersonalisation that operate in the prison system as *O prisioneiro* does, in *Juízo* the interchangeability of the characters lies at the root of its principal message – young people from disadvantaged backgrounds run similarly high risks with regard to potential involvement in criminal activity. The film creates the impression of an endless flow of young

bodies simply waiting to be sucked into crime and the justice system and delivers no glimmer of hope or possible remedy for this state of affairs. The plight of minors involved in crime also calls to mind the well-known *Pixote: A lei do mais fraco* (1981, directed by Hector Babenco), referred to in chapter 1. Although a work of fiction, it similarly exploits notions of authenticity, as its protagonist, the young Fernando Ramos da Silva, was a non-actor already involved in petty crime when selected to play Pixote.

With one of *Juízo*'s defendants listing his job title as *engraxate* (shoe shiner) and another describing his work as picking up rubbish with a *carroça* or cart, it is clear that the employment spectrum and prospects for most of these adolescents is extremely limited and limiting. This is surmised in the words of the judge herself as she reprimands one boy for his behaviour: 'podia estar lavando um carro, podia estar vendendo uma bala. Mas não, está roubando os outros!' It is hard to imagine her dispensing the same advice to a middle-class child from a more affluent neighbourhood. Although we could of course argue that Fiala simply adopts a realistic stance, such statements are partly responsible for validating the low expectations held by and for these children and are yet another contributing factor to weigh upon low or immobilised horizons.

Despite professing in a newspaper interview that her behaviour during the hearings is not rehearsed but simply an unaltered expression of a naturally passionate disposition (M. Ventura, 2008: 8), Judge Fiala is – whether for the benefit of the camera or for the young detainees – both highly theatrical and personal in her approach to the task of law enforcement. A far cry from the abstract and dispassionate qualities of the law that are often evoked, this extremely expressive judge, with her raised eyebrows and occasionally sarcastic remarks, gives a performance worthy of reality TV as she admonishes the youths as we might expect an overbearing mother or relative to do (Figure 2.23). As Nichols points out, the question of how differently events might have evolved without the presence of the 'invisible' camera lingers perennially around documentary film (2001: 114–115). Fiala's dramatic behaviour stands in stark contrast to the actual performances given by the stand-in defendants, which appear almost unbelievably natural. As Lins and Mesquita highlight, 'é mesmo difícil usar a palavra "ator" para falar dessas intervenções, tamanha a possibilidade de esses jovens estarem no lugar dos acusados' (2008: 72).

Carceral Cycles: Caught in the Motions

Although the film features periodic images of caged holding areas as defendants are transported between the Instituto Padre Severino (IPS) and the tribunal, of concrete cells and barred windows, the nature of the trap in which these young people find themselves confined appears to be as bureaucratic

Figure 2.23. *Juízo* (2007), dir. by Maria Augusta Ramos. Diler & Associados. Original in colour

Figure 2.24. *Juízo* (2007), dir. by Maria Augusta Ramos. Diler & Associados. Original in colour

as it is physical. A sequence following the opening title of the film shows stacks of paper files that fill the screen from different angles, with the camera distancing itself in the final shot to take in the entirety of the large room in which a small group of women are working. The impact of the overwhelming quantity of piled papers is acutely experienced when we consider that, like the files that the lawyers leaf through during hearings, each represents a case and by extension a human being (Figure 2.24). Such large numbers require mechanical systems, as is clearly illustrated in a scene documenting the registration procedure for a group of boys arriving at the IPS. The dull flat

Figure 2.25. *Juízo* (2007), dir. by Maria Augusta Ramos. Diler & Associados. Original in colour

tone of an administrator who repeats the same series of questions over and over again is chillingly rhythmic: 'qual é seu nome? Qual é sua idade? Estuda até que série? Seu número aqui será '142'. Pode ir … Próximo!' With the utterance of 'Próximo!', which reverberates throughout the film, the next youth is called forward to be processed in whatever queue he may be situated. From this point on, each must learn to identify himself with and respond to a given number that will be shouted whenever his attention is required – a system that likewise receives clear emphasis in *O prisioneiro*. There can be little doubt that as people are transformed into paper and numbers, so the possibilities of interacting with them in a human or humane way are considerably diminished. Uniform dress and haircuts, together with the gruff language of wardens and the submissive body language they demand from the youths are simply part of the package (see Figures 2.25 and 2.26). 'Se tem ou não tem a estrutura adequada, não é o problema do judiciário' responds the judge to the notice that the internment of two teenage mothers will prohibit them from looking after their young children. Whilst the judge is clearly not to blame for this fact, it is nonetheless a poignant example of the incompatibility of individual responsibility and compassion within such depersonalised environments.

In the final scene, disguised as light relief from an otherwise bleak series of occurrences, we are given a reminder of perhaps the most serious fault line in the terrain that Ramos has depicted: language. Brought before the law once again for illicitly escaping from the IPS, the defendant's legal records when finally untangled inform us – and the boy himself – that he ran away unnecessarily, having already been granted *liberdade assistida* (parole) at his hearing earlier the same day. The fact that he evidently had not understood the

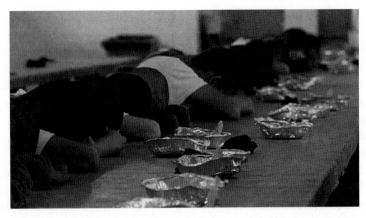

Figure 2.26. *Juízo* (2007), dir. by Maria Augusta Ramos. Diler & Associados. Original in colour

verdict indicates the level of estrangement and miscommunication that exists between the law and those most immediately affected by it. Commenting on the high number of prison films produced in Brazil, Escorel observes 'é um modo de gritar de novo o que Graciliano definiu como nossa condição: agimos nos estreitos limites a que nos coagem a gramática e a lei' (2003: 200). That Judge Fiala's language oscillates continuously between the legal terminology she uses in translating the defendants' responses to the court typist, street slang intended to approximate herself to the youths and strict moralist admonishment, is no less confusing than if she had limited herself to formal jargon alone. The effect of this switching between styles adds to the sense of the youths being caught in the motions of a ludicrously baffling system. Criticism of the legal system's inaccessibility also comes from within, as Judge Mazina's comment demonstrates, 'desde os trajes grotescos que vestem até a linguagem estridente que empregam, tudo é feito para não conversar, para não dialogar, para não entender e para não ser entendido' (Juízo, 2012: 11).[33]

As in *O prisioneiro*, it is made clear that incarceration is ineffectual and possibly counterproductive as a means to promote the re-socialisation of the individual. Foucault suggests that 'for the observation that prison fails to eliminate crime, one should perhaps substitute the hypothesis that prison has succeeded extremely well in producing delinquency […]; in producing delinquents, in an apparently marginal, but in fact centrally supervised milieu' (1991: 277). This point finds expression in the film when a defence lawyer fervently argues against the measure of imprisonment for a boy guilty of parricide, stating that it will only expose him to those who already possess

33 These comments are not included in the film but are provided amongst other interviews and statements in the film's press pack.

highly developed criminal tendencies and thus set him on a lifelong path of crime. An explicit awareness that the consequences of enforcing measures at the law's disposal will most probably be negative ones paints a system in dire need of reform. The penultimate sequence likewise reinforces the futility of all the mechanisms and procedures that we have observed during the film. Clips of the youths at home or in their local neighbourhood are accompanied by intertitles detailing their progress following the legal procedures – with only one girl in education, many have already run away from the institutes to which they were referred. As Jailson de Souza e Silva observes, 'cria-se um ciclo reprodutor do crime, da criminalidade, dos criminosos. Porque na definição do crime, você já define um perfil do criminoso' (in Araújo and Castro, 2010: 100). Whereas *O prisioneiro* and 'Imprisoned Spaces' direct their gaze both forwards and backwards, in their documentation of a space both 'soon to be demolished' at the time of filming or photographing and now a notorious part of the nation's history, *Juízo* remains trapped in the present-ness of the scenes that it observes and the sense of circularity and repetition that its interchangeable figures embody.

The idea of transformation is central to each of the works discussed in this chapter, whether woven to ambivalent effect into the discourse of the documented and documenting subjects of the text, contained in the desire to recapture a negatively perceived space in a different light, or communicated as an almost inevitably negative change for those landing at a certain point on the conveyor belt of an overloaded and adverse legal system. In chapters 1 and 2 we have considered the social and symbolic functions of wasteland and prison space as 'invisible' zones commonly placed externally and in radical contrast to the city as a space of dwelling and citizenship. In the next chapter we move on to consider a series of artistic projects motivated by the contestation of central urban spaces. These struggles between low-income individuals/communities and the state, as well as the manner in which they are portrayed, provide an important opportunity to question the concept of the 'informal' city and its frequent criminalisation, particularly in relation to social tensions surrounding real-estate speculation and wall-building.

Zones of Contestation

In the extensions and proliferations of cities, housing is the guarantee of reproductivity, be it biological, social or political. (Lefebvre, 1991: 232)

Introduction

In the previous chapter we observed the links often made between carceral spaces and *favelas* or communities of a similarly low socio-economic status. One very disturbing connection is expressed in the disproportionate number of prisoners fitting the profile of 'homens, jovens, negros ou pardos e com baixa escolaridade' (Araújo and Castro, 2010: 85) – a demographic frequently cited for involvement in the illegal drugs trade that has had devastating effects within Rio de Janeiro's *favelas* in particular over the last few decades. As Teresa Caldeira notes, 'crime and criminals are associated with the spaces that supposedly engender them, namely favelas and *cortiços*' and these 'informal' living spaces are thus frequently perceived by dominant social sectors as breeding grounds for criminality (2000: 78). This point is highlighted in the penultimate sequence of director Maria Ramos' *Juízo* (2007), discussed above, when we visit the young protagonists following their court hearings. Observing them in their domestic or working environments, the film clearly identifies the precarious material conditions we see with their position as juvenile offenders. Such associations inadvertently stimulate a reproductive logic that homes in upon the threat of crime from poorer areas, ignoring the fact that the vast majority of inhabitants occupy themselves performing not threatening acts but essential services that are highly integrated into the informal or formal economies of the city and nation. This focus on criminality also distracts from one of the primary issues at stake: a consistent lack in the provision of affordable 'formal' housing options in major cities to cater for expanding urban populations.

During the last century a seismic rural to urban shift has occurred throughout the world. In Latin America this movement has been particularly striking during the latter half of the twentieth century, when industrialisation from the 1940s to the 1960s provoked an accelerated mass migration of labourers to its cities (Hernández, Kellett and Allen, 2010: 5). Although the search

for work and a better standard of living have long been common motivations for relocation to urban centres, 'overurbanisation' today is symptomatic not of plentiful job opportunities in the city but simply of a 'reproduction of poverty' and, one might infer, a lack of appealing or reasonable rural alternatives (Davis, 2007: 16). From 1970 onwards, slums – the major low-income response to the primary and urgent necessity of housing – have become the fastest growing urban spaces in the global South (2007: 17). 'Thus, the cities of the future, rather than being made out of glass and steel as envisioned by earlier generations of urbanists, are instead largely constructed out of crude brick, straw, recycled plastic, cement blocks, and scrap wood' (2007: 19). In addition to being one of the most visible and thus readily identifiable expressions of poverty and disparity, these are highly dynamic spaces that defy common associations between built space and the qualities of stasis and fixity.

Before moving any further, it is imperative to stop and examine the terms used to describe such spaces and to ensure that those employed reflect an adequate understanding of the issues at stake. As Koonings and Kruijit observe, 'since the 1980s, informality has been one of the key terms with which to designate the complex configuration of livelihood, social relations and identity construction in the poor parts of Latin American cities' (2007: 7). The term 'informal', however, is itself an increasingly problematic and misleading term for *favelas* and other low-cost housing solutions in Brazil, with critics pointing to its inability to address adequately the complexities in play (Hernández, Kellett and Allen, 2010: 1). Placing primary emphasis on the binary opposition between informal/formal masks the numerous distinctions between different communities, some of which have in fact obtained formal tenure for land that was originally occupied illegally, or indeed pay rent, taxes or standardised fees for services such as electricity and water where they are provided by authorised companies (as opposed to siphoned off through illegal local initiatives). It also disavows 'formal' developments already present in certain *favelas* – Rocinha in Rio de Janeiro for instance has two banks, a post office, real estate agents and diverse retail outlets and is home to many local businesses (Freire-Medeiros, 2009: 59). Although Mike Davis prefers the term 'slum' as in his *Planet of Slums* (2007), this is also a problematic label due to its intensely negative connotations, which quash any recognition of positive aspects or developments (Perlman, 2010: 37). This leaves us with the use of the word *favela* itself. Although this also comes under fire – as a number of these words do – for acting as a homogenising umbrella that flattens distinction, many inhabitants have nonetheless now reclaimed it as an affirmative term. Likewise, *comunidade* is widely used by those living in such spaces and through its invocation of harmony and unity clearly embodies a desire to contest preconceptions of disorder and isolation (Gama, 2009: 97). Finally, *territórios populares* or *espaços populares*

serve a similar purpose with an additional emphasis upon the asserted right to occupy these spaces. Within this study I give preference to the terms *favela*, *comunidade* and *espaços populares*, as those commonly favoured by inhabitants and organisations that explicitly foreground the objective to combat prejudice (such as the well-known Observatório de Favelas). I would argue, however, that the terms formal/informal remain useful to us as a means to refer to an accompanying set of values and judgements, and it is in this capacity that the terms appear during my analysis.

Although similar low-income housing patterns exist across the world, *favelas* of course have a particular Brazilian history. This is linked to the war of Canudos in the late 1890s, in which the federal government struck down the leader and followers of a thriving community in the north-east of Brazil that had chosen to combat poverty and marginalisation with its own hands. Following the massacre, soldiers returned to Rio de Janeiro, only to be denied land rights and pay for their services, and decided to settle illegally on a hillside which they named the 'Morro da Favella' after the thorny bushes they had encountered in the Canudos region (Perlman, 2010: 25). Thus, from the beginning of the *favelas'* history, there exists the idea of contested territory and a population defrauded and ignored by a state that chose not to fulfil its promises. Recognised in the early twentieth century as a new 'território da pobreza', initially defined by the temporary nature of its constructions (Valladares, 2005: 26), by the 1920s *favela* had 'become the generic term for squatter settlements, shantytowns, and all types of irregular settlements' (Perlman, 2010: 27). If many of these original settlers had served their country in battle or as former slaves, a great number of its present occupants might be said to serve the city in their provision of low-wage services such as cleaning, domestic labour, construction and private security. With rising levels of unemployment due to 'the kind of industry that employed many *favela* residents in the 1960s and 1970s […] either moving elsewhere within Brazil or to cheaper labour markets elsewhere in the world', such populations were evidently set to grow (Koonings and Kruijt, 2007: 23).

How are these settlements imagined today? The criminalisation of *favelas* and their occupants in the media continues frequently to overshadow the primary motivation for these spaces (that of catering for a housing necessity brought about by a huge rural to urban population shift, unemployment and varying degrees of poverty) in favour of issues of public security, almost invariably portrayed as a concern for the middle and upper-middle classes. Commenting on spatial segregation in her landmark study of São Paulo, *City of Walls*, anthropologist Caldeira observes the way in which:

> Discussions about fear of crime reveal the anguish produced when social relations can no longer be decoded and controlled according to

old criteria. Although there are certainly many positive aspects to the disintegration of old power relations in Brazil, it is also clear that many social groups have reacted negatively to the enlargement of the political arena and the expansion of rights. These groups have found in the issue of crime a way of articulating their opposition. (Caldeira, 2000: 51)

The restructuring of metropolitan space and the development of 'grandes projetos de reurbanização de áreas até então de baixa ocupação ou marginais, para novos usos empresariais ou residenciais' may in some senses be interpreted as a socio-economic expression of the reaction to this perceived threat (Peixoto, 2009: 396).

The works analysed in this chapter each focus on a contested urban living space either on the brink, in the process, or enduring the impact of a significant transformation. Decisions made or validated by the authorities to either shift or contain the low-income and often, at least originally, illegal occupants of these areas instigate both destructive and creative agendas. Sometimes culminating in the complete or partial removal of homes and communities, they may also bring into existence new structures and landmarks. The immediate and long-term consequences of such shifts are often complex, affecting large numbers of individuals and families. Whether experienced as a physical displacement of the home to a new location or as the negotiation of a significant alteration to an existing environment, the concept of *dislocation* – its verb form defined by the OED as: 'to put out of place'; 'to displace'; 'to throw into confusion or disorder, upset […], disconcert' – provides a useful lens through which initially to engage with some of the issues raised. This is, after all, a dynamic that governs the lives of vast numbers of people across the planet:

> At the beginning of the twenty-first century, displacement rather than attachment to a fixed and settled place or location has become a more 'normal' way of life for increasing numbers of people from the war-torn countries of central Africa to the temporary and permanent migrations for work in almost all the world's regions. (McDowell, 2003: 25)

The first piece explored is director Gabriel Mascaro's *Avenida Brasília Formosa* (2010). Set in Recife, capital of the north-eastern state of Pernambuco, the film's title refers to an avenue built as part of an urban infrastructure project to rejuvenate the coastal area in the south of the city where the *favela* of Brasília Teimosa is situated. With the neighbourhood's most precarious houses demolished to make way for the new thoroughfare and create beachfront leisure space, numerous families were relocated to new government-funded housing blocks or *conjuntos habitacionais* in distant areas of the city. The film blurs traditional boundaries between fiction and non-fiction as it follows the

trajectories of four central characters from Brasília Teimosa going about their daily lives.

In the second section we shift our attention to the megacity of São Paulo to look at the work of photographic collectives Cia de Foto and Garapa.[34] Here I examine two series of images, '911' (Cia de Foto, 2006) and 'Morar' (Garapa, 2007), which both approach the phenomenon of the mass forced evacuation of low-income squatters or legal residents from apartment buildings in run-down central areas of the city.[35] The act of either laying claim to or asserting the continued right to inhabit these central spaces demonstrates a clear reaction against the movement of expulsion that continually pushes low-income groups to the fringes of the city. Although the photographers from both collectives share a background in photojournalism, their aesthetic responses to two similar situations are distinct (yet both distance themselves from a photojournalistic style) and provide an interesting point of comparison.

The final section takes us to Rio de Janeiro and, more specifically, to the well-known *favela* of Santa Marta. Here, another photographic series produced by Garapa entitled 'O muro' (2010) addresses the recent and highly controversial government initiative of wall building that has taken place around some of the city's *favelas*. Driven by other large-scale interventions such as the Unidade de Polícia Pacificadora (UPP, Police Pacification Unit) movement – whose mission statement involves bringing peace to *favelas* by installing a police presence designed to recuperate territory formerly under the command of drug traffickers or mafias – and the Programa de Aceleração do Crescimento (PAC, Growth Acceleration Programme) – another government-funded initiative to improve urban infrastructure – the project and its potential ramifications have created a rift in opinion that has undoubtedly deepened existing mistrust between residents and the authorities.

Avenida Brasília Formosa

> O real não deve ser respeitado na sua intocabilidade, mas deve ser transformado, pois o próprio filme coloca-se como um agente de transformação. (Bernardet, 1985: 64)

Although the cities of Rio de Janeiro and São Paulo have long operated as the two central poles of film production in Brazil, voices from a young

34 Note that Cia de Foto ceased functioning as a collective in 2013.

35 As the *Morar* project has been ongoing with no definitive end date given, I cite 2007 here as the starting point of the initiative.

and vibrant community of filmmakers in the north-east of the country are attracting increasing and well deserved attention. Building on the success of an older generation of local cineastes who gained national recognition from the 1990s onwards with films such as *Baile perfumado* (Paulo Caldas and Lírio Ferreira, 1996), *O rap do pequeno príncipe contra as almas sebosas* (Paulo Caldas and Marcelo Luna, 2000), *Amarelo manga* (Cláudio Assis, 2002) and *Cinema, aspirinas e urubus* (Marcelo Gomes, 2005), collaboration and camaraderie have remained leading characteristics of filmmaking in the region (Joaquim, 2010: 34). The film festivals Cine PE Festival do Audiovisual and the younger Janela Internacional de Cinema do Recife attract short and feature-length films from across the country and around the world, serving as a meeting ground for current filmmaking debates and, of course, filmmakers themselves. With the creation of a 'Cinema e Audiovisual' course at the Universidade Federal de Pernambuco (UFPE, Federal University of Pernambuco) in 2008, it seems we are witnessing not only sustained interest but also a growing impetus in local film production.

A graduate of the UFPE department of Comunicação, Gabriel Mascaro directed two feature-length documentaries, *KFZ-1348* (co-directed with Marcelo Pedroso, 2008) and *Um lugar ao sol* (2009), before making the docu-fiction *Avenida Brasília Formosa* (henceforth *Avenida*) set in his home-town of Recife. The film follows the everyday activities of four protagonists as they work, travel, eat, joke, dance and play their way around and about the community of Brasília Teimosa. Cauan (a petulant schoolboy turning five), Débora (a manicurist and aspiring 'Big Brother Brasil' contestant), Pirambu (a local fisherman now living in a distant *conjunto habitacional* as a result of the avenue development) and Fábio (a waiter and freelance video maker) provide us with a moving window onto a rich sensorial world of neighbour-hood sights and sounds. As a result of Fábio's video-making enterprise – for which he is hired to record special events such as Cauan's fifth birthday party and Débora's *videobook* application – parts of these different lives subtly interweave throughout the film. Pirambu alone experiences no contact with Fábio, creating a narrative disconnection that perhaps reflects his physical displacement from the community.

In spite of a wealth of local slang and fast-paced dialogue, *Avenida* has found success with audiences and juries at prominent film festivals across Brazil, Latin America and Europe, including the São Paulo Mostra Interna-cional (São Paulo International Film Festival), Buenos Aires Festival Interna-cional de Cine Independiente (BAFICI, Buenos Aires International Festival of Independent Cinema), El Festival Internacional de Documentales de Santiago (FIDOCS, International Documentary Festival of Santiago) and the Interna-tional Film Festival Rotterdam (IFFR). Though less controversial than his earlier *Um lugar ao sol* – a documentary addressing the relationship between

architecture, power and desire through interviews with wealthy Brazilian socialites living in penthouses in Recife, Rio de Janeiro and São Paulo – the films share an interest in the different ways that people inhabit urban spaces and the diverse relationships they form with their environment. Commenting on correlations between the home and identity, anthropologist Roberto DaMatta observes a 'significant cultural equation between the physical construction of a home and the social construction of its residents' (DaMatta, 1995, Working Paper 10: 23). The nature of one's living space is often closely linked to social standing and profoundly affects the way in which an individual experiences the city on a daily basis, making it an especially poignant domain in which to observe and question the construction of certain social identities. This is an avenue Mascaro pushes to the limit in his latest documentary *Doméstica* (2012), comprised of intimate footage taken by seven adolescents who undertook to film their live-in housemaids over a week.

Mascaro's encounter with the penthouse occupants, at a far remove from the streets below, raises another crucial issue, that is, the negotiation of access to different social groups for filming opportunities and their willingness (or lack thereof) to expose themselves as documentary subjects:

> Not only are the poor – the working classes, the lower strata – unequal, they are accessible, and more than willing to take part in research projects, since they see them as a channel of communication for their grievances, and since the wealthiest groups are hostile to any kind of enquiry, the first become a happy hunting ground for researchers while the second are off-limits. (Cattani, 2012: 24)

Um lugar ao sol represents a rare and highly ambitious attempt to counteract this trend. Though not alone in gaining permission to document some of the wealthier echelons of society – Mexican photographer Daniela Rossell's images of wealthy compatriots posing in their own homes in *Ricas y Famosas* (2002) come to mind, as does the Brazilian reality TV series *Mulheres Ricas* (2012), widely criticised for the frivolous and decadent lifestyles and attitudes displayed[36] – Mascaro's film distinguishes itself in forming a more unusual relationship between 'image producer' and subject. Unlike Daniela Rossell, he is not a part of the exclusive social world depicted and he also lacks the weight of mass media influence enjoyed by those producing for television. Mascaro instead approaches his subjects here from a position of relative weakness – something many directors shy away from, given the practical difficulties it can present, particularly when antagonistic values and

36 See Phillips (2012) and Setti (2012).

beliefs are at stake. Unafraid to bare its ethical dilemmas and ambivalence in uncomfortable ways, this film takes a positive step towards redressing a stark representational imbalance that continues to exist in visual culture at large.

With *Avenida* we witness a dramatic shift in content and form as, back at street level, Mascaro moves away from participatory interviews towards what initially appears to be a more observational style and tone. Just as observation is often associated with non-interference and 'direct' representation, there is no doubt that setting the film in a historically pertinent location also heightens expectations of representational 'authenticity'. Originally known as Areal Novo, the area was first occupied in 1947 by a fishermen's guild eager to establish homes near the sea that brought their livelihood. During the 1960s, its growing population struggled alongside the newly inaugurated capital of Brasília to put down its roots in inhospitable land, earning it the name of Brasília Teimosa ('Defiant' or 'Stubborn' Brasília). Unlike its celebrated namesake, however, it was far from officially endorsed. As is often the case in such illegal settlements, police would tear down houses during the day only to see them re-emerge the next, reconstructed by their residents under the cover of darkness. Such tenacity and perseverance earned Brasília Teimosa a concrete victory in the popular struggle for land rights when these were finally granted to a much increased population of squatters during the 1980s (Moura, 1987: 166). In January 2003, it stood once again in the political limelight with a visit from the then president Luiz Inácio Lula da Silva. This event lent momentum to a campaign to remove the precarious *palafitas* ('stilt houses' built above the sea water and regularly subject to flooding and fatalities) and rehouse their residents elsewhere as part of a wider effort to regenerate the beachfront area (Jornal Recife Melhor, 2013) and (Prefeitura do Recife, 2012).

Despite such a tangible backdrop, however, the relationship that the film establishes between fact and fiction is neither explicit nor straightforward. Though the actors' real-life names are used, suggesting that they 'play' themselves, what occurs is accurately described by Cezar Migliorin as an 'evidente permeabilidade entre o que é a vida dos personagens e o que é a vida dos atores, até a indistinção, mas sempre dois' (2010: 50). Creative licence is employed throughout in the situations that are portrayed and some of the actors are in fact not even residents of Brasília Teimosa at all. So whilst many audiences perceive the film to be a very authentic portrayal of life in the area, for the local inhabitants it often appears 'muito mentiroso'.[37] With the particular outlook, taste and knowledge (or ignorance) of the subject matter that each viewer brings to a film, it is hardly surprising that questions of authenticity should prompt diverse reactions. It is important to recall, however, that

37 Conversation with director Gabriel Mascaro, November 2010, São Paulo.

although debates concerning boundaries between fiction and documentary have occupied a central position over recent years, this is a distinction that simply did not exist in the early days of cinema (Comolli, 2008: 28). After all, the 'oposição ficção x não ficção é só um recorte possível' (Hilda Machado in Escorel, 2003: 248).

Whilst acknowledging a categorical difference between the two, film theorist Noël Carroll provides a more fluid and insightful way of approaching the topic of reality in relation to cultural production with his observation that 'the distinction between nonfiction and fiction is a distinction between the commitments of the texts, not between the surface structures of the texts' (Carroll, 1996: 287). Without making an issue of formal conventions and delimitations, Mascaro transforms a lack of clarity into an empowering gesture of complicity. *Avenida*'s protagonists exist not as objects of a visual study designed to reveal truths about their existence, but as collaborators in a creative process that may or may not deliver its own truths. This approach naturally raises questions about the use of performance and staging during filming, as addressed in the following section.

Where Bodies Meet Machines

> Desse encontro nasce um *registro* único, não repetível, não simulável. E o que é registrado nada mais é do que, em última análise, a *relação* de alguma coisa de humano com alguma coisa de maquínico. (Comolli, 2008: 111)

The most prominent way in which issues of performance, spectacle and staging arise in the film is through the use of *mise en abyme*. With the absence of any overarching narrative storyline, Fábio's video production operates not only as a central connective strand linking characters and spaces, but also ensures that the process of filmmaking itself is never far from viewers' eyes and minds. We touch upon this chain of events at various stages: accompanying telephone conversations in which Fábio's services are initially contracted and the filming of his clients at home or around the neighbourhood, through to direct or doubly mediated screenings of the final edited and stylised products. The presence of camera and director is also reinforced in less explicit ways, perhaps most notably in the use of disconcerting framing techniques explored in further detail below.

A mesh of gazes criss-crossing through the film makes our gaze as the 'external' audience just one to be counted alongside many. In featuring numerous images of people watching the performances, events or spectacles that take place around them, Mascaro legitimises a multiplicity of viewpoints and in so doing democratises the position of spectator. Rather

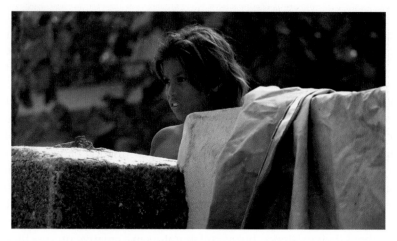

Figure 3.1. *Avenida Brasília Formosa* (2010), dir. by Gabriel Mascaro. Plano 9 Produções

than a privileged or secretive activity that easily becomes associated with voyeurism in cinema, watching is a common pastime here – in the sense of one both frequent and shared. These gazes often converge, as demonstrated in a sequence where Fábio films Débora posing on top of a boat as fishermen mend their nets nearby. The presence of onlookers shown in a sequence of medium shots (see Figures 3.1 and 3.2) is multiplied through the catcalls of 'gostosa!' and 'tira o shortinho!' that we hear off-screen and attribute to the surrounding fishermen. The decision to identify the gaze visually with that of a young boy and an old man (whose expressions are puzzled or curious rather than predatory) creates a disjuncture that disarms the remarks of more serious intent. Likewise, the obvious pleasure that Débora takes in the experience, despite occasional inhibition, complicates any simplifying or moralistic judgements about the clearly sexualised role that she performs.

In the sequences where Fábio films Débora or Cauan we also witness the heavy-handed way in which he directs his protagonists. Instructing a bikini-clad Débora on how to run her hand through the water or splash herself as she lies beside a rock pool, or staging clapping and chanting during Cauan's party games, operates as a constant reminder of how the act of filming impacts upon the behaviour and occurrences that it 'documents'. Fábio's instructions to Débora on what to include in her address to the camera and his reassurance that he will wipe out the fishermen's comments with an overlaid soundtrack, foreground the devices and manipulations that commonly play a part in most filmmaking practice to varying degrees. It is nigh on impossible then to watch this film without being highly consciousness of such interference and of the fundamentally artificial nature of the endeavour.

Figure 3.2. *Avenida Brasília Formosa* (2010), dir. by Gabriel Mascaro. Plano 9 Produções. Original in colour

Fábio's artistic vision and the expectations of the characters that contract him simultaneously expose the web of desires that surround these visual products. A later shot of Débora and her friends watching the *videobook* shows her satisfaction with the imagery that has been created (Figures 3.3 and 3.4) – underlined by the fact that following the production of *Avenida* she used this footage to submit a genuine application to 'Big Brother Brasil'.[38] The production of such images is motivated not by an intention to capture matters as they stand, but to represent them as people want them to be remembered and as they themselves wish to be perceived by others. Of course, the types of behaviour exhibited clearly register influences and ideological currents present in advertising and the media, though the film itself does not attempt to exercise such concepts as Marxist 'false consciousness' in an overtly critical dimension. We might also remember here that performance may itself be used 'not as a means of invalidating the documentary pursuit but of getting to the truth each filmmaker is searching for' (Bruzzi, 2000: 125–126). What Mascaro presents us with is a successful portrayal of a common human relationship with the camera and the resulting imagery that we produce around our lives. The 'truth', if you like, of this scenario is contained within that relationship and the ever-increasing search for personal transformation and (social) betterment through visual media – often achieved through what might even be termed a highly 'inauthentic' projection.

Although the above examples feature some of the more obvious displays of performativity during the film, there are many more subtle occurrences that

38 Conversation with director Gabriel Mascaro, November 2010, São Paulo.

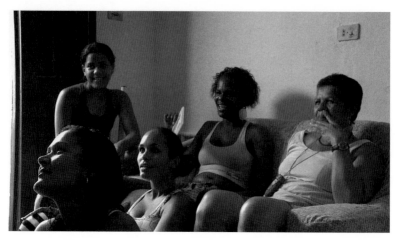

Figure 3.3. *Avenida Brasília Formosa* (2010), dir. by Gabriel Mascaro. Plano 9 Produções. Original in colour

Figure 3.4. *Avenida Brasília Formosa* (2010), dir. by Gabriel Mascaro. Plano 9 Produções. Original in colour

warrant attention and challenge us to question and expand our notions of what might constitute a performance. Whether it is a low-lit scene featuring couples dancing intimately in a local bar as we look on together with those at tables bordering the 'dance floor', Fábio's attempt to teach a dance routine to a shy young relative at home, or Cauan's classroom ordeal discussed below, we are never far from scenarios that place individuals and their actions to be judged before diverse audiences. Indeed, these scenes bring to life the quotidian nature of both performance and spectatorship as incidental acts that

Figure 3.5. *Avenida Brasília Formosa* (2010), dir. by Gabriel Mascaro. Plano 9 Produções. Original
in colour

continuously occur around us in various forms – and not simply as those con-
sciously constructed for and directed towards traditional viewing contexts.

An especially poignant scene captures Cauan standing alone in front of
a whiteboard with his back to the camera and the rest of the classroom,
as he sets about the task of copying his name from where it is written
above (Figure 3.5). The obvious difficulty he experiences – erasing several
attempts only to replace these letters with other distorted or unrecognis-
able ones – provokes a barrage of impatient and amusing comments from
his young classmates who watch off-screen, increasing his perplexity still
further. A comical and moving scene that often provokes laughter, it also
underlines several fundamental issues. In addition to touching on the subject
of education and literacy levels in a low-income area, it directly engages the
concept of mimesis that resides at the core of the film as an artistic enterprise.
The impossibility of a faithful or 'true' imitation is most evident when we
acknowledge that any representation is first mediated by an individual's
perception of the 'original' in question, itself entirely subjective. In this case,
somewhere between Cauan's interpretation of the letters written by the
teacher and his own reformulation of the same, critical information has been
lost, resulting in a considerable discrepancy between the two versions.

Imitation and replication are key aspects of another activity that features as
a spectacle in the film: video gaming. One sequence shows Cauan engrossed
in an arcade fighting game with other young boys and later in the film we
see Fábio playing a dance-off game in a living room as his friends look on. It
is interesting that both of these episodes exude intense impressions of corpo-
reality – with soft-focused close-ups of hands as they rapidly punch buttons
and of faces and limbs fixed or contorted in concentration as the characters

Figure 3.6. *Avenida Brasília Formosa* (2010), dir. by Gabriel Mascaro. Plano 9 Produções. Original in colour

Figure 3.7. *Avenida Brasília Formosa* (2010), dir. by Gabriel Mascaro. Plano 9 Produções. Original in colour

interact with their onscreen doubles and compete to outstrip physical or virtual opponents (Figures 3.6 to 3.11). This projection of self into an image world clearly reflects the filmmaking encounter between machine (camera) and body (actor) that enables us to witness these very scenes. The living body exists here as a threshold, 'a place of transition between the depths and the surface' (Lefebvre, 1991: 283).

Figure 3.8. *Avenida Brasília Formosa* (2010), dir. by Gabriel Mascaro. Plano 9 Produções. Original in colour

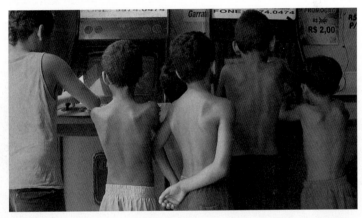

Figure 3.9. *Avenida Brasília Formosa* (2010), dir. by Gabriel Mascaro. Plano 9 Produções. Original in colour

That Fábio ultimately fails the dance contest, despite obtaining high scores throughout, reinforces the gap between actions taking place on and off the screen. Whilst the fact that his on-screen avatar is a woman is indicative of the fluidity of identity that image worlds facilitate, it is also undeniably a further marker of distinction. The distance between living bodies and the surfaces on which they find themselves projected or reconstituted is expressed in these representational fissures, which repeatedly underscore the impossible nature of 'faithful' imitation or mediation. What is at stake, as Gayatri Spivak reminds us, is not only representation as an artistic or philosophical endeavour ('re-representation'), but representation as a political gesture ('speaking for') (Spivak, 1994: 70). In drawing attention to these complexities, Mascaro simultaneously distances himself from the characters and from any notion

Figure 3.10. *Avenida Brasília Formosa* (2010), dir. by Gabriel Mascaro. Plano 9 Produções. Original in colour

Figure 3.11. *Avenida Brasília Formosa* (2010), dir. by Gabriel Mascaro. Plano 9 Produções. Original in colour

of the director's capacity to ethically and politically represent, or *dar voz*, to others via his lens.

Mapping the Neighbourhood

> Entre o real e o imaginário, o figurativo e o abstrato, o movimento e o repouso. Entre o visível e o invisível. A paisagem contemporânea é um vasto lugar de trânsito. (Peixoto, 2009: 233)

The contrast between title and opening shot immediately introduces a tension that resonates through the entire film. Whilst the words *Avenida* and *Brasília*

Figure 3.12. *Avenida Brasília Formosa* (2010), dir. by Gabriel Mascaro. Plano 9 Produções. Original in colour

clearly present the notion of flux – the latter bringing to mind the large waves of migration from the north-east and other areas of the country that occurred upon the relocation of the nation's capital – this remains starkly at odds with the first visual impression we receive. The film begins with a black screen as a *brega* song fades in (literally 'kitsch' or 'corny', this is the name given to a particular genre of popular music originating in the north and north-east of Brazil) before we are presented with a static straight-on shot of part of a building's façade (Figure 3.12). Exposed brickwork, peeling paint and rooftop water tanks immediately locate us in a lower income area of the city. The shot is held for almost a full minute as a cacophony of different songs and street noises indicate the activity going on below. It is this extended duration, particularly at such a prominent point in the film, that gives the scene its high impact – the average shot length in a Hollywood movie for example (not an unreasonable benchmark for cinema audience expectation) lies in the realm of between three to six seconds only.[39]

Similarly long static takes of buildings and urban landscapes appear frequently during *Avenida* and often combine 'formal' and 'informal' spaces in a single frame (Figure 3.13). In addition to reinforcing the material and architectural spaces that lie at the film's centre, these interludes create a contemplative space which lies at odds with the accelerated imagery of TV and advertising that is such a constant presence in the lives of most people today. As philosopher Nelson Brissac Peixoto concludes, 'O olhar contemporâneo não tem mais

39 For a fuller discussion of the reduction in average shot lengths in recent cinema see Bordwell (2006: 121–124).

Figure 3.13. *Avenida Brasília Formosa* (2010), dir. by Gabriel Mascaro. Plano 9 Produções. Original in colour

tempo' (2009: 209). Likewise, where classic fiction privileges the seamless progression from one image to the next in a manner that lessens awareness of cuts and therefore of the filmic medium, we might interpret Mascaro's technique of suspension in opposition to this dominant trend. Not only do these pauses create a change in tempo, but in doing so they draw film back to reflect upon its own 'truth', still photography. After all, it is only time – the short duration that each still image is held for and the rapid rate at which successive images flash by – that deceives the eye into perceiving movement and the cinematic effect.

> A pausa serve de fissura para introduzir um outro tempo no cinema. Faz surgir, no movimento do filme – o próprio princípio do cinema – o fotográfico. Os segundos que suspendem o movimento, em que o filme é impregnado pela fotografia, tornam-se 'instantes decisivos'. (Peixoto, 2009: 215)

These moments contrast with highly dynamic sequences in which we accompany the trajectories of the protagonists. Camera variation heightens the awareness of its presence and creates a continuously shifting perspective – a handheld tracking shot following behind a character, for instance, cuts to one in profile before again moving in close behind so that we peer over the character's shoulder. As Henri Lefebvre reminds us, 'it is by means of the body that space is perceived, lived – and produced' (1991: 162). Accompanying the characters in such an intimate and 'physical' way allows us to become acutely aware of the different spaces that they occupy, their individual paths weaving together a sense of the neighbourhood through heterogeneous

Figure 3.14. *Avenida Brasília Formosa* (2010), dir. by Gabriel Mascaro. Plano 9 Produções. Original in colour

Figure 3.15. *Avenida Brasília Formosa* (2010), dir. by Gabriel Mascaro. Plano 9 Produções. Original in colour

experience. In one sequence we follow Pirambu as he exits the Conjunto Habitacional de Cordeiro in the dark of early morning and cycles across the city to Brasília Teimosa where his boat is moored. By the time he arrives at a local store to buy supplies for the fishing trip, it is already broad daylight. Here we witness in very concrete terms the impact of the relocation upon his daily routine (Figures 3.14 and 3.15).

Our first encounter with Pirambu occurs in the second sequence of the film, immediately following the opening shot. Close-ups of his rapidly moving hands, perspiration-drenched body and finally his face as the camera pans upward, show him mending a large net strung out between two apartment

Figure 3.16. *Avenida Brasília Formosa* (2010), dir. by Gabriel Mascaro. Plano 9 Produções. Original in colour

blocks. The sea is nowhere in sight. It is worthwhile noting at this point that the Portuguese word *rede* encompasses the English concepts of 'net', 'hammock' (where we later observe one of Fábio's colleagues resting), 'network' and 'web'. It has the capacity, therefore, to effectively link the physicality of fishing net and hammock – work and leisure – to both the ideal network of community and the virtual space of the web. The neighbourhood appears as an interconnected space, with characters creating physical networks as they trace paths around and beyond the community and entering virtual ones via the simulated realm of video games or reality TV. Joking with a fellow fisherman who still resides in Brasília Teimosa, Pirambu offers to exchange places – houses, wives and lives – and it is clear that he begrudges his new disconnectedness and distance from the ocean. A long journey and the fact he cannot afford a car mean that whilst his altered circumstances look greatly improved on paper – moving from a dangerous *palafita* to a newly built apartment – the negative consequences are in his case significant.

Such episodes encourage us as an audience to question the nature of the transformation that has taken place. Nowhere is this change signalled more clearly than in the substitution of terms used to refer to the area. Homing in at one point upon a plaque periodically illuminated by the headlights of passing vehicles, we observe how large letters celebrating the new avenue dominate the smaller ones acknowledging the neighbourhood it borders (Figure 3.16). In the government rebrand, Recife's Brasília is no longer to be regarded as *teimosa* ('defiant') but *formosa* ('beautiful'). Whilst in an ideal world defiance would be obsolete, there is something suggestively disempowering – a transition from active to passive – in this particular instance of re-naming when it is precisely the community's stalwart resistance that has earned it the

Figure 3.17. *Avenida Brasília Formosa* (2010), dir. by Gabriel Mascaro. Plano 9 Produções. Original in colour

right to exist and thus its formal visibility. Perceptions are, of course, crucial to the formation and hence the combating of stereotypes and discrimination. In this respect, the logic behind the new label is clear and we might hope that the influence of positive association may ultimately render it empowering. However, the price for such processes is paid in time. A conversation in the beauty salon between Débora and her friends suggests that the physical and aesthetic changes that have taken place have yet to impact upon the social sphere. Despite the assertion that in material terms Brasília Teimosa 'não é mais favela!', the women all acknowledge that it continues to be regarded as such.

The landscapes through which we shadow our protagonists are not only visual but also distinctly aural ones. As Fábio walks home from work, passing by houses, bars and shops that each emit their own *brega* song or local radio announcement, his passage is marked by his immersion in and transition from one micro-soundscape to the next. At other times these sound bubbles are themselves mobile – as with the loudspeakers that are mounted on bicycles and pedalled around the district, blasting out local announcements and advertisements. On one such occasion, the questions: 'seu filho ou sua filha casou? Vai subir mais um andar?' introduce a special deal on building materials and draw to our attention another significant issue – the flexibility present in 'informal' settlements. Many scenes in Brasília Teimosa show construction materials lying in the road or people in the process of building, supporting the view that it is an environment in constant transformation (Figure 3.17). This dynamic relationship to living space is of course curbed in the move to *conjuntos habitacionais* where each spatial allocation is fixed. Sound also travels differently in the new living space, as observed in conversations amongst Pirambu and his family. Disturbed by the unaccustomed sounds of cows and

Figure 3.18. *Avenida Brasília Formosa* (2010), dir. by Gabriel Mascaro. Plano 9 Produções. Original in colour

horses in the surrounding fields and the manner in which voices from nearby flats easily infiltrate those around them, his mother-in-law feels the displacement particularly intensely.

Of course, this constructive activity is not limited to the informal sphere. Following a sequence in which we witness Débora and Cauan enjoying themselves on the packed local beach, we are shown the other side of the coin as the camera tilts up and pans across the horizon facing inland. Our eyes are met with a series of enormous high-rise buildings under construction, casting an ominous shadow over the crowded sociability below (Figure 3.18). It is impossible to ignore the fact that urban infrastructure projects that 'clean up' or 'sanitise' an area – particularly one in a prime location – simultaneously and inevitably pave the way for real-estate speculation. As big companies develop nearby stretches of grassland for giant luxury apartment blocks, it is only a matter of time before surrounding neighbourhoods become the target of further expansion, perpetuating a cycle where poorer members of society are continually expelled from such locations to other less desirable corners of the city.

It is the constructed nature of the film itself that Mascaro emphasises through a series of more unusual and conspicuous framing choices. In a number of scenes, the main or a significant part of the 'action' occurs either on the frame's margin or out of our field of vision entirely. In Figure 3.19, for instance, the children playing on swings become visible to the audience only when they reach the highest point of their trajectory, or a group playing volleyball are only occasionally glimpsed as the immobile camera obstinately ignores the players, instead fixing its sights down the dividing 'mid-court' line (Figure 3.20). Concrete posts or telegraph poles, often appearing at centre

Figure 3.19. *Avenida Brasília Formosa* (2010), dir. by Gabriel Mascaro. Plano 9 Produções. Original in colour

Figure 3.20. *Avenida Brasília Formosa* (2010), dir. by Gabriel Mascaro. Plano 9 Produções. Original in colour

screen, present visual obstacles that spectators would not normally have to deal with during the cinematic experience. This very conscious decision to deprive the viewer of the full picture is registered in the final scene when Cauan engages in a play fight with an invisible foe. Sheltered by a newly built wall that keeps the pounding waves at bay, he scoops up sand and throws it off-screen right before fleeing in the opposite direction as return sand missiles splatter in the water at his feet (Figure 3.21). Mascaro's tendency to withhold information means that characters and situations remain ultimately elusive and unknowable.

Figure 3.21. *Avenida Brasília Formosa* (2010), dir. by Gabriel Mascaro. Plano 9 Produções. Original in colour

Figure 3.22. 'Brasília Teimosa' series (2005), © Barbara Wagner. Original in colour

As Migliorin underlines, *Avenida*'s political punch lies in its very instability, 'na própria inconsistência de qualquer ponto de vista privilegiado sobre aquele espaço' (2010: 49). It brings to mind in some respects Barbara Wagner's 'Brasília Teimosa' (2005) – a series of photographs of the community's residents at leisure on the local beach that distances itself from documentary using an aesthetic approach more akin to the world of fashion advertising (Figure 3.22) – though the aging and pot-bellied figures evidently subvert the latter's conventions of lean and youthful beauty. Both hold a dialogue with

personal desire and the way an individual wishes to be seen by others, at the same time as breaking away from aesthetic conventions to question the historically limited access to certain modes of representation. If we accept Jean-Louis Comolli's propositions that successful filming should aim not to *capturar* but to *transformar* and that a spectator in turn needs to *crer* and *duvidar* simultaneously, it certainly seems that *Avenida* approximates this ethos (Comolli, 2008: 41, 46). Likewise, Edgardo Dieleke's call for 'an "untameable" gaze that does not lead the spectator to a comfortable identification with a character, nor simply provoke a reaction of pity' will find plenty to satisfy it in this film of oppositions and unresolved tensions (Dieleke, 2009: 77).

São Paulo: Occupying the Centre

As a megacity with a metropolitan population exceeding 21 million, São Paulo is the largest city in South America and the world's eleventh largest by population (Brinkhoff, 2012). Its image and reputation is closely tied not only to the overwhelming nature of its scale, but also to its role as the nation's financial and business capital and to the high levels of violence and crime that have been portrayed as a constant preoccupation for its inhabitants over recent years. Unlike Rio de Janeiro, which is famously cited for the close proximity between different socio-economic populations living in relatively central zones due to its undulating geography and the tendency of many informal settlements to occupy inhospitable sloping terrain, the term *periferia* has tended to lend itself more readily to São Paulo where the great majority of *favelas* are located on the outskirts of the constantly expanding city. This is not to suggest that such a dynamic has always been prevalent, as 'until the peripheral *favela* boom that began in the early 1980s, most of São Paulo's poor were traditionally housed in rented rooms in inner-city tenements known as *cortiços*' (Davis, 2007: 34). Caldeira cites an earlier period – the 1940s to 1980s – for the predominance of this centre-periphery formation. Maintaining that from the 1980s São Paulo's development has followed a dual trajectory, she observes that a continuation of the centre-periphery split has been accompanied by an opposing movement in which different socio-economic groups have once again been brought into proximity in central areas, with walls and other increased security measures and barriers serving the function that physical distance has elsewhere (Caldeira, 2000: 213).

Whatever way we choose to interpret these shifts in patterns of urban growth and occupation, it is clear that *periferia*, despite implying a relative spatial location, is best understood here as a spatial *type* and may thus exist in the centre of a city just as readily as upon its fringes (Sá, 2007: 114). It is this intermingling and lack of clear spatial definition that appears at the

root of much anxiety and fear amongst the city's wealthier residents. 'São Paulo transformou-se num campo de batalha' writes Peixoto in the opening to his chapter on urbanism and art in the megacity, 'Uma terra de ninguém, uma área conflagrada' (2009: 393). An apocalyptic vision that registers both a certain nostalgia for a lost era of perceived order – the dream of the Modern and modernising state – and a sense of rising concern surrounding the use of central urban space by low-income or 'peripheral' groups for the purposes of informal habitation, work or commerce. The fiction film *O invasor* (Beto Brant, 2002) captures this sense of alarm at infiltration very effectively, though the theme of occupation has also found itself the subject of more earnest 'socially concerned' documentaries such as Evaldo Mocarzel's *À margem do concreto* (2005), which directly accompanies violent confrontations between the police and those attempting to 'invade' an empty apartment building.

Of course, in wealthy urban zones it is not just privately owned but also so-called public spaces that are inhospitable and off-limits to the 'wrong sorts'. In such exclusive spaces pedestrian activity and circulation is severely discouraged – a similar phenomenon is frequently observed in wealthy areas of Los Angeles where pavements or 'sidewalks' are entirely absent precisely to this end (Caldeira, 2000: 311, 327). At times, such silent territoriality erupts in open displays of hostility, as in the case of Higienópolis (the uncanny relevance of the name will not be lost) where proposals to build a metro station in this well-off Paulista neighbourhood were met with a petition by a group of local residents. The endeavour to improve accessibility via increased public transport links prompted concern at the potential influx of street activity and vendors, or what one particularly vocal resident described as *gente diferenciada* (O Globo, 2011). The proposal was subsequently moved amidst much controversy to a nearby location in an adjacent neighbourhood. What conclusions may be drawn? That accessibility and flux are being interpreted as a direct threat to the notion of place; that rights to urban spaces remain an extremely sensitive issue with the capacity to mobilise large numbers of individuals when the protection of territory is at stake (even in an age when apathy is supposedly rife and a sense of community often absent); and that interaction with and proximity amongst different social groups continue to be a very real source of horror for many in the upper echelons of society.

Even Peixoto's text, which appears to celebrate the resilient and ingenious capacity of people to find or create a place in a hostile environment from which they have been officially and legally excluded, there is tension at play between this appreciation and a recognition of the threat (to upper-middle class domination of urban space) contained within such a movement. A threat that is registered in the very language he uses, a language of conflict and battle: 'ataques', 'guerrilha urbana', 'invadir', 'reconquista', 'tomando as áreas'; of liquid infiltration by uncontrollable, formless forces: 'espalha-se',

'submerge o que encontrar pela frente', 'misturado', 'indistinção', 'fluxo', 'urbanismo liquefeito', phrases that might be used to describe a volcanic eruption, an oil spill or some other environmental disaster. Perhaps this tone is unsurprising given that the contestation and claim to unused or vacant land is at the basis of many of the great inequalities and conflicts that Brazil has struggled with over the last century (Sachs, Wilheim and Pinheiro, 2009: 47). From the historical development and present contentions of *favelas* and the world renowned Movimento Sem Terra (MST, Brazil's Landless Workers Movement), whose battles for rural reform have established one of the strongest social movement networks in Latin America, to *sem-teto* (literally 'roofless') organisations operating for the homeless in an urban milieu, the drive by low-income groups to access rights to living (and working) spaces has long been on the agenda.

The strategic use of networks and stimulation of dialogue is an integral part of the functioning of *sem-teto* organisations and of the processes that facilitate the initial occupation of a building and any resistance to the authorities' evacuation tactics or negotiation of their terms. It seems somewhat fitting, then, that both of the photographic projects analysed in this section are the product of collectives and as such are explicitly collaborative endeavours. Cia de Foto and Garapa also operate using a *rede* or network paradigm – sometimes in the procurement of funding and most often in the dissemination of their work or participation in topical discussion. For both these artistic and social organisations, individual authorship or original ownership (of images or built spaces) becomes a secondary or insignificant question in the face of more tangible collective gains – an exhibition in a gallery or securing residency in an empty block of flats, for example. Both partake of an ethos that recognises the strength of combined effort and the rewards of shared benefit.

'911'

> A quebra, o esfarelamento, a oxidação são processos inerentes a esses cenários. A fragilidade do material corresponde à falta de perenidade da paisagem. (Peixoto, 2009: 288)

This series takes its name from the number of the building it depicts on Rua Prestes Maia in central São Paulo, occupied three years prior to Cia de Foto's project (henceforth Cia) by a large group of *sem-teto* or homeless immigrants to the city. Having stood empty for over six years before this occupation led by the *Movimento dos Sem Teto do Centro* (MSTC, Homeless Movement of Central São Paulo) organisation, it is calculated that 468 families came to reside in the building over a four-year period, with a total of 1680 individuals making it the 'largest single vertical occupation of the Latin Americas' (Guardian,

2009; Cia de Foto, 2013).[40] Despite attracting press coverage exposing some positive facets of the initiative, such as the residents' construction of a large community library in the building's basement, they were finally evicted by the authorities in 2006 (Balazina, 2006). The building was re-occupied, however, with families continuing to reside there early in 2012 according to web postings (Frente de Luta por Moradia, 2011). The decision to claim (unused) central urban space is a clear act of resistance by low-income sectors to pressures to settle in peripheral zones where the only affordable housing is located and where huge commutes represent a continual drain on both time and finances. It also carries with it the benefit of increased access to public services absent in more distant areas of the city. Famous for its sheer size, the Prestes Maia building is also seen to represent a small victory for the homeless due to government rehousing concessions obtained by many residents prior to the 2006 evacuation.

Cia's working method follows a rigorous procedure of research, fieldwork, post-production and self-criticism and the project itself took place over six months – including two months of intense conviviality with the residents followed by a further four in which the collective often frequented the build-ing.[41] Their methodology is perhaps best understood as a reaction against the widespread phenomenon of opportunistic 'rapid fire' photojournalism, prone to vacate the scene before those captured on camera have a chance to fully engage with the photographers' presence. That is not to say that the group harbours illusions with regard to their own relationship with those they pho-tograph, as acknowledged in their project statement:

> Não é imparcial como se pretendem tantas reportagens feitas sobre o tema, não é engajado como as intervenções feitas por diversos artistas naquele mesmo local. É um exercício de descoberta de um lugar por olhares que se assumem estrangeiros [...] que não esconde o impacto gerado por uma presença estranha. (Cia de Foto, 2013)

Indeed, Cia is far from the only group to have taken an interest in and inspi-ration from such urban phenomena and the emblematic 911 Prestes Maia in particular. One high-profile example to do so is Julio Bittencourt's photo-graphic series *In a Window of Prestes Maia 911 Building* (2008), for which he received several international awards. Bittencourt's objective is to provide a glimpse of the diversity and 'humanity' of the building's residents (a group

40 The direct quotation is taken from Cia's project video located at: www.ciadefoto .com/911.

41 Conversation with Cia member Pio Figueiredo, 22 August 2011, São Paulo.

Figure 3.23. '911' series (2006), © Cia de Foto. Original in colour

often dehumanised by the media) using a single formal concept – framing different apartment windows from the outside as their occupants engage in various poses or gestures. In some cases these images are collated into mass mosaics, presumably to impress upon us the vast scale of the inhabitation. The marked similarity these bear to one of Cia's photographs (Figure 3.23) and the fact that Bittencourt worked alongside the collective during certain stages of '911'[42], exposes the extremely blurry and fragile line surrounding the notion of conceptual authorship in photography. It also highlights the potential risk contained in any collaborative enterprise within an artistic domain, where singularity and originality are so highly prized.

Moving away from a traditional documentary aesthetic – which encourages the minimal use of post-production techniques or overt manipulation of photographs – Cia's dramatic images capture residents and communal spaces of the building on the brink of a forced evacuation. The thirteen photographs and one five-minute video (an extended sequence of still images accompanied by a musical soundtrack) that make up the '911' series depict a dark environment of urban decay. For the purpose of this analysis I focus on photographs selected for the principal essay rather than the broader spectrum contained in the video. The collection is composed of empty interior scenes and posed individual portraits of occupants taken against the uniform backdrop of an inner patio. Cia's decision not to show the impressive

42 Conversation with Cia member Pio Figueiredo on 22 August 2011, São Paulo.

Figure 3.24. '911' series (2006), © Cia de Foto. Original in colour

exterior of the building – though the patio is open air, it is nestled between its two tower blocks and thus retains an inner and inward-looking quality (Figure 3.24) – allows their gaze to rest upon internal spaces, namely a stairwell, corridor and communal bathroom. These are both public and interstitial or transitory zones, designed for temporary use or passage rather than as destinations or spaces for inhabitation. This focus on 'in-between' spaces reflects the occupants' ongoing experience of and relationship with their urban environment as a place of temporary shelter, consistently overshadowed by uncertainty and instability (as testified by the evacuation that awaits them). Likewise, we might interpret a broader commentary on the nature of the contemporary metropolis as a territory marked by such 'espaços fraturados' and 'vazios' just waiting to be occupied by the resourceful (Peixoto, 2009: 398, 404).

The interior scenes privilege an awareness of layers, partly achieved through a focus on peeling and decaying materials and partly via the juxtaposition of different textures or the use of light to create contrasts. In Figure 3.25, for instance, it appears that a telephoto lens has been used to compress the visual distance between elements in the foreground and background of the image, which together with the photograph's monochromatic appearance serves to flatten the image and highlight geometrical form. Although this emphasis on form may remind us of modernist photographic traditions, the peeling paint and worn surfaces, damp and mould that the image also registers undermine the crisp and more sharply defined lines and contrasts we might expect to find in pictures of that ilk. Despite the fact that the doorway and stairwell are both the focal point of the image, neither are

Figure 3.25. '911' series (2006), © Cia de Foto. Original in colour

accessible – the former is closed and, due to the angle of the shot and its lack of depth, appears blocked by several preceding layers of concrete, whilst the stairs designed to facilitate movement are invisible to the viewer. This serves as a suggestion of the very physical inaccessibility of urban living spaces to the homeless, or perhaps as a reminder to us as observers of our own incapacity to access a world that we might pretend to know through photographs.

In Figure 3.26, a corridor whose walls are made from fragments of wood and other discarded materials takes on the form of a radiating spiral as light filters in through windows and doors along its passage, once again creating a layering effect. Likewise, in Figure 3.27, it is not the dank conditions of the bathroom that first jump out at the viewer (though they are clearly apparent) but the illuminated form of a cross at its centre. A sign of the power and prevalence of religious belief and the hope that sometimes accompanies it? Or simply some playful visual tactics? The ambiguity of such images contributes to their strength and complexity, drawing them beyond the realm of the didactic and into the dialectic. This use of light to emphasise symbolic form over material degradation is another element of the group's work that places it closer to the world of art than observational documentary.

Perhaps the most salient aspect of Cia's movement away from the 'reality' that documentary photography has long endeavoured to represent is their heavy use of post-production techniques and digital manipulation. Indeed, the impression of layering that permeates so much of the imagery is also linked in a very practical manner to the post-production process. Superimposing copies of the original image using computer software, layer upon layer is built up and contoured as a sculptor might mould clay. This

Figure 3.26. '911' series (2006), © Cia de Foto. Original in colour

Figure 3.27. '911' series (2006), © Cia de Foto. Original in colour

technique results in the dramatic contrasts of light and dark tonality that are particularly evident in the portrait photographs and which play a key role in the creation of what is an intense and almost theatrical space. The process of constructing the final images thus brings them closer in many respects to an artistic composition than a photographic document.[43]

43 Technical production discussed with Cia member Pio Figueiredo, 22 August 2011, São Paulo.

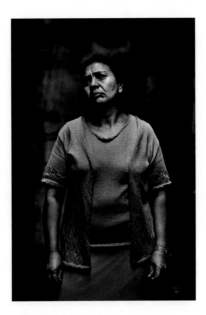

Figure 3.28. '911' series (2006), © Cia de Foto

There is nothing here of the traditional documentary ideal of minimal inter-ference, where the photographer should endeavour to alter as little as possible the course of events going on around them, erasing their presence from the scene as it were (Meyer, 1995: 11). The protagonists stand in centre frame and in many instances stare directly at the camera, exhibiting wildly divergent expressions, from what might be interpreted as despondent misery to a mim-icking of the overtly self-confident postures of poster boys or simply guarded composure (see Figures 3.28 to 3.30). In each case, absolute awareness of the photographer is demonstrated, for whom these poses are indeed performed. A certain dialogue exists between some of these images and those taken over a century earlier by photographers keen to expose poor living conditions in city slums, such as the portrait 'Shoeshine Boy' taken by Jacob Riis (*c*.1890) in New York.[44] Such practices have since been criticised for consistently ren-dering low-income populations as passive victims in the public eye (Wells, 2000: 82–83). Also common around the turn of the twentieth century, ethno-graphic photography – often motivated by desires to substantiate highly prej-udiced 'scientific' claims about racial difference – provided another forum for exploitative behaviour towards those of lower social standing.

44 The photograph may be viewed via the Getty Images archive, www.gettyimages
.co.uk.

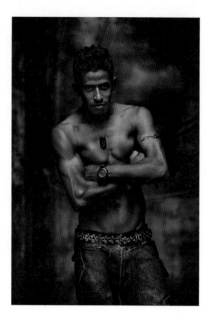

Figure 3.29. '911' series (2006), © Cia de Foto. Original in colour

What then of Cia's attitude to this photographic heritage and the power dynamic present in the encounters of which they are participants and 'documentarians'? As suggested above, there is strong cause to believe that the group's work references such traditions, for instance in their choice of a homogenous backdrop which results in a greater emphasis upon the physical differences between those photographed, the frequent use of a frontal angle and even, we might conjecture, the fact that the males appear semi-nude – in ethnographic photographs men and women would often appear fully nude as in the example of Walter Hunnewell's 'Inhabitant of Manaus', from 1865. However, these references are subsequently shattered through the stylistic choices the group makes. The portraits show the protagonists framed from the knee upward in a typical cinematic three-quarter or 'American' shot, rather than exhibiting the body in its entirety as ethnographers keen to catalogue human features were prone to do. Their facial and bodily expressions, which are rendered in a visual language more akin to advertising or cinema, draw us away from the field of scientific observation and towards a world of fiction, fantasy and desire. As with *Avenida*, we experience the impression that those photographed are (to a limited extent) collaborators in the creative process, actively engaged in consciously projecting characteristics and emotions with which they wish to be identified. This idea is compounded in the short video in which we witness people move unexpectedly across scenes that initially appear entirely static, undermining the notions of fixity and

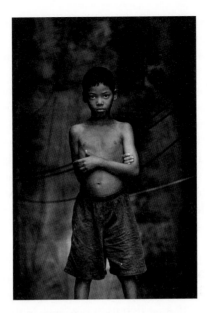

Figure 3.30. '911' series (2006), © Cia de Foto. Original in colour

passivity that we often associate with photography. Likewise, in choosing to photograph the occupants in the semi-public space of the patio (rather than in their apartments, for example) Cia acknowledges the public nature of these interactions in which fluid and changeable personas rather than private personalities are portrayed.

In many respects, Cia's approach may be regarded as a legacy of an earlier period of scepticism within the anthropological field itself, in which the values historically attributed to photographs came under serious scrutiny. As visual anthropologist Elizabeth Edwards observes, 'photography, especially its role in the production of the colonial body as an anthropological object, became a key site of cultural critique in the 1970s' (2011: 160). Edwards draws particular attention to the negative opinion surrounding any use of posing or acknowledgement of the subjects' awareness of the camera in anthropological practice during the first half of the twentieth century:

> Looking into the camera, in self-conscious representation, marks the presence of the subject, the author, and the viewer, challenging the authority of the anthropologist as it disrupts the sense of immediacy, spontaneity, and naturalism on which observational validity and illusionistic re-presentation is grounded. (2011: 162)

There is definitely nothing spontaneous about the carefully crafted images that Cia have laboriously produced, which in turn transform the above

criticism into a reflexive technique. Destabilising the authoritative position of the image producers paradoxically becomes part of their mission, undermining in the process a traditional equation between image and knowledge production.

Are Cia's photographs ultimately about creating and celebrating beauty and strength in the face of adversity and conflict? Or are their dramatic contours and dark intensity a way of denouncing the injustices that the photographers witness as they interact with those struggling to secure the basic human right to shelter and a home? There is, of course, no straightforward or definitive answer. As Susan Sontag is wont to remind us, 'photographing is essentially an act of non-intervention' (1979: 11). The collective makes no pretension to effect concrete social change, which, of course, does not preclude a desire to promote awareness of the issues at stake. We might simply conclude that in listening and reacting to the experiences of 911's occupants over that troubled six-month period, Cia have not only captured something of the quotidian environment beyond the frenetic encounters with the police broadcast by the media, but have also created a valuable record of their own response to the aesthetic and ethical challenges that their presence in the building stimulated.

'Morar'

> Perdeu-se a relação entre construir e morar. Quando se muda sempre de lugar, criam-se abrigos, não testemunhos culturais. (Peixoto, 2009: 301)

Although both '911' and 'Morar' may at first glance appear to focus upon almost identical themes, it should be noted that the contexts in which the images were produced are in fact markedly different. Both apartment blocks are located in a degenerated downtown area of central São Paulo with little more than a fifteen-minute walk to separate them. Somewhat ironically, they are relatively close also to the bustling financial hub of Avenida Paulista. The most obvious contrast between the two environments occurs then not in geographical but in legal terms. Edifício Mercúrio – the subject of Garapa's 'Morar' project – was constructed in the 1950s, specifically to house some of the vast numbers of migrant workers attracted to the booming city. Unlike 911 Prestes Maia, it was not the site of an *invasão* or illegal occupation and when the order for its eviction came into force in 2008 it affected families who were paying both rent and bills for services – some of whom had lived there for several decades. It is hard to believe that these contrasting circumstances would not have affected both the nature of the relationship between the inhabitants and these respective spaces and the reactions of the photographers to the same. We might even perceive this in the choice of titles: although '911' is evidently a marker of the building's location, it is additionally a widely

recognised US dialling code for soliciting an emergency response; 'Morar', on the other hand, speaks of a human desire to settle and inhabit space that exists beyond any immediate or urgent necessity for shelter. From the outset this contextual contrast permeates the aesthetic approaches that the two collectives pursue.

The trajectory of the 'Morar' project has developed over two distinct phases. When Garapa first began to photograph the building in 2008 the process of evacuation was already well under way with only about 30 families remaining. Beyond this small number determined to resist the upcoming change – or simply unable to find an alternative residence – the vast majority of the 142 apartments already lay abandoned (Prefeitura de São Paulo, 2011; Garapa, 2013a). The first stage thus documented the building on the brink of this final *esvaziamento*, a process that the group accompanied over a period of four months.[45] The building remained empty and unaltered for several years following the eviction – testifying directly to the slow bureaucratic processes in play – with the decision in 2010 to finally demolish it prompting the second stage of the project. At this decisive moment the collective resumed contact with the families they had previously photographed in order to retake their portraits, using the opportunity to explore life changes resulting from the enforced move, their memories of a former home and their reactions to its destruction.

Rather unusually, Garapa succeeded in financing the second stage of the project through a crowdfunding website, a technique more commonly employed for film projects than still photography and facilitated here precisely by the group's ability to mobilise people and capital in functioning as a network.[46] They have also created a blog to which information surrounding the project is continually added and updated (http://morar.tumblr.com/). This approach offers the work itself as a dynamic process developing through time, overturning traditional perceptions and practical expectations of the artwork as a crystallised product readied for final consumption. For the purpose of this analysis, my focus lies on a series of twelve photographs and a short video produced during the initial stage of the project in which the building underwent its contested transition from a living space to one entirely emptied of human presence.

The most immediate visual difference between the projects of the two collectives is their highly contrastive stylistic approaches. Where Cia create

45 Information regarding the timeframe and development of the project and the collective's contact with residents was gained through conversation with Garapa members on 23 August 2011, São Paulo.

46 The crowdfunding site used is http://catarse.me/pt/projects/100-morar.

a hybrid world in which desire, material precariousness and beauty are permitted a dramatic entanglement, Garapa aligns itself with a naturalistic aesthetic closer to the tradition of straight documentary photography. Of course, the images are subject to the usual degrees of manipulation that occur 'naturally' during the photographic process. This is what Joan Fontcuberta describes as the 'pequeña dosis de "manipulación"' with which each image is born, resulting from the inevitable selection process of framing, focusing and timing (2007: 125–126). The digital images that Garapa's photographers produce, however, do receive additional and varying degrees of digital post-production treatment.[47] This is less intrusive and clearly intended to appear less obvious to the viewer than that carried out by Cia's members, who place a strong emphasis on precisely this creative aspect of their work. Of course, given the impossibility of generating a neutral viewpoint, we might choose to be more wary of alterations glossed over using a realist visual code than of foregrounded artistic interventions. As subsequent observers, the decision ultimately to place our trust (or not) in the intentions, integrity and capabilities of the photographer(s) is a matter of individual choice.

Fontcuberta is quick to remind us that 'el realismo no tiene nada que ver con "la realidad", que es un concepto vago e ingenuo; el realismo sólo adquiere sentido en tanto que opción ideológica y política' (2007: 156). Rather than creating a world nestled on the fringes between fact and fiction, Garapa's aim to increase the visibility and awareness of what it perceives to be a gross social injustice is driven by an underlying desire to alter political will, and with it a course of related events in a way that benefits the individuals involved (Setefotografia, 2011). Their adherence to a realist aesthetic is thus based upon a desire to inspire credibility in an existing state of affairs, just as we might interpret their use of technology to visually 'enhance' the scenes as an endeavour to inspire positive responses towards their leading protagonists.

Whilst Cia are directed by an inward-looking focus, Garapa chooses to contextualise Edifício Mercúrio within its surrounding environment (Figure 3.31). Towards the bottom left-hand corner of the image we see the large Mercado Municipal Paulistano, appearing almost as a horizontal reflection of the towering Mercúrio. This may be a reference to the fact that many of the residents worked in the market and its surrounding area and, therefore, to the high impact that relocation will have had upon their working lives. Of the many residents employed in the informal sector the majority will have experienced difficulty in procuring alternative rental properties, as obtaining the necessary documentation often relies explicitly upon formal

47 As discussed in conversation with Garapa members, 23 August 2011, São Paulo.

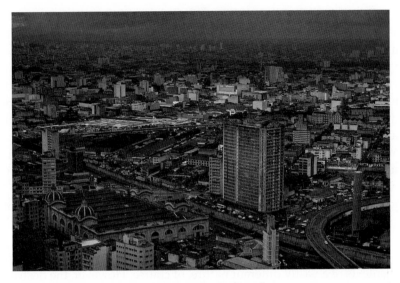

Figure 3.31. 'Morar' series (2007), © Garapa. Original in colour

employment. As DaMatta points out, 'documentation, legalism, and power are interrelated in a deep cultural equation, an association that affects the constitution of citizenship and the way in which Brazilians utilize the public services of their country' (1995, Working Paper 10: 41). Such factors play an integral part in perpetuating many exclusionary cycles which contribute, along with more obvious economic barriers, to preventing 'formal' and central zones of the city from becoming realistic zones of habitation for the city's large unofficial workforce.

This same image of Edifício Mercúrio, set amidst a vast urban expanse, has been used as the basis for the short video mentioned above. Lasting four and a half minutes in total, it is not until about halfway through that we become aware that the building is gradually disappearing from the otherwise static scene at a speed almost imperceptible to the human eye. The exercise introduces qualities of temporality and duration into the static realm of the photographic image, interfering with the concepts of fixity and instantaneity so central to the medium – much as Cia members achieved through the use of movement in their own video. The soundtrack accompanying Garapa's online video is a recording of a previous audience reaction to the projection when it was exhibited in 2011.[48] As we watch, we are thus aurally connected to a distant group of viewers appreciating the scene in another space and

48 This seems reasonable to infer from the title 'Vídeo exibido no VII Paraty Em Foco, em 2011'.

time. Amidst coughs and shuffling, the sudden realisation that the building is disappearing provokes an outburst of laughter – a reaction totally at odds with the emotional significance of what the imagery represents and one which lays bare the potential chasm between production and exhibition contexts into which meaning may fall. That Garapa chose to re-exhibit and foreground such an apparent incongruity on its website – further multiplying the video's reach across space and time – shows an openness to acknowledging those pitfalls that are, after all, beyond the artist's control.

We might compare this visualisation of Edifício Mercúrio's permanent erasure from the urban scene to the dramatic gesture in which São Paulo's Carandiru prison was wiped out in 2002. As commented in chapter 2, *O prisioneiro* (2004) actually shows the footage of Carandiru's implosion in reverse, suggesting the futility of the state's endeavour to erase associated negative memories of human suffering and its own incompetence from public consciousness via the building's physical destruction. We are referring to two contexts of a vastly different nature, of course. However, the destructive gestures are motivated by the same desire to stimulate fresh investment and usage of a particular urban space by symbolically severing its links to the past – a history in these two examples of urban living spaces occupied either forcefully or freely by predominantly low-income populations. Whilst the motivation for Carandiru's demolition seems entirely comprehensible, we may struggle to see the rationale behind Edifício Mercúrio's demise and the resulting loss of low-income housing at a time of shortage and high demand for the same. In this light, the audience's reaction of laughter we hear during the video becomes itself a strangely fitting, if unintentional, reflection on the absurdity of the situation.

The emphasis that Garapa places upon both memory and context introduces us to several vital forces at play through the series, which themselves pose challenges to some fundamental beliefs about photography and its relation to politics and ideas. In her seminal work *On Photography*, Sontag draws attention to the limitations of the medium by stressing its inability to narrate (an activity which necessarily takes place across time), its instantaneous nature making it an unsuitable vehicle for conveying knowledge or generating understanding (Sontag, 1979: 23). Although acknowledging its capacity to rouse the conscience, she goes on to conclude that 'the knowledge gained through still photographs will always be some kind of sentimentalism' (1979: 24).

Whilst this argument continues to hold weight in relation to a great deal of photographic practice today – particularly when applied to individual images – such limitations are also being imaginatively stretched and tested. Analysing 'Morar' as a series, we may appreciate that the photographers have been able to generate a sense of the passage of time in a way that does

not occur in '911', for example. That is not to say that Cia's photographs capture nothing of the idea of duration, as the crumbling and worn surfaces they focus on are testament precisely to time's passing. However, Garapa's approach – which has consisted in revisiting and re-photographing specific places and people in order to record the site at various stages of its transformation – has been instrumental in fostering a sense of narrative progression in relation to both the space and the people so clearly attached to it. The project has in this way tied itself to the story of the building; hence the photographers' decision to resume their work after its fate is sealed in order to record its final chapter. The residents' willingness to extend their engagement with the photographers, though they are in fact no longer 'resident' and the cause itself appears lost, also reflects positively upon the nature of the relationships established during the course of these encounters.

In Figures 3.32 and 3.33 we witness one of the physical consequences of the evacuation in very dramatic terms. What is recognisable in the first image as the entrance to the building – its name engraved above the double doorway – is so altered in the second image that the contrast barely allows us to acknowledge it as the same view. What has changed? To avoid the risk of people invading or returning to the apartments the entranceway and the windows above it have been walled up with concrete breeze blocks. Graffiti artists subsequently adopted this new façade as a blank slate on which to create their own colourful responses to the city council's action. With access denied, the building has been converted from a private living place into a public spectacle. Yet another more radical transformation has led to its present state as a vacuum, one of Peixoto's 'terreno[s] vago[s]' in which past and future clash, at once a space of loss and of potential and possibility (Peixoto, 2009: 398).

The photographs of residents consist of both portrait-style poses in which the women look directly towards the camera, fully engaging with its presence, and more 'observational' style imagery designed to privilege the inhabitants' relationship with their environment above any interaction with the photographers. Amongst this latter group, Figure 3.34 presents us with a scene of particularly striking contrasts. The figures of two children, backlit against the light streaming through the apartment window behind them, occupy the centre of the frame. A woman's face (their mother perhaps) appears in the left-hand corner of the image but remains out of focus and obscure. The features of the young boys are likewise concealed and separated from the viewer by the veil of a lace curtain or their position relative to the camera. Through the soft floral pattern of the lace we pick out the sharp lines of thin metal bars stretched across the window frame. An image of shadows and silhouettes, it hints at the intimate detail of family life housed within the building's walls: a material and emotional existence that is rendered vulnerable in the absence of more robust and protective legal structures.

Figure 3.32. 'Morar' series (2007), © Garapa. Original in colour

Figure 3.33. 'Morar' series (2007), © Garapa. Original in colour

The suggestion of an inhabited space may be powerfully conveyed without the presence of human bodies, of course. In Figure 3.35, for example, our gaze rests upon a small vase of artificial flowers sitting on a table. A harmonious green hue links the flowers to both the live foliage of trees outside the window and a woollen jumper resting over the back of a chair. A belt lies discarded on the adjacent tabletop, awaiting its owner. Pale lace curtains, draped on one side and carefully knotted on the other, reveal a strip of brown sticky tape

Figure 3.34. 'Morar' series (2007), © Garapa. Original in colour

fastening a crack in the broken windowpane. These are objects that bear evidence of human gestures and actions. They are traces containing their own personal narratives of inhabitation and care for one's living environment. Such images contrast with photographs of already abandoned rooms whose upturned tiles, ruffled bed sheets and finally deserted items speak of the transformation taking hold of other areas of the building (Figure 3.36). In observing the significance of the work of French photographer Atget, Walter Benjamin compares the deserted streets he captures to crime scenes, suggesting that such images offer 'evidence for historical occurrences, and acquire a hidden political significance' (1999: 220). The traces of temporality that linger across the empty rooms of Edifício Mercúrio rise to the surface in the photographs Garapa produces, offering themselves as evidence of a place soon to exist only in memory.

If at any moment we believed these to be casual scenes, we are reminded of the photographers' intentionality not only through the careful and artistic composition of the images but the messages they contain. Figures 3.37 and 3.38 are a clear example of the group's endeavour to foster a narrative around the eviction in the form of a 'before and after' scenario. In the first of the two images we see a woman seated on a stool in the middle of an apartment room. The scene exudes domesticity and behind her corpulent figure we glimpse pots on the stove, a large refrigerator, an ironing board and piles of neatly folded clothes. Her wry smile and theatrical pose address the viewer with resolve, confidently asserting her position as *dona* of the space she occupies. This impression is reinforced by a caption accompanying the

Figure 3.35. 'Morar' series (2007), © Garapa. Original in colour

Figure 3.36. 'Morar' series (2007), © Garapa. Original in colour

same photograph in an online video sequence: 'aqui é ótimo! Eu não acredito que vão derrubar esses prédios, estamos com as contas pagas … acho que não podem nos tirar daqui' (Garapa, 2013b).[49] Here Maria, from apartment 56 as we learn, expresses her opinion directly just one month before the eviction takes place, believing (or perhaps trying to convince herself) that such a fate might still be avoided. In Figure 3.38 we observe Maria once again seated in centre frame, this time following her displacement. With her former hopes squeezed out of the frame, her posture and expression appear deflated and withdrawn. Perched somewhat precariously on the edge of a chair she leans away from the viewer, receding into the large pile of objects stacked behind her that likewise await rehoming. It is possible that her expression also reflects wariness and disappointment in the collective itself, in whose activities she might have understood the potential to alter the course of

49 This citation is taken from a video of the 'Morar' series.

Figure 3.37. 'Morar' series (2007), © Garapa. Original in colour

Figure 3.38. 'Morar' series (2007), © Garapa. Original in colour

events then unfurling. The effect of these posed portraits differs somewhat from that created through Cia's imagery. Here, the additional narrative function communicated via the combined impact of the woman's facial expressions and the context of the different spaces she inhabits at these two contrasting moments in time distracts from a more direct problematisation of the relationship between photographer and photographed subject and its accompanying ethnographic heritage, as occurs in Cia's work.

John Berger is careful to emphasise the danger inherent in what he terms the 'public photograph' (as opposed to images destined for a personal audience in family albums or the hands of a loved one) in which elements are so easily de-contextualised and divorced from their original meanings (Berger, 2009: 56). It is the capacity to turn 'subjects into narrators', to adopt a position in which the camera might become a 'listener' that defines, therefore, the quality and impact of the imagery that a photographer will be able to produce (2009: 48). Where Cia rely heavily upon the notoriety of the Prestes Maia squat to provide some of that context, Garapa preoccupies itself with some of the individual stories and trajectories it encounters through pro-longed contact with the space in question. In some ways the two projects pull in opposite directions: Cia's engagement with a more temporary occupation results in a focus upon the transitory, in-between and public spaces within the building, simultaneously acknowledging in this gesture the inevitably superficial nature of the images generated, whilst Garapa's desire to place Edifício Mercúrio within a broader debate and social context leads it to home in upon the private realm of individually inhabited spaces. What unites both projects, however, is a sense of injustice and indignation at the blatant depreciation and wastage of central urban space that a profit-driven capitalist system allows at the expense of those most in need.

'O muro'

It is hard to imagine an element more closely and iconically bound to the idea of territoriality than a wall. From the Great Wall of China, to the Berlin Wall, to the wall that separates Israelis and Palestinians on the West Bank or that marking the United States' border with Mexico, these structures have long been employed to demarcate political divisions: to prevent or at least moni-tor the flow of human bodies from one area to another. Whether designed to keep people out or to keep them in, walls speak to us of both 'fear and the desire for control' (Bowden, 2007). They represent an attempt to impose force and jurisdiction, delimiting bodies governed by different beliefs and inten-tions and potential threats to an established space or way of life. As Lefebvre comments, walls are both 'scenes' and 'obscene' areas – they are involved at once in bringing to attention and obscuring a perceived danger – for 'what-ever is inadmissible, be it malefic or forbidden, […] has its own space on the near or far side of a frontier' (Lefebvre, 1991: 36). Walls, with their historic and present-day ties to conflict and violence, make the twenty-first century citizen nervous. Their symbolic resonance makes them easy to demonise, of course, and we should not ignore their benign function as protective barriers – as in the closing shot of *Avenida Brasília Formosa* (Figure 3.21), where the beachfront

wall protects young Cauan from the force of pounding waves beyond, providing a sheltered space in which to play. The purpose that a wall serves, after all, depends on which side of it you stand.

Given these considerations, it is unsurprising that when the Rio de Janeiro state government unveiled plans in 2009 to build approximately fourteen kilometres of wall around thirteen of its *favelas* this should have provoked furious debate and a multitude of questions (Agência Estado, 2009). The ostensible motivation behind the project to erect *eco-barreiras* has been cited by the authorities as a concern to protect the remaining forest areas of Mata Atlântica vegetation that border the *favelas* in question, making it necessary to contain and prevent the further expansion of these settlements (Observatório de Favelas, 2009). It is but one of numerous infrastructure and service initiatives that have been driven by the nationwide Programa de Aceleração do Crescimento (PAC), created in 2007, and the state specific Unidade de Polícia Pacificadora (UPP) project whose instalment of special police units in designated *favelas* throughout Rio de Janeiro aims to 'recuperar territórios perdidos para o tráfico e levar a inclusão social à parcela mais carente da população' (UPP, 2012).

However, these endeavours continue to be viewed with cynicism and suspicion by many *favela* residents who are wary of veiled attempts by the state to carry out what *favela* eradication programmes most active between 1968 and 1975 sought to do in less subtle terms during the military dictatorship (Zaluar and Alvito, 1999: 36). The fact that many of these projects involve destroying homes in the process – alongside the 550 houses earmarked for removal during this wall-building project, other examples include the destruction of houses in the Morro da Providência and Metrô *favelas* for the construction of a cable car route and infrastructure for the nearby Maracanã football stadium respectively – has lent residents no reassurance that their interests will not be sidelined in favour of larger economic and political motivations such as those related to the 2014 Football World Cup or 2016 Olympic Games, for instance, when the city and country come under international scrutiny (Gerbase, 2011; Romero and Andolfato, 2012).

This lack of trust reaches its pinnacle in the troubled relationship between *favela* inhabitants and the police force cultivated by many violent encounters occurring over the decades. Since the mid-1980s, the presence and increasing control exercised within and over communities by drug dealing gangs has brought a new and urgent dimension to old concerns regarding the occupation of and dominion over these spaces (Perlman, 2010: 7). As Koonings and Kruijt observe, 'the police, with few exceptions, have not made the transition from protecting the state, as was their role in the time of dictatorship, to protecting its citizenry, and especially its low-income citizenry, who continue to be treated as the enemy, as was the left during the military regime', leading

them to 'adopt a war-like posture, invading *favelas* in full battle gear with SWAT-style operations' (2007: 28). With police forays into the *favelas* resulting not rarely in bloodshed and the repeated targeting of low-income civilians, their actions have been compared by many to a form of 'social cleansing' (2007: 18). The idea that Rio de Janeiro lives in a state of civil war has been promulgated by critics emphasising high death tolls and espoused by authors such as Luís Mir in his in-depth study of violence in Brazil *Guerra civil: estado e trauma* (2004).

In the cultural arena, this focus upon the *favelas* as zones of violence has been reflected in the creation of combat video games featuring *favela* scenarios such as 'Modern Warfare 2' – where the Cristo Redentor statue appears in the background, situating the player firmly in the iconic Rio de Janeiro – and the online game 'Fuga da Vila Cruzeiro' which was released shortly after and as a direct response to the events of 25 November 2010, in which the Batalhão de Operações Policiais Especiais (BOPE, Special Police Operations Battalion) invaded the Vila Cruzeiro settlement causing a mass exodus of drug traffickers. The web game is clearly directly based on images from Globo's television coverage of the event and invites players to choose whether or not to fire at the largely pedestrian figures fleeing across the scene.[50] The experience of urban space as divided into regulated territories is an everyday phenomenon for some residents of *favelas* where drug traffickers operate, with allegiance to commanding gangs limiting the flux of people between non-affiliated zones (Koonings and Kruijt, 2007: 25). Under such circumstances, we might easily comprehend how the idea of the *cidade partida* entered currency as a popular term alongside the notion of a city divided into zones of 'ordem' and 'desordem' (Z. Ventura, 1994: 90). The fact that the term *cidade dual* became fashionable during an electoral campaign, however, indicates the extent to which it was aligned from the outset with a political discourse interested in capitalising on existing concerns for public security and indeed strengthening and aggravating new ones (1994: 90). As with any successful slogan or stereotype, it lends itself to repetition and reproduction. In portraying itself as self-evident 'fact' it dispels the desire or need to be unpacked and questioned.

With such tensions deeply embedded in the landscape and the mentalities and attitudes that surround it, the decision to build a wall around the edge of these areas takes on a particularly violent and calculating quality. It is into this unsettled climate that the Garapa collective entered in order to document

50 The game and TV footage have both been posted on YouTube: 'Fuga da Vila Cruzeiro, o jogo' https://www.youtube.com/watch?v=B9U3oCWkdig, and 'Helicoptero abatendo traficantes em fuga na Vila Cruzeiro - RJ - 25/11/10' https://www.youtube.com/watch?v=PDPMPesOaQg

the first recipient of the wall-building scheme, the *favela* of Santa Marta (also known as Dona Marta) near the well-to-do neighbourhood of Botafogo in the south of the city. Initially commissioned by the Wall Street Journal to provide photographs for a short article, the group later returned under the banner of the Encontro de Colectivos Fotográficos Latino-Americanos e Europeus (E. Co, Conference of Latin American and European Photography Collectives) in an attempt to gain a deeper understanding of what was occurring within the community. 'O muro', a series of nine analogue photographs and one short stop-motion video, is the product of this period of further research.[51]

Santa Marta has not been short of public attention over the years. The location for the documentaries *Santa Marta: duas semanas no morro* (1987, directed by Eduardo Coutinho) and *Notícias de uma guerra particular* (1999, directed by Kátia Lund and João Moreira Salles), it was also famously visited by Michael Jackson in 1996 in order to film scenes for his music video 'They Don't Care About Us' and by pop queen Madonna in 2009 during a charity tour. Given its position in the limelight, perhaps it is unsurprising that Santa Marta should have been chosen as the first of Rio de Janeiro's *favelas* to be 'pacified' via the UPP system in 2008.[52] However, this association creates an unsettling disjuncture, as many will struggle to reconcile the UPP's proclaimed objective to establish peace in zones notoriously linked to violence with its endorsement of wall building. For walls fracture space; they are physically and symbolically indicative of rupture (Peixoto, 2009: 369). It is hard to see them as instruments of harmony when they testify so directly to a conflict of interests – a wall is erected to block another's perceived or anticipated desire to escape from or to infiltrate a designated area.

Even prior to its termination the wall had successfully created a sharp rift in public, official and journalistic opinion. Although the explanation from the government is a straightforward one – that of preventing Santa Marta's inhabitants from entering and potentially constructing further housing in the adjacent forest – suspicion of this justification has stimulated diverse opinions and speculation about possible ulterior motivations. Such mistrust appears justified when we consider that 'segundo dados do Instituto Pereira Passos (IPP, Pereira Passos Institute), o Santa Marta foi uma das favelas

51 Information gained from conversation with Garapa members, 23 August 2011, São Paulo.

52 According to the official website http://www.upprj.com/, 38 out of the city's approximately 800 *favelas* now have an UPP presence; many of these are situated in or near Rio's wealthy and touristic Zona Sul or south zone (calculations of the total number of *favelas* have oscillated over recent years between 600 and over 1000 according to varying methods of classification). See the Estado de São Paulo online article for a further discussion of the matter (Leal, 2011).

que não registrou expansão territorial entre os anos de 1998 e 2008. Pelo contrário, a comunidade encolheu em 1%' (Observatório de Favelas, 2009), a statement that explicitly undermines the argument that the wall is a *necessary* eco-barrier to contain the *favela*'s expansion. The collective's stop-motion video containing interviews with numerous residents brings to the fore their impression of the project's futility: with Santa Marta already naturally bounded and unlikely to expand, the estimated R$40 million budget designated by the government cannot but be seen as wasteful in communities where improvements in housing, education and healthcare facilities are cited as key priorities for development.[53] A short video report by British director Phil Cox brings to light additional interests in the form of the police force's appreciation of the wall as a tool to limit entry and exit points to the community, thus facilitating their pursuit of criminals (2010).

International reactions to the project appear in the O Globo article cited above, which focuses on the inadequate response of Brazilian officials faced with the statement of a concerned UN human rights specialist that 'sociedades democráticas não erguem muros' (Agência Estado, 2009). Likewise, the *Wall Street Journal* interprets the wall as a symbol of inequality, suggesting that its purpose has more to do with curtailing freedom and reassuring the wealthy than protecting the environment (Regalado, 2009). The Guardian, on the other hand, examines the official line, citing the impact of urban deforestation in Rio de Janeiro during the past three years and leaving us with an ambiguous statement from a resident about the possible psychological effects of living alongside the wall. It is interesting to note the observation drawn from a public opinion survey by the Datafolha research institute that 'quanto menor a renda e a escolaridade do entrevistado, maior a aprovação à construção de muros no entorno das favelas' (Datafolha, 2009). One way to interpret this information is to suggest that a lack of knowledge of the historical and cultural contexts in which walls have been used to exert power over people and spaces significantly reduces an appreciation of their symbolic weight. The controversy attached to the wall is as much about the message it conveys as it is about cement and mortar.

How then do the Garapa photographers respond to the material and psychological aspects embedded in such divisive circumstances? In a contextualising movement similar to that created in the 'Morar' essay, the collective sets the scene with an 'establishing shot' of Santa Marta, much as one would expect to find in a film (Figure 3.39). The image is taken from a position outside the settlement and we look out first over the rooftops of large buildings at the

53 The video may be found on the collective's website (Garapa, 2013c), and the estimation of costs in an *O Globo* online newspaper report (Agência Estado, 2009).

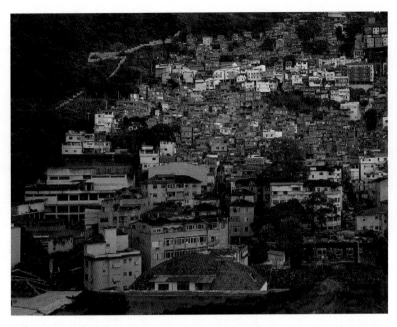

Figure 3.39. 'O muro' series (2010), © Garapa. Original in colour

edge of the Botafogo neighbourhood before these merge into the more com-
pact 'informal' housing of Santa Marta, rising up the crowded hillside into
the distance. Light illuminates parts of the *favela*, whilst the foreground and
background of the image rest in shadow. However, the overall effect stresses
not contrast but continuity, as the two contiguous zones blend into a single
residential space. From this distant perspective the *favela* dwarfs the wall that
snakes diagonally alongside it across the top left-hand corner of the photo-
graph, its jagged contours echoing the jutting rooftops. Bordered to the left by
an expanse of forest that appears to swallow it in places, the wall even appears
flimsy and relatively insignificant. Yet this does not prevent the eye from being
repeatedly drawn to and distracted by what is essentially an unnerving scar
upon the landscape. Reminiscent of Roland Barthes' *punctum*, we might like-
wise describe it as a 'wound', 'prick' or 'mark', a 'detail […] which attracts
or distresses' the viewer (Barthes, [1979] 2000: 26, 40). It is interesting to note
that the image featured on Santa Marta's official UPP profile webpage at the
time was a view *from*, rather than *of*, the *morro* (although the photograph has
since been removed, Figure 3.40 shows an example of this well-known vista)
and one which thus avoided directly engaging with this new feature of the
landscape.

The second image of the series brings to the fore questions surrounding
the demarcation and recognition of boundaries using an animal emblematic

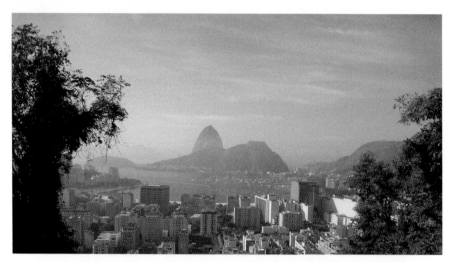

Figure 3.40. 'Sugar Loaf from the favela Santa Marta' (2011), Monomakh. Source: Flickr. Original in colour

of territoriality, the dog. It should be mentioned at this point that if we look at the photographs in the order they appear on Garapa's website, what we observe is a pendulum action in which the gaze, having absorbed the wider scene through the initial contextualising frame, shifts from one side of the wall to the other and back again, before coming to rest directly upon it. For the purpose of this analysis I look first at the images taken within Santa Marta, before examining those depicting the other side of the new boundary, and finally the material frontier itself.

A well-fed dog lies across a step, ear cocked, head turned to rest its gaze upon us as it blocks the entrance to a house with its body (Figure 3.41). Whilst not overly hostile, this obvious spatial encroachment has nonetheless elicited suspicion and a watchful concern. In Figure 3.42 the reaction to the photographers' presence is a more aggressive one. The camera looks down from a neighbouring rooftop onto what might be a front or back yard, finding its focus on a barking dog. Raised upon its hind legs it stares back at the invasive eye as it sounds the alarm of intrusion. Once again the observer's external status is the subject of the photograph. The backdrop of a blue tarpaulin separating the dog's territory from another yard beyond also reminds us of the many benign barriers that form a part of our daily lives, those we choose to erect around ourselves and come to rely on for the protection of privacy in any shared living environment.

The rustic wooden façade that fills the frame in Figure 3.43 speaks of the rural origins of the *favelas* and their connection to nature – not only did most of their inhabitants initially hail from the countryside but the land that they

Figure 3.41. 'O muro' series (2010), © Garapa. Original in colour

Figure 3.42. 'O muro' series (2010), © Garapa

occupied upon arrival was by necessity unsettled rural or scrubland at the edges of the city or, in the case of Rio de Janeiro, often forested hillsides close to its heart. From this 'still life' – in which the careful arrangement of a draped curtain, flowers and the corner of a picture frame in an otherwise obscure interior conjure an impression of humanly imposed order – we move to the wilderness of exuberant greenery nearby.

Figure 3.43. 'O muro' series (2010), © Garapa. Original in colour

Mankind's attitude to nature has long been a conflicting and contradictory one. Considered on the one hand as a brutish force representing the opposite of the 'civilised' world, on the other hand it has served to feed romantic notions of an ideal way of life (Berger, 2009: 17). The latter interpretation signals precisely freedom and release from the more repressive aspects of the modern world we humans have anxiously constructed for ourselves. Tropical nature has played an integral role in the Brazilian cultural imaginary, from romantic and regional literature – José de Alencar's landmark *Iracema*, first published in 1865, paved the way in this domain (1990) – to Modernist artworks such as Anita Malfatti's *Tropical* (1916). Such imagery, together with the ideas surrounding racial mixing and hybridity that it brought to the fore, played a key part in forging 'interpretations of the "imagined nation"' (Stepan, 2001: 124). Nancy Stepan points out that shortly after the abolition of slavery in the 'national census of 1890, 65 percent of the population was estimated to be black or various shades of brown […]. Thus Brazil in no way approximated the white norm considered essential in Europe to civilized development' (2001, 125).

Negative views surrounding the country's tropical climate and racial mix – deemed by European observers to be highly conducive to physical and social degeneration – would leave a lasting impression on a Brazilian elite anxious to affirm their European heritage (Stepan, 2001: 125). Only in the 1930s with theories espoused by the father of 'Lusotropicalism', sociologist Gilberto Freyre, did these characteristics begin to be embraced as factors that might contribute positively to the idea of a unique Brazilian identity

Figure 3.44. 'O muro' series (2010), © Garapa. Original in colour

(Stepan, 2001: 145). It is important to note, of course, that his assertions of the existence of racial harmony would do as much in their own way to stifle the acknowledgement of racial inequality as earlier attempts to deny or mask Brazil's racially mixed heritage had done. Another prominent later example of the way in which hybridity has continued to be celebrated in Brazilian culture may be found in the artistic Tropicália movement of the 1960s, which drew on diverse musical influences to create innovative fusions.

Garapa's engagement with these ideas comes to the fore most prominently in Figure 3.44. Naked and anonymous, the back of a man's head and shoulders are framed from a low angle against the backdrop of a tree. As we peer upwards, light piercing the canopy bounces off the dark skin of his broad shoulders. His body appears to take the place of the lower tree trunk; he becomes the structural support from which the tree's branches and leaves spring. The camera angle immediately suggests idealisation of the subject and plays upon historical evocations of the 'noble savage', the quintessential romantic and primitive 'other'. To test whether the image really does contain a race-related message, we might imagine instead a white man in exactly the same position. Do the connotations of the image change? Perhaps we think now of religion, of Adam in the earthly paradise of Eden. My point is that such imagery is laden with uncountable layers of cultural sediment and that we each bring to every image our own individual and collective baggage. In addition to simply highlighting the immediate enjoyment of nature by Santa Marta's residents (in the process of being curtailed by the imposed wall, of course), Garapa's decision to employ such loaded references engenders a point of articulation with the complex historic understandings and prejudices surrounding race and national identity. The image also leads us towards the following questions: how much is anxiety over the reinforcement

Figure 3.45. 'O muro' series (2010), © Garapa. Original in colour

of boundaries a legacy of older concerns influenced by (negative) portrayals and interpretations of racial difference? And to what extent might we consider racial concerns to have been superimposed by and absorbed into overarching and ambiguous 'social' concerns in the context of contemporary Brazil?

Human figures are absent from the next two images, which are nonetheless powerfully suggestive both of some of the attitudes historically directed towards *favelas* and of the new dynamic created by the wall. In Figure 3.45, for instance, we observe a vine tightly wrapped around the trunk of a tree that stretches up the centre of the frame. Whilst not all vines exert a negative impact on their host environment, they are commonly perceived as destructive and pernicious organisms that weaken and often eventually kill the plants that they latch onto. When we consider the way in which *favelas* have been presented in the past as a 'perigo a ser erradicado pelas estratégias políticas que fizeram do favelado um bode expiatório dos problemas da cidade, o "outro", distinto do morador civilizado da primeira metrópole que o Brasil teve', the image becomes a highly charged metaphor for this perceived threat (Zaluar and Alvito, 1999: 8). This time the *favelas* find themselves on the other side of the equation, however. Now rather than being likened to an uncivilised force of nature, it is nature herself who needs to be rescued from the *favelas'* constructive and civilising expansion. In Figure 3.46, these opposing tensions again rise to the surface as we observe the wall – a symptom of the regulatory desires of the city's official law enforcers – being swallowed up by the natural growth surrounding it. In this light the construction takes on a slightly absurd and futile air and is only rescued from

Figure 3.46. 'O muro' series (2010), © Garapa. Original in colour

ridicule by the oppressive and violent gesture it performs upon the eye, severing its enjoyment of the formerly panoramic vista.

Figures 3.47 and 3.48 finally draw us in close to the wall itself. In both images the structure fills the frame almost entirely, leaving only the space at its foot where the men stand amidst discarded construction materials, rubbish and the fresh green shoots of a few defiant plants. The act of photographing a person in front of a wall contains a violence beyond what Sontag cites as the 'aggression implicit in every use of the camera' (1979: 7). Walls, after all, have been the favoured sites of many firing squads over the years. Of course the gun/camera metaphor, which operates most notably via shared terminology ('shooting' etc.), is nothing new and has historically been used by advertisers to bestow a sense of power upon the latter (Sontag, 1979: 14).

Figure 3.47 shows one of the men employed to build the wall. Leaning his weight on one leg, his lopsided pose and reluctant expression suggest an awkward discomfort. He appears to be pulled in two directions at once – although he extends a hand towards the viewer in which he holds his work permit, the position of his shoulder and arm in fact suggests an opposing motion, as if he were ready to withdraw it at any moment. We might explain the strange tension captured in this image by the fact that many of the construction workers were also residents of the communities where the walls were being built. The photograph appears to comment upon the sense of conflict potentially experienced by individuals trying to reconcile short-term economic gain with the possible long-term implications of creating physical barriers around their community. As Caldeira states in

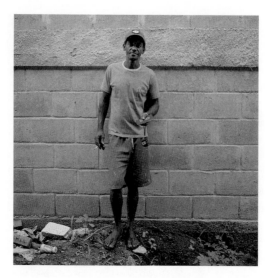

Figure 3.47. 'O muro' series (2010), © Garapa. Original in colour

Figure 3.48. 'O muro' series (2010), © Garapa. Original in colour

no uncertain terms, 'cities of walls do not strengthen citizenship but rather contribute to its corrosion' (2000: 334).

Not everyone agrees with this interpretation, however, as we may clearly observe in some of the official lines of argumentation:

Officials [...] insist the wall is being misinterpreted. After all, the city's upper crust also lives behind fences and guards. *Favelas* 'are communities just like an apartment building', says Marilene Ramos, Rio's secretary for environment. 'It's natural they would be surrounded'. (Regalado, 2009)

The shocked, angry and perturbed expression witnessed in Figure 3.48 is a rather unambiguous and visceral response to this assertion. The tattoo marking the man's right-hand shoulder echoes the scar of the wall against which his bare flesh appears in striking contrast. The distinction between the two marks visualised here – one etched across skin and the other across the landscape the man inhabits – is one that the environmental secretary fails to dwell upon: choice. Although the wall clearly does not physically segregate a poor from a wealthy area, the message it conveys is that it is acceptable to raise borders around a low-income community irrespective of and without consultation with its inhabitants. It is hard to envisage a situation where the government might decide to erect a wall through a condominium garden or local park without first consulting the neighbourhood's residents. The wall thus reinforces an existing line of separation between what kind of rights and treatment different groups of people can expect to receive from the authorities according to, as is often the case, the area they live in.

Whether taking momentum from an inward-looking dynamic that reflex-ively foregrounds the constructed nature of the medium in which they work – as occurs in *Avenida* and '911' – or creating a more outward-looking movement that stresses context and narrative – as Garapa achieves in both 'Morar' and 'O muro', the works discussed above find their own way to engage with the relationship between those who 'record' these transforma-tions and those who find themselves in front of the camera. As Caldeira notes, 'if the experiences of separateness expressed in the urban environment become dominant in their societies, people will distance themselves from democracy' (2000: 335). Embracing the desires and personal expression of the participating subjects is one way in which this tendency is counteracted within these image-making processes. Questions of time, of flux and stasis, rise to the surface here as the artists challenge traditional boundaries between media: a contemplative photographic space finding its way into film, and movement and duration seeping into the still domain of the photograph. While this chapter has centred on the concept of contested urban space across a variety of geographical contexts, chapter 4 provides us with an opportunity to consider the particular and iconic role that the *favelas* of Rio de Janeiro have played in the city, the nation and its contemporary visual cultural production.

Shifting Perspectives on/from the Morro

The essence of colonization inheres less in political overrule than in seizing and transforming 'others' by the very act of conceptualizing, inscribing and interacting with them on terms not of their choosing; [...] in assuming the capacity to 'represent' them. (Comaroff and Comaroff in Gregory, 1994: 31)

Introduction

As capital of the country during a period of almost two hundred years (1763–1960) and home to the Portuguese court from 1808 to 1822, Rio de Janeiro has occupied a historically central space in the national imagination that is not easily shaken. The loss of its political centrality following the transfer of the capital to the newly constructed Brasília in 1960, and the trauma of this identity shift, has nonetheless received very little attention over the years. In fact, there is a distinct lack of focus on the city's history as former capital, which may partly be explained by a preferred emphasis on the hedonistic clichés that have served to brand the city as an attractive tourist destination (B. Jaguaribe, 2007: 127). In discussing the reasons for the strength and growth of cultural movements geared to *inclusão visual* in the city, FotoRio curator Milton Guran opines that in Rio de Janeiro 'a situacão é mais aguda e as soluções procuradas são sempre mais urgentes e mais radicais'.[54] The idea that a special historical moment has arrived where the city is finally starting to *assumir* the *favelas*, suggests that many feel an intense process of transformation – catalysed by big international events such as the 2014 World Cup and 2016 Olympics – is already well underway.[55] Despite its relegation to a position of relative political and economic marginality, Rio de Janeiro remains a producer of, and locus for, much of the iconic imagery associated with the city and nation and thus continues to operate in many

54 Quotation from a discussion held on 6 December 2010, Rio de Janeiro.
55 Opinions expressed by Milton Guran during the above meeting.

respects as a window on Brazil. We may be more specific still in observing the prominent place that *favelas* occupy amongst such imagery, 'becoming the dominant cultural image of Brazil outside the country' (Williams, 2007: 246).

As such, there is no doubt that representations of *favelas* occupy an important and increasingly controversial space in contemporary Brazilian cultural production at large. In her article 'Favelas and the Aesthetics of Realism', critic Beatriz Jaguaribe emphasises an important displacement of national narratives within Brazilian culture. This might be described as the transition from a modernising discourse (prevalent during the nationalist dictatorship of Getúlio Vargas, 1930–1945 and 1951–1954) that romanticised certain forms of popular culture – such as the previously criminalised samba which originated in the *favelas* – adopting them as icons through which to project a cohesive national identity, to a more recent and critical cultural production that has set its sights on the construction of 'new portraits of Brazil that focus on marginalized characters, favelas, drug cultures and the imaginaries of consumption' (B. Jaguaribe, 2004: 328).

The *favela* has thus been represented and reconstructed both as a positive, if imagined, locus of culture and community, and as a negative 'emblem of Brazil's uneven modernisation', a much-feared hotbed of poverty, deprivation, violence and criminality. This is an impression that has been consistently fuelled by sensationalist media coverage (B. Jaguaribe, 2004: 327, 329). Whether inspired by allure or repulsion, exoticism or fear, such perceptions clearly reinforce the idea of a singular and homogenised space alien to the city 'proper' – as espoused by the title of journalist Zuenir Ventura's emblematic *Cidade partida* (1994) – and thus of a space of social and economic exclusion. The dualistic mode of thought that constructs for the *favelas* the role of urban anomaly or lacking and dysfunctional other has a long and influential conceptual presence (Zaluar and Alvito, 1999: 7–8). Notwithstanding, Zaluar and Alvito stress the artificial and ideological nature of the imagined spatial divides nurtured by such a vision of the city (1999: 16). The reconfiguration of this hierarchical conception must therefore be a priority for those working towards a better understanding of the current urban dynamic in which the *favelas'* interrelatedness rather than isolation, together with the desire to be recognised as constituent parts of and within the city, can no longer be denied.

However, the weighty discourse of violence and fear that surrounds these spaces is no small obstacle to such endeavours. This is further complicated by the blurring of boundaries between fact and fiction exemplified in the trend in both recent fiction and non-fiction *favela* films to create 'an interpretive code of realism that allowed them to become focal points of discussion concerning the real events and experiences of Brazilian cities' (B. Jaguaribe, 2004: 331).

B. Jaguaribe draws attention to the highly successful but controversial fiction film *Cidade de Deus* (Meirelles and Lund, 2002) to which we might add the later and equally poignant examples of José Padilha's *Tropa de elite* (2007) and its 2010 sequel. Both productions are based on literary works clearly inspired in biographical experience and historical occurrence – the book *Elite da tropa* (2005), co-authored by former special unit policemen together with the renowned anthropologist Luiz Eduardo Soares, includes commentary on violent encounters with drug-related gangs in the *favela* of Babilônia (the setting for the film explored below) in 1997. Although frequently perceived as a symbol of disparity and segregation, emphasis on the *favelas'* role in the illegal drugs trade associates them conversely with a highly interconnected form of economic circulation and exchange, an identification that has in turn led to problematically glamourised and pervasive representations of a violent and macho gun culture.

It should not be overlooked, however, that economic exchange and frequent and routine interaction between *favela* residents and those of more elevated socio-economic status also take place through numerous uncontroversial and mundane channels. As Platt and Neate emphasise in *Cultura é a nossa arma*, the manual labour force that sustains the city's daily functioning – its builders, bus drivers, waiters, shop assistants, cleaners and maids amongst many others – is largely composed of those who live in *favelas* (2008: 13), making them an integral (if poorly remunerated) part of what has often been referred to in isolation as the 'formal' city. Likewise, the increasingly widespread use of social media in such areas mark *favelas* not as zones of isolation but of flux and interconnectivity – teenager René Silva's use of Twitter to report on the November 2010 police invasion of the Complexo do Alemão *favelas* where he lives offers a highly visible example of this trend (Hirsch, 2010).

Representations of *favelas* in still photography have been no less problematic. As observed in the presentation of *Mídia e violência*, there have been many improvements in the quality and nature of press coverage over the last decade with respect to the representation of violence and *espaços populares* (Beraba, 2007). However, many share the opinion that there is much improvement still required:

> O jornalismo brasileiro contemporâneo age muito mais como mantenedor do que como transformador do quadro social. E como os poderes políticos se diluem em clareza de posicionamento, os jornais veiculam uma visão muito ofuscada sobre as chamadas minorias, composta pelos moradores de favelas, os trabalhadores rurais, o MST, os índios brasileiros, os quilombolas, que formam, na verdade, a grande maioria da população brasileira. (Ripper, 2009: 28)

The pervasive presence of violent imagery surrounding the city has undoubtedly played a significant role in the formation and strengthening of fears about public security and exposure to those of different social backgrounds (particularly amongst dominant social groups). As photographic curator Sérgio Burgi (Instituto Moreira Salles) suggests, 'a violência filtra as imagens'.[56] That is to say that violence causes people to see things in a single light and to anticipate and look for images that validate these expectations. 'Os imaginários do risco e do medo, por sua vez, dependem da circulação das narrativas e imagens de violência e conflito social promovidas pela mídia visual e impressa' (B. Jaguaribe, 2007: 107). Some critics go as far as to say that:

> It is as if the system benefitted from violence and even counted on it in order to justify its own existence. The alternative, however, is to convert the daily violence into a symbolic force via cultural production, which is then seen as a model of organization for the community itself. (J. C. de C. Rocha, 2004: 33)

Perhaps one of the most forceful criticisms directed toward both conservative and progressive lines of thought concerns their tendency to homogenise *espaços populares* via a discourse of absence and lack that naturalises poverty. Jailson de Souza e Silva is quick to point out that representations of *favelas* are often 'marcada[s] pelo distanciamento, pela idealização estereotipada, seja positiva ou negativa, e pelo anacronismo, com a persistência da imagem dos espaços populares nos termos de sua definição nas décadas de 40/50' (Souza e Silva, 2001: 83). As Fabiene Gama remarks, it is not only the press (as frequently cited villains in this debate) but also 'atores sociais' such as NGOs that are responsible for the perpetuation of this homogenising discourse (2009: 98). After all, the concepts of absence and lack are often what motivate and 'justify' an NGO's presence and involvement in these areas in the first place.

The first work broached in this chapter is Claudia Jaguaribe's 'Rio – entre morros', a series of photographs that showcase the city of Rio de Janeiro from a variety of unusual vantage points, often focusing on *favela* communities. Although not always immediately apparent, the majority of these images are digitally manipulated photo collages that create awe-inspiring visualisations of scenery in which natural and built elements compete to dominate the frame and terrain of the megalopolis. The photographs thus dialogue in a unique way with the cityscape as an imagined space, touching upon the fears, anxieties and desires that weave their way across it.

56 Conversation, 8 December 2010, Rio de Janeiro.

In the second section, I move on to discuss *Babilônia 2000*, a film by one of the nation's most renowned documentarians, the late Eduardo Coutinho, set within the Morro da Babilônia *favela* on the eve of the twentieth century. Characterised by the director's particular interview-based style, the focus shifts away from a more common emphasis on the nature of truth and reality in documentary to privilege an understanding of the filmmaking process as, above all, an experience of encounter between different parties. Taking ownership of and responsibility for his own relative position of power during the filmic situation, Coutinho engages with the complex expressions of these relationships throughout the film in a manner that highlights and ultimately questions the arbitrary nature of such parameters.

An analysis of a diverse selection of images by photographers who have all historically worked within the Imagens do Povo collective, forms the basis of the final section of the chapter. Using works that have all been included in the collective's publication entitled *Imagens do Povo* (2012a), I analyse the ways in which conventional limitations and borders are stretched in order to interrogate both stereotypical representations of *espaços populares* and the photographic medium itself.

'Rio – Entre morros'

> Las grandes ciudades desgarradas por crecimientos erráticos y una multiculturalidad conflictiva son el escenario en que mejor se exhibe la declinación de los metarrelatos históricos, de las utopías que imaginaron un desarrollo humano ascendente y cohesionado a través del tiempo. (García Canclini, 1995: 100)

A *carioca* by birth, photographer and visual artist Claudia Jaguaribe has since become a long-term resident of the city of São Paulo, the so-called *cidade cinza* often diametrically opposed to the colourful and vibrant *cartão postal* of the luso-tropics. With her works held in the collections of prestigious cultural institutions within and outside Brazil such as the Museu de Arte Moderna de São Paulo, the Joaquim Paiva collection (Rio de Janeiro) and the Maison Européenne de la Photographie (Paris), amongst many others, there is no doubt that C. Jaguaribe occupies a firm position within numerous dominant cultural circuits. As the daughter of sociologist, political scientist and writer Hélio Jaguaribe (elected to a Chair of the Academia Brasileira de Letras in 2005), the photographer was brought up amidst regular contact with the intellectual and social elite of Rio de Janeiro (R. Soares, 2009). Having temporarily relocated to California with her family as a child during the military dictatorship in 1964, she later spent another four years in the United States

completing a degree in history of art at Boston University before returning to Brazil in 1980 where her need to privilege 'uma relação mais direta com o mundo' in her work led her to specialise in photography (R. Soares, 2009).

A prolific output over the last two decades has resulted in numerous collective and individual exhibitions, with many works demonstrating a clear interest in transformations occurring across both natural and built environments, together with the anxieties that such growth and/or destruction often inspires. In *Quando eu vi* (2007–2008) a video installation shows a Mata Atlântica forest scene with multiple screens dissolving at different rates into new images to create ever shifting and transitional landscapes. An ominous synthetic hum mixed with the exuberant noises of wildlife accompanies the imagery, building an unsettling and perturbing soundscape around this state of constant change. In *Você tem medo do que?* (2006), responses collected via an online survey form the basis for the artist's exploration of the individual anxieties of modern living. Fear is addressed at a collective level in *Olho da rua* (2007), where photographs of private security booths are used to create new urban cartographies of insecurity.

Many of these elements find their continuation in 'Rio – Entre morros' (2010) (henceforth 'Entre morros'), a series of nineteen cityscapes that show this famous urban landscape as it has never been seen before. Initially inspired by the theme of growth, the intense colour-rich tonality and 'hyper-real' definition of these photographs create an almost apocalyptic vision of overwhelming urban sprawl. The extensive mass of human construction appears at times to consume the surrounding natural environment as it rises and swells around islands of 'unconquered' greenery and rock face (Figure 4.1). Such a vision might be understood to reflect a position of estrangement and distance from the city – as seen through the eyes of a person whose sudden confrontation with the impact of urban growth will be experienced in a far more intense manner than by those who have witnessed changes occurring on a gradual day-to-day basis. The title itself registers a point of slippage and ambiguity in its use of the term *morro*, which simultaneously refers to a 'hill' as part of the *natural* landscape and to the *favelas* as *constructed* landscapes. The meaning of the title hangs upon our interpretation of this key word, which will in turn affect our definition of the Rio that is *entre* these *morros*. In the first instance (*morros* as nature), Rio is defined by contrast as the integral built environment, whilst in the second instance (*morros* as *favelas*) Rio necessarily becomes an oppositional and 'formal' city. Interestingly, this latter example also involves recognising the 'formal' as *entre* or 'in-between' – a state usually ascribed to 'marginal' entities as a position from which to resist dominant 'central' forces. This indicates a fundamental instability that exists even in the very framing of the project.

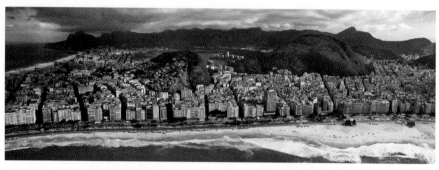

Figure 4.1. Copacabana, 'Rio – Entre morros' series (2010), © Claudia Jaguaribe. Original in colour

Inapprehensible Landscapes

> O que está em jogo são os limites de figuração, a incapacidade da mente humana para representar as enormes forças da natureza e da metrópole. (Peixoto, 2009: 416)

It will not have escaped the reader's notice that both the topographies discussed above – undulating green and granite hillsides and heterogeneous and illegally constructed communities – form a key part of Rio's attraction as an international tourist destination. Indeed, if we look back to the heritage of landscape photography, we may see its intimate relation with the emergence and development of tourism in the nineteenth century. Daguerreotypes and calotypes captured scenes of natural beauty that provided souvenirs for an increasingly mobile middle class and tempting glimpses of far-off and exotic places for those unable to make such journeys (Rosenblum, 2007: 95). Photography also played an important role in endeavours to comprehend some of the rapid developments that were altering urban landscapes as 'the camera itself became part of the shifting relationship between traditional and modern perceptions of nature and the built environment' (2007: 95). It is this overwhelming sense of mushrooming urban growth that comes to the fore in 'Entre morros', leading us to contemplate not the grandeur of nature but the force of human expansion and construction to dominate natural surroundings. As the artist herself comments, 'nesse novo Rio o humano derrotou o natural; o tecido social tapou quase tudo; um povo emergiu. Civilização ou barbárie?' (C. Jaguaribe, 2011).

Earlier painterly representations of *favelas* make for an interesting point of comparison here. Tarsila do Amaral's 'Morro da favela' (1924), for instance, shows a picturesque scene of colourful and orderly houses in a characteristically undulating landscape, its curves complemented by spherical bushes and greenery that dominate the foreground and peek up between the

Figure 4.2. "Morro da favela" (1924), Tarsila do Amaral, Photograph: © Romulo Fialdini / Tempo Composto. Original in colour

Figure 4.3. "Favela com Músicos" (1957), Cândido Portinari © Reproduction right kindly provided by João Candido Portinari

buildings behind (Figure 4.2). The image appears to celebrate the *favela* as a semi-rural idyll, a spacious and harmonious place still heavily connected to the countryside and to familial ideals. Painted over 30 years later by another iconic artist, Cândido Portinari's 'Favela com Músicos' (1957) depicts a now intensely urbanised space (Figure 4.3). Here the constructions of the *favela* are registered as a dense horizontal and horizon-less expanse. Gone are the hills and any references to the natural landscape, although the use of vertical strips of colour provides an interesting contrast with the otherwise flat scene and contributes a sense of organisation and coherence to the space.

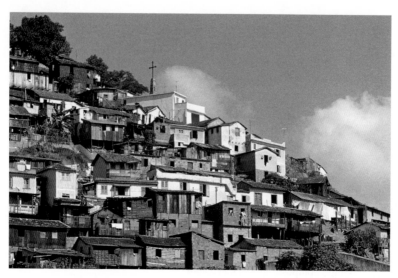

Figure 4.4. Morro da Mangueira (1963), © Henri Ballot / Acervo Instituto Moreira Salles. Original in colour

In photographic terms, Henri Ballot's forays into the Favela da Mangueira during the 1960s provide considerable insight into both this particular community and the photographer's attitude towards it. In Figure 4.4, although the houses indisputably dominate the landscape they do so in an orderly fashion, rising in a diagonal line to meet a horizon of blue sky and cloud the image is a far cry from urban sprawl. Likewise, another of Ballot's photographs from the same era shows *favela* constructions nestled in a valley amidst, and at harmony with, the vegetation of the natural environment. Ballot himself became caught up in a controversial tussle regarding the representation of poverty in the city following the publication of photographs depicting the adverse conditions of a poor family living in the *favela* of Catacumba by American *Life* magazine in 1961. Indignant at the imperialistic suggestion that poverty was a foreign and 'third world' affair, Brazil's most famous illustrated magazine of the twentieth century, *O Cruzeiro*, retaliated by sending Ballot to compile a photographic essay on miserable living conditions among the poor in New York (Ribeiro, 2011). We may thus justifiably interpret in Ballot's work and agenda an intention to avoid conventional images of poverty and the spaces with which it is associated.

Although photographic, the highly constructed images that C. Jaguaribe produces for 'Entre morros' are in many respects better understood as artistic creations than as a documentation of the city's landscape (which is not to say that they cannot function as a subjective and sensorial documentation of urban experience). For what are captured and communicated in

these compositions are not real cityscapes, but the contours of imaginary landscapes defined by fractured perspectives and impossible spatial arrangements. This consideration distances the project from the early scientific and rational objectives that saw photography as an instrument with which to represent accurately various topographies (Rosenblum, 2007: 95). The photographs are essentially collages, with numerous fragments of vistas creating distorted perspectives more obviously manipulated in some images than others. The explosion of representational strategies via the use of new technology 'as the computer extends the realm of what the visual sense encompasses' and the confused effects this may create for conceptions of the real and imagined has been on the agenda for some time (Wells, 2000: 315). In this instance, the use of a fragmentary aesthetic creates 'um ritmo instável' that exposes viewers to the risk of 'desorientação espacial e desinformação sensorial' (Fernandes Junior, 2012).

In *Menina na laje* (Figure 4.5), a small girl playing on a rooftop occupies the foreground whilst a vast tract of 'informal' housing stretches out behind her, blending into high-rises and coastline in the distance. The image has an abysmal quality, as the fragmented perspectives mean that the constructed mass appears simultaneously to sink down away from the girl and yet to rise up above her. The impression created is of a vast sprawl of inapprehensible quality and magnitude. The series also clearly plays upon the horizontality of the landscape tradition and the contrasting verticality of the city (E. Grosz, 1995: 108). In fact, two-thirds of the images are rendered as vertical panels. As the eye is so accustomed to seeing vistas as horizontal panoramas, this more unusual vision creates a heightened awareness of the way in which the eye is channelled, drawing attention to the artificiality of image borders. There is also a sense in which the eye resists this container, compelled to drift laterally in search of a continuation beyond these imposed limits.

Borders also form the explicit subject of several photographs. In Figure 4.6, for example, a metal railing upon which two children play dissects the centre of the frame creating a firm division between an open foreground and the jostling buildings competing for space below. This difference is further emphasised by the juxtaposition of the bright colours of adjacent houses toward which the rail recedes. Despite the harsh contrast between the contours of bodies and bars, the railing is, nonetheless, a transparent and permeable barrier that serves an obviously ludic function in this particular context. A sliver of green vegetation separates the areas of 'informal' and 'formal' construction, which are both seen from different angles – we look down over the rooftops of the *favela* and directly across at the high-rise apartments in the distance. Natural borders are no less visible than artificial ones, as in *Ipanema* (Figure 4.7) where a glistening blue-black ocean fills the bottom half of the image before reaching land and the residential strip of this

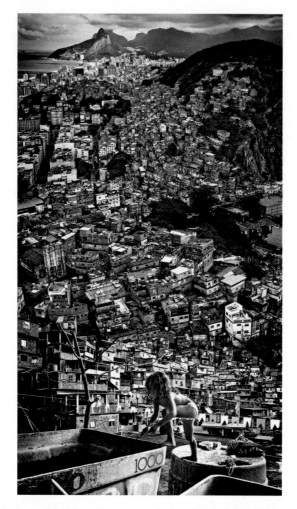

Figure 4.5. Menina na laje, 'Rio – Entre morros' series (2010), © Claudia Jaguaribe

famously chic neighbourhood. Prime real estate is here squeezed between two expanses of water with the Lagoa Rodrigo de Freitas stretching back toward a minute and barely distinguishable Cristo Redentor. In contrast to many of the other photographs that privilege the *morro* as *favela*, here it is nature's beauty that dominates the picturesque scene. We might even read from this an intimation of the possible harmonious coexistence of nature and the 'formal' city in opposition to the somewhat antagonistic relationship portrayed between nature and the 'informal' environment.

Indeed, these images clearly engage with the debate stirred by the wall-building project discussed above in relation to Garapa's 'O muro'. The graphical proximity of *muro* and *morro* also hints at the idea of a city *entre*

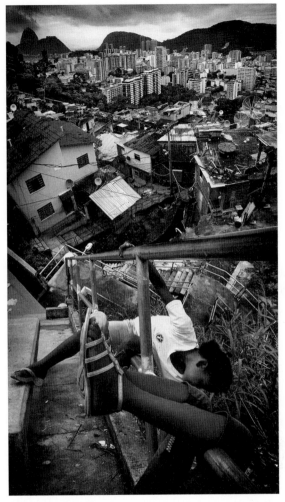

Figure 4.6. Mariana e amiga, 'Rio – Entre morros' series (2010), © Claudia Jaguaribe. Original in colour

muros, as suggested in Figure 4.8, where the corner of one such wall cuts imposingly down the centre of the photograph, dividing the greener wilderness to one side from built space to the other. The image directly addresses the idea of *favelas* in particular being spaces whose growth threatens the city as a whole and must therefore be curtailed. The efficacy of the wall as a mechanism to control the built environment is put into question, however, by the fact that structures visually spill out beyond its reach, pointing to the very futility of such efforts to contain urban growth. What is ultimately limited in this image is not urban expansion but the viewer's own perspective.

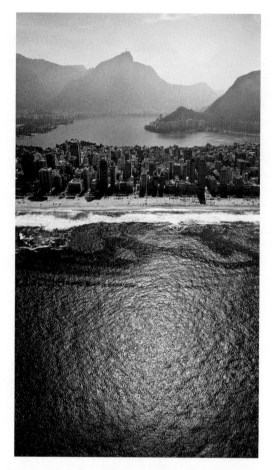

Figure 4.7. Ipanema, 'Rio – Entre morros' series (2010), © Claudia Jaguaribe. Original in colour

An Anti-cartography: or Where Am I?

> As novas grandes escalas demandariam, então, um mapeamento cog-
> nitivo que, através de seu próprio fracasso representacional, evidencie
> os limites da cartografia, dos dispositivos tradicionais de localização.
> (Peixoto, 2009: 417)

The iconic city of Rio de Janeiro has been transformed by the artist's vision
into an unsettling landscape at once familiar and deeply unfamiliar to the
viewer, an expressive response to the experience of facing a metropolis too
vast for individual comprehension and contemplation. Capturing privileged
aerial perspectives by helicopter is one way in which C. Jaguaribe chooses to
deal with such overwhelming scale. Photographing the city from the air, of

Figure 4.8. Muro, 'Rio – Entre morros' series (2010), © Claudia Jaguaribe. Original in colour

course, creates an immediate distance between the landscape and the viewer, who is no longer grounded within the scene but instead situated above and apart from it. Although 'verticality and great height have ever been the expression of potentially violent power', it should be emphasised that these elevated perspectives are most often spliced here with grounded and proximate viewpoints (Lefebvre, 1991: 98). The cityscape presented in 'Entre morros' thus retains a profoundly heterogeneous quality at odds with the flattening and homogenising trend often associated with a bird's-eye view.

As Henri Lefebvre observes, 'linear perspective developed as early as the Renaissance [and implies] a fixed observer, an immobile perceptual field, a stable visual world' (1991: 361). That this fixed viewpoint is itself at odds with any possible experience of the space in question and has functioned largely to convey an impression of coherence and harmony upon the individual's position in the world cannot be overlooked (Harvey, 1990: 244). Representations of the world around us are inextricably linked to both cultural understandings of space and dominant socio-political interests, suggesting that ultimately 'we dwell not just in concrete spaces, but in the metaphors and representations that we create to imagine them' (Jordan, 2010: 138). If we consider that the map, that most rational and utilitarian of spatial measures, presents us with 'a idéia de uma "visão" que abrange o que nenhum ponto de vista pode abarcar', we begin to grasp the level of complexity contained in the notion of a truthful or realistic representation of the environment in relation to the human body (Peixoto, 2009: 408). During the Renaissance, mapping played an important role in promoting the concept of space as a knowable entity that might be visualised in its totality, thus highlighting the potential to possess and control what now took on the properties of a 'conquerable and containable' resource (Harvey, 1990: 246).

In light of the above observations, C. Jaguaribe's technique of shattering the individual viewpoint in favour of bringing together multiple perspectives within a single image has highly significant implications. Could we perhaps

interpret the artist's decision to provide us with simultaneous access to multi-form vistas as a desire to create a panoptic vision of the city? Or is it precisely via this act of fragmentation, in which the viewing subject is multiplied, that any attempt to situate oneself and thus establish a relationship with the space is undermined? I would suggest that the relationship between the imagery and the city's touristic identity points firmly toward the validity of the latter interpretation. As Bianca Freire-Medeiros observes in her study of tourism in the *favelas* of Rio de Janeiro:

> O olhar do viajante dirige-se precisamente às características do lugar de destino que o separam da experiência ordinária, o tornam exótico em alguma medida. Sua criação e permanência estão diretamente ligadas à interpretação desse lugar como *paisagem* – à seleção de certas características particulares como atraentes para o consumo. (2009: 100)

With its very attraction based upon an encounter with places and people marked as different and unfamiliar, tourism is in fact a powerful mechanism for reinforcing a stable sense of the visitor's own 'lugar no mundo' (Freire-Medeiros, 2009: 88). In order to function, however, it also relies upon the easy recognition of highly visualised and familiar landmarks and views that define this space in its 'otherness'. The decision to deprive the viewer of these iconic features (or at the very least to diminish their visual impact) in her presentation of the city thus undermines the facilities of orientation necessary to establish firm hierarchies of identity in relation to the space.

In Figure 4.9, we are presented with what may at first appear to be a conventional city scene photographed from the air. A small group of houses and apartment blocks in the foreground gives way to an expanse of high-rise buildings and avenues leading to the bay on the horizon. Despite the way in which different images seamlessly blend into one another, softened by the occasional smattering of greenery, the coincidence of contrasting angles soon reveals the highly composed nature of the photograph. It is only in the far corner of the frame that we discern the subject of the photograph after which it is named, the iconic *Pão de Açucar*, fading into a distant haze of sky and mist. The conspicuous absence of prominent tourist landmarks throughout the series or their rendering as incidental background features, rather than customary focal points, constitutes a radical reframing of the city. The impossibility of stably positioning oneself as either tourist or local in relation to these imaginary landscapes makes for scenes that consistently elude traits of both exoticism and familiarity.

If 'city photography speaks to the general problem of negotiating space, and to the specific problem of negotiating a space for dwelling', what might we infer about the artist's own position in, and relationship to, the

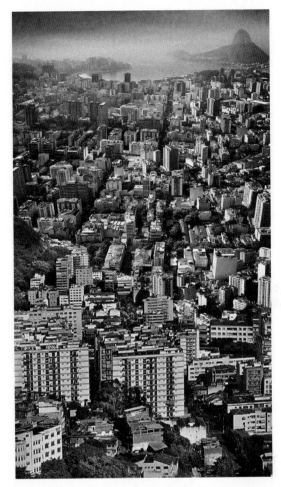

Figure 4.9. Pão de Açucar, 'Rio – Entre morros' series (2010), © Claudia Jaguaribe. Original in colour

city she photographs (Jordan, 2010: 138)? I would suggest, first, that the multi-temporal traces contained within these images stress the continual processes of transformation to which the city is subject. In C. Jaguaribe's images, the fixed and abstracting functionality of the map is laid aside and information is instead intensified and compressed to reflect the pace of twenty first-century living in the megalopolis. One of the primary factors to emerge through this imagery is a distinct sense of non-navigability. This is an impression created not only by the ultimately 'fictitious' nature of many of the scenes, but also in the quality of their composition. An image entitled *Vidigal* (Figure 4.10) positions the observer on a sloping road leading to the community of the same name. Although a motorcycle parked on the road

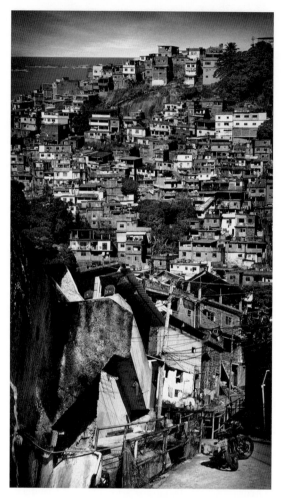

Figure 4.10. Vidigal, 'Rio – Entre morros' series (2010), © Claudia Jaguaribe. Original in colour

gestures to the possibility of an onward journey, the road almost immediately disappears from view, blocked by a mass of houses that rise in awkward and conflicting angles away from the viewer. A discrepancy in the shadows that fall in different sections of the photograph suggests spatial incoherence, as here even the measure of the sun cannot be relied upon for bearings.

Of course, as previously remarked, many shots are taken from a helicopter: a means of transport that bypasses conventional navigational limits, allowing wealthy passengers to escape from the dreary routine of traffic blockages that cast their invariable shadow upon those travelling at street level – a phenomenon that has attracted a great deal of attention in the 'helicopter capital of the world', São Paulo (Phillips, 2008). The freedom enjoyed by an increasing

number in the air, however, appears to undergo annihilation on the ground, where anxiety becomes a constant companion: 'ao transitar pela cidade, trancamos a porta do carro, fechamos a janela, apressamos o passo, nos esquivamos do mendigo, driblamos o pivete, fugimos do assalto' (B. Jaguaribe, 2007: 123). A pervading sense of fear amongst wealthier citizens isolates and disconnects them from the city streets, leading the producer of *5 x Favela: agora por nós mesmos* (2010), Renata Magalhães, to observe of those living in *favelas* that 'eles circulam, a gente não circula',[57] a point that has previously been made by Claire Williams (2007: 235). Of course, this does not alter the fact that such physical limitations are frequently accompanied by the facile navigation of many economic circuits that remain inaccessible to the majority of the population.

The ownership of private property and navigation of public spaces in the city might be said in some respects to experience an inverse and antagonistic relationship. The complexity of attitudes to growth and transformation in Rio de Janeiro, particularly in relation to the natural environment, bubble at the surface of C. Jaguaribe's intriguing and highly original visualisation of this iconic space. If we look to an aerial photograph of *Rocinha* (Figure 4.11), the city's largest *comunidade* that is also home to the most active and longstanding *favela* tour operations, we see a synthesis of some of these issues. Looking vertically down on the dense accumulation of housing, it is easy to understand how *favelas* came to receive the label of 'cidades sem mapas' (B. Jaguaribe, 2007: 151). Even from this viewpoint it is impossible to pick out routes of navigation. Bordered on one side by lush forest and an impossibly angled cliff face on the other, Rocinha takes the form of an unstoppable man-made river of construction, built by:

> Um povo que avança mata adentro e morro acima. Que ocupa o que não é seu e o toma para si. Que ergue paredes, constrói uma laje em cima e vive dentro. É um povo pobre, vê-se, que vive na precariedade. Mas que se adensa e se espalha, soberano. (C. Jaguaribe, 2011)

In recognising and assuming a diverse and complex series of positions and reactions to the city's growth, C. Jaguaribe's dynamic and experimental imagery presents the viewer with an ambiguous collage of fear and admiration, domination and vulnerability, celebration and anxiety that precludes judgement upon, and ownership of, the spaces that come under the photographer's gaze.

57 Conversation with the producer, 10 December 2010, Rio de Janeiro.

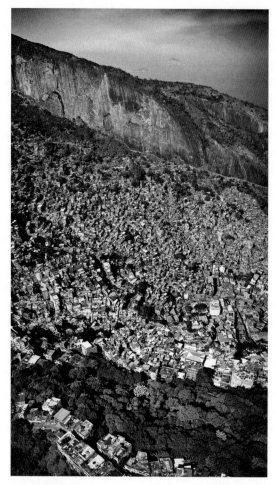

Figure 4.11. Rocinha, 'Rio – Entre morros' series (2010), © Claudia Jaguaribe. Original in colour

Babilônia 2000

Described by cineaste and critic Felipe Bragança as 'um dos maiores pensadores do cinema brasileiro hoje e também um dos mais selvagens realizadores', Eduardo Coutinho has been without doubt one of the most influential figures in the history of Brazilian documentary film (Bragança, 2009: 11). If his work remains relatively little known outside Brazil, a powerful explanation lies in the difficulty of subtitling his films, in which the subtlety and diversity of linguistic expression, particularly that of so-called 'popular' or 'marginal' subjects, constitutes an unresolved challenge. It was whilst working in television journalism for the Globo Repórter from the

mid-1970s to the mid-1980s that Coutinho discovered his interest in and talent for documentary, although it was the reception of his landmark *Cabra marcado para morrer* (1985) that truly made his name in the field.

Although a great many of Coutinho's films have been located in 'marginalised' spaces such as the rural north-east (*O fim e o princípio*, 2006), *favelas* (*Santa Marta – duas semanas no morro*, 1987) and rubbish dumps (*Boca de lixo*, 1993), a lower middle-class apartment block (*Edifício Master*, 2002) and the theatre (*Jogo de cena*, 2007 and *Moscou*, 2009) have more recently caught the attention of his camera and listening ear. Coutinho's heavily interview-based style privileges 'conversation' above simple 'observation' and his work continues to elicit pertinent questions surrounding the notion of film's capacity to speak for others or to allow others successfully to speak for themselves. In this process, common conceptions regarding performance, authorship and authenticity in documentary film frequently come under scrutiny and are problematised in complex ways.

The one-off screening of his *Um dia na vida* at the Mostra de São Paulo film festival in 2010 provides a poignant example of the director's willingness to break with conventional parameters in thought-provoking ways. The film is in fact a product of nineteen hours spent watching and recording terrestrial television subsequently edited into a 90-minute compilation (E. Valente, 2010). As we might expect, a hefty proportion of the footage was advertising material. Interestingly, though unsurprisingly, the film was screened only on a single occasion due to copyright laws and does not appear on Coutinho's IMDB profile. In addition to questioning the nature of this widely consumed imagery, the enterprise draws attention to the transformation that the material and its meaning undergo as a result of editing and an altered exhibition context.

Just as the spaces in which certain visual products appear can drastically alter their meaning and interpretation, so it is poignant to consider the place given to certain spaces within filmic production. The use of the *favela* as a filming location is a subject that emerges and frequently resurfaces in *Babilônia 2000* (henceforth *Babilônia*), notably in references by the director and interviewees to the classic fiction film *Orfeu negro* (1959), by Marcelo Camus. These references draw attention both to the historically prevalent tendency to portray poverty in the *favelas* in a romantic or exotic light (Bentes, 2006: 134–135) and to the subject of performativity in relation to the documentary genre. Not only was a significant portion of Camus' production filmed on the Morro da Babilônia, but several of the *favela*'s residents played key roles, with the practice of using non-actors emerging in Latin America during the 1950s and inspired by the Italian neo-realist tradition (King, 1990: 70). Emphasis on the performative nature of representation in the documentary filmmaking process is evident throughout *Babilônia* and has been commented

upon widely, leading critic Ismail Xavier to refer in respect of Coutinho's work to the 'efeito-câmera, gerador de performances' (2010: 72). In her essay 'A Cinema of Conversation' (2003), Verônica Ferreira Dias emphasises the clear presence of reflexive elements in the film that, whilst distancing it from the idealised notion of documentary as a mirror for reality, bring it closer to its own representational truth: that of the encounter between the filmmakers and the inhabitants living on the *morro*. Consuelo Lins' analysis highlights the transformational nature of this encounter and its potential for positive impact upon participants, whilst also drawing attention to the fact that the film eludes the problem-solving dynamic common to much traditional documentary (2004b: 182). The filmed participants, she notes, are treated in their singularity rather than as sociological types (2004b: 195). Mariana da Cunha likewise stresses the central role played by the encounter in Coutinho's work and further observes the 'construction of a performance through the discourses of the characters' (2009: 134). This heightened sense of self-awareness surrounding the type of role that the *favela*'s inhabitants might be expected to play within a cultural product destined for a different social context (and their refusal to re-enact such roles) is clearly registered throughout the film. Given that the subject has been explored so extensively in the above works, I take the opportunity here simply to reiterate its significance: through engagement with the performative nature of the characters' on-screen interactions, Coutinho demonstrates a reflexivity clearly designed to interrogate the complexities and antagonisms inherent in both the filmic documentary medium and broader notions of identity and authenticity.

An examination of voice and perspective established during the documentary becomes particularly significant in these terms. Indeed, it is upon the voice that many critiques of *Babilônia* and of Coutinho's works in general have focused their attention – a privileging of words over images, that has led to its widespread labelling as a 'cinema of conversation' (Dias, 2003: 105). This emphasis upon the spoken word is undoubtedly crucial, for it stresses the potential of such works to act as a form of empowerment for 'marginalised' populations in their provision of what Cunha terms a space of 'counter-discourse' (2009: 144). However, such a focus has tended to overlook or at least detract from appraisal of the film's fundamental visual qualities. Analysis of editing or camerawork is often downplayed, leaving some critics occasionally to dismiss it entirely (Dias, 2003: 114). This is unsurprising for several reasons: first, the straightforward filming style is devoid of any overt aesthetic manipulation; second, as highlighted by Lins, who took part in both the research and filming of the project, the film in fact comprises footage taken by five different camera crews working simultaneously in separate locations on the Morro da Babilônia, albeit under the director's single mandate. This in turn leads to an undermining and fragmentation of

the 'director-author figure' (Lins, 2004a: 125). In addition to his characteristic self-imposed geographical limitation or 'singular location', in this instance Coutinho adopts a second, temporal, constraint that restricts filming to a period of under 24 hours and editing to the chronological use of footage. This is clearly marked by the inclusion of intertitles showing hours and minutes at the start of each new sequence counting down to the New Year (2004a: 124).

However, the creative 'prison' (Lins, 2004b: 189), or constraint within which the filmmaker locates the project, should be seen not as reductive but as productive of meaning; for it is precisely in the negotiation of such limitations that important significations may be formed and original qualities emerge. Minimal technical interference with subject matter does not result in an erasure or veiling of the camera's presence – as occurs in a fly-on-the-wall or 'observational' style documentary (Nichols, 2001: 99) – as the inclusion of shots exhibiting technical failure, rapid camera movement and unusual angles together with images of the film crew displays. It is my contention that a closer analysis of the subtleties that emerge from the editing process, and the visual framework within which this speech-orientated cinema plays out, illuminates nuances and important interpretive possibilities in the consideration of this controversial space.

As Webber and Wilson note, the opening shot of a film is paramount in establishing the dynamics of the spatial exploration that follows (2008: 3). It is revealing, therefore, that the opening scene of *Babilônia* provides a remarkable contrast to representational patterns observed both in the landmark *Rio 40 graus* (Pereira dos Santos, 1955) and in the more recent high-profile documentary films such as *Ônibus 174* (Padilha and Lacerda, 2002) and *Notícias de uma guerra particular* (Lund and Salles, 1999). Whilst these films show sweeping aerial perspectives of *favelas* (see Figures 4.12 and 4.13), *Babilônia* offers as its initial image a static view from the *morro* looking out across the famous neighbourhood of Copacabana and its iconic beach beyond (Figure 4.14). It is interesting to note that Coutinho did include an aerial shot in the opening of an earlier version of the film before concluding that this conflicted with the overall dynamic and opting for the static panorama (Lins, 2004a: 127–128). In contrast to an external and totalising view, this grounded and outward-looking perspective clearly aligns the spectator's position with that of the *favelas'* inhabitants and simultaneously sets the framework for a compelling and pervasive engagement with the interplay between spatial, temporal and power relations within and beyond this specific social context.

The periodic repetition of this viewpoint throughout the film at different times of day may be interpreted as 'a constant reminder of the position from which the image is being constructed', thus cultivating the impression of an 'insider's perspective' (Cunha, 2009: 140). I would further suggest that it serves to cultivate a sense of interrelatedness between the Morro da

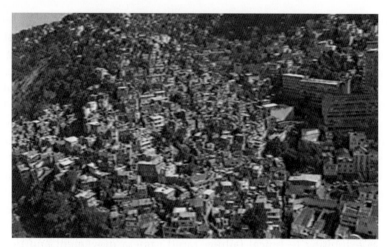

Figure 4.12. *Ônibus 174* (2002), dir. by José Padilha and Felipe Lacerda. Zazen Produções. Original in colour

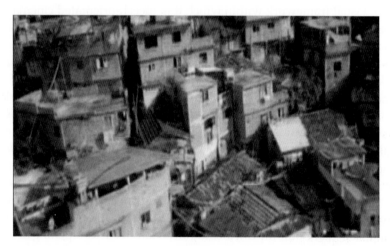

Figure 4.13. *Notícias de uma guerra particular* (1999), dir. by Kátia Lund and João Moreira Salles. Bretz Filmes. Original in colour

Babilônia and the legitimised urban space of the neighbourhoods of Leme and Copacabana below, visually connecting the two spaces in a manner that counteracts the disassociation or social distancing facilitated by a common emphasis on urban segregation. Such a gaze might also be interpreted as an expression of desire for integration or communion – a notion supported by the fact that the two *favelas* later established a joint community website under the name of 'Alto Leme' (www.altoleme.com.br).

The opening shot is followed by footage of the film crew emerging from the interior of the Associação de Moradores (Residents' Association) – an

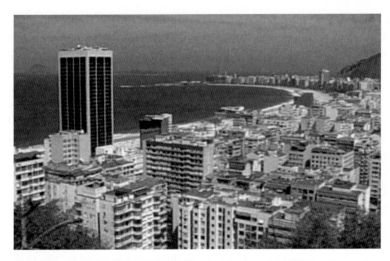

Figure 4.14. *Babilônia 2000* (2000), dir. by Eduardo Coutinho. Videofilmes. Original in colour

important reference to an organising force that contradicts the notion of *favelas* as chaotic and lawless, or zones under the exclusive command of drug-traffickers – before beginning their ascent along the plant-fringed path that leads not into wilderness, as it might first appear, but to the afore-mentioned *favelas*. This shot of the crew literally *subindo o morro* not only emphasises their external relationship to the space represented, but also holds connotations of historic colonial explorations and their objective to visually 'map' unchartered or unfamiliar territories. In this manner, subtle allusions are drawn to the exploitative capacity of film and its links to colonial anthropology. The on-screen presence of the crew serves continually to reinforce the film's mediated nature to the audience, simultaneously heightening a sense of the filmmakers' identity, role and responsibility in this process. The initial sequence thus juxtaposes two distinct perspectives – that of the *morro's* inhabitants and that of those who undertake to film them – creating what we might term a 'double frame' that sets the tone for the shifting and dynamic approach to perspective taken throughout the film.

It is the particular and superior geographic location of the *favela* that facilitates *Babilônia's* striking engagement with notions of verticality and power, and here it is useful to draw on Michel de Certeau's essay 'Walking in the City' (*c*.1984), which deals with precisely these considerations of verticality, vision, and power in the city. What is arresting in this instance is the perceived inversion of traditional power relations that takes place. The unifying and totalising aerial perspective that de Certeau evokes (in Ward, 2000: 101) – a panoptic vision frequently associated with the authoritarian eye of the state and with voyeurism – is here explicitly recognised as the vantage

point of the *favela* inhabitants who are often those effectively excluded from rights the state would normally be expected to grant its citizens. Numerous comments by interviewees on the privileged nature of the view from the *morro* are complemented by the framing of subjects against its backdrop, creating a pervasive vocal and visual reinforcement of a clearly subversive dynamic. In repeatedly confronting the viewer with this statement of visual empowerment, Coutinho performs a levelling gesture in which the difference between *favela* inhabitant and cinematic viewer is collapsed through a common voyeuristic perspective.

The spatial interconnectivity established in the opening sequence is repeatedly foregrounded through numerous shots of people passing up and down the stairs leading from the *morro* to the *asfalto* and vice versa ('asphalt' referring to the built environment of legitimised city space). These shots feature with increasing frequency and prominence towards the end of the film as we accompany the crescendo and explosion, literally captured by the fireworks, of the new millennium. Rapid cuts then occur between celebrations on the *morro* and on Copacabana beach, creating an effect of simultaneity where difference in vertical space is compressed or rendered immaterial.

Although this observation hints at the overcoming of difference, it is the persistent allusion to spatial continuity through time – expressed most notably in the punctuating, repetitive shots of the view from the *morro* (Figure 4.14) – that in fact reflects the unchanging nature of the social relationships formed through these spaces. This is a new millennium about which the characters interviewed harbour no illusions with regards to the potential for positive social, economic or political change and an air of resignation resonates throughout the film. (A notable exception is the short interview with Rio de Janeiro's Vice-Governor, Benedita da Silva, who describes her incredible life transformation from poor scavenger to politician.) There is, however, an underlying tension formed between the sense of stability alluded to by most interviewees in their interpretation of poverty and inequality as natural and enduring states of being – as captured in the following statement of resident Luiz Carlos: 'não é de agora que a pobreza vem. Vem de séculos' – and a counteractive stream of visual tropes referencing liminality. Aside from the obvious connection this establishes with the framework of the film as a temporal documentation of the threshold of a new year, century and millennium, it also constructs an unstable space that is simultaneously end and beginning, inside and outside, within and without, and thus a space radically open to shifts in both meaning and perception.

The documentary process is one that regularly crosses conventional boundaries between the private and the public and this is echoed in the frequency with which characters are filmed hovering on such borders – doorways, windows, balconies, stairs –locations that often give rise

Figure 4.15. *Babilônia 2000* (2000), dir. by Eduardo Coutinho. Videofilmes. Original in colour

to an explicit or implicit visual engagement with relations of power. At times it is the camera and thus filmmaker that is forced to direct its gaze in uncomfortable and unaccustomed ways, demonstrating not a position of dominance over subjects but one that is quite literally inferior, with the upward tilt of the camera echoing a perspective originating in the city space below. In Figure 4.15, for example, traditionally vulnerable members of society (a woman and a child) occupy a clear position of relative power, protected by the ability to withdraw themselves at any point from the gaze of the film crew below. What the image registers most prominently is the gaze exerted *by* the filmed subjects, echoing Jean-Louis Comolli's reminder that 'todo mundo, inclusive o cineasta, está sob o olhar dos outros' (2008: 82).

A similarly poignant moment occurs during the interview of an elderly lady named Djanira. As the film cuts to a shot of Coutinho standing by her chair (he had previously been sitting off-screen) the discussion turns to the uneven distribution of workload and power she observes in traditional heterosexual relationships. As a result of the director's shift in position, Djanira is forced to look upwards at Coutinho in a strained manner that echoes the gendered relationship of inequality she simultaneously describes. I do not suggest that these are premeditated or calculated manoeuvres conceived at the time of filming, but instead that the selection and juxtaposition of such material during the editing process subtly draws attention to the complex interweaving of human interactions and relations of power that occur before the camera and are evidently symptomatic of broader sets of social relations.

What Coutinho exposes through his inclusion of awkward interactions between the camera crew and interviewees is the conflicting nature of an irreconcilable difference. The closing sequence of the film is particularly significant in this regard and highlights an antagonism present in the act of filming a so-called 'marginalised other'; that is precisely the clear position of power occupied by the filmmaker and the subsequent ease with which a film with the most egalitarian intent may ultimately constitute an acutely disempowering act and representation of its subjects. Whilst the ideal intention to create an 'insider's perspective' is registered from the initial shot, representation is reflexively problematised throughout *Babilônia* in a manner that acknowledges the impossibility of such a realisation and offers instead a fragmented, plural and complex perspective that despite, or perhaps precisely due to, its inconclusiveness is undoubtedly more convincing. Locating itself in what initially appears to be a stable and fixed set of spatial and temporal parameters, as indicated by the film's title, what emerges via editing and framing techniques is a mounting sense of instability and a fundamental ambivalence that precludes facile conclusions or intellectual ownership of the subjects or spaces portrayed.

Rocha observes of contemporary Brazilian cultural production that 'it is no longer a question of reconciling differences, but rather of pointing them out and refusing to accept the improbable promise of compromise between the tiny circle of the powerful and the expanding universe of the excluded' (2004: 31). Despite the many overtly empowering filmic gestures made during *Babilônia*, ultimately it is these fissures that Coutinho regularly exposes as he forces spectators to acknowledge inequality not as a lofty and isolated concept to be battled against, but as an inevitable and uncomfortable set of relations in which all are implicated. As the director himself acknowledges, 'eu não sou igual duplamente: porque estou atrás da camera e porque não sou igual socialmente. Ao não fingir você começa a limpar a área. É a partir dessa diferença assumida que certa igualdade pode se estabelecer' (Bragança, 2009: 67).

In consistently bringing these boundaries of inequality to the fore, Coutinho contributed his own radical gesture toward their erasure. It is to the question of the fixing of such boundaries through stereotypes and the task of combating prejudice resulting from such unequal relations that I turn in the following section.

Imagens do Povo

> Physical and conceptual boundaries are integrally tied to the creation, maintenance, transformation and definition of social and societal relations – of socio-cultural behaviour and action. (Pellow, 1996: 3)

Founded in 2004 by the photographer João Roberto Ripper, Imagens do Povo (IP, Images of the People) describes itself as 'um centro de documentação, pesquisa, formação e inserção de fotógrafos populares no mercado de trabalho' (Imagens do Povo, 2012b). Located in the Maré area of Rio de Janeiro, it operates under the umbrella of the Observatório de Favelas (Observatory of Favelas), 'uma organização social de pesquisa, consultoria e ação pública dedicada à produção do conhecimento e de proposições políticas sobre as favelas e fenômenos urbanos', itself created in 2001 (Observatório De Favelas, 2012). The IP programme operates a range of initiatives including the Escola de Fotógrafos Populares (EFP, School of Popular Photographers), a photographic agency, an extensive online image archive, an exhibition gallery (Galeria 535) and the provision of workshops in pinhole photography for children. Most of the agency's contracted photographers are graduates of the EFP, whose ten-month course combines practical and theoretical elements designed to stimulate the 'reflexão do papel da imagem na sociedade e seus desdobramentos nas relações sociais', offering concrete validation of IP's remit to encourage and facilitate entry into the professional sphere (Lira, 2011: 51).[58]

The organisation's outward-looking ethos is demonstrated not only in the successful dialogue established with institutions historically representative of society's dominant knowledge producers and gatekeepers – since 2006 the course has been accredited by the highly respected Universidade Federal Fluminense (UFF, Federal Fluminense University) and later formed a partnership with the Universidade Federal do Rio de Janeiro (UFRJ, Federal University of Rio de Janeiro) – but in its willingness to embrace pupils, researchers and photographers from different backgrounds. Whilst most of the students come from *espaços populares* across Rio de Janeiro, Niterói and the Baixada Fluminense regions, from 2006 places have also been given to university students from other 'formal' areas of the city (Imagens do Povo, 2012b). The Galeria 535 hosts diverse exhibitions showcasing the work of photographers from across the country in addition to those based locally or directly affiliated with the organisation. IP has also exhibited its own work at important cultural institutions within Brazil and internationally in Cancún, Paris and London, with the previously affiliated photographer and EFP graduate Ratão Diniz participating in the 'Rio Occupation London' – a month-long celebration of the city's artists and culture during the 2012 London Olympics, an event that was to be reciprocally hosted by Rio de Janeiro in April 2013 (Rio Occupation London 2012).

58 Of the photographers whose work is featured in this section, Francisco Valdean is the only member still affiliated with IP in 2016.

These factors illustrate the extent to which IP has achieved insertion within a range of cultural circuits. Of course, where historic disadvantages exist, protectionist attitudes are often fostered (with good reason) and any movement towards or absorption within dominant cultural circuits may attract the suspicion of those who see the potentially harmful effects of stripping an 'outsider' of their political position of resistance. Such a standpoint can be useful and necessary in maintaining the centrality of a group's interests where a serious power imbalance exists. However, in hindering interaction between those of different socio-economic and cultural backgrounds it unfortunately also diminishes opportunities to establish positive dialogues that might lead to more deep-seated forms of social change. I would argue that IP's actions have been instrumental in forging contact designed to privilege interaction and *two-way* informational flows, and that this phenomenon is driven and strengthened by a strong focus upon valuing *espaços populares*, a subject explored in further detail below. The role that IP has played in promoting the circulation of information to increase awareness and understanding of social and cultural differences – both within the community where it is based and in other national and international contexts – thus constitutes an important step in the process towards recognising that there is empowerment in forms of mutual acceptance rather than conflict and mistrust.

Many of the values that IP has promoted find a clear precedence, as one might expect, in the thinking of its founder. It is important, therefore, to examine some of these key beliefs before moving on to look at a selection of the works in detail. At the forefront of the movement to establish independent photographic agencies in Brazil, Ripper has set his sights over the years on exposing injustices and defending the rights of those both in front of and behind the camera (Carminati, 2009: 70). In his own words, 'a fotografia deve funcionar como um elemento de comunicação e como um direito universal à informação' and is clearly perceived as a mechanism to raise awareness around particular issues and to drive social change. His own work addresses themes such as modern day slave labour, the treatment of neglected diseases and rural conflict experienced by the MST (Ripper, 2009: 27). Ripper's philosophy centres on the importance of the photographic encounter as a shared experience between the photograph*er* and the photograph*ed* and aims to produce images that generate affect and more specifically a desire to *querer bem* for those who feature in them. This process of recognising and portraying dignity through beauty leads us back to a highly familiar debate that accuses such imagery of cultivating an *estética da miséria*. In discussing such charges, Ripper points to their own discriminatory nature, suggesting that 'o processo de exclusão passa pela anulação da beleza' in marking the latter as the exclusive

property of dominant classes (2009: 25). At stake is nothing less than a redefinition of the notion of beauty itself. In directly challenging this dominant paradigm, Ripper makes a highly political call to shift historic boundaries in order to embrace people and spaces that have formerly been denied such affirmative associations. This is an attitude that finds a clear reflection and continuation in the work of many of those who have photographed for IP over the years.

The unease that surfaces around these types of conceptual boundaries and their maintenance (together with the fact that they are perceived as boundaries in the first instance) hints at their close relationship with stereotyping. Stuart Hall reminds us that stereotypes are a key example of the 'exercise of *symbolic power* through representational practices' and states that such forms of 'symbolic violence' operate most forcefully where 'gross inequalities of power exist' (1997: 258–259). Designed to reinforce existing perceptions, 'os estereótipos agem como força estabilizadora e, neste sentido, são a negação do pensamento crítico' (Pinto, 1998: 187). It is not hard to appreciate why stereotypes are thus a prime target in the 'luta representacional' currently underway in *favelas* and other *espaços populares* (Gama, 2009: 97). Recognition of the important role that cultural manifestations can play in reshaping perceptions has resulted in numerous cultural initiatives being situated at the forefront of the drive to combat stereotypes. This phenomenon is reflected in the strength and success of organisations such as AfroReggae, Central Única das Favelas (CUFA, Central Union of Favelas), Nós do Morro (Us from the hillside), Escola Livre de Cinema (Free Cinema School), Favela em Foco (Favela in Focus) and Viva Favela (Long Live Favela), together with events like the biannual Encontro sobre Inclusão Visual (EIV, Visual Inclusion Conference) and Festival Audiovisual Visões Periféricas (Peripheral Visions Audiovisual Festival), both held in Rio de Janeiro.

Whilst the achievements of these groups have been highly significant, it cannot be denied that the barriers to such endeavours remain substantial. A blurb introducing an article on IP for the cultural magazine Revista Continente reads: 'coletivos propõem ações e projetos que promovam a desmistificação do repertório visual comumente associado a comunidades carentes' (Lira, 2011: 49). Unless the sentence is ironic (and there is nothing to suggest so), the author seems to have failed to acknowledge that 'carente', the adjective she attributes to these spaces, is precisely one of the mythic words that such collectives are trying to combat. The example simply demonstrates the incredibly pervasive nature of some of the terms historically associated with *favelas* and the significant challenge presented to any who wish to call them seriously into question.

Upside Down Inside Out, or 'Stretching Limits'

> The whole history of life has been characterized by an incessant diver-
> sification and intensification of the interaction between inside and out-
> side. (Lefebvre, 1991: 176)

In the passage where this quotation originates, Lefebvre conjures the image of
an embryo to draw us back to our collective point zero, the moment one cell
penetrates the border of another to form what is considered to be a unified
and separate organism within the female body where it temporarily resides.
So a new identity, a new being, is established. The observation is employed
by Lefebvre to explain in some measure the primacy that we humans afford
the inside/outside relationship in our lives. Our conception of self and other
upon which notions of identity are based, is inextricably linked to the defini-
tion of such parameters, which are themselves drawn according to notions of
difference. Stereotypes, however, work with borders in a particularly complex
manner. Not only do they serve as fixers that form rigid and unchanging con-
ceptions of identities through time, but they also lack stable definition – as
Bhabha notes of certain racial stereotypes, 'the black is both savage [...]
and yet the most obedient and dignified of servants' (Bhabha, 1994: 82). The
co-existence of apparently contradictory notions lends stereotypes a funda-
mental ambivalence and fluidity that renders them difficult targets of attack.

Limitations and borders are the subject of the first selection of photographs
that I have chosen to examine. A number of these speak directly to some of
the preconceptions directed toward those who live in *favelas*, specifically their
identification as 'marginais inatos' or 'indivíduos intrinsecamente passivos'
(Souza e Silva, 2001: 85). Photographs taken by A. F. Rodrigues show young
people jumping across, off and between rooftops within the Nova Holanda
area of the Maré *favela* complex, evoking an impression of bodies pushing to
and even beyond what might be considered conventional physical param-
eters. A silhouette suspended against the sky shows a body poised mid-air,
furled into an almost foetal position. Blocking out the sun, the figure is neither
marginal nor passive but a picture of self-possessed control. The crisp lines of
the silhouette register no sign of movement, creating an impression of stillness
and effortlessness that gives the image a somewhat surreal quality. Another
of his photographs shows a young boy in the moment he jumps from a build-
ing, his body appearing to hover weightlessly in an act that defies 'normal'
boundaries, suspended in perpetual defiance of the laws of gravity. Though
his gaze is fixed beyond the frame in the direction he jumps, in our own vision
he appears pinned against the sky and an open expanse of possibility. Again,
a fast shutter speed results in clean lines and relatively little blurring, can-
celling out any visual traces of movement. These images call to mind French

photographer Denis Darzacq's series 'La chute' or 'The Fall'.[59] Where dancers and athletes stage leaps in various locales of Paris' 19th arrondissement, creating what look like impossible physical feats out of what are nonetheless 'real' events devoid of photographic manipulation (Chardin, 2007: 1). Whilst these photographs showcase similarly superior performances of corporeal elasticity, strength and audacity, they also evoke the potential calamity of upcoming impact (as suggested in the title) and in this way differ markedly from Rodrigues' more affirmative images that point instead towards a liberation from bodily constraints.

The theme of bodies in suspension continues in Figure 4.16 where we see a line of girls jumping in unison over an invisible rope. The harmonious impression conveyed in this united action is undermined by the fact that the photograph frames the girls mid-torso, cutting off their upper bodies from the observer together with the rope which drives their movement (this may also be a decision not to infringe upon the identities of the individuals of course). The photographer, Léo Lima, plays with notions of scale and perspective by including a single sandal in the immediate foreground of the image. This visually substitutes the rope as the object that the girls jump over, thus allowing them to remain the focal point of the image despite being dwarfed by the 'giant' piece of footwear. The sandal also serves to mark clearly the viewing position at floor level, consciously distancing our perspective from a more 'passive' or less involved posture such as sitting or standing. The vibrant colours and sense of euphoric suspension in 'leisure time' lend the photograph a surreal air, blurring the boundaries between fantasy/dream and reality.

If we recognise the body as 'a hinge between the population and the individual' (E. Grosz, 1995: 109), we may likewise appreciate the wider implications these images contain as forms of commentary upon the stigma that can affect whole populations. The defiance of physical barriers draws attention to the possibility of overcoming other limiting factors – limitations denoting in this case both the boundaries that are drawn to define identities and the ways in which these same boundaries may curb potential action. As Lefebvre argues, 'Any revolutionary "project" today, whether utopian or realistic, must, if it is to avoid hopeless banality, make the reappropriation of the body, in association with the reappropriation of space, into a non-negotiable part of its agenda' (1991: 166–167). As illustrated in the above examples, reclaiming the body from certain forms of disempowering discourse and creating new

59 The series may be consulted online via the artist's website http://www.denis-darzacq.com/chute-vignettes.htm.

Figure 4.16. Meninas brincando de pular cordo. Jacarezinho (2010), © Léo Lima. Original in colour

ways of looking at these often hyper-visualised spaces are prominent features of the collective's work.

In the next group of images we shift our focus from the immediacy of corporeal boundaries to those experienced in the surrounding environment. As Jacques observes in her work on the architecture of *favelas*, *Estética da ginga* (2007), 'a própria idéia de território não tem escala […]. Pode variar: território do próprio corpo, casa, corpo social, um grupo específico (comunidade), bairro e assim por diante' (2007: 141). It is important to note at this stage the level of detail included in the image captions, which specify the communities featured and also often include the name of a house, road or person. This contextualising practice is another way in which homogenising tendencies are consistently avoided in the representation of these territories.

The questioning of binary notions of interior/exterior and public/private space comes to the fore in many of the works selected for the published collection. In *Pia na laje* (Figure 4.17) Lima shows us the domestic scene of a sink full of washing up framed against a sunny backdrop of the Morro do Alemão, also identified by the cable car station on the horizon. That the sink is on the *laje* – a rooftop space that has taken over the function of patios or backyards in many communities due to dense living conditions and the consequent demand to use space efficiently – interrogates common associations between domesticity and interiority (the home as an inward-facing and private domain), flaunting instead in the pile of crowded plates an outward-facing sociability. This collapse of an interior/exterior divide has not only spatial but temporal consequences. The implications of a movement

Figure 4.17. Pia na laje. Morro do Alemão (2011), © Léo Lima

from private to public space or vice versa in cinema involve the idea of simultaneously shifting from private to public time. Where exterior space is associated with dense spatio-temporal activity, the pace of the interior is perceived by contrast to be slower and extended (Webber and Wilson, 2008: 4). Ratão Diniz captures this particular idea of temporal difference very effectively in Figure 4.18. With the camera positioned down the mid-line of an open doorway, a wide-angle lens is used to incorporate both the interior of the house – in which an elderly lady sits watching television – and the exterior of the street – where we see the blurred outlines of several people rushing past. This co-existence of multiple temporal and spatial zones lends the image a distinctly cinematic quality.

Another domestic threshold is featured in Edmilson de Lima's photograph of an orderly line of white flip-flops propped up against a contrastingly vibrant pink wall (Figure 4.19). The image refers to the practice of assigning different sets of footwear for inside and outside the home and thus expresses a social code of order that openly flouts the charges of disorder and poor hygiene that have been historically and indiscriminately directed toward *favelas* at large over the years. Whilst this image shows a mechanism of social control that clearly reinforces the division between internal and external space, the same photographer subjects such divisions to intense scrutiny elsewhere. Figure 4.20 shows a woman framed in a doorway as she walks past, turning her head at that same moment to become aware of the photographer's presence. The resulting image creates a sense of *mise en abyme* as the doorway reflexively echoes the framing device of the camera

Figure 4.18. Nevinha em sua casa na Rua da Alegria. Parque Maré (2011), © Ratão Diniz. Original in colour

Figure 4.19. Morro do Alemão - "Interiores" - RJ (2011), © Edmilson de Lima / Favela em Foco. Original in colour

and its capacity to freeze action. However, doorways are also a reminder of movement and passage, bearing witness to the 'traces of daily routines, of time and body rhythm, which mark the urban surface' (Jordan, 2010: 144). Although the woman appears to us framed *inside* the space of the doorway, she is simultaneously *outside* on the sunlit street beyond the alley where the photographer/observer stands.

Figure 4.20. Morro do Alemão - RJ (2011), © Edmilson de Lima / Favela em Foco. Original in colour

The unresolved and pervasive tensions stretching across and through these images fundamentally destabilise simplified perceptions of borders and boundaries, illuminating the frequently inadequate way in which we conceive of these complexities, which are both incidentally and deeply embedded in quotidian life. In the visual roller coaster offered by these photographers there is an invitation addressed to all those ready to accept it: that is to see *favelas* beyond the simplified and hegemonic definitions that locate them as spaces that are non-centric or 'outside'.

Resisting the Gaze

> A estética resultante da experiência desses espaços – fragmentados, labirínticos e rizomáticos – é, conseqüentemente, uma estética espacial do movimento, ou melhor, do espaço-movimento. (Jacques, 2007: 149)

One response to the hyper-visualisation that has occurred around *favelas* can be seen in the recourse to reflexive imagery. In Figure 4.21, a boy climbs a pole against the backdrop of a large colourful *favela*scape mural that fills the entire frame. A degree of colour rhyme exists between the boy's shorts and the glowing red-orange lights in the background of the mural, feeding the impression that he is in fact climbing out of the image. At an immediate level, we might see the image as a celebration of graffiti art, which has a

Figure 4.21. Robson da Silva Junior em busca da pipa. Conjunto de Favelas do Alemão (2011),
© Ratão Diniz. Original in colour

recurrent presence in Diniz's work. However, in reflecting back towards the
viewer a stylised image of a space in place of its 'real' outline, the photograph
encourages us consciously to engage with the *favela* as an image with its own
currency and trading value. Boys flying kites have been part of the typical
imagery surrounding *favelas* for many decades – indeed such an image by
Henri Ballot is featured in the Instituto Moreira Salles archive. Whilst in
Diniz's image the kite entirely eludes the viewer (the boy is busy climbing
to fetch it), in Figure 4.22 the kite flyer himself is obscured from view. Of
course, kites have served an additional and more sinister function in certain
areas as a method of alerting drug traffickers to an approaching threat and
Lima's photograph – showing dramatic clouds ready to burst overhead as
the kite tugs urgently at its string – perhaps also gestures toward this less
playful side of the practice. The blurred outline of the kite not only reflects the
physical elements playing across the image space but also the role that this
piece of material plays in directly shielding the identity of the boy from the
viewer. However we interpret the picture, it undoubtedly presents a critical
counter-image to the poor smiling/happy-go-lucky/desperate/miserable
and, most importantly, intrinsically curious and grateful children of the
'global South' whose anonymous faces are consistently disseminated across
the globe, most notably via channels such as the press, tourism and charity
campaigns. In another photograph by Henri Ballot taken in the 1960s, the
frame is filled almost to bursting with the faces of an agglomeration of curious
children from the Morro da Mangueira. We might argue that even in imagery
produced for a domestic audience, the accentuation of difference that occurs

Figure 4.22. Criança soltando pipa sobre a laje. Jacarezinho (2011), © Léo Lima. Original in colour

via the mechanism of a 'foreign encounter' often creates an impression of 'availability' that is both potentially damaging and acutely class-bound.

One of the most iconic images of Rio de Janeiro is the Cristo Redentor statue, often photographed from the air with its arms outstretched over the city in a gesture of inclusion that embodies a symbolic wish for peace. It is thus an image we would be unlikely to associate with a combat situation, making the resurfacing of this unmistakeable reference in the context of a Judo class all the more unexpected (Figure 4.23). As in Lima's photograph above, the protagonist's identity is hidden from the gaze and we only become aware of their stance in off-screen space via the doubly projected shadows of outstretched arms that fall in front of and behind the absent body. The shadow shapes we see stretched across the gym mats and the background wall are essentially negative copies of this body and thus also gesture in no uncertain terms to the process of photographic production. In re-contextualising this powerful icon in a particular community environment, photographer Francisco Valdean asserts the incorporation of this visualised space within the city as a whole, whilst simultaneously challenging the viewer to question other iconic imagery operating across both 'formal' and 'informal' areas. In Figure 4.24, we see further documentation of the diverse sporting and physical activities embraced in different communities. Here break dancing is the subject of Willian Nascimento's photograph, although the character involved in the display of poise, balance and physical control appears to us only in reflection. The subject of the image thus exceeds the camera's frame and the protagonist,

Figure 4.23. Aula de judô no Projeto Vamos à Luta. Vidigal (2007), © Francisco Valdean. Original in colour

Figure 4.24. Douglas Barreto, Ângelo Luiz e Fabrício treinando Tekno Boxe. Parque União, Maré (2009), © Willian Nascimento. Original in colour

multiplied and fragmented by the mirror surfaces, retains an impression of distance and partiality.

This reflexive focus on negotiating the intrinsic limitations of photography's capacity to represent those captured by the lens reaches full expression

Figure 4.25. Grafite do artista Goaboy, integrante do Grupo Máfia 44. Nova Holanda, Maré (2009), © Ratão Diniz. Original in colour

in Figure 4.25. The silhouetted figure of a girl is caught between the camera of the photographer and an image-camera peeping out of a large graffiti tag on the mural behind her. The flash of the painted camera signals that this is 'the moment' of image production, but the girl turns her head away from the mural and directs her gaze instead towards that of the 'real' camera and photographer present on the scene. The image clearly plays upon the conventional usage of chiaroscuro, with the light used in this case not to lend volume and substance to the figure but to flatten its contours in a manner that denies its corporeality. The photograph is yet another example of the way in which images can be encouraged and permitted to overflow their 'natural' frames and more obvious boundaries. Just as the mural refuses to respect the end of the wall it is painted on, instead leaping across the gap of a doorway to continue on the next available surface, so the photographs here examined continually challenge our sense of beginning and end, of the real and imagined.

As Hall comments, one method that has been used to try and confront stereotypes is that of 'construct[ing] a positive identification with what has been abjected' (1997: 272). However, he maintains that this strategy is flawed, for while constructing an alternative vision around the subject via positive imagery increases the *range* of representation, it does nothing to dislodge negative stereotypes, which thus continue unabated (1997: 274). Although IP has clearly done work to broaden the type of imagery associated with *espaços populares*, I would argue that the subtle and complex tactics employed reach well beyond the simple creation of positive imagery with which 'outsiders' might

identify. Identification is in fact sometimes actively discouraged, as discussed above, and the relationship between observed and observer severely problematised despite the endogenous nature of the image production. It is not by dismissing stereotypes but by creating dialogue with them that the photographers achieve their most powerful results.

As is widely acknowledged, much of the media imagery surrounding Rio de Janeiro's *espaços populares* during the last decade has taken violence and criminality as a central theme, particularly armed conflict related to drug-trafficking (S. Ramos and Paiva, 2007: 77). Whilst IP is clearly engaged in creating a visual repertoire that steers away from such well-trodden terrain, that is not to say that the collective excludes the theme of violence from its work. A photograph by A. F. Rodrigues of a military officer's hands clasping a gun addresses the subject explicitly. It was taken in the Conjunto de Favelas do Alemão during its occupation by the military police towards the end of 2010, a particularly fraught and unsettled period for those living in the area and one that unsurprisingly received heavy news coverage. Rodrigues' decision to frame the officer's hands in close-up emphasises an existing tension between the hard metal of the weapon and the plump feminine hands of the officer, her nails painted with pink varnish. Depriving the viewer of further superficial physical or facial characteristics prevents any attempt to judge or ascribe an imagined character to the woman who remains elusive and indistinct. The focus of the image, however, is far from impersonal. The woman's finger extends across the trigger to point directly to a gold wedding ring that is doubled via a reflection in the vehicle she leans against. How might we interpret this resounding emphasis upon her femininity and marital status? Perhaps as a mechanism to draw our attention to everyday domestic life as embodied in rituals of personal grooming and familial relations? This is an impression that contrasts with the stereotypes and expectations surrounding not the *favelas'* residents as 'targets' of police violence, but the latter group as both 'aggressors' and 'targets'. The image acknowledges the fact that the *militares* have also suffered dehumanisation and stereotyping as a result of such urban conflicts. What Rodrigues accomplishes here is a successful reframing of the subject without glossing over any fundamentals – the *militar* still has a weapon in her hands and looks poised to fire if need be, but she holds it now as a human and a woman, rather than a muscle-bound male avenger in *Tropa de elite* style.

It is hard to picture a scenario where vast numbers of personal and collective interests might find themselves in perpetual accordance, for the precise reason that interests and desires remain heterogeneous. Conflict is an inevitable part of human difference and interaction and the best intentions can thus only be to avoid collisions where possible and to mitigate the scale and price paid for those that circumstance and time prove inescapable.

Figure 4.26. Pomba da paz (2011), © Elisângela Leite. Original in colour

This co-existence of conflicting elements comes to the fore in a photograph of a mural in the Maré *favelas* by Elisângela Leite (Figure 4.26). Here the desire for peace represented in the expression of the dove and the blue background is disrupted by the bullet holes scattered across the wall, marks that simultaneously constitute both the stimulus for, and negation of, that very desire.

Horizons Old and New

> Demonizing of the urban poor grows, in part, out of images about how poor urban dwellers live. (Dennis, 2005: 83)

The above observation highlights just how important is the objective to transform and, at the very least, broaden the type of imagery that *espaços populares* create and in which they feature. How best to avoid producing a one-sided discourse in the process and ensure instead that persisting issues of material precariousness and inadequate infrastructure remain on the agenda where necessary? We might interpret a possible response to this question in an evocative image by Ju Freitas of an elderly woman crossing a disintegrating bridge. Although the topsy-turvy collapsing bridge looks to be heaving its last breaths, the woman negotiating the failing structure remains upright as she holds on to the railing. By locating the woman firmly in the centre of the frame, with her back to the camera, Freitas avoids evoking pity or 'victimhood', cultivating instead an impression of strength in the face of adversity. Although the image recognises a need for material improvement (there is no attempt to romanticise the situation of

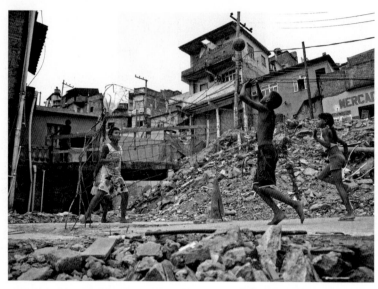

Figure 4.27. Crianças jogam vôlei em meio às demolições provocadas pelas obras do Teleférico. Morro do Alemão (2009), © Fábio Caffé

difficulty that the woman negotiates), the photographer avoids the common fate of synergising the state of the physical environment with those who occupy it.

With approximately 90 percent of the Imagens do Povo book taken up by colour images, it is interesting to note that two of the photographs dealing most obviously with the themes of destruction and creation should be rendered in black and white. In Figure 4.27, a group of children play volleyball amidst the rubble of demolitions caused by the (now completed) controversial government project to install a cable car across the Morro do Alemão. Two background spectators frame the game on either side – a boy leaning across a railing and a woman watching from a nearby window – their presence encouraging us to question what makes the sight appealing to the eye. Perhaps we might consider the photograph a celebration of human resourcefulness, as the 'net' is quite clearly not a conventional piece of sporting apparatus but a metal grid probably unearthed during the surrounding destruction. This creates a bizarre tension between our expectation of soft penetrable material and the uncompromising boundary formed by the actual hard metal structure dividing the space. Given the angle from which the photograph has been taken, the boy on the far side of the 'net' appears to be partially wrapped up in the grid, hinting also at more widespread concerns surrounding protection and security in the city.

At the opposite end of the spectrum, Leite's image clearly celebrates the construction work being carried out on an art centre in Maré (Figure 4.28).

Figure 4.28. Centro de Artes da Maré (2009), © Elisângela Leite

In addition to the obvious practicalities of photographing the scene from below, this angle fosters a clear sense of admiration for the worker. Whilst many construction works in *favelas* have found themselves the subject of controversy as a result of the frequent destruction of existing buildings, including homes and community spaces, carried out in order to realise the projects, here Leite brings a positive light to a project backed by the local NGO Redes de Desenvolvimento da Maré. The image thus also draws attention to positive transformations and community development gener-ated from within the locale (in contrast to externally imposed wide-scale government initiatives). That is not to say that the latter necessarily attract negative responses from the group. Edmilson de Lima's photograph of a scene entitled 'A Favela e seu Cotidiano' demonstrates how life goes on for citizens down below as the cable cars travel overhead (Figure 4.29). The destruction that Caffé captured in his volleyball scene above thus translates a year later into what we might interpret as a positive image of material progress.

The final photograph that I would like to consider here is an aerial per-spective of the Baixa do Sapateiro and Nova Maré communities by Valdean (Figure 4.30). The angle of the shot is much lower than C. Jaguaribe's pre-ferred viewpoint and that of typical cinematic *favela*scapes (suggesting that it was taken from another structure or crane rather than a helicopter) with the result that these *espaços populares* are conveyed not as an overflowing expanse that exceeds the visual capacity of a dislocated and *downward*-looking viewer, but as a landscape from within which the located individual looks out *across*.

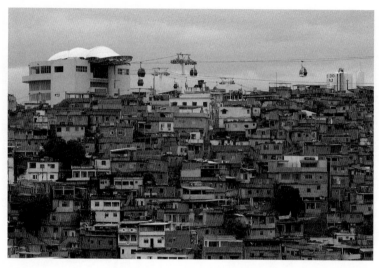

Figure 4.29. A Favela e seu Cotidiano - RJ (2011), © Edmilson de Lima / Favela em Foco. Original in colour

If we look back to earlier photographs, such as Ballot's Favela da Mangueira (Figure 4.4), we might appreciate that *favelas* have not always been shown in such a disorderly light. The paved road stretching away from the foreground of Valdean's photograph leads the viewer into a heterogeneous space (there is a clear difference between the types of construction materials and house styles from one community to the other, for instance) far from the hyper-visualised homogeneous *favela* that has gained such notoriety. In place of an overwhelming sprawl suggestive of an uncontrollable and haphazard growth to be feared, the images produced by the IP collective literally return to the *favelas* their own horizon and with it an accompanying sense of possibility.

> The essence of politics resides in the modes of dissensual subjectification that reveal a society in its difference to itself. (Rancière, 2010: 42)

Although each of the above works has been conceived of and produced by artists coming from a variety of socio-economic backgrounds, a common thread binds their different approaches to *favela* spaces. This consists in a radical challenge to the particular boundaries associated with historical modes of viewing these spaces, together with the conceptual use of boundaries within art to question mechanisms that define the ways in which we experience identity and relate to those around us. It is useful to return at this juncture to the epigraph opening this chapter, in which Comaroff and Comaroff highlight the past and potential damage caused by the assumption that it

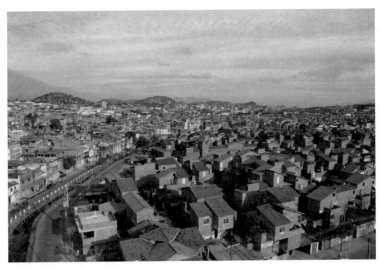

Figure 4.30. Comunidades Baixa do Sapateiro e Nova Maré. Maré (2004), © Francisco Valdean. Original in colour

is possible to represent others adequately. Here we return to a crucial issue addressed in chapter 3, that is Spivak's problematisation of the very term 'representation', which in Portuguese as in English collapses the distinction between two interlinked but separate concepts relating to art and politics respectively.

In the first section on 'Entre morros', Claudia Jaguaribe uses her appreciation of the ungraspable nature of the megalopolis to reframe the city and corresponding notions of fixed and coherent positions and perspectives. In Babilônia, we witness a foregrounding of the unequal relationships at stake in the filmic encounter. Examining the work of those who have collaborated with the Imagens do Povo collective, we see how a dialogue with common stereotypes is stimulated in order to exceed and destabilise the boundaries upon which such stereotypes rely. In each case, what becomes clear is the significance of the artists' decision to acknowledge and accept their own position as image producers. For it is in displaying rather than concealing this point of distinction that it becomes possible to separate the notion of representing an entity *artistically* from the claim to represent it *politically*. Whilst the person or space explicitly filmed or photographed clearly remains the artistic subject of the image, the political focus of the image shifts under these circumstances to the *relationship* between the artist and that subject.

Although the complexities of negotiating social difference in urban spaces of the twenty-first century have led to interpretations of the *favela* as an 'ícone que sintetiza os impasses da cidade', by the same token we might also

recognise the significant potential contained in such spaces to unlock and resolve some of the same predicaments (B. Jaguaribe, 2007: 151). There is little sense and much futility in conjuring unrealistic and anachronistic notions about the capacity of art to pave the way to an urban Utopia. However, to suggest that we each have a responsibility to recognise the absolute feasibility of alleviating tensions inspired by negative reactions to difference and improving the quality of social relations is an entirely different matter.

Conclusion

Se na modernidade a resistência obedecia a uma matriz dialética, de oposição direta das forças em jogo, […] o contexto pós-moderno suscita posicionamentos mais oblíquos, diagonais, híbridos, flutuantes. (Pelbart, 2003: 142)

Art does not become critical or political by 'moving beyond itself', or 'departing from itself', and intervening in the 'real world'. There is no 'real world' that functions as the outside of art. Instead there is a multiplicity of folds in the sensory fabric of the common, folds in which outside and inside take on a multiplicity of shifting forms, in which the topography of what is 'in' and what is 'out' are continually criss-crossed and displaced by the aesthetics of politics and the politics of aesthetics. (Rancière, 2010: 148)

Each of the works examined in the body of this study has at its centre a preoccupation with questions of social difference. What is ultimately at stake in these analyses of artistic expression is a re-examination of an old and well-used filter, one that has repeatedly tinged the subject of inequality with the colours of segregation and exclusion. Cities in Brazil and throughout the world continue to be, due in large part to the nature of their gravitational economic pull, loci and motors of difference. As a social product inseparable from the power interests that help to conceive and define it in its numerous forms, socio-economic difference remains a constant source of tension, of both potential and fully fledged conflict. The naturalisation of extreme social contrasts through the channels of visual media, in which both advertising and documentary film and photography have played a role, is one powerful manner in which patterns of inequality have been fixed over the years. The enduring nature and consequences of these social hierarchies – the most common of which are often based on definitions of gender, race and class – remain a serious challenge for humanity in the twenty-first century.

In the preceding chapters we have seen how the use of reflexivity and innovative aesthetic approaches to what are often historically highly visualised subject matters and spaces can function to heighten viewers' awareness of the intricate stakes at play in such representations. As Anna Grimshaw notes, 'vision functions as a metaphor for knowledge, for particular ways of knowing the world' (2001: 7). Here, the filmed subjects are no longer openly 'available' to the all-knowing and all-seeing eye of the spectator, but are explicitly mediated and indeed transformed by the phenomenon of the image-making

process. A clear recognition of the complicity of visual media with various power interests has replaced a former belief in the media's own capacity to impact concretely upon a documented situation. It should be noted, however, that such an acknowledgement does not necessarily cancel out a desire for change, which may well continue to fuel interest in the subject matter.

At work is a highly complex dynamic that impacts upon the notion of distance and/or proximity in the viewing experience. Although techniques such as reflexivity distance spectators from the idea that film or photography is able to capture a reality authentically and without interference, they simultaneously perform a collapsing function with respect to traditional roles. In many of the cases we have examined above, the viewer is no longer simply an aloof receptor of information but becomes instead a participant in an often ambiguous dialogue. This is an involvement that requires re*action*, as opposed to the state of passive absorption traditionally understood to accompany the viewing experience. This crucial conceptual shift is one stressed by Jacques Rancière in his statement that 'emancipation begins [...] when we understand that viewing is also an action that confirms or transforms [the] distribution of positions. The spectator also acts, [...] observes, selects, compares, interprets' (2009: 13).

The repeated presentation of poverty as a self-contained issue has done much in its own way to discredit the premise upon which social documentary is founded. In the project to *dar voz* and lend visibility to underrepresented and 'marginalised' populations, artists often rendered *themselves* absent and invisible. This tendency in fact echoed much earlier anthropological endeavours to produce 'objective' and supposedly unadulterated knowledge about the people it sought to document. The inequality and dependency that rests at the core of such historic practices is deeply and paradoxically disempowering. As Elizabeth Edwards observes, it is for this reason that photographs taken within this tradition later came to be regarded as 'a mine of a century of disciplinary assumptions and asymmetrical power relations to be excavated' (2011: 173). Visual anthropology may thus be seen as a locus where much of the debate surrounding ethical practices in both ethnographic and documentary filmmaking and photography have been played out. We are led once again to the question posed in the introduction to this study: is there still a space for thinking about transformation within contemporary documentary production?

On the one hand, the idea that it is possible to create a narrative or a single image that reflects upon serious issues occurring in the external or 'real' world clearly remains in circulation. On the other hand, the belief that such reflection can lead to meaningful action has largely been severed, leading much cultural production to stagnate in a static and depoliticised domain. In an environment where any possibility for change is categorically denied, viewers are given

licence to assume a position entirely external to the viewing matter, where they are no longer bound by any sense of implication or responsibility. The borders and divisions that have arisen around the documentary experience may be perceived in this light as mechanisms for social distancing and absolution. Is it not perhaps overly and unnecessarily cynical, however, to suggest that this industry is built entirely upon a desire to make ourselves – the filmmakers, photographers, and viewers of such pictures – feel better about our own lives? Such a stance would also fail to take into account the highly significant movement of *inclusão visual*.

As filmmaker Renzo Martens suggests, one way to break out of this impasse is for the artist openly to claim responsibility for their own position and influence upon the subjects and themes they portray. To do otherwise, at least in the domain of documentary, is in many respects the most artificial and unrealistic gesture an artist can perform. After all, 'la cámara impone sus propias reglas a la vida, el fotógrafo nunca podrá ser un *outsider*' (Fontcuberta, 2007: 111). At this juncture we might also remind ourselves of the important observation that 'a documentary aware of its own artifice is one that remains sensitive to the flow between fact and fiction' (Minh-ha, 1993: 99). The increasing trend to assume creative responsibility has been coupled in many instances by a shift towards making images *for*, rather than *about*, those who feature in them. This 'striking contrast' is emphasised by both Liz Wells (2000: 140) and John Berger, the latter stating that 'for the photographer this means thinking of her or himself not so much as a reporter to the rest of the world but, rather, as a recorder for those involved in the events photographed' (Berger, 2009: 62). This distinction should not be oversimplified, however, and by no means necessarily entails a greater authenticity of representation. As the films *Avenida Brasília Formosa* (2010) and *Babilônia 2000* (2000) both clearly demonstrate, the ambiguous 'liberty' of their subjects' performances may just as easily place them *within* as *outside* the parameters of established visual paradigms.

Performance is employed in a variety of manners and to differing effect in most of the projects analysed in this book and thus makes an interesting point of comparison. For some of those featured in these images, performance clearly operates as an empowering gesture, a means to counter and pre-empt perceived audience expectations or perhaps to enter a privileged code of representation. In this context, performance constitutes a tool via which subjects not only become 'visible' but also exert a degree of ownership upon the imagery produced around them. This ownership should be recognised in its limited capacity, however, as there are no illusions as to who possesses ultimate editorial control. Examples of works that use performativity to this end are: *Estamira* (2004), where Marcos Prado's aesthetic approach reinforces the fact that what we are shown is Estamira's own performance,

through which she communicates a particular worldview that challenges the audience to look beyond conventional parameters; *O prisioneiro* (2004), where prisoners perform for themselves and anticipated viewers, creating an intermingling of perspectives that destabilises some common preconceptions about the prison environment; *Babilônia 2000*, where performance articulates the encounter between filmmakers and subjects and reinforces the distance between lives enacted on and off the screen; and '911' (2006), where the subjects' awareness of the camera is placed into the context of a historic anthropological discourse where it is transformed into a means by which to undermine notions surrounding intellectual authority and property.

Other works that we have examined use performance as an integral part of the narrative process. This is the case with *Lixo extraordinário* (2010), for instance, where subjects perform re-enactments of famous artworks in response to an artist's explicit desire to empower that nonetheless falls short of the mark, instead reinforcing a divide between the artist/intellectual and the model/labourer; 'Morar' (2007), where theatrical poses are used to narrate personal journeys of displacement; and *Juízo* (2007), where disadvantaged youths stand in and perform for others, narrating in this reflexive gesture a sense of interchangeability that illustrates the hapless flow of criminalised bodies through the youth justice system. Performance is often used to reflect upon the image-making process, heightening audience awareness of image producers and problematising the notions of both artistic and political representation, as in *Avenida Brasília Formosa*. In this instance, as in the film *Juízo*, the co-existence of reflexive and observational techniques may initially strike the viewer as highly paradoxical, given that the former reinforce the presence of the filmmaker whilst the latter tend to mask it. It becomes far less problematic, however, when we take into account the pragmatic conclusion that 'observational cinema is not about a superficial, distanced encounter; rather it requires intense engagement with what is happening around the camera' (Grimshaw, 2002: 13). In photographic works such as 'Jardim Gramacho' (2004), 'Imprisoned Spaces' (2004) or 'Rio – Entre morros' (2010) it is often the particular quality of the space conveyed by the artist and the way in which subjects and viewers are positioned in relation to this environment and each other that engages most effectively with questions of (dis)empowerment.

What many of these works share is the use of performance to engage a particular truth value, whether this takes the form of a statement about the futility of the current youth justice system, or the encounter at the heart of the documentary process. Performance involves recognising the camera's presence and acknowledging the roles played by those either side of its lens. The tension at the core of these projects signals the intricate forces in play, with artists often distancing themselves through reflexive techniques designed to

undermine their own sense of authorship at the same time as they collapse the boundaries between inside and out to implicate image-maker, subject and audience within a single frame. In his paper 'The Subjective Turn in Brazilian Documentaries', Pablo Gonçalo remarks upon a transition within Brazilian documentary-making from a privileging of the 'sociological voice' to that of autobiographical narratives, arriving finally at 'the current valorization of role-play and performance within the new ethical dimensioning of the documentary' (2012: 15). This move away from formulaic portrayals of sociological types and phenomena to complex portrayals of individuals is clearly reflected in the works discussed in this book. Indeed, the participatory and collaborative tendencies present in these contemporary practices may be seen to play a significant role in fostering the thriving relationship between creative and socially motivated projects that is so singularly prevalent in Brazil today.

What many of the works discussed throughout this study have shown via both aesthetic and thematic means is the highly blurred nature of the boundaries we customarily experience and live by. Wearing away at the fixity of such perceptions simultaneously undermines the notion of segregation as anything other than a political tool used to reinforce certain hierarchies, thus opening up and exposing the rigid categories of stereotypes and prejudices to the possibility of change. Just as we have observed the infiltration of the traditionally static medium of photography by temporality and flux (for example in 'Morar' or 'Rio – Entre morros'), so too we have seen immobility and stagnation effectively conjured through the medium of film (as in *O prisioneiro da grade de ferro* and *Juízo*). Playing with the permeability and even erasure of frontiers at the level of the media underscores the artists' diminishing inclination to restrict their work to prescribed documentary expectations. This is not to say that such acts are revolutionary in themselves, but rather that they are involved in the highly significant task of questioning wider sets of values and paving the way for new forms of expression:

> Displacing art's borders does not mean leaving art, that is making the leap from 'fiction' (or 'representation') to reality. Practices of art do not provide forms of awareness or rebellious impulses *for* politics. Nor do they take leave of themselves to become forms of collective political action. They contribute to the constitution of a form of common sense that is 'polemical', to a new landscape of the visible, the sayable and the doable. (Rancière, 2010: 149)

Whilst it may be both anachronistic and unproductive to continue thinking about documentary in terms of its traditional world-changing goals, this does not mean that the concept of transformation need be banished from the debate altogether. In the contexts we have examined, an established visual repertoire

and degree of awareness of core issues already exists. *Conscientização* in such cases is often about combating distorted or heavily biased forms of awareness. Many of the above works suggest that documentary is entirely capable of positively contributing to these discussions, not least via its ability to widen an individual's field of view. In destabilising personal and conventional perceptions about the location and existence of social and aesthetic boundaries, of the distinctions between inside and out (as achieved particularly effectively in *Estamira* and much of the photography from the Imagens do Povo collective (2012a)), these creative endeavours have within their grasp the means to shift our own relative positions as spectators. Changing the way that social 'others' are represented and potentially perceived on screen is a step towards altering viewers' notions of involvement and responsibility, stimulating an acknowledgment of the mutual location of view*ers* and view*ed* within a single existential frame.

As Teresa Caldeira highlights, 'among the conditions necessary for democracy is that people acknowledge those from different social groups to be co-citizens, having similar rights despite their differences' (2000: 334). Any drive towards greater equality must hold this statement to account. What remains unchanged in the domain of cultural production is the heavy predominance of 'disadvantaged' populations as the subjects of documentary. That is to say that those seen to be *in need of* change dominate discourse, whilst those we might assume to possess the political *power to effect* systemic change remain consistently and conspicuously underrepresented in these art forms. Similarly, the socio-economic upper echelons of the population, when not featured in glossy cover stories or biographies, remain largely in the shadows so far as radical documentary practices are concerned. A reluctance to turn cameras upon these subjects is in great part due to the practicalities of access of course – as discussed above in relation to Gabriel Mascaro's *Um lugar ao sol* (2009). Whilst initially developing this study I was particularly keen to include materials that defied this pattern. A sheer shortage of relevant works, however, ultimately rendered this an impractical consideration. That is not to say that there have not been successful moves in this direction – Coutinho's *Edifício Master* (2002), João Moreira Salles' *Entreatos* (2004), Marcelo Pedroso's *Pacific* (2009) and Mascaro's *Doméstica* (2012) are all symptomatic of a desire to break this mould. Nonetheless, examples in the field of recent Brazilian documentary photography are much harder to come by.

As Paula Rothenberg crucially observes in her discussion of racial difference and discrimination:

> To redesign social systems we need first to acknowledge their colossal unseen dimensions. The silences and denials surrounding privilege

are the key political tool here. They keep the thinking about equality or equity incomplete, protecting unearned advantage and conferred dominance by making these taboo subjects. (2008: 127)

Privilege is a historically invisible and silent terrain in documentary. It is one that clamours for attention from both image producers behind cameras and those in the academic domain. Not only is it important that the frequently dominant social and political positions of artists and critics be assumed rather than concealed, but that the subjects and patterns of dominance themselves are expressed and examined within documentary. This will undoubtedly constitute an important direction for future research.

References

Academia Brasileira de Cinema (2013) 'Juízo'. [WWW document]. URL http://www.academiabrasileiradecinema.com.br/site/index.php?option=com_content&task=view&id=603&Itemid=424&limit=1&limitstart=2 [accessed 15 September 2013].

Agência Estado (2009) 'Na ONU, ministro critica muros em favelas do Rio'. *G1 - Política*, 8 May. [WWW document]. URL http://g1.globo.com/Noticias/Politica/0,,MUL1113628-5601,00-NA+ONU+MINISTRO+CRITICA+MUROS+EM+FAVELAS+DO+RIO.html [accessed 25 November 2012].

Alencar, J. de ([1865] 1990) *Iracema*. Publicações Europa-America: Mem Martins.

Allen, A. (2013) 'Shifting Perspectives on Marginal Bodies and Spaces: Relationality, Power, and Social Difference in the Documentary Films Babilônia 2000 and Estamira'. *Bulletin of Latin American Research* 32: 78–93.

Andrade, C. (2012) 'Saqueos en Bariloche: hay 20 heridos y el gobierno envía a la gendarmería'. *Clarín*. 20 December. [WWW document]. URL http://www.clarin.com/sociedad/Bariloche-encapuchados-saquean-destrozan-supermercado_0_832116963.html [accessed 25 January 2013].

Andrade, O. de (1928) 'Manifesto antropófago'. *Revista de Antropofagia* 1(1): 3, 7.

Appadurai, A. (1996) *Modernity at Large: Cultural Dimensions of Globalization. Public Worlds* Vol. 1. University of Minnesota Press: Minneapolis and London.

Araújo, M. and Castro, V. (eds.) (2010) *Rebelião cultural*. Favela a Quatro: Rio de Janeiro.

Armstrong, P. (2009) 'Essaying the Real: Brazil's Cinematic *Retomada* and the New Commonwealth'. *Journal of Iberian and Latin American Studies* 15(2–3): 85–105.

Balazina, A. (2006) 'Sem-teto faz biblioteca em prédio invadido'. *Folha de São Paulo*, 1 February. [WWW document]. URL http://www1.folha.uol.com.br/folha/cotidiano/ult95u117855.shtml [accessed 23 October 2012].

Baltar, M. (2010) 'Cotidianos em performance: *Estamira* encontra as mulheres de *Jogo de Cena*' in C. Migliorin (ed.) *Ensaios no real: o documentário brasileiro hoje*. Azougue Editorial: Rio de Janeiro, 217–234.

Barthes, R. ([1979] 2000) (trans. R. Howard) *Camera Lucida: Reflections on Photography* (Howard). Vintage: London.

Bauman, Z. (1987) *Legislators and Interpreters: On Modernity, Post-modernity, and Intellectuals*. Cornell University Press: Ithaca.

Bauman, Z. (2004) *Wasted Lives: Modernity and Its Outcasts*. Polity Press: Cambridge and Malden.

BBC (2011) 'Trouble Erupts in English Cities'. *BBC News*, 10 August [WWW document]. URL http://www.bbc.co.uk/news/uk-england-london-14460554 [accessed 1 February 2013].

Becher, B. and Becher, H. (1988) *Water Towers*. MIT Press: Cambridge and London.

Becher, B. and Becher, H. (1990) *Blast Furnaces*. MIT Press: Cambridge and London.

Benjamin, W. ([1968] 1999) *Illuminations* (trans. H. Zorn). Pimlico: London.

Bentes, I. (2001) 'Da estética à cosmética da fome'. *Jornal do Brasil*–Caderno B, 8 July, 1–4.
Bentes, I. ([2003] 2006) 'The *Sertão* and the *Favela* in Contemporary Brazilian Film' in L. Nagib (ed.) *The New Brazilian Cinema*. I. B. Tauris: London, 121–137.
Bentes, I. (2007) 'Sertões e favelas no cinema brasileiro contemporâneo: estética e cosmética da fome'. *Alceu* 8(15): 242–255.
Beraba, M. (2007) 'Blurb' in S. Ramos and A. Paiva *Mídia e Violência*. CESeC; IUPERJ; SEDH: Rio de Janeiro.
Berger, J. ([1980] 2009) *About Looking*. Bloomsbury: London.
Bernardet, J,-C. (1985) *Cineastas e imagens do povo*. Brasiliense: São Paulo.
Bhabha, H. (1994) *The Location of Culture*. Routledge: London.
Bisilliat, M. (ed.) (2003) *Aqui dentro: páginas de uma memória: Carandiru*. Memorial: Imprensa Oficial: São Paulo.
Bittencourt, J. (2008) *In a Window of Prestes Maia 911 Building*. Dewi Lewis: Stockport.
Bordwell, D. (2006) *The Way Hollywood Tells It: Story and Style in Modern Movies*. University of California Press: Berkeley.
Bowden, C. (2007) 'US- Mexico Border'. *National Geographic Magazine*, May. [WWW document]. URL http://ngm.nationalgeographic.com/2007/05/us-mexican-border/bowden-text/1 [accessed 27 November 2012].
Bragança, F. (ed.) (2009) *Encontros: Eduardo Coutinho*. Beco do Azougue Editorial: Rio de Janeiro.
Brettle, J. and Rice, S. (eds.) (1994) *Public Bodies–Private States: New Views on Photography, Representation and Gender*. Manchester University Press: Manchester.
Brinkhoff, T. (2012) 'The Principal Agglomerations of the World: Population Statistics and Maps'. 15 October [WWW document]. URL http://www.citypopulation.de/world/Agglomerations.html [accessed 8 January 2013].
Bruzzi, S. (2000) *New Documentary: A Critical Introduction*. Routledge: London.
Buarque de Holanda, S. ([1936] 2000) *Raizes do Brasil*. Gradiva: Lisbon.
Caetano, D. (2005) *Cinema Brasileiro 1995–2005: Revisão de uma década*. Azougue Editorial: Rio de Janeiro.
Caldeira, T. Pires do Rio (2000) *City of Walls: Crime, Segregation, and Citizenship in São Paulo*. University of California Press: Berkeley.
Cannabrava, I. (2009) *Uma outra cidade*. Editora Terceiro Nome; Museu da Casa Brasileira: São Paulo.
Carminati, T. Z. (2009) 'Imagens da favela, imagens pela favela: etnografando representações e apresentações fotográficas em favelas cariocas' in M. A. Gonçalves and S. Head (eds.) *Devires imagéticos: a etnografia, o outro e suas imagens*. 7Letras: Rio de Janeiro, 68–91.
Carroll, N. (1996) 'Nonfiction Film and Postmodernist Skepticism' in D. Bordwell and N. Carroll *Post-theory: Reconstructing Film Studies*. University of Wisconsin Press: Madison, 283–306.
Castellote, A. (2003) *Mapas abiertos: fotografía latinoamericana, 1991–2002*. Lunwerg: Barcelona.
Castro, J. (2008) 'Gramacho: a vida no maior aterro sanitário da América Latina'. *UOL Notícias*, 5 November. [WWW document]. URL http://mais.uol.com.br/view/1575mnadmj5c/gramacho-a-vida-no-maior-aterro-sanitario-da-america-latina-04023170D0C12326?types=A& [accessed 5 January 2013].

Cattani, A. D. (2012) 'The Old Class: The Dark Side of the Rich'. *Brazilian Studies Programme, University of Oxford* (Occasional Paper BSP-08-12). [WWW document]. URL http://antoniodavidcattani.net/publicacoes/artigos/the-old-class-the-dark-side-of-the-rich [accessed 19 August 2012].

Chakrabarty, D. (2002) *Habitations of Modernity: Essays in the Wake of Subaltern Studies*. University of Chicago Press: Chicago.

Chanan, M. (2007) *The Politics of Documentary*. British Film Institute: London.

Chardin, V. (2007) 'The Fall, Variation on the Theme of the Leap into the Void'. *Denis Darzacq*. March. <denisdarzacq.com/The%20Fall%20Virginie%20Chardin.pdf > [accessed 13 December 2012].

Cia de Foto (2013) '911'. *Cia de Foto*. [WWW document]. URL http://www.ciadefoto.com/911 [accessed 28 February 2013].

Coleção Pirelli/MASP (2013) 'Marcos Prado - Biografia'. *Coleção Pirelli/MASP de Fotografia*. [WWW document]. URL http://www.colecaopirellimasp.art.br/autores/88/obra/309 [accessed 15 September 2013].

Comolli, J.-L. ([2004] 2008) *Ver e poder: a inocência perdida*. UFMG: Minas Gerais.

Costa, H. (2011) 'Fotoclubismo e fotojournalismo no Brasil: duas manifestações da fotografia moderna (1940–1950)'. Conference paper, Instituto Moreira Salle: Rio de Janeiro.

Cox, P. (2010) 'The Dark Side of Rio: Brazil 2010'. *YouTube*, video. [WWW document]. URL http://www.youtube.com/watch?v=YgT1D623U9I [accessed 28 February 2013].

Cunha, M. da (2009) 'Between Image and Word: Minority Discourses and Community Construction in Eduardo Coutinho's Documentaries' in M. Haddu and J. Page (eds.) *Visual Synergies in Fiction and Documentary Film from Latin America*. Palgrave Macmillan: Basingstoke, 133–150.

Cypriano, A. (2001) *O caldeirão do diabo*. Cosac & Naify: São Paulo.

Cypriano, A. (2012) '*The Devil's Caldron*'. [WWW document]. URL http://www.andrecypriano.com/#a=0&at=0&mi=2&pt=1&pi=10000&s=1&p=1 [accessed 7 June 2012].

DaMatta, R. (1987) *Relativizando: uma introdução à antropologia social*. Rocco: Rio de Janeiro.

DaMatta, R. (1995) (trans. C. Dunn) *On the Brazilian Urban Poor: An Anthropological Report. Democracy and Social Policy Series* (Helen Kellogg Institute for International Studies). Working Paper: 10. University of Notre Dame, Helen Kellogg Institute for International Studies: Notre Dame.

Datafolha (2009) '*Opinião sobre construção de muros ao redor de favelas no Rio de Janeiro*'. 9 April [WWW document]. URL http://datafolha.folha.uol.com.br/po/ver_po.php?session=877 [accessed 25 November 2012].

Davis, M. (2007) *Planet of Slums*. Verso: London and New York.

Dennis, R. (ed.) (2005) *Marginality, Power and Social Structure: Issues in Race, Class, and Gender Analysis*. Elsevier: Amsterdam and London.

Dias, V. F. (2003) 'A Cinema of Conversation –Eduardo Coutinho's Santo Forte and Babilônia 2000' in L. Nagib (ed.) *The New Brazilian Cinema*. I. B. Tauris: London, 105–117.

Diaz Camarneiro, F. (2010) '5x favela: agora por nós mesmos – críticas contradições'. *Revista Cinética*. September. [WWW document]. URL http://www.revistacinetica.com.br/5xfavelafabio.htm [accessed 31 January 2013].

Dieleke, E. (2009) '*O Sertão Não Virou Mar*: Images of Violence and the Position of the Spectator in Contemporary Brazilian Cinema' in M. Haddu and J. Page (eds.) *Visual Synergies in Fiction and Documentary Film from Latin America*. Palgrave Macmillan: Basingstoke, 67–85.

Diler & Associados (2013) '*Maria Augusta Ramos – Biografia*'. [WWW document]. URL http://www.diler.com.br/filmes2/curriculos/maria_augusta_ramos. pdf [accessed 15 September 2013].

Douglas, M. ([1966] 2002) *Purity and Danger: An Analysis of Concepts of Pollution and Taboo*. Routledge: London and New York. [WWW document]. URL http://lib. myilibrary.com?id=19533 [accessed 15 March 2012]

Eduardo, C. (2004) 'Estamira, de Marcos Prado: a mulher, o lixo e o mito'. *Revista Cinética*. [WWW document]. URL http://www.revistacinetica.com. br/estamira.htm [accessed 25 March 2013].

Edwards, E. (2011) 'Tracing Photography' in M. Banks and J. Ruby (eds.) *Made to be Seen: Perspectives on the History of Visual Anthropology*. University of Chicago Press: Chicago and London, 159–189.

Ellis, J. (2007) 'Dancing to Different Tunes: Ethical Differences in Approaches to Factual Film-making' in G. Pearce and C. McLaughlin (eds.) *Truth or Dare: Art & Documentary*. Intellect: Bristol.

Escorel, E. (2003) *Objetivo Subjetivo*, Vol. 36: *Cinemais*. Aeroplano: Rio de Janeiro.

Escorel, E. (2010) 'De fora, de dentro'. *Piauí*. August. [WWW document]. URL http://revistapiaui.estadao.com.br/edicao-47/questoes-cinematograficas/ de-fora-de-dentro [accessed 28 May 2012].

Eye On Films (2013) 'Marcos Prado'. *Eye On Films*. [WWW document]. URL http://eyeonfilms.org/film/artificial-bibdises-en/ [accessed 15 September 2013].

Fernandes Junior, R. (2012) 'Escalada para além do documental' in *O Estado de São Paulo*, 26 September. Secretária da Cultura: São Paulo.

Filme B (2016a) '*Quem é quem no cinema – Marcos Prado*'. www.filmeb.com.br/ quem-e-quem/diretor-documentarista-produtor/marcos-prado [accessed November 2016].

Filme B (2016b) '*Quem é quem no cinema – Maria Augusta Ramos*'. www.filmeb .com.br/quem-e-quem/diretor-documentarista/maria-augusta-ramos [accessed: November 2016].

Folha Online (2006) 'Em 2001, megarrebelião comandada pelo PCC atingiu 29 penitenciárias'. *Folha Online – Cotidiano*, 13 May. [WWW document]. URL http://www1.folha.uol.com.br/folha/cotidiano/ult95u121415.shtml [accessed 10 May 2012].

Folha Online (2011) 'Protagonista do filme "Estamira"'. *Folha Online – Cotidiano*, 30 July. [WWW document]. URL http://www1.folha.uol.com.br/fsp/ cotidian/ff3007201115.htm [accessed November 2016].

Fontcuberta, J. (2007) *El beso de Judas: fotografía y verdad*. G. Gili: Barcelona.

Foucault, M. (1991) (trans. A. Sheridan) *Discipline and Punish: The Birth of the Prison*. Penguin: London.

França, A. (2012) '*Os dois corpos do réu ou as duas faces da imagem*'. [WWW document]. URL http://www.juizoofilme.com.br/php/imprensa_release.php? lang=pt [accessed 31 May 2012].

Fraser, M. and Greco, M. (eds.) (2005) *The Body: A Reader*. Routledge: London.

Freeman, J. (2002) 'Democracy and Danger on the Beach: Class Relations in the Public Space of Rio De Janeiro'. *Space and Culture* 5(1): 9–28.

Freire-Medeiros, B. (2009) *Gringo na laje: produção, circulação e consumo da favela turística*. Editora FGV: Rio de Janeiro.

Frente de Luta por Moradia (2011) '*Ocupação "Prestes Maia", comemora mais um ano neste sábado'*. 8 October. [WWW document]. URL http://www.portalflm. com.br/noticias/ocupacao-prestes-maia-comemora-mais-um-ano-neste-sabado/1516 [accessed 25 October 2012].

Gama, F. (2009) 'Etnografias, auto-representações, discursos e imagens: somando representações' in M. A. Gonçalves and S. Head (eds.) *Devires imagéticos: a etnografia, o outro e suas imagens*. 7Letras: Rio de Janeiro.

Garapa (2013a) 'Morar – Jornal'. *Morar*. [WWW Document]. URL http://issuu. com/fehlauer/docs/morar_garapa?mode=window [accessed 28 February 2013].

Garapa (2013b) '"Morar" on Vimeo'. *Vimeo*. Video. [WWW Document]. URL http://vimeo.com/11585818 [accessed 28 February 2013].

Garapa (2013c) 'O muro'. *Garapa*. [WWW Document]. URL http://garapa.org/ portfolio/o-muro/ [accessed 28 February 2013].

García Canclini, N. (1995) *Consumidores y ciudadanos: conflictos multiculturales de la globalización*. Grijalbo: Mexico City.

Gardnier, R. (2004) 'Entrevista com Paulo Sacramento e Aloysio Raulino'. *Contracampo: Revista de Cinema*, 14 April. [WWW Document]. URL http://www. contracampo.com.br/59/entrevistapaulosacramento.htm [accessed 10 April 2012].

Gee, S. (2010) *Making Waste: Leftovers and the Eighteenth-Century Imagination*. Princeton University Press: Princeton and Oxford.

Gerbase, F. (2011) 'Moradores do morro da providência protestam contra interdição de praça'. *O Globo*, 19 July. [WWW Document]. URL http://oglobo. globo.com/rio/moradores-do-morro-da-providencia-protestam-contra-interdicao-de-praca-2713856 [accessed 20 November 2012].

Globo (2011) 'Morre Estamira, personagem-título de premiado documentário brasileiro'. *Globo G1 Pop & Arte*, 28 July. [WWW Document]. URL http://g1. globo.com/pop-arte/noticia/2011/07/morre-estamira-personagem-titulo-de-premiado-documentario-brasileiro.html [accessed 14 December 2012].

Globo – Ação (2011) '*Jardim Gramacho: a vida num dos maiores aterros sanitários do mundo'*. 28 May. [WWW Document]. URL http://g1.globo.com/ acao/noticia/2011/05/jardim-gramacho-vida-num-dos-maiores-aterros-sanitarios-do-mundo.html [accessed 26 March 2012].

Gonçalo, P. (2012) 'The Subjective Turn in Brazilian Documentaries'. Conference paper. *Congress of the Latin American Studies Association*, San Francisco, California, 23–26 May. [WWW Document]. URL http://www.academia.edu/ 3350002/The_subjective_turn_in_Brazilian_Documentaries [accessed 15 September 2013].

Gregory, D. (1994) *Geographical Imaginations*. Blackwell: Cambridge, Oxford.

Grimshaw, A. (2001) *The Ethnographer's Eye: Ways of Seeing in Modern Anthropology*. Cambridge University Press: Cambridge.

Grimshaw, A. (2002) 'Eyeing the Field: New Horizons for Visual Anthropology'. *Journal of Media Practice* 3(1): 7–15.

Grosz, E. (1994) *Volatile Bodies: Toward a Corporeal Feminism*. Indiana University Press: Bloomington.

Grosz, E. (1995) *Space, Time and Perversion: Essays on the Politics of Bodies*. Routledge: New York.

Guardian (2009) 'Windows on a Fragile World'. *The Guardian - Art and Design*, 7 February. [WWW Document]. URL http://www.guardian.co.uk/artanddesign/2009/feb/07/prestes-maia-bittencourt-squat-brazil [accessed 23 October 2012].

Haddu, M. and Page, J. (eds.) (2009) *Visual Synergies in Fiction and Documentary Film from Latin America*. Palgrave Macmillan: Basingstoke.

Hall, S. (ed.) (1997). *Representation: Cultural Representations and Signifying Practices*. Sage: London.

Haraway, D. (1997) *Modest_Witness@Second_Millennium.FemaleMan_Meets_ OncoMouse: Feminism and Technoscience*. Routledge: New York–London.

Harazim, D. (2007) 'Foco distanciado: a trajetória de uma documentarista solitária'. *Revista Piauí online* (14). November. [WWW Document]. URL http://piaui.folha.uol.com.br/materia/foco-distanciado/ [accessed 20 November 2016].

Harrison, R. P. (2008) *Gardens: An Essay on the Human Condition*. University of Chicago Press: Chicago and London.

Harvey, D. (1989) *The Urban Experience*. Basil Blackwell: Oxford.

Harvey, D. (1990) *The Condition of Postmodernity: An Enquiry into the Origins of Cultural Change*. Blackwell: Oxford.

Hernández, F., Kellett, P. and Allen, L. K. (eds.) (2010) *Rethinking the Informal City: Critical Perspectives from Latin America*. Berghahn Books: New York and Oxford.

Herzog, H. M. and Levi Strauss, D. (eds.) (2002) *La Mirada: Looking at Photography in Latin America Today*. Daros Latin America Collection: Edition Oehrli: Zürich.

Hirsch, T. (2010) 'Rio Favela Tweets Create Overnight Celebrity'. *BBC News*, 29 November. [WWW Document]. URL http://www.bbc.co.uk/news/world-latin-america-11862593 [accessed 30 December 2012].

Hollanda, R. de (2000) 'Augusto Malta y el fotodocumentalismo brasileño' in *V Coloquio Latinoamericano De Fotografia*. Centro de la Imagen: Mexico, 273–275.

Imagens do Povo (2012a) *Imagens do Povo*. NAU Editora: Rio de Janeiro. [WWW Document]. URL http://www.imagensdopovo.org.br/portfolio/ [accessed 13 December 2012].

Imagens do Povo (2012b) [WWW Document]. URL http://www.imagensdopovo.org.br/ [accessed 9 December 2012].

Jacques, P. B. (2007) *Estética da ginga: a arquitetura das favelas através da obra de Hélio Oiticica*. Casa da Palavra: Rio de Janeiro.

Jaguaribe, B. (2004) 'Favelas and the Aesthetics of Realism: Representations in Film and Literature'. *Journal of Latin American Cultural Studies* **13**(3): 327–342.

Jaguaribe, B. (2007) *O choque do real: estética, mídia e cultura*. Rocco: Rio de Janeiro.

Jaguaribe, B. (2010) 'Beyond Reality: Notes on the Representations of the Self in Santo Forte and Estamira'. *Journal of Latin American Cultural Studies* **19**(3): 261–277.

Jaguaribe, C. (2011) 'Rio Emergente'. *Piauí*, May. [WWW Document]. URL http://revistapiaui.estadao.com.br/edicao-56/portfolio/rio-emergente [accessed 18 December 2012].

Jesus, C. M. de (1960) *Quarto de despejo*. Editora Paulo de Azevedo: São Paulo.

Joaquim, L. (2010) 'Cinema Pernambucano'. *Filme Cultura*, April.

Jocenir (2001) *Diário de um detento: o livro*. Labortexto Editorial: São Paulo.

Johnson, R. and Stam, R. (eds.) (1995) *Brazilian Cinema*. Columbia University Press: New York.

Jordan, S. (2010) 'The Poetics of Scale in Urban Photography' in C. Lindner (ed.) *Globalization, Violence, and the Visual Culture of Cities*. Routledge: Abingdon, 137–149.

Jornal Recife Melhor (2013) 'Um ano após a visita do presidente, Brasília Teimosa já é outra'. *Recife Melhor – Inclusão Social*. [WWW Document]. URL http://www.recife.pe.gov.br/recifemelhor/noticia.php?_Grupo_=20&EdicaoJornalAno=3&EdicaoJornalNumero=19&MateriaJornalSequencial=23 [accessed 8 January 2013].

Juízo (2012) Production website. [WWW Document]. URL http://www.juizoofilme.com.br/ [accessed 30 April 2012].

King, J. (1990) *Magical Reels: A History of Cinema in Latin America*. Verso: London.

Koonings, K. and Kruijt, D. (eds.) (2007) *Fractured Cities: Social Exclusion, Urban Violence and Contested Spaces in Latin America*. Zed Books: London and New York.

Kristeva, J. (1982) (trans. L. S. Roudiez) *Powers of Horror: An Essay on Abjection*. Columbia University Press: New York.

Labaki, A. (2006) *Introdução ao documentário brasileiro*. Francis: São Paulo.

Lauerhass, L. and Nava, C. (eds.) (2007) *Brasil: uma identidade em construção*. Atica: São Paulo.

Leal, L. N. (2011) 'Ninguém sabe quantas favelas existem no Rio'. *Estado de São Paulo*, 11 December. [WWW Document]. URL http://www.estadao.com.br/noticias/impresso,ninguem-sabe-quantas-favelas-existem-no-rio-,809440,0.htm [accessed 29 November 2012].

Lefebvre, H. (1991) (trans. D. Nicholson-Smith) *The Production of Space*. Basil Blackwell: Oxford.

Lemgruber, J. and Paiva, A. (2010) *A dona das chaves: uma mulher no comando das prisões do Rio de Janeiro*. Editora Record: Rio de Janeiro.

León, C. (2005) *El cine de la marginalidad: realismo sucio y violencia urbana*. Universidad Andina Simón Bolívar; Abya Yala; Corporación Editora Nacional: Quito.

Leu, L. (2009) 'Brazilian Cinema, Mass Media, and Criminal Subjectivities' in *Urban Mediations*. Conference paper. CRASSH: Cambridge.

Lindner, C. (ed.) (2006) *Urban Space and Cityscapes: Perspectives from Modern and Contemporary Culture*. Routledge: London.

Lins, C. (2004a) *O documentário de Eduardo Coutinho: televisão, cinema e vídeo*. Jorge Zahar: Rio de Janeiro.

Lins, C. (2004b) 'O Cinema de Eduardo Coutinho: uma arte do presente' in F. E. Teixeira (ed.) *Documentário no Brasil: tradição e transformação*. Summus Editorial: São Paulo, 179–198.

Lins, C. and Mesquita, C. (2008) *Filmar o real: sobre o documentário brasileiro contemporâneo*. Zahar: Rio de Janeiro.

Lira, A. (2011). 'Imagens de um olhar afetivo'. *Continente*, 11 June.

Low, J. and Malacrida, C. (eds.) (2008) *Sociology of the Body: A Reader*. Oxford University Press: Don Mills

Magalhães, A. (2000). 'Panorama de la fotografía moderna en Brasil'. *V Coloquio Latinoamericano de Fotografía*, Centro de la Imagen: Mexico, 41–47.

Magalhães, A. and Peregrino, N. (2004) *Fotografia no Brasil: um olhar das origens ao contemporâneo*. FUNARTE; Ministério de Cultura: Rio de Janeiro.

Martin, M. T. (1997) *New Latin American Cinema: Theory, Practices, and Transcontinental Articulations*, Vol. I. Wayne State University Press: Detroit.

Mascarello, F. (2004) 'O dragão da cosmética da fome contra o grande público: uma análise do elitismo da crítica da cosmética da fome e de suas relações com a universidade'. *Intexto* **11**: 1–14.

Mayes, S. (ed.) (1996) *This Critical Mirror: 40 Years of World Press Photo*. Thames and Hudson: London.

McDowell, L. (2003) 'Place and Space' in M. Eagleton (ed.) *A Concise Companion to Feminist Theory*. Blackwell: Malden and Oxford.

Melo Carvalho, M. L. (1996) *Novas Travessias: Contemporary Brazilian Photography*. Verso: London and New York.

Mendes, L. A. (2001) *Memórias de um sobrevivente*. Companhia das Letras: São Paulo.

Meyer, P. (1995) *Truths and Fictions: A Journey from Documentary to Digital Photography*. Aperture: New York.

Meyer, P. (2006) *The Real and the True: The Digital Photography of Pedro Meyer*. New Riders: Berkeley.

Migliorin, C. (2010) '5 x *Favela: agora por nós mesmos* e *Avenida Brasília Formosa*: da possibilidade de uma imagem crítica'. *Devires: Cinema e Humanidades* **7**(2): 38–55.

Migliorin, C. and Mesquita, C. (2011). '*Obra em processo ou processo como obra?*' Conference paper. Centro Cultural Banco do Brasil: Rio de Janeiro. [WWW Document]. URL http://www.revistacinetica.com.br/anos2000/debate05rj.php [accessed 28 May 2012].

Milliet, M. A. (ed.) (2005) *Mestres do Modernismo: exposição*. Pinacoteca, Imprensa Oficial: São Paulo.

Minh-ha, T. T. (1993) 'The Totalizing Quest of Meaning' in M. Renov (ed.) *Theorizing Documentary*. Routledge: New York, 90–107.

Mir, L. (2004) *Guerra civil: estado e trauma*. Geracão Editorial: São Paulo.

Morris, N. and Rothman, D. J. (eds.) (1995) *The Oxford History of the Prison: The Practice of Punishment in Western Society*. Oxford University Press: Oxford–New York.

Moura, A. Sobreira de (1987) 'Brasília Teimosa: The Organization of a Low-income Settlement in Recife, Brazil'. *Development Dialogue* **1**: 152–169.

Museum of Modern Art in Warsaw (2012) *Renzo Martens, Episode III: Enjoy Poverty*. Vimeo. Video. [WWW Document]. URL http://vimeo.com/30477574 [accessed 21 November 2012].

Nagib, L. (2002) *O cinema da retomada: depoimentos de 90 cineastas dos anos 90*. Editora 34: São Paulo.

Nagib, L. (2003) *The New Brazilian Cinema*. I. B. Tauris: London.

Nair, P. (2011) *A Different Light: The Photography of Sebastião Salgado*. Duke University Press: Durham.

Nichols, B. (1991) *Representing Reality: Issues and Concepts in Documentary*. Indiana University Press: Bloomington.

Nichols, B. (2001). *Introduction to Documentary*. Indiana University Press: Bloomington.

O Globo (2011) 'Governo paulista desiste de construir estação do metrô em Higienópolis'. *O Globo*, 12 May. [WWW Document]. URL http://oglobo.globo.com/pais/governo-paulista-desiste-de-construir-estacao-do-metro-em-higienopolis-2770984 [accessed 28 February 2013].

O'Brien, M. (2008) *A Crisis of Waste? Understanding the Rubbish Society*. Routledge: New York.

Observatório de Favelas (2009) 'Muros nas favelas'. *Observatório de Favelas*, 29 April. [WWW Document]. URL http://www.observatoriodefavelas.org.br/observatoriodefavelas/noticias/mostraNoticia.php?id_content=517 [accessed 13 February 2013].

Observatório de Favelas (2012). [WWW Document]. URL http://www.observatoriodefavelas.org.br/observatoriodefavelas/home/index.php [accessed 9 December 2012].

Ortiz, R. (1998) 'Diversidad cultural y cosmopolitismo'. *Nueva Sociedad* **155**: 22–36.

Page, J. (2009) 'Introduction: Fiction, Documentary, and Cultural Change in Latin America' in M. Haddu and J. Page (eds.) *Visual Synergies in Fiction and Documentary Film from Latin America*. Palgrave Macmillan: Basingstoke, 3–24.

Peixoto, N. B. (2009). *Paisagens urbanas*. Senac Editora: São Paulo.

Pelbart, P. P. (2003) *Vida capital: ensaios de biopolítica*. Iluminuras: São Paulo.

Pellow, D. (1996) *Setting Boundaries: The Anthropology of Spatial and Social Organization*. Bergin & Garvey: Westport.

Perlman, J. (2010) *Favela: Four Decades of Living on the Edge in Rio de Janeiro*. Oxford University Press: Oxford and New York.

Phillips, T. (2008) 'High Above Sao Paulo's Choked Streets, the Rich Cruise a New Highway'. *The Guardian*, 20 June. [WWW Document]. URL http://www.guardian.co.uk/world/2008/jun/20/brazil [accessed 29 December 2012].

Phillips, T. (2012) 'Mulheres Ricas: Brazil's Rich Women Brings Lives of Super-rich to TV'. *The Guardian - World News*, 3 January. [WWW Document]. URL http://www.guardian.co.uk/world/2012/jan/03/mulheres-ricas-brazil-rich-women [accessed 23 August 2012].

Pinto, L. de Aguiar Costa ([1953] 1998) *O negro no Rio de Janeiro: relações de raças numa sociedade em mudança*. Editora UFRJ: Rio de Janeiro.

Plantinga, C. (1996). 'Moving Pictures and the Rhetoric of Nonfiction: Two Approaches' in D. Bordwell and N. Carroll *Post-theory: Reconstructing Film Studies*. University of Wisconsin Press: Madison, 307–324.

Platt, D. and Neate, P. (2008) *A cultura é a nossa arma: AfroReggae nas favelas do Rio*. Civilização Brasileira: Rio de Janeiro.

Prado, M. (1999) *Os carvoeiros: The Charcoal People of Brazil*. Epigrama: Brazil.

Prado, M. (2004) *Jardim Gramacho*. Argumento: Rio de Janeiro.

Prefeitura de São Paulo (2011) 'Demolição dos edifícios São Vito e Mercúrio e prédios no entorno'. *Portal da Prefeitura da Cidade de São Paulo*, 25 October. [WWW Document]. URL http://www.prefeitura.sp.gov.br/cidade/secretarias/infraestrutura/noticias/?p=27745 [accessed 28 February 2013].

Prefeitura do Recife (2012) *'Recife sem palafitas'*. *Prefeitura do Recife*. [WWW Document]. URL http://www.recife.pe.gov.br/especiais/ recifesempalafitas/index.php [accessed 15 August 2012].

Ramos, F. P. (2008) *Mas afinal ...o que é mesmo documentário?* Editora Senac São Paulo: São Paulo.

Ramos, G. (1965) *Memórias do cárcere*. Martins: São Paulo.

Ramos, M. A. 'Não é apenas sobre a justiça'. Interview. [WWW Document]. URL http://www.juizoofilme.com.br/php/imprensa_release.php?lang=pt [accessed 1 June 2012].

Ramos, S. and Paiva, A. (2007) *Mídia e violência: novas tendências na cobertura de criminalidade e segurança no Brasil*. CESeC; IUPERJ; SEDH: Rio de Janeiro.

Rancière, J. (2009) (trans. G. Elliott). *The Emancipated Spectator*. Verso: London.

Rancière, J. (2010) (ed. S. Corcoran). *Dissensus: On Politics and Aesthetics*. Continuum: London–New York.

Regalado, A. (2009) 'Walls Around Rio's Slums Protect Trees But Don't Inspire Much Hugging'. *The Wall Street Journal*, 15 June. [WWW Document]. URL http://online.wsj.com/article/SB124501964322813585.html [accessed 28 November 2012].

Reynaud, A. T. J. (1998) *Brazilian Video Works: Diversity and Identity in a Global Context*. Unpublished PhD Thesis, University of Sussex, Falmer.

Ribeiro, M. (2011) 'Em plena guerra fria, disputa entre revistas "Life" e "O Cruzeiro" evidenciava preocupação dos EUA com avanço da esquerda no Brasil'. *O Globo - Política*, 7 May. [WWW Document]. URL http://oglobo. globo.com/politica/em-plena-guerra-fria-disputa-entre-revistas-life-o- cruzeiro-evidenciava-preocupacao-dos-eua-com-avanco-da-esquerda-no- brasil-2773019 [accessed 17 December 2012].

Rio Occupation London (2012) *Rio Occupation London*. [WWW Document]. URL http://www.riooccupationlondon.com/ [accessed 10 December 2012].

Ripper, J. R. (2009) *Imagens Humanas*. Dona Rosa Produções: Rio de Janeiro.

Rivkin, J. and Ryan, M. (2004) 'Introduction: Feminist Paradigms' in J. Rivkin and M. Ryan (eds.) *Literary Theory: An Anthology*. Blackwell: Oxford, 765–769.

Rocha, G. (1965) 'Uma estética da fome'. *Revista Civilização Brasileira* 1(3): 165–170.

Rocha, J. C. de Castro (2004) 'The "Dialectic of Marginality": Preliminary Notes on Brazilian Contemporary Culture'. Working Paper 62. Centre for Brazilian Studies, University of Oxford: Oxford.

Romero, S. and El Khouri Andolfato, G. (2012) 'Favelas são obstáculo para os grandes planos do Brasil para as Olimpíadas'. *UOL Notícias*, 6 March. [WWW Document]. URL http://noticias.uol.com.br/internacional/ultimas- noticias/2012/03/06/favelas-sao-obstaculo-bib-os-grandes-planos-do- brasil-bib-as-olimpiadas.htm [accessed 20 November 2012].

Rosenblum, N. (2007) *A World History of Photography*. Abbeville: New York.

Rossell, D. (2002) *Ricas y famosas* (trans. L. Gago). Turner Publicaciones: Madrid.

Rothenberg, P. (2008) *White Privilege: Essential Readings on the Other Side of Racism*. Worth Publishers: New York.

Sá, L. (2007) *Life in the Megalopolis: Mexico City and São Paulo*. Routledge: London–New York.

Saad-Filho, A. and Johnston, D. (eds.) (2005) *Neoliberalism: A Critical Reader*. Pluto Press: London.

Sachs, I., Wilheim, J. and Sérgio Pinheiro, P. (eds.) (2009) (trans. R. N. Anderson). *Brazil: A Century of Change*. University of North Carolina Press: Chapel Hill.

Salgado, S. (1990) *An Uncertain Grace: Photographs*. Thames & Hudson: London.

Salgado, S. (2000) *Êxodos*. Caminho: Lisbon.

Salvatore, R. D. and Aguirre, C. (eds.) (1996) *The Birth of the Penitentiary in Latin America: Essays on Criminology, Prison Reform, and Social Control, 1830–1940*. University of Texas Press: Austin.

Scheper-Hughes, N. (1992) *Death Without Weeping: The Violence of Everyday Life in Brazil*. University of California Press: Berkeley and Oxford.

Scheper-Hughes, N. (2010) 'Rubbish People'. *Berkeley Review of Latin American Studies* (Fall): 36–45.

Schreber, D. P. (1988) *Memoirs of My Nervous Illness* (trans. I. Macalpine and R. A. Hunter). Harvard University Press: Cambridge–London.

Setefotografia (2011) 'Diálogo 17 – Garapa e o Coletivo Morar'. *Setefotografia: Fotografia, Pesquisa e Debate*. 6 June. [WWW Document]. URL http://sete-fotografia.wordpress.com/2011/06/06/dialogo-015-garapa-e-o-coletivo-morar/ [accessed 20 November 2012].

Setti, R. (2012) 'Mulheres ricas não estão gostando do programa "Mulheres Ricas"'. *Veja*, 2 February. [WWW Document]. URL http://veja.abril.com.br/blog/ricardo-setti/tema-livre/mulheres-ricas-nao-estao-gostando-do-programa-mulheres-ricas/ [accessed 23 August 2012].

Shiel, M. and Fitzmaurice, T. (eds.) (2001) *Cinema and the City: Film and Urban Societies in a Global Context*. Blackwell: Oxford.

Soares, L. E., Batista, A. and Pimentel, R. (2005) *Elite da tropa*. Objetiva: Rio de Janeiro.

Soares, R. (2009) 'Olhar Liberto'. *Private Brokers - Coelho Da Fonseca*. Website, February. [WWW Document]. URL http://www.privatebrokers.com.br/edicoes/artigo.asp?cod=136 [accessed 18 December 2012].

Sodré, M. (1999) *Claros e escuros: identidade, povo e mídia no Brasil*. Editora Vozes: Petrópolis.

Sontag, S. (1979) *On Photography*. Penguin: Harmondsworth.

Souza e Silva, J. de (2001) 'A pluralidade de identidades no bairro Maré – Rio de Janeiro' in *GEOgraphia* 3(5): 76–88. [WWW Document]. URL http://www.uff.br/geographia/ojs/index.php/geographia/article/view/56/54 [accessed 31 January 2017].

Spivak, G. (1994) 'Can the Subaltern Speak?' in P. Williams and L. Chrisman (eds.) *Colonial Discourse and Post-colonial Theory: A Reader*. Longman: Harlow, 66–111.

Stallabrass, J. (1997) 'Sebastião Salgado and Fine Art Photojournalism'. *New Left Review* **223** (June): 131–160.

Stam, R. (1999) 'Palimpsestic Aesthetics: A Meditation on Hybridity and Garbage' in J. Fink and M. Joseph (eds.) *Performing Hybridity*. University of Minnesota Press: Minneapolis and London, 59–78.

Stepan, N. (2001) *Picturing Tropical Nature*. Cornell University Press: Ithaca.

TED (2013) 'Speakers – Vik Muniz: Artist'. TED conference presentation. [WWW Document]. URL http://www.ted.com/speakers/vik_muniz.html [accessed 6 January 2013].

Teixeira, F. E. (ed.) (2004) *Documentário no Brasil: tradição e transformação*. Summus Editorial: São Paulo.

Thompson, K. and Bordwell, D. (2003) *Film History: An Introduction*. McGraw-Hill: Boston.

Trotter, D. (2000) *Cooking with Mud: The Idea of Mess in Nineteenth-Century Art and Fiction*. Oxford University Press: Oxford.

UPP (2012) 'Unidade de Polícia Pacificadora - RJ'. *Unidade de Polícia Pacificadora – RJ*. [WWW Document]. URL http://upprj.com/wp/?page_id=20 [accessed 20 November 2012].

Valente, E. (2003) 'Autoria e autoridade em xeque: auto-retrato de um país'. *Contracampo*. [WWW Document]. URL http://www.contracampo.com.br/58/prisioneirocineclube.htm [accessed 10 April 2012].

Valente, E. (2010) '*Um dia na vida*, de Eduardo Coutinho'. *Revista Cinética*, October. [WWW Document]. URL http://www.revistacinetica.com.br/umdianavida.htm [accessed 29 December 2012].

Valente, R. (2011) 'STJ anula provas e condenação de Daniel Dantas'. *Folha.com – Poder*, 7 June. [WWW Document]. URL http://www1.folha.uol.com.br/poder/926730-stj-anula-provas-e-condenacao-de-daniel-dantas.shtml [accessed 7 June 2012].

Valladares, L. do Prado (2005) *A invenção da favela: do mito de origem a favela.com*. Editora FGV: Rio de Janeiro.

Varella, D. (1999) *Estação Carandiru*. Companhia das Letras: São Paulo.

Velloso, M. P. (2008) 'Os restos na história: percepções sobre resíduos'. *Ciência & Saúde Coletiva* 13(6): 1953–1964. [WWW document]. URL http://www.scielo.br/scielo.php?script=sci_arttext&pid=S1413-81232008000600031&lng=pt&nrm=iso&tlng=pt [accessed 25 March 2012].

Ventura, M. (2008) 'Dois sucos e a conta … com Luciana Fiala'. *Revista O Globo*, 2 March.

Ventura, Z. (1994) *Cidade partida*. Companhia das Letras: São Paulo.

Vidler, A. (1991) 'Agoraphobia: Spatial Estrangement in Georg Simmel and Siegfried Kracauer'. *New German Critique* 54: 31–45.

Wacquant, L. (2001). *As prisões da miséria* (trans. A. Telles). Jorge Zahar: Rio de Janeiro.

Walmsley, R. (2011) 'ICPS World Prison Brief - BRAZIL'. *International Centre for Prison Studies*. [WWW Document]. URL http://www.prisonstudies.org/info/worldbrief/wpb_country_print.php?country=214 [accessed 24 April 2012].

Ward, G. (ed.) (2000) *The Certeau Reader*. Blackwell: Oxford.

Watts, J. and Cartner-Morley, J. (2007) 'Waste Land'. *The Guardian*, 31 March. [WWW Document]. URL http://www.guardian.co.uk/environment/2007/mar/31/china.waste [accessed 3 January 2013].

Webber, A. and Wilson, E. (eds.) (2008) *Cities in Transition: The Moving Image and the Modern Metropolis*. Wallflower: London.

Wells, L. (ed.) (2000) *Photography: A Critical Introduction*. Routledge: London.

Williams, C. (2007) 'The Favela's Revenge: Portrayals of Life in the Shantytowns in Recent Brazilian Fiction' in V. Carpenter (ed.) *A World Torn Apart: Representations of Violence in Latin American Narrative*. Peter Lang: Oxford, 231–247.

Williams, C. (2008) 'Ghettourism and Voyeurism, or Challenging Stereotypes and Raising Consciousness? Literary and Non-Literary Forays into the Favelas of Rio De Janeiro'. *Bulletin of Latin American Research* 27(4): 483–500.

Winant, H. (2001) *The World Is a Ghetto: Race and Democracy Since World War II*. Basic Books: New York.

Wirth, L. (1938) 'Urbanism as a Way of Life'. *American Journal of Sociology* **44**(1): 1–24.

Xavier, I. (2001) *O cinema brasileiro moderno*. Paz e Terra: São Paulo.

Xavier, I. (2010) 'Indagações em torno de Eduardo Coutinho e seu diálogo com a tradição moderna' in C. Migliorin (ed.) *Ensaios no real: o documentário brasileiro hoje*. Azougue: Rio de Janeiro, 65–79.

Zaluar, A. and Alvito, M. (eds.) (1999) *Um século de favela*. Fundacão Getúlio Vargas: Rio de Janeiro.

Zazen Produções (2016) '*Estamira* – Official Site'. [WWW Document]. URL http://www.zazen.com.br/estamira2/ [accessed November 2016].

Filmography

Primary Materials

Avenida Brasília Formosa, 2010. Directed by Gabriel Mascaro. Recife: Plano 9 Produções.

Babilônia 2000, 2000. Directed by Eduardo Coutinho. Rio de Janeiro: VideoFilmes.

Estamira, 2004. Directed by Marcos Prado. Rio de Janeiro: Zazen Produções.

Juízo, 2007. Directed by Maria Augusta Ramos. Rio de Janeiro: Diler & Associados.

Lixo extraordinário, 2010. Directed by Lucy Walker, João Jardim, Karen Harley. Brazil/UK: O2 Filmes/Almega Projects.

O prisioneiro da grade de ferro: auto-retratos, 2004. Directed by Paulo Sacramento. São Paulo: Olhos de Cão Filmworks.

Other Works Referenced

5 x favela: agora por nós mesmos, 2010. Directed by Cacau Amaral, Cadu Barcelos, Luciana Bezerra, Manaira Carneiro, Rodrigo Felha, Wagner Novais, Luciano Vidigal. Rio de Janeiro: Globo Filmes/Luz Mágica.

Amarelo manga, 2002. Directed by Cláudio Assis. Pernambuco: Olhos de Cão Produções.

Baile perfumado, 1996. Directed by Paulo Caldas and Lírio Ferreira. Brazil: Saci Filmes.

Bicho de sete cabeças. 2001. Directed by Laís Bodanzky. Brazil: Buriti Filmes/ Dezenove Som e Imagem/Fabrica Cinema/Gullane Filmes.

Boca de lixo, 1993. Directed by Eduardo Coutinho. Brazil: Centro de Criação de Imagem Popular.

Brasília, um dia em fevereiro, 1996. Directed by Maria Augusta Ramos. Netherlands/Brazil: NFTA/Fundação Athos Bulcão.

Butterflies in your Stomach. 1999. Directed by Maria Augusta Ramos. Netherlands: VPRO Television.

Cabra marcado para morrer, 1985. Directed by Eduardo Coutinho. Brazil: Eduardo Coutinho Produções Cinematográficas/Mapa Filmes.

Carandiru, 2003. Directed by Hector Babenco. Argentina/Brazil/Italy: Oscar Kramer S.A./Globo Filmes/Columbia TriStar Filmes do Brasil/HB Filmes/ BR Petrobrás/Lereby Productions.

O cárcere e a rua, 2005. Directed by Liliana Sulzbach. Brazil: Zeppelin Filmes.

Os carvoeiros, 2000. Directed by Marcos Prado. Brazil: Zazen Produções.

Cidade de Deus, 2002. Directed by Fernando Meirelles and Kátia Lund. Brazil/France: O2 Filmes/VideoFilmes.

Cinco vezes favela, 1962. Directed by Miguel Borges, Joaquim Pedro de Andrade, Carlos Diegues, Marcos Farias and Leon Hirszman. Brazil: Centro Popular de Cultura da UNE/Saga Filmes.

Cinema, aspirinas e urubus, 2005. Directed by Marcelo Gomes. Brazil: Dezenove Filmes/Rec Produtores Associados.

Cronicamente inviável, 2000. Directed by Sérgio Bianchi. Brazil: Agravo Produções Cinematográficas.

Desi, 2000. Directed by Maria Augusta Ramos. Netherlands: Pieter van Huystee Film/VPRO Television.

Deus e o diabo na terra do sol, 1964. Directed by Glauber Rocha. Brazil: Copacabana Filmes.

Um dia na vida, 2010. Directed by Eduardo Coutinho. Brazil: VideoFilmes.

Doméstica, 2012. Directed by Gabriel Mascaro. Brazil: Desvia.

Edifício Master. 2002. Directed by Eduardo Coutinho. Brazil: VideoFilmes.

Entre a luz e a sombra, 2009. Directed by Luciana Burlamaqui. Brazil: Zora Mídia.

Entreatos, 2004. Directed by João Moreira Salles. Brazil: VideoFilmes.

Episode 3 'Enjoy Poverty', 2009. Directed by Renzo Martens. Netherlands: Inti Films/ Renzo Martens Menselijke Activiteiten/VPRO/ Lichtpunt Televisie.

O fim e o princípio, 2006. Directed by Eduardo Coutinho. Brazil: VideoFilmes.

Ilha das flores, 1989. Directed by Jorge Furtado. Brazil: Casa de Cinema de Porto Alegre.

Inside Job, 2010. Directed by Charles Ferguson. USA: Representational Pictures.

O invasor, 2002. Directed by Beto Brant. Brazil: Drama Filmes.

Jogo de cena, 2007. Directed by Eduardo Coutinho. Brazil: Matizar/VideoFilmes.

Justiça, 2004. Directed by Maria Augusta Ramos. Brazil/Netherlands: Selfmade Films/Limite Production/NPS Television.

Leite e ferro, 2009. Directed by Cláudia Priscila. Brazil: PaleoTV.

Um lugar ao sol, 2009. Directed by Gabriel Mascaro. Brazil: Plano 9 Produções/Símio Filmes.

Manufactured Landscapes, 2006. Directed by Jennifer Baichwal. Canada: Foundry Films/National Film Board of Canada.

À margem do concreto, 2005. Directed by Evaldo Mocarzel. Brazil: Casa Azul Produções Artísticas.

Memórias do cárcere, 1984. Directed by Nelson Pereira dos Santos. Brazil: Embrafilme/Luiz Carlos Barreto Produções Cinematográficas/Regina Filmes.

Moscou, 2009. Directed by Eduardo Coutinho. Brazil: Matizar/VideoFilmes.

Notícias de uma guerra particular, 1999. Directed by Kátia Lund and João Moreira Salles. Brazil: VideoFilmes.

Ônibus 174, 2002. Directed by José Padilha and Felipe Lacerda. Brazil: Zazen Produções.

Orfeu negro, 1959. Directed by Marcelo Camus. Brazil/France/Italy: Dispat Films/Tupan Filmes/Gemma Cinematografica.

Pacific, 2009. Directed by Marcelo Pedroso. Brazil: Símio Filmes.

Pixote: a lei do mais fraco, 1981. Directed by Hector Babenco. Brazil: Embrafilme/HB Filmes.

Quem Matou Pixote?, 1996. Directed by José Joffily. Brazil: Coevos Filmes.

O rap do pequeno príncipe contra as almas sebosas, 2000. Directed by Paulo Caldas and Marcelo Luna. Brazil: Luni Produções/Raccord Produções/Rec Produtores Cinematografica/Superfilmes.

Rio 40 graus, 1955. Directed by Nelson Pereira dos Santos. Brazil: Equipe Moacyr Fenelon.

Santa Marta: duas semanas no morro, 1987. Directed by Eduardo Coutinho. Brazil: Instituto Superior de Estudos da Religão.

Slumdog Millionaire, 2008. Directed by Danny Boyle and Loveleen Tandan. UK: Celador Films.

Tropa de elite. 2007. Directed by José Padilha. Brazil: Zazen Produções/The Weinstein Company/Feijão Filmes/Posto 9.

Tropa de elite 2: o inimigo agora é outro, 2010. Directed by José Padilha. Brazil: Zazen Produções/Globo Filmes/Feijão Filmes/Riofilme.

Television Series

Big Brother Brasil, 2002. Brazil: Rede Globo de Televisão.

Pop Idol, 2001–2003. UK: ITV.

Ídolos, 2006–2012. Brazil: Rede Record.

Mulheres ricas, 2012–2013. Brazil: Band.

Why Poverty?, 2012. UK: BBC Four.

Online Photography Collections

Cia de Foto [WWW document] URL http://www.ciadefoto.com/ [accessed February 2013].

Garapa 'Morar' and 'O muro' [WWW document] URL http://garapa.org/ [accessed February 2013].

Imagens do Povo [WWW document] URLhttp://www.imagensdopovo.org.br/ [accessed February 2013].

Jaguaribe, Claudia [WWW document] URL http://www.claudiajaguaribe.com.br/br/obra/ [accessed February 2013].

Lobo, Pedro http://www.pedrolobofoto.com [accessed November 2016].

Index